Art in Public

Politics, Economics, and a Democratic Culture

Why should governments provide funding for the arts? What do the arts contribute to daily life? Do artists and their publics have a social responsibility? Challenging questionable assumptions about the state, the arts, and a democratic society, Lambert Zuidervaart presents a vigorous case for government arts funding, based on crucial contributions the arts make to civil society. He argues that the arts contribute to democratic communication and a social economy, fostering the critical and creative dialogue that a democratic society needs. Informed by the author's experience leading a nonprofit arts organization as well as his expertise in the arts, humanities, and social sciences, this book proposes an entirely new conception of the public role of art with wide-ranging implications for education, politics, and cultural policy.

Lambert Zuidervaart is Professor of Philosophy at the Institute for Christian Studies, Toronto, and an Associate Member of the Graduate Faculty in Philosophy at the University of Toronto. He is the former president of the Urban Institute for Contemporary Arts in Grand Rapids, Michigan. His book *Adorno's Aesthetic Theory* (1991) was the first major study in English on Adorno's aesthetics. His most recent books with Cambridge University Press – *Artistic Truth: Aesthetics, Discourse, and Imaginative Disclosure* (2004) and *Social Philosophy after Adorno* (2007) – received Symposium Book Awards from the Canadian Society for Continental Philosophy.

Art in Public

Politics, Economics, and a Democratic Culture

LAMBERT ZUIDERVAART

Institute for Christian Studies
University of Toronto

CAMBRIDGE
UNIVERSITY PRESS

CAMBRIDGE UNIVERSITY PRESS
Cambridge, New York, Melbourne, Madrid, Cape Town,
Singapore, São Paulo, Delhi, Mexico City

Cambridge University Press
32 Avenue of the Americas, New York, NY 10013-2473, USA

www.cambridge.org
Information on this title: www.cambridge.org/9780521130172

First published 2011
Reprinted 2012

A catalog record for this publication is available from the British Library.

Library of Congress Cataloging in Publication Data

Zuidervaart, Lambert
Art in public: politics, economics, and a democratic culture / Lambert Zuidervaart.
 p. cm.
Includes bibliographical references and index.
ISBN 978-0-521-11274-1 – ISBN 978-0-521-13017-2 (pbk.)
1. Goverment aid to the arts. 2. Democracy and the arts.
3. Arts and society. I. Title.
NX720.Z85 2011
700.1´03–dc22 2010030603

ISBN 978-0-521-11274-1 Hardback
ISBN 978-0-521-13017-2 Paperback

For Ron Otten
You are a gift.

Contents

Preface

The initial impetus for this book came from my study of Theodor
W. Adorno's socially critical and modernist aesthetics. I argued in
Adorno's Aesthetic Theory that his conception of artistic truth has much
to offer aesthetics today, but it employs an autonomist theory of art
that is both flawed and outdated. In making this argument I drew on
Jürgen Habermas's insights into the paradoxes of modernization. Yet
I found Habermas's social philosophy insufficiently attuned to the
concerns of contemporary artists.

Having learned from both Adorno and Habermas, I set out to
develop a social philosophy of the arts that addresses cultural contro-
versies. This has required two volumes. The first, titled *Artistic Truth*,
examines the aesthetic, linguistic, and epistemological frameworks
of contemporary art. Discussing both analytic and continental phi-
losophies, it weds Adorno's idea of artistic truth with Habermas's
emphasis on communicative rationality, while modifying both. The
second volume is the book you are now reading. *Art in Public* provides
a social philosophical context for the first volume's claims about artis-
tic truth, and it employs those claims to develop a new understanding
of art's role in civil society. Together the two volumes aim to provide
a comprehensive critical theory that breaks the grip of modernist aes-
thetics without discounting the importance of modernist ideas.

Early indications of what this aim entails occurred in two essays
published in 2000. Substantial portions of Chapters 8 and 9 herein
stem from these essays: Chapter 8 from "Creative Border Crossing in

New Public Culture," in *Literature and the Renewal of the Public Sphere*, edited by Susan VanZanten Gallagher and Mark D. Walhout (London: Macmillan; New York: St. Martin's Press, 2000); and Chapter 9 from "Postmodern Arts and the Birth of a Democratic Culture," in *The Arts, Community and Cultural Democracy*, edited by Lambert Zuidervaart and Henry Luttikhuizen (London: Macmillan; New York: St. Martin's Press, 2000). These materials are reproduced here with the permission of Palgrave Macmillan. Linda Nemec Foster's poem "Immigrant Children at Union School," quoted in Chapter 8, comes from her collection *Amber Necklace from Gdansk: Poems* and is used with the permission of Louisiana State University Press. I thank these publishers for their permissions.

Nancy Fraser once observed that cultural theorizing in North America is "largely dissociated from social theorizing." She urged critical theorists to adopt a "bivalent" approach, one that integrates "the social and the cultural, the economic and the discursive." Although many scholars now recognize the need for a bivalent approach, surprisingly few work it out in detail. It rarely occurs among philosophers who specialize in aesthetics. This book and its companion volume aim to be an exception. They seek to provide a cross-disciplinary philosophy of the arts that addresses not only issues within philosophy and the humanities but also questions of social theory and cultural policy.

Although *Art in Public* discusses social scientific literature and cultural policy debates, my approach is theoretical rather than empirical. I am especially interested in uncovering and elaborating conceptual frameworks. Rather than simply take one side in ongoing debates about government funding for the arts, for example, I ask what the advocates and opponents assume with respect to the arts, the state, and a democratic society. I also offer a normative critique, questioning the social vision within various theoretical models and policy positions and articulating a different social vision. Both commentary and critique serve a constructive purpose. I aim to develop a new sociocultural theory, spelling out the premises and conclusions not only of the positions I challenge but also of the positions I hold.

Philosophical interventions in public debates about cultural policies cannot be neutral. Necessarily philosophers will have positions that align them with one side or another, and preferably they will

announce and defend those positions. As a scholar, as a citizen, and as a participant in the arts, I have political and cultural allegiances, and these inform my views about cultural policies and the theoretical questions they raise. Yet I disavow narrow-minded partisanship. Intellectual integrity and the norms of democratic discourse require that a scholar who addresses issues of public debate does so with care, attending to possible objections and alternative voices, and acknowledging genuine insights, no matter where these arise. The persons with whom one disagrees, and the institutions one criticizes, should receive the same degree of respect to be claimed for one's own contribution. I hope to have shown such respect in the current volume.

Perhaps there was a time in North American public life when a scholar's explicit denial of nonneutrality would not have been acceptable, just as an explicit disavowal of narrow-mindedness would not have been necessary. If there was such a time, it has faded into cultural myth or memory, calling forth mixed interpretations. Whereas for some the new forms of positional and oppositional inquiry signal intellectual decay and societal fragmentation, for others they promise an era of intellectual creativity and societal transformation. I incline toward the second reading. At the same time, however, I share a concern that the new forms of inquiry will not sustain genuine creativity unless intellectuals and the cultural institutions they inhabit forge new patterns of democratic discourse and inculcate an ethos of mutual recognition.

Two organizations in particular have nurtured this concern. They have also taught me what socioculturally engaged and cross-disciplinary inquiry should be like. The first is the Institute for Christian Studies (ICS) in Toronto. I have been associated with ICS for nearly forty years, originally as a graduate student and most recently as a faculty member. ICS is an independent graduate school for interdisciplinary philosophy with sources in a transformational branch of Dutch Calvinism. Most of ICS's operating income comes from members and supporters who have not attended graduate school but enthusiastically endorse the organization's mission. While this fact makes ICS vulnerable to economic pressures, it also fosters an ethos of collaboration and commitment that is unusual in the academic world. Combined with ICS's conviction that philosophy should address the central issues of life and society in dialogue with

other disciplines, this ethos makes ICS an incubator for the sort of inquiry that I pursue. Were it not for my long association with ICS, I might never have dreamed up this book, not to mention actually writing much of it during the release time ICS granted.

My association with the second organization began more recently but has had an equally profound impact on my scholarship. As the preface to *Artistic Truth* mentions, my interactions in the 1990s with artists, volunteers, staff, board members, and a broader public at the Urban Institute for Contemporary Arts (UICA) in Grand Rapids, Michigan, have permeated my reflections about the role of art in civil society. This is readily apparent in the current book, where several examples come from my experience as UICA's board president and capital campaign co-chair, including the "UICA Story" told in Chapter 6. This experience has convinced me that vibrant civic-sector organizations are crucial in a democratic society and that art needs such organizations in order to thrive. Like ICS, UICA has demonstrated patterns of democratic discourse and mutual recognition that socioculturally engaged scholarship and art require. Here I simply record with appreciation my indebtedness to both organizations.

I also am grateful for funding from the Social Sciences and Humanities Research Council of Canada (SSHRC). The Standard Research Grant I received from SSHRC supported the work of three doctoral candidates at ICS: Allyson Carr, Michael DeMoor, and Matthew Klaassen. I thank all three of them for their valuable research and timely advice. Matt also prepared the index for this book, as he had done for *Artistic Truth* and for *Social Philosophy after Adorno*, a book published in 2007 that articulates the central ideas in my social philosophy.

Last year Matt and Allyson joined me in organizing a conference at ICS, co-sponsored by the Centre for Ethics at the University of Toronto, on "The Arts and Social Responsibility." Held in March 2009, this conference provided a congenial setting to explore themes that *Art in Public* makes prominent. I wish to thank all of the conference participants for their lively and informed discussions, especially keynote speaker Mary Devereaux and fellow panelists Sara Diamond, president of the Ontario College of Art and Design, and Melissa Williams, director of the Centre for Ethics at the University of Toronto.

My colleague Rebekah Smick chaired our conference panel. Rebekah occupies the position at ICS in Philosophy of the Arts and Culture once held by Calvin Seerveld. Cal, who has been my mentor since I began graduate studies at ICS in 1972, offered extensive and insightful comments on several draft chapters. I am grateful to both Rebekah and Cal for their encouragement and support. I also am thankful for the love and understanding of Joyce Recker, my partner for life. Perhaps more than anything else, Joyce's work as an artist and volunteer at UICA in the 1990s inspired my conception of art in public.

Twenty years ago, on the occasion of my fortieth birthday, I received a present from Ron Otten. He gave me *The Gift: Imagination and the Erotic Life of Property* by Lewis Hyde. Inscribed on the inside cover of the book are the following words: "Lambert, you are a gift." That present and Ron's friendship launched a voyage of philosophical and sociocultural exploration that only now is reaching a harbor.

In the immediately preceding years, Ron had received an MFA in acting at York University. Convinced, as Hyde was, that the arts are primarily gifts, not commodities, he then established a new not-for-profit troupe in Toronto. The Joker Man Theatre Company did not last long. During its final months Ron and Joyce and I, along with our cat Ebony and dog Rosa, lived together for a semester in Toronto. I taught at ICS, Joyce pursued her art projects, and Ron worked for TVO, a provincially funded broadcaster. As the three of us shared meals and daily conversations, and as we watched with mounting frustration the destructive spectacle now known as the "First Gulf War," the compass for this book was set.

In subsequent years my travels frequently took me to Amsterdam, where Ron had moved. Conversations with him there provided the inspiration and challenge I needed to continue the journey he had helped me begin. Now, with the end in sight, and on the occasion of his fiftieth birthday, I take delight in returning his favor. I inscribe this book to him: Ron, you are a gift.

Lambert Zuidervaart
Toronto
June 17, 2010

PART I

DOUBLE DEFICIT

1

Culture Wars

Whenever I hear the word "culture" I reach for my revolver.

Friedrich Thiemann[1]

In 1989 Senator Jesse Helms called artist Andres Serrano "a jerk." Speaking on the floor of the United States Senate, the Republican senator from North Carolina endorsed a letter to the National Endowment for the Arts (NEA), drafted by Senator Alfonse D'Amato (R-N.Y.), which objected to the NEA's supporting "a so-called 'work of art' by Andres Serrano entitled 'Piss Christ.'"[2] According to Senator Helms, "What this Serrano fellow did, he filled a bottle with his own urine and then stuck a crucifix down there – Jesus Christ on a cross. He set it up on a table and took a picture of it. For that, the National Endowment for the Arts gave him $15,000, to honor him as

[1] Friedrich Thiemann is a character in the play *Schlageter*, written by the German playwright and Nazi Poet Laureate Hanns Johst and performed to celebrate Hitler's birthday and his coming to power in 1933. See *Hanns Johst's Nazi Drama Schlageter*, trans. Ford B. Parkes-Perret (Stuttgart: Akademischer Verlag Hans-Dieter Heinz, 1984). The actual line spoken by Thiemann (p. 89) is "When I hear the word culture ..., I release the safety on my Browning!" ("Wenn ich Kultur höre...entsichere ich meinen Browning!") – a less snappy phrase, and perhaps one less easily misattributed to a whole rogues' gallery of Nazi "leaders," including Hermann Göring, Heinrich Himmler, and Joseph Goebbels. They might not have said it, but the sentiment expressed was not foreign to their ideology.

[2] Letter dated May 18, 1989, addressed to Mr. Hugh Southern, acting chairman of the NEA, and signed by D'Amato, Helms, and more than twenty other senators; reprinted in Richard Bolton, ed., *Culture Wars: Documents from the Recent Controversies in the Arts* (New York: New Press, 1992), pp. 29–30.

3

an artist. I say…he is not an artist. He is a jerk. And he is taunting the American people, just as others are.…And I resent it. And I do not hesitate to say so."[3] The lines of battle could hardly be more starkly drawn: a powerful conservative senator attacking an accomplished artist and defending "the American people" from the alleged taunts of this "jerk" – with a federal arts agency caught in the middle. The so-called culture wars, described by one observer as a "struggle to define America," had begun.[4]

The American battle over federal arts funding and its less heated counterpart in Canada continued through the 1990s, until the events of September 11, 2001, and a "war on terrorism" diverted cultural warriors to other controversies. Yet the struggle has not ended. One notes, for example, a federal election in Canada during the fall of 2008. Defending his government's decision to cut $45 million in funding for the arts and culture, Prime Minister Stephen Harper remarked: "I think when ordinary working people come home, turn on the TV and see…a bunch of people at, you know, a rich gala all subsidized by taxpayers claiming their subsidies aren't high enough, when they know those subsidies have actually gone up – I'm not sure that's something that resonates with ordinary people."[5] More politely than Helms, perhaps, yet targeting many artists rather than one, Harper in effect called all of them jerks and asked "ordinary working people" to back him up. An undercurrent of pseudopopulism and resentment runs through the speeches of both politicians, despite the national borders and nearly twenty years that separate them.

Such attacks on artists by prominent politicians add both urgency and confusion to questions that are in any case hard to answer. What should the arts contribute to a democratic society? What is the proper

[3] From the *Congressional Record* for May 18, 1989, reprinted in ibid., p. 30.
[4] James Davison Hunter, *Culture Wars: The Struggle to Define America* (New York: Basic Books, 1991). For a contemporaneous sociological account of the art–political skirmishes within this larger struggle, see Steven C. Dubin, *Arresting Images: Impolitic Art and Uncivil Actions* (New York: Routledge, 1992). These and similar skirmishes are put into historical perspective by Michael Kammen, *Visual Shock: A History of Art Controversies in American Culture* (New York: Alfred A. Knopf, 2006). For reflections that are closer to the artistic ground, see *Art Matters: How the Culture Wars Changed America*, ed. Brian Wallis, Marianne Weems, and Philip Yenawine (New York: New York University Press, 1999).
[5] Quoted in "Ordinary Folks Don't Care about Arts: Harper," *Toronto Star*, September 24, 2008, http://www.thestar.com.

role of government with respect to the arts? And, in light of the first two questions, what justifies government funding for the arts?

In the past few decades, public debates about these questions in Canada and the United States have revolved around three other questions: Is government funding beneficial to artists and their publics, or would it be better for artists to compete in the economic marketplace without government support? Should government funding come "with no strings attached," or should it uphold standards of decency and social order? Are contemporary artists progressive agents of social change, or are they a decadent menace to society? This book argues that to frame the debate in these three ways is counterproductive. Both advocates and critics of government arts funding assume outdated and questionable views of the state, the arts, and the nature of a democratic society. I challenge these assumptions by developing the concepts of civil society, relational autonomy, and cultural democracy.

I realize, of course, that controversies about government funding for the arts raise many specific questions and point to numerous fields of study. But my goal is to call attention to recurring themes and shared topics, to uncover and challenge widely shared philosophical assumptions, and to propose an alternative conception of art in public. I recognize, too, that the cultural, political, and economic issues surrounding government funding in North America vary for different types of art and in different jurisdictions. Yet the philosophical vocabularies and positions framing debates on these issues do not differ significantly from one art form or political jurisdiction to the next.

This chapter aims to identify commonalities at the level of conceptual framework. After describing three polarities in recent debates about government funding for the arts and exposing shared assumptions to critical commentary, I propose a different approach to these issue, which is elaborated in subsequent chapters.

1.1 POLARITIES

Three conceptual polarities pervade North American debates about government funding for the arts. The first is an opposition between endorsing government support and advocating a strictly free market

approach. The second is a tension between protecting the freedom of artistic expression and maintaining the authority of traditional values. The third is a conflict between images of contemporary art as a provocative challenge to the status quo and portrayals of it as a decadent menace to society. The two main camps waging cultural warfare include those who call for government support, freedom of expression, and provocative challenges, on the one hand, and those who defend the free market and traditional values while blasting cultural decadence, on the other. Let me describe the three polarities in more detail, with a view to the philosophical assumptions the two camps share.

Government Versus Market

Both those who advocate government funding for the arts and those who oppose it cast their arguments in instrumental terms. The advocates claim that many deserving artists and arts organizations would not thrive or even survive without government funding. Moreover, because government funding attracts corporate and individual support, governments get an incredible return on their minimal investment in the arts. Often the advocates of government funding avoid difficult questions about which arts should thrive and why they should thrive.

Proponents of the free market approach, by contrast, think that the government has no business meddling in what they regard as essentially a private enterprise. They trust the market to sort out which artists and arts organizations will survive. In fact, they often embrace a Social Darwinian view: the arts that make it in a capitalist economy are precisely the arts that deserve to thrive. Furthermore, they think government support, whether through direct funding or through tax policy, usually leads to the imposition of undesirable art on unwilling taxpayers without their knowledge or their consent.

Put in such starkly instrumental terms, the debate between advocates and opponents of government funding skirts crucial philosophical issues. Unless one has already established that (some) art is a good whose support is in the public interest, there is little reason in principle why the government should be involved, and claims about the beneficial effects of government funding are beside the

point. Similarly, unless one has already established that (all) art is a commodity-producing and commodity-consuming enterprise whose operation should meet economic criteria of efficiency and market-ability, there is little reason in principle why the marketplace should be preferred over government support, and claims about the advantages of the free market are neither here nor there. Each camp in its own way accepts the current politico-economic system: one side has confidence in the political system and mutes its democratic deficits, while the other side trusts the economic system and ignores its cultural deficits. Yet the philosophical issues at stake in their debate pertain precisely to questions about democracy and culture.

Freedom Versus Authority

Before the 1960s, North American advocates of free market forces made common cause with those who defended the freedom of artistic expression. With the creation of the Canada Council for the Arts (CCA) in 1957 and the establishment of the National Endowment for the Arts (NEA) in 1965, however, and the rise of new social movements and a religious Right, a dramatic realignment occurred. Now advocates of free market forces regularly team up with outspoken critics of artistic freedom who defend the authority of traditional values. So too advocates of government funding now usually cooperate with those who insist on the freedom of artistic expression. Just as protecting the freedom of artistic expression is no longer a primary reason for opposing government funding, so too promoting social cohesion is no longer a primary reason for urging government support. The conceptual polarities under discussion reflect larger shifts in the political, economic, and cultural terrain.

The most heated debates in recent years have occurred amid legal battles over government-administered projects (such as Richard Serra's *Tilted Arc*, 1981), state-funded works (such as Andres Serrano's *Piss Christ*, 1987), and publicly accessible exhibitions and performances (such as the Robert Mapplethorpe exhibit at Cincinnati's Contemporary Art Center in 1990). Given the legal context, those who promote the freedom of artistic expression couch their case in the language of rights. More specifically, they make or assume a connection between the freedom of artistic expression and the right to

free expression guaranteed in the United States by Article I of the Bill of Rights and in Canada by Section Two of the Canadian Charter of Rights and Freedoms.[6] The advocates of free artistic expression often regard this as the equal right of each individual artist to pursue his or her own project.

On the other side, contemporary champions of "family values" can be dangerously dismissive of individual rights. Many who have wanted to shut down the NEA do not merely object to government funding for art that challenges traditional values. They also think the government should actively promote traditional values, even if this means squelching the voices of opposition. When it comes to questions of civil liberties and public expression, there is not that large a distance between positions taken by Reverend Donald Wildmon's American Family Association and Nazi cultural policy[7] – a proximity made apparent by the 1991 *Degenerate Art* exhibition in Los Angeles and Chicago.[8]

Confusion reigns on both sides of the freedom-authority divide. The freedom side too often collapses two different concepts of freedom: the occasion and opportunity to engage in artistic expression, and the constitutionally guaranteed right to engage in governmentally unabridged public discourse. Although there are situations where the denial of the first type of freedom coincides with the denial of the second, the discouragement of artistic expression (e.g., by refusing to fund a show) need not violate a person's or community's public discourse rights. I hasten to add, however, that informed discussions and decisions about artistic freedom, discourse rights,

[6] Strictly speaking, Article I of the Bill of Rights secures the freedoms of speech, petition, and assembly. Collectively they have come to be known as the freedom of expression.

[7] See, for example, the summary of Wildmon's claims and tactics in Richard Bolton's introduction to *Culture Wars*, pp. 8–11.

[8] See the exhibition catalog *"Degenerate Art": The Fate of the Avant-Garde in Nazi Germany*, ed. Stephanie Barron, with contributions by Peter Guenther et al. (Los Angeles: Los Angeles County Museum of Art, 1991). The exhibition was held at the Los Angeles County Museum of Art and the Art Institute of Chicago. The catalog's foreword, written by the directors of these museums, emphasizes the timeliness of this exhibition in light of right-wing attacks on federal arts funding in the United States: "As the 1990s begin, museum exhibitions are in a precarious position. If government support for the arts is jeopardized, the ability of all museums to organize exhibitions will be affected and the museum as an educational institution will be seriously diminished" (p. 6).

and their relationship in a particular case require acute sensitivity to matters of context.

The authority side of the debate nearly fuses two different concepts of authority: the ability to enact and enforce legal codes, and the ability to inculcate moral standards or inspire religious devotion. While it would be a mistake to think that legal authority and moral or religious authority are completely disconnected, as some defenders of the liberal state suggest, a fusion in the manner of fundamentalists worldwide can only be disastrous for law, morality, and religion, not to mention the many victims of zealotry and repression. Just as the development of legal codes need not inculcate moral standards or inspire religious devotion, so moral and religious authority need not depend on legal and administrative power.

Common to both sides is an inability to regard artists as anything more than isolated individuals who are dependent on either government generosity or free market fortune. Advocates of free artistic expression picture artists as atomistic individuals having equal rights to pursue their own projects. Those who champion authoritative traditional values view contemporary artists as undesirable deviants on the margins of society. Both sides fail to recognize the way in which artists are full-fledged members of social institutions and cultural communities. Recognition of such membership, I suggest, would help remove the impasse into which civil libertarians and religious fundamentalists have brought debates about government funding for the arts.

Provocation Versus Decadence

Introducing his anthology of documents from the battle over the NEA's budget and reauthorization in 1989 and 1990, Richard Bolton correctly observes: "The clash over government funding was much more than an argument over art; it was a debate over competing social agendas and concepts of morality, a clash over both the present and the future condition of American society."[9] Just how deep and hateful the clash became is clear from the promotional literature of each side.

[9] Bolton, introduction to Bolton, *Culture Wars*, p. 3.

In opposing the proposed NEA budget, the Christian Coalition's *Washington Post* advertisement on June 20, 1990, signed by Pat Robertson, asked members of Congress: "Do you...want to face the voters with the charge that you are wasting their hard-earned money to promote sodomy, child pornography, and attacks on Jesus Christ? You could choose to fund the NEA while refusing public funding for obscenity and attacks on religion. But the radical left wants you to give legitimacy to pornography and homosexuality. So you are being asked to vote like sheep for $175,000,000 with no strings attached."[10] This is just one example of the threats, smear tactics, and outright lies common to advocacy from the religious Right.

The NEA's defenders were not above using similar tactics. To explain the religious Right's "War on Art," for example, C. Carr wrote in the *Village Voice*: "The Saved are always a minority among the Damned. Practicing zealots don't feel powerful, but beleaguered. That's why they're obsessed with policing the boundaries of the permissible....How will they erase those sex-crazed Jimmies (Bakker/ Swaggart) from our minds? Regroup around some unseen enemy. And wouldn't ya know, fresh outta godless Communists, they've discovered the art world – a rich new motherlode of sinners."[11] One can find many other such examples of demonization and ridicule.

A strong image supports the rhetoric of each side. On one side is a portrait of the artist as a decadent menace to civilization. As C. Carr points out, the works singled out for greatest outrage are discussed "in metaphors of chaos, dissolution, sewage, engulfment: 'the river of swill' (representative Dana Rohrabacher); 'stinking foul-smelling garbage' (an American Family Association coordinator); 'a polluted culture, left to fester and stink' (Patrick Buchanan)....There's an apocalyptic quiver at the heart of the religious right's anti-NEA campaign. For in this art, they see the decline of civilization."[12] On the other side is an image of contemporary artists as provocative challengers of the status quo. Their art is cutting edge. It's in your face. It transgresses established boundaries in art and life: "Up yours."

Here the shared and dubious assumptions of both sides surface in an especially powerful way. Each side assumes that contemporary art

[10] Reproduced in ibid., p. 316.
[11] C. Carr, "War on Art," *Village Voice*, June 5, 1990, reprinted in ibid., p. 231.
[12] Ibid., p. 232.

is in the vanguard of culture and society – an assumption inherited from the modernist movement, and one that even astute postmodernists such as Jean-François Lyotard have had trouble surrendering.[13] Pat Robertson and company see contemporary art out front on the road to destruction. The advocates of contemporary art make it a progressive pathfinder for the perpetual negation of established boundaries. Neither side sees contemporary art as part of a sustaining tradition. Neither side hears it as bringing voices to a multifaceted conversation. This shared inattention feeds on the two other assumptions already noted, namely, that the current politico-economic system is acceptable and that artists are isolated individuals.

1.2 EXPOSURE

Status Quo

At first glance, it might seem preposterous to portray either advocates or critics of government arts funding as favoring the systemic status quo. The advocates seem always to want more government money than they can get, and the critics seem intent on dismantling the entire structure of government funding for the arts, not to mention education, the humanities, and other areas of culture.

Nevertheless, most advocates of government funding do endorse an arrangement whereby government agencies act as pump primers for an art world dominated by large businesses (e.g., media conglomerates), corporate donors, and wealthy individuals.[14] On the other side, most critics of government support do not object to corporate dominance as such but to the supposed hegemony of what they label, rather indiscriminately, as the cultural elite, liberals, secular humanists, or

[13] Arguably, the project of radical experimentation is what Lyotard endorses for both art and science in the "postmodern condition." In both areas, there must be no attempt to reinstate the master narratives of liberation and truth. See Jean-François Lyotard, *The Postmodern Condition: A Report on Knowledge*, trans. Geoff Bennington and Brian Massumi (Minneapolis: University of Minnesota Press, 1984).

[14] The dilemma for a progressive critic of this arrangement is that every challenge to the government-supported "corporate takeover of culture" plays into the hands of reactionaries who would abolish government funding altogether. See Hans Haacke, "Beware of the Hijackers!" in *Culture and Democracy: Social and Ethical Issues in Public Support for the Arts and Humanities*, ed. Andrew Buchwalter (Boulder, Colo.: Westview Press, 1992), pp. 139–53.

the radical Left. Their preferred solutions are to eliminate govern-
mental pump primers such as the NEA, to threaten specific corpora-
tions with boycotts, and to build their own culture industry. Moreover,
although they oppose government funding for the arts, they strongly
favor the government's regulating and contesting immoral or sacrile-
gious content. Advocates and critics of government arts funding criti-
cize different aspects of the political and economic status quo, but in
general they find it an acceptable system.

Unfortunately, the problems noted by each side in the debate are
not minor flaws to be corrected by either increasing or decreasing
the level of government support. Instead, they are symptoms of a sys-
temic malfunction. Put briefly, the current system constantly subor-
dinates cultural organizations to the structural imperatives of the
administrative state and a late capitalist economy. By helping to cre-
ate and reinforce both democratic and cultural deficits, such sub-
ordination impedes the formation and maintenance of a vital civil
society. Moreover, the dominant political and economic imperatives
are largely incompatible with institutional arrangements that would
let the arts flourish. What we need instead, as I argue in subsequent
chapters, are a robust public sphere and a thriving social economy, as
well as arts organizations that help form and foster them.

Isolation

The reverse side of accepting the systemic status quo is to think of art-
ists as little more than isolated individuals. Defenders of "family val-
ues" view artists as undesirable and marginal deviants. Advocates of
free artistic expression picture artists as atomistic provocateurs pur-
suing their own projects. Hence, the debate over government fund-
ing easily degenerates into attacks on individual artists and artworks,
countered by defenses of them in isolation from their contexts.[15]

[15] This tendency has been exacerbated by the impetus to decide matters in court.
Philip Yenawine observes, for example, that "in the cases made infamous by the
culture wars, the principle defenses...came from the legal community: the artist's
generalized right to freedom of speech was argued, not the inherent value or mean-
ing of their art....To the artists, it felt as if they were in a debilitating process over
which they had no power. Their work multiplied in meaning beyond their intent
and control, and they were seldom invited to represent or defend themselves."
Philip Yenawine, "Introduction: But What Has Changed?" in *Art Matters*, p. 20.

All of this feeds on the romantics' not-quite-dead myth of creative genius, as kept alive in Bohemian countercultures and exploited by a media system of celebrities and superstars. Among the remnants of nineteenth-century high culture attacked by modern, avant-garde, and postmodern intellectuals, this myth is the most resilient and most popular. Yet the myth of creative genius and images of the marginal or atomistic artist reflect untenable understandings of what art making is like. Artists participate in the same social institutions and cultural communities to which other members of society belong: educational and academic; linguistic and communicative; social and economic; political, ethical, and religious. Just like the rest of us, persons who are artists are citizens, voters, and taxpayers. They are employees, business owners, and union members. They belong to families and have friendships and affectional relations. Participation in such institutions and communities inevitably nourishes and informs artistic practices and products. Yet such connections get ignored or forgotten by those who regard artists as either undesirable deviants or atomistic provocateurs.

One reason for this is that "creative genius" is not a free-floating myth. Rather, it has an art-institutional counterpart: contemporary arts organizations, from art schools to museums, from concerts halls to the Academy Awards, often isolate arts professionals from the public at large. To counter such isolation, in theory and in practice, one needs to acknowledge both the differentiation of art and its imbrication with the rest of society. In other words, as is explained later, one needs to acknowledge art's relational autonomy.

There are two sides to this acknowledgment. On the one hand, although artists participate in the same institutions and communities as the rest of us, they carry out their artistic work within an intricate web of special organizations and practices. My own term for this web, reflecting the shifts and disappearances of organizational boundaries in recent years, is the social institution of art. As Nicholas Wolterstorff suggested many years ago, the social institution of art encompasses all the organizations and practices established to produce and promote the various arts, whether "high" or "low."[16]

[16] Nicholas Wolterstorff, *Art in Action* (Grand Rapids, Mich.: Eerdmans, 1980), pp. 21–3.

It includes what Adorno calls "the culture industry,"[17] as well as what Becker and Danto call "the artworld."[18]

On the other hand, *all* members of North American society, not only artists and other arts professionals, participate in the institution of art. Even though many nonartists overlook or forget just how significant the art institution is for their lives and for the welfare of society as a whole, their participation is important. Take away the movies, novels, recordings, television programs, and live performances that people enjoy from day to day, and a huge hole would appear at the heart of our lives and communities. Understanding how artists relate to their publics, and how publics relate to artists, is crucial for counteracting misguided individualism and the damage wrought by the romantic myth.

Yet it is the artists whose professional livelihoods especially depend on the institution of art and help shape it. They are just as central to the institution of art as scientists are to what could be called the technological complex. In fact, illuminating parallels could be drawn between the structure of the scientific profession (e.g., pure research, applied research, commercial science) and the structure of the artistic profession (e.g., experimental creation, performance and presentation, commercial arts). The immediate temptation of arts advocates is to place a price tag on artists' contributions to society and thereby generate an economic justification for government funding – a strategy similar to that followed by the science lobbyists from universities, industries, and the health professions. That, however, is not the point I want to make, nor do I think that *economic* justifications will carry the day when people are not convinced of the *cultural* worth of what is advocated. Rather, my point is that artists are core members of a social institution whose cultural significance would be hard to exaggerate. Nevertheless, as a social institution, art is embedded in a larger societal whole, and its many nonartist members have a stake in it.

[17] "The Culture Industry: Enlightenment as Mass Deception," in Max Horkheimer and Theodor W. Adorno, *Dialectic of Enlightenment: Philosophical Fragments*, ed. Gunzelin Schmid Noerr, trans. Edmund Jephcott (Stanford, Calif.: Stanford University Press, 2002), pp. 94–136. See also Theodor W. Adorno, *The Culture Industry: Selected Essays on Mass Culture*, ed. J. M. Bernstein (London: Routledge, 1991).

[18] Howard S. Becker, *Art Worlds* (Berkeley: University of California Press, 1982); Arthur C. Danto, "The Artworld," *Journal of Philosophy* 61 (1964): 571–84. See also Arthur C. Danto, *The Transfiguration of the Commonplace* (Cambridge, Mass.: Harvard University Press, 1981).

Vanguard

When artists are considered creative geniuses, the claim that they are central to art as a social institution easily comes across as a claim that they are avant-garde. Even stripped of the romantic myth, the vanguard image has some plausibility. Just as "pure research" provides the theories and formulates the anomalies that sustain the entire technological complex, so too does experimental creation provide the visions and enact the disruptions that sustain the entire institution of art. A significant portion of so-called high-art production, including its curatorial functions, can be called the "research and development" wing of the art institution as a whole.[19] That is why, if such research and development activities are not regarded as important in their own right, arts advocates have a hard time convincing the public and government officials that state funding is deserved. To make this case, in turn, advocates must show that the contributions of experimental creation are both intrinsically worthwhile and essential to the welfare of art as a whole (if we assume that they have already established the cultural significance of art as a social institution). From there it is but a small step to the assumption, shared by both advocates and critics of government funding, that contemporary art is in the vanguard of society, for good or ill.

Indeed, by mentioning experimental creation's functions of vision and disruption, I might seem to have accepted the vanguard image. This, however, is not the case. One can claim that some artistic practices and some artists have the legitimate task of exploring new territories and testing old boundaries, yet insist that not all arts or artists have this task and that no particular artist has this task all the time. And one can argue that the performance of this task is significant without thereby claiming that the arts (and, in particular, experimental creation) will or should be in the vanguard of society.

It is so, of course, that experimental creation will be "ahead of its time." If it is not ahead, it will not be experimental. But the image of being "out front" or "on the cutting edge" obscures the fact that

[19] I borrow this characterization from Paul Wittenbraker, formerly executive director of the Urban Institute for Contemporary Arts in Grand Rapids, Michigan, and currently associate professor in art and design at Grand Valley State University, where he directs the award-winning Civic Studio Project.

experimental creation also aims to delve deeply into the *current* time as well as to remember and revitalize times *past.* Genuine experiments do not occur in a vacuum. They require acute awareness of both what they avoid or reject and what they embrace.

Another problem with the vanguard image is that the impetus for social change can shift from one sector or conjuncture or class to another. Nothing in the history of art or in the structure of contemporary society guarantees either that there will be a vanguard or that this vanguard will be artistic. Nor is there any guarantee that the leading sector, conjuncture, or class will actually be followed. Often both advocates and critics of contemporary art simply ignore such complications, despite good evidence that in recent years the main impetus for change has come not from the arts as such but from the new social movements and technological innovations with which the arts mesh.

While I argue that experimental creation is a legitimate and important part of artistic endeavor and that such creation can promote social change, I would resist the conclusion that contemporary art is or should be in the vanguard of society. It is neither the sacrificial lamb nor the black sheep of culture. Rather, the contributions of contemporary art depend more on its nurturing cultural democracy than on the formal innovation and provocative social content that have excited advocates and critics alike.

My exposure of the dubious assumptions shared by advocates and opponents of government arts funding has introduced the notions of civil society, relational autonomy, and cultural democracy. To elaborate these notions, I need to excavate the philosophical and sociological underpinnings to the polarities already identified. This archaeological work will point toward an alternative social philosophy of the arts, one that makes sense of contemporary trends, addresses both conceptual and structural constraints, and provides a new framework for cultural policy.

1.3 EXCAVATION

In the debate over government arts funding as I have reconstructed it, both sides seem to accept a system in which governments play a supportive role on behalf of business interests. The debate often boils

down to an argument as to whether the arts merit this kind of government funding. Upon entering the territory of government economics, one immediately confronts the question whether the products or services under consideration are "public goods" or "private goods." To the ordinary participant in cultural creation, however, it is not immediately obvious that such terms adequately capture the political and economic realities of the arts, nor is it a foregone conclusion that governments and corporations should call the shots. Indeed, artists sometimes talk as if they would prefer not to have to deal with government agencies and business interests at all. Occasionally it appears as if there are two cultures – not the scientific and literary cultures identified by C. P. Snow around the time federal arts agencies arose in North America,[20] but the managerial culture of state capitalism and a creative culture of transgressive critique, with agencies such as the NEA and CCA caught in between.

A more precise examination will show that social realities are more complex than these simple polarities suggest. Government and business would not have their dominant roles in contemporary society if other social institutions did not give them legitimacy and support. To the extent that the arts themselves play legitimizing roles, they are not innocent victims of forces beyond their control. Moreover, if the arts are truly centers of creativity and critique, as their advocates claim, then artists and arts organizations should be able to challenge government and redirect business. In addition, the relationships between government and business are probably more dissonant than the official debate indicates, just as considerable tension might hold sway between the politics and the economics of the arts. In order to map these relationships, the next two chapters consider theoretical arguments with regard to government arts funding, the arguments of both mainstream economists (Chapter 2) and prominent political thinkers (Chapter 3). These chapters call attention to a "double deficit" in culture and democracy.

The chapters that follow in Part II propose my own account of the political and economic roles of the arts in civil society. The political account involves a construal of art's role in the public sphere

[20] C. P. Snow, *The Two Cultures and A Second Look* (Cambridge: Cambridge University Press, 1965). Snow gave his Rede Lecture on the two cultures in 1959.

(Chapter 4). The economic account requires a theory of art's role in
what I label the "civic sector" (Chapter 5). I also examine systemic
political, economic, and technological pressures that threaten art's
roles in civil society (Chapter 6). These three chapters argue that the
arts are vital to civil society, for both political and economic reasons.
Politically, the arts help give public voice to issues and interests that
require government attention. Economically, arts organizations in
the civic sector foster significant alternatives to the capitalist market-
place. Contemporary arts need government regulations that protect
the public sphere to which the arts contribute. They also need gov-
ernment funding that strengthens the social economy of the civic sec-
tor in which they participate. As elements and agents of civil society,
the arts merit and require government support.

Connecting the arts with the public sphere and civic sector pro-
vides a way to understand odd alignments surrounding the notions
of artistic freedom and traditional values. Despite historic tensions
in North America between fiscal conservatives and social conserva-
tives concerning tax policy and government expenditures, they share
a worry that contemporary forms of cultural expression undermine
"Canadian culture" or "the American way of life." Insofar as con-
temporary artists challenge ways of life that give primacy to capital-
ism and traditional values, conservatives have reasons for concern.
Similarly, despite historic tensions between political liberals and the
cultural Left concerning the role of government in society, they share
a concern to protect personal freedoms against state coercion. To the
extent that a moralistic tone pervades common understandings of
how the state should relate to culture, they too have reason for con-
cern. The so-called war on terrorism and more recent government
responses to an economic meltdown may have lessened the attention
given to arts funding. Yet the conservative worry and the left-liberal
concern have not vanished.

These conflicting emphases on traditional values and personal
freedoms have become rallying points in part because a more overtly
cultural manner of doing politics came to the fore in the 1960s and
1970s. The civil rights movement, the anti–Vietnam War movement,
feminism, the ecology movement, and the Moral Majority and its
spin-offs all stressed new forms and media of cultural engagement
as they worked toward social change. To a surprising extent, they

focused their energies on communicating in public, and their success depended on developing new organizations and alliances in civil society. This has raised the stakes in struggles over government involvement in culture, for which the debate about arts funding is emblematic.

Despite these developments, however, underlying views of the artist and of artistic freedom have not changed very much, nor have the practical realities of government funding encouraged flexibility in this regard. Advocates of artistic freedom cannot afford to let social conservatives box them in with a spurious but rhetorically effective argument that worthwhile art will follow "community standards." Similarly, advocates of traditional values cannot afford to let cultural progressives carry the day with vague but stirring appeals to "freedom of expression." In the process, neither side has shaken highly individualistic views of the artist in society, even though cultural politics on both sides can expose the limitations of individualism.

In response, the chapters in Part III challenge two central assumptions of modernist aesthetics that support such views and derail debates about government funding – namely, the claim that art is properly independent from the rest of society, and the idea that artists must above all be true to their own experience or vision. I show that three concepts have particular significance for a more complex, accurate, and fruitful view of the artist and artistic freedom. The first is the notion of the autonomy of art. Whereas modernist accounts anchor art's autonomy in the individual work of art, the conception of relational autonomy proposed in Chapter 7 ties it to the existence of certain types of relationships, organizations, and practices. I also argue that a proper mixture of independence and interdependence toward other social institutions is crucial for art's flourishing and enables it to contribute to society as a whole.

The second concept is that of authenticity, which plays a central role in pleas for artistic freedom. The third concept is that of social responsibility, which surfaces in attempts to subordinate artistic practices to community standards. Chapter 8 develops an alternative account of these concepts, claiming that neither authenticity nor social responsibility can be had without the other. Artists cannot be true to their own experience, I argue, if they do not pursue their social responsibilities as artists. Rather, a creative tension between

authenticity and responsibility is crucial for achieving artistic freedom. Like the autonomy of art, the freedom of artists is relational.

By playing down the individual work of art and linking authenticity with social responsibility, I also challenge a vanguardist assumption inherited from the modernist movement and, ironically, shared by postmodernists and their fundamentalist opponents: the assumption that contemporary art is in the vanguard of society, for good or ill. The exaggerated terms in which postmodernists celebrate "transgression" or "resistance" and fundamentalists attack "decadence" or "corruption" indicate that neither side understands the full extent to which the arts depend on contemporary political and economic structures and participate in civil society. A modernist focus on discrete works of art has obscured such connections from people who in other respects reject modernist aesthetics. As will become apparent, my conception of "art in public" aims to make the connections obvious. Given the crisscrossing filaments of polity, economy, and culture, one can hardly regard contemporary art as either the cutting edge of societal progress or the burglar alarm of a society in crisis.

Nevertheless, it is important to examine more carefully what contemporary art can contribute at this particular juncture. Without wishing to suggest that the arts can, by themselves, bring about dramatic social change, I do see significant compatibility between contemporary artistic practices and the emergence of a more fully democratic culture. This compatibility is significant because the democratization of culture is needed to sustain political democracy. In addition, the participation of contemporary arts organizations in a social economy can help democratize the economy, which would also be conducive to political democracy. The arts have an important role to play in fostering a more fully democratic culture. In developing these reflections, Chapter 9 articulates three concepts of democracy: participation, recognition, and freedom. Once articulated, they will appear in retrospect as a contested terrain beneath the haze of government funding debates.

These arguments suggest that current programs of government arts funding in North America might be seriously flawed but for reasons that most advocates and critics of such funding overlook. After reviewing the previous chapters, Chapter 10 presents an alternative sociocultural case for government arts funding. Then I explore some

implications of this case for cultural policy. I claim that government funding for the arts should support art's ability to articulate public issues and interests. It should strengthen art's participation in a social economy. And it should foster the development of a democratic culture. Funding provided within this conceptual framework would promote the practices of social criticism and cultural dialogue that mark contemporary art at its best. Such practices, I submit, are vital to a democratic society.

Although I look for insights and blind spots on both sides of the government funding debate, I do not disguise where my own sympathies lie. The spread of democracy beyond politics to culture and economy is not something most conservatives would embrace, despite the pseudopopulism of Stephen Harper and Jesse Helms. The pages that follow aim to articulate a postcapitalist social theory that gives normative priority to neither the administrative state nor the corporate economy; a critical hermeneutics of art that is neither individualistic nor dogmatic; and a progressive politics that is not blinded by myths of progress.

2

What Good Is Art?

It is self-evident that nothing concerning art is self-evident anymore.
 Theodor W. Adorno[1]

In 1997 the National Endowment for the Arts released a report titled
American Canvas. The report urges its readers to "support the vital
part of government in ensuring that the arts play an increasing role in
the lives and education of our citizens."[2] But the endless saga of NEA
bashing, to which this report responds, raises a question it does not
adequately address: "What precisely is the government's proper part,
and why is it vital?"

A quick answer might go like this: the arts play an important role
in contemporary society; they cannot survive or thrive without govern-
ment support; therefore, the government should give them the sup-
port they need. A moment's reflection indicates why this quick answer
will not do. It does not say what role the arts play in society and why that
role is important. It does not establish why they cannot survive or thrive
without government support. And it does not say why the government
should be expected to give such support. Even the notion of "govern-
ment support" is vague. Government support of the arts can take many
forms: legislation and regulation (e.g., copyright law and regulations

[1] Theodor W. Adorno, *Aesthetic Theory*, trans. Robert Hullot-Kentor (Minneapolis:
University of Minnesota Press, 1997), p. 1.
[2] *American Canvas: An Arts Legacy for Our Communities*, by Gary O. Larson (Washington,
D.C.: National Endowment for the Arts, 1997), p. 150.

governing mass communication), state ownership and operation of arts-related ventures (e.g., national monuments and municipal museums), state-sponsored informational and educational services (e.g., tourism bureaus and arts education in schools), and state subsidies.[3]

Standard arguments for government support of the arts usually concern state subsidies. Such subsidies can be either direct or indirect. In countries such as Canada and the United States, where government revenues rely heavily on property taxes and income taxes, *indirect* subsidies tend to be substantial. They occur as tax concessions for donors and tax exemptions for artists and arts organizations. The total of such indirect subsidies far exceeds the amount governments allocate to direct subsidies. Yet *direct* subsidies such as arts grants awarded by the NEA or the Canada Council for the Arts (CCA) have been the most contentious. They have also drawn the most sustained efforts at justification. Accordingly, this chapter and the next consider attempts to justify direct state subsidies for the arts, which I label "government arts funding."

A complete case for direct subsidies would need to address three questions: Why should government funding be provided? How should it be procured? And what are the optimal means of provision? Philosophically the first question takes priority. If the question why such funding should be provided does not receive an adequate answer, questions about procurement and provision easily distract us from the most difficult justificatory issues. So let me leave to one side questions about how government funding should be procured and provided. To achieve sufficient focus, this chapter also sets aside political arguments (to be taken up in the next chapter) and considers only the reasons given by economists to justify government arts funding. First I review standard economic arguments for government arts funding. Then I uncover a cultural deficit in such arguments and discuss one attempt to avoid it. The chapter concludes with an alternative that aims to overcome the cultural deficit.

2.1 ECONOMIC JUSTIFICATIONS

Most economists base their arguments for government arts funding "on Paretian welfare economics and all that this entails – perfect competition,

[3] David Throsby, "The Production and Consumption of the Arts: A View of Cultural Economics," *Journal of Economic Literature* 32 (March 1994): 1–29.

a given set of tastes and technology and given endowments of human capital and wealth."[4] Mainstream economists see a world "populated by adult individuals" who are clear about their self-interest and who "will use their wealth and capabilities to pursue that self-interest in a rational way." Under certain conditions, their interactions in competitive markets result in "a sort of efficiency" that is best for everyone.[5] Although prominent cultural economists such as Bruno Frey and David Throsby have questioned whether such assumptions can support a properly nuanced economics of art,[6] these remain the accepted framework.

From this framework two economic roles emerge for government: to correct market conditions that lead to inefficiency; and to counteract outcomes that, while efficient, display unacceptable inequities across a population. Accordingly, mainstream economists offer two types of arguments for government arts funding: efficiency or public good arguments and equity or distributional arguments.[7] To this one can add a third type, merit good arguments, which some economists dismiss as being unsupported by standard economic assumptions.[8] Let me comment on each type of argument in turn.

[4] Ruth Towse, "Achieving Public Policy Objectives in the Arts and Heritage," in *Cultural Economics and Cultural Policies*, ed. Alan Peacock and Ilde Rizzo (Dordrecht: Kluwer, 1994), p. 145.

[5] Michael Rushton, "Public Funding of Artistic Creation: Some Hard Questions" (Regina: University of Regina, Saskatchewan Institute of Public Policy, 2002), p. 2.

[6] Bruno S. Frey, *Arts and Economics: Analysis and Cultural Policy* (Berlin: Springer, 2000); David Throsby, *Economics and Culture* (Cambridge: Cambridge University Press, 2001). Frey and Throsby do not wish to abandon the standard economic framework but to modify it through interdisciplinary enrichment, whether through psychology or through cultural anthropology. See also Mark Blaug, "Where Are We Now on Cultural Economics?" *Journal of Economic Surveys* 15, no. 2 (2001): 125–6.

[7] Dick Netzer, *The Subsidized Muse: Public Support for the Arts in the United States* (Cambridge: Cambridge University Press, 1978), pp. 43–52, points out that efficiency and equity arguments are particularly relevant for countries like Australia, Canada, the United Kingdom, and the United States because government revenues depend heavily on property and income taxes. Correlatively, and unlike continental European countries that have different tax regimes, these countries have emphasized tax exemptions, tax concessions, and direct subsidies through arms-length agencies, rather than state ownership or patronage for specific cultural organizations. For more detailed and historically oriented comparisons between the "American" and the "European" approaches to state subsidies, see John W. O'Hagan, *The State and the Arts: An Analysis of Key Economic Policy Issues in Europe and the United States* (Cheltenham, U.K.: Edward Elgar, 1998).

[8] My typology partially overlaps the one employed by O'Hagan, *The State and the Arts*, pp. 19–69. O'Hagan distinguishes (1) "non-private benefit" arguments from (2) "information failure" and (3) "distributional" arguments. The first and third

<h2 style="text-align:center">Efficiency Arguments</h2>

Contemporary cultural economics originated with the publication of *Performing Arts – The Economic Dilemma* in 1966. William J. Baumol and William G. Bowen claimed that the performing arts confront a "cost disease," a significant and unavoidable economic inefficiency that justifies government intervention. Because theater, opera, concert music, and dance are labor-intensive, and are relatively inflexible in that regard, they cannot offset rising wage rates through technological advances in productivity. Either performing arts groups will need to charge admission prices that only the very wealthy can afford or their costs will become unsustainable because of a growing gap between revenues and expenditures. Despite subsequent challenges and modifications, the Baumol-Bowen thesis provided impetus for both efficiency and equity arguments during a rapid expansion of government arts funding in English-speaking countries.[9]

Efficiency arguments regard the arts as "public goods" involving "externalities" for which individual consumers cannot be expected to pay. These externalities lead to "market failure" and can create a need for government intervention in the market.[10] Externalities are benefits that accrue to third parties who are not directly involved in a market

of these are equivalent to what I call "efficiency" and "equity" arguments, respectively. I do not consider information failure to be a distinct basis for justifying state subsidies. Rather, as O'Hagan, p. 49, also suggests, it becomes relevant to the question of state subsidies only when either significant inefficiencies or significant inequities arise and, in that connection, people do not properly recognize the issues at stake. It is noteworthy that O'Hagan does not even mention merit good arguments.

[9] See William J. Baumol and William G. Bowen, *Performing Arts – The Economic Dilemma: A Study of Problems Common to Theater, Opera, Music, and Dance* (New York: Twentieth Century Fund, 1966). For summaries of the Baumol-Bowen thesis and of responses to it, see Throsby, "The Production and Consumption of the Arts," pp. 14–16, and Netzer, *The Subsidized Muse*, pp. 28–32.

[10] Besides externalities, the other causes of market failure said by some to justify government arts funding include declining cost industries (e.g., museums), consumers' lack of information, and the "cost disease" or productivity lag discovered by Baumol and Bowen. I do not discuss these, both because they involve more technical economic analysis and because, to justify government arts funding, they usually must be combined with externalities, inequities, or an appeal to the notion of merit goods. For a summary of efficiency arguments that point to factors other than externalities, see James Heilbrun and Charles M. Gray, *The Economics of Art and Culture: An American Perspective* (Cambridge: Cambridge University Press, 1993), pp. 213–19.

transaction, such as that between concert presenters and the pur-
chaser of a ticket. If the market price (i.e., the cost of the ticket) does
not adequately account for the external benefits, then on standard
economic assumptions the good or service will tend to be underpro-
duced. If the third party cannot be made to pay for the external ben-
efits through the market itself, and if the good or service is a public
good, then the government may need to correct the market's failure
to provide an adequate supply for the (implicit) demand.[11]

In the language of welfare economics, a "pure public good" is a
product, resource, or service that has two characteristics: one person's
using it does not prevent others from using it (the "non-rivalry" condi-
tion), and no one can be denied access to it, whether or not one pays
for using it (the "non-excludability" condition). National defense and
clean air are two examples of pure public goods. Dick Netzer points
out that "few artistic goods and services meet the criteria that charac-
terize pure public goods."[12] While your buying a ticket to a concert or
purchasing a book of poetry does not prevent others from enjoying
them, these artistic goods do not have the same open-ended availabil-
ity as, say, clean air. A national monument, by contrast, would more
closely approximate a pure public good. Nevertheless, all of the arts
provide "external benefits" or "externalities" that are not restricted
to the actual consumer. In that sense, all of the arts are public goods.
Perhaps they should be called "partial public goods."[13]

Which external benefits mark the arts as public goods and pro-
vide a justification for government arts funding? Although econo-
mists have identified and debated a long list of these, I would group

[11] Netzer, *The Subsidized Muse*, p. 22; Rushton, "Public Funding of Artistic Creation,"
pp. 3–4.

[12] Netzer, *The Subsidized Muse*, p. 21. See also Mark Blaug, "Introduction: What Is
the Economics of the Arts About?" in *The Economics of the Arts*, ed. Mark Blaug
(London: Martin Robertson, 1976), pp. 16–17.

[13] The equivalent term suggested by Baumol and Bowen is "mixed commodities,"
defined as "goods and services whose characteristics are partly private, partly
public" (*Performing Arts*, p. 381). They argue that, like education, the performing
arts are "mixed commodities." I avoid this term both because it seems imprecise
and because it relies on a distinction between "public" and "private" that I find
problematic. I should also note that some economists do claim that "the external
benefits allegedly produced by the arts have the characteristics of a pure public
good: they are subject to joint consumption, but not to exclusion." Heilbrun and
Gray, *The Economics of Art and Culture*, p. 209.

them into three sorts: cultural, political, and economic. Many of the cultural benefits have to do with the arts themselves: passing on the arts to subsequent generations,[14] contributing to the arts education of current generations,[15] fostering related art forms,[16] and encouraging experimentation and creativity in the arts.[17] These benefits have different strengths and weaknesses as part of a rationale for government arts funding. Yet all of them presuppose that the arts are important – important enough to warrant cultural transmission, education, interdisciplinary cross-fertilization, or innovative efforts. Unfortunately, economists have little to say about why the arts are important in the first place and distinct from other fields of market transaction. Arts organizations have often shared their silence.

[14] In the language of economics, the willingness to pay to keep the arts going, even though one does not currently participate in them as a consumer, is a type of "option demand." See Towse, "Achieving Public Policy Objectives in the Arts and Heritage," p. 147, and Rushton, "Public Funding of Artistic Creation," p. 4. On the argument for state subsidies based on option demand, see O'Hagan, *The State and the Arts*, pp. 28–30.

[15] This would include but exceed what Ruth Towse, "Achieving Public Policy Objectives in the Arts and Heritage," p. 148, discusses as "taste-formation." Blaug, "Introduction: What Is the Economics of the Arts About?" pp. 16–17, points out two paradoxes in connection with the first two cultural benefits listed here: including intergenerational benefits "converts every private good whose provision entails an accumulated heritage…into a pure public good," and emphasizing the benefit of "cultivating a taste for the arts" conflicts with the standard economic assumption "that consumer's tastes are given." In a more recent survey of cultural economics, he says "the study of cultural economics militates against the complacent orthodox view that preferences are given and that the formation of tastes is a subject best studied by sociologists rather than economists." Blaug subsequently suggests that cultural economists should "scrap the entire neoclassical framework in order to take up a long series of inductive case studies of taste formation in the…arts, which may eventually result in some genuine theories of taste formation." Blaug, "Where Are We Now on Cultural Economics?" pp. 125–6.

[16] Netzer, *The Subsidized Muse*, pp. 22–3, mentions this as a primary reason for direct state subsidies. The idea is that activities in one art form such as music tend to support activities in other art forms such as opera and dance, but this interdependence cannot be readily factored into straightforward market transactions.

[17] Towse, "Achieving Public Policy Objectives in the Arts and Heritage," p. 147, places this under the rubric of "market failure due to risk and uncertainty" and compares the case required to that "for public funding of Research and Development in industry." She says that the case would need to show "that marginal expenditures produce at least as much return in the arts as they would in other sectors of the economy." This strikes me as an insurmountable hurdle. How does one quantify the returns of "R&D" in the arts to make them comparable with other sectors while also preserving the unique qualities of artistic innovation?

A second set of justificatory external benefits cited by economists is broadly political. These benefits include the prestige art confers on nations (and presumably also on states or provinces and cities or regions); the formation of national identity (and presumably also of nonnational group identities); and, more controversially, the raising of political and social consciousness.[18] The first two political benefits figure prominently in the mandates for federal granting agencies such as the CCA and the NEA. Many economists doubt, however, that the arts are particularly effective in this regard. They also worry that an emphasis on national prestige and identity is incompatible with such cultural objectives as nurturing people's tastes and fostering artistic innovation.[19] Moreover, the economic and political effects of globalization now raise questions about the viability and significance of national cultures.[20]

A third set of justificatory external benefits is economic. They include "spillover benefits," such as the development of a creative work force for commercial enterprises;[21] multiplier effects of arts activity on local commerce, tourism, migration, and new investments; and the benefit, where relevant, of nurturing "infant industries" in the arts themselves.[22] Although arts advocates who are eager to persuade government officials often tout spillover benefits and multiplier effects,[23] many economists doubt the validity of such arguments. Summarizing one such expression of economic skepticism, Mark Blaug suggests that "economic impact studies of artistic events"

[18] On consciousness-raising, see Throsby, "The Production and Consumption of the Arts," p. 25, and Rushton, "Public Funding of Artistic Creation," pp. 5–6.
[19] Towse, "Achieving Public Policy Objectives in the Arts and Heritage," p. 147, says, for example, that it is not clear "that the arts do the job better than sport or war." She also claims that the national prestige argument "suggests that subsidy should be directed at the most prestigious personalities, institutions and events, those that attract the most acclaim."
[20] For a brief survey of such questions, see David Held and Anthony McGrew, *Globalization/Anti-Globalization* (Cambridge: Polity Press, 2002), pp. 25–37.
[21] Towse, "Achieving Public Policy Objectives in the Arts and Heritage," p. 147.
[22] The infant industry argument presupposes that new ventures in the arts are important in their own right, and not simply as sources of new employment and revenue. Hence, it falls under strictures similar to those already mentioned for artistic innovation.
[23] New impetus for such advocacy stems from Richard L. Florida, *The Rise of the Creative Class: And How It's Transforming Work, Leisure, Community and Everyday Life* (New York: Basic Books, 2002).

prove little; "using the same methods, we could easily show that even earthquakes generate an excess of economic benefits over costs."[24]

It would appear that, of the three sorts of externalities used in efficiency arguments for government arts funding, cultural benefits have greater plausibility than the political and economic benefits. Yet the reticence of mainstream economists to say what makes the arts important in their own right, regardless of such externalities, makes even cultural benefits less persuasive than they might otherwise be. This points to a cultural deficit in mainstream economics.

Equity Arguments

Economists recognize that even an efficient market can generate sizable disparities in the distribution of public goods across a population. This gives rise to arguments for government arts funding to address inequity in distribution. Ruth Towse identifies three types of distributional inequity: "social" (tied to levels and types of education), "economic" (tied to income), and "geographical" (tied to place of residence).[25] To these one could add a fourth: "multicultural" inequities (tied to considerations of age, gender, race, ethnicity, and the like), which mainstream economics has been slow to analyze, despite their prominence in recent cultural politics.

Whatever the distributional inequity, standard economic arguments focus on issues of access. They claim that, left to its own devices, the market does not allow a specific segment of the population sufficient access to certain types of art. If the inequity cannot be adequately addressed through market means (e.g., through differential pricing of tickets), then government intervention may be required and direct state subsidies warranted. Once economists have identified a significant distributional inequity, their debates focus on whether government intervention would be effective, what form it should take, and how one can demonstrate its effectiveness.

Equity in access is not so transparent a concept as it might first seem, however. John O'Hagan distinguishes three types of equal access: "*equality of rights* to participate in cultural life," such that no

[24] Blaug, "Where Are We Now on Cultural Economics?" p. 132.
[25] Towse, "Achieving Public Policy Objectives in the Arts and Heritage," p. 149.

"legal or institutional barriers" block anyone's participating; "*equality of opportunity*," such that every social grouping is enabled and encouraged "to participate on an equal footing with others"; and actual "*equality of participation*," such that equal rights and equal opportunities result in comparable levels and quality of participation "across broad socioeconomic groups."[26] Because the third of these is easiest to measure, statistical studies in this area tend to focus on actual rates of participation rather than on rights or opportunities. The studies O'Hagan cites suggest that, short of massive state intervention, which would introduce another set of problems, equitable distribution is no easier to achieve in the arts than it is in schooling or health care, where governments have made much greater investments. Indeed, it appears that "the bulk of public money goes to high art forms...not attended by those with low incomes/educational attainment."[27] At the same time, neoconservative attacks have lessened the rhetorical appeal of distributional equity, even as economists have failed to say why governments should give priority to a cultural right to participation.

Such considerations do not automatically defeat equity arguments. One could reply, for example, that the problem lies not in government arts funding but in an unjust societal structure. Or one could say that the existing participation rates show either that much more government funding is needed or that current funding should be allocated differently.[28] In addition, one could ask, as O'Hagan does, whether equity arguments should focus on distribution to (potential) audiences. Perhaps the more pressing issues, or at least the ones more easily addressed, pertain to equity in production – not only regulatory matters to be handled via copyright law and international trade agreements but also questions concerning artists' income and their powers to make decisions that appropriately targeted state subsidies could address.[29] In order for such questions to have more prominence in equity arguments, however, economists and politicians would need to regard the work of artists as important in its own right and not simply because of external benefits supposedly generated when art

[26] O'Hagan, *The State and the Arts*, pp. 54–5.
[27] Ibid., p. 61.
[28] Ibid., pp. 62–3.
[29] Ibid., pp. 51–3.

products are distributed and used. And to make the case for such importance, they would have to overcome a cultural deficit in mainstream economics.

Merit Good Arguments

The need to regard artistic practices as important in their own right points us toward merit good arguments for government arts funding. Yet, unlike efficiency and equity arguments, merit good arguments have an uncertain status in mainstream economics because economists disagree about the content and legitimacy of the concept of merit goods. The concept is controversial because it suggests that "consumer sovereignty" either does not apply or must be significantly modified with respect to certain goods and services. Because the assumption of consumer sovereignty – the "freedom" of adult individuals to make "rational" choices in their own self-interest – is so fundamental in microeconomics, merit goods can seem economically incalculable and thus also resistant to both efficiency and equity arguments for government arts funding. Moreover, many economists think the intrinsic merits of art, if they exist, do not suffice to justify government arts funding. Nevertheless, merit good arguments have been prominent in debates about government arts funding,[30] and they are worth considering in their own right.

According to Netzer, "[T]he arts are generally viewed as 'merit goods,' whose production and consumption should be encouraged by public subsidy because they are meritorious rather than because the market alone would not supply enough of them or because income barriers deprive some people of access to them."[31] Behind this view lies a concept introduced by Richard Musgrave in the late 1950s, and a topic of economic debate ever since. Musgrave defines "merit goods"

[30] After studying public pronouncements among politicians in English-speaking countries, Throsby and Withers concluded in 1979 that "merit good considerations have probably been the most significant single explanation of government involvement in the arts." C. D. Throsby and G. A. Withers, *The Economics of the Performing Arts* (New York: St. Martin's, 1979), p. 192; quoted by Heilbrun and Gray, *The Economics of Art and Culture*, p. 219. A year earlier Netzer, *The Subsidized Muse*, p. 16, made a similar claim: "The meritorious nature of the arts is the most widely espoused argument for public subsidy."
[31] Netzer, *The Subsidized Muse*, p. 16.

as those whose evaluation "derives not simply from the norm of con-
sumer sovereignty but involves an alternative norm." The clearest
examples occur, he says, in settings "where individuals, as members
of the community, accept certain community values or preferences,
even though their personal preferences might differ. Concern for
maintenance of historical sites, respect for national holidays, regard
for environment or learning and the arts are cases in point."[32] "Public
goods," by contrast, are ones where the norm of consumer sovereignty
still applies, but the non-rivalry and non-excludability conditions are
in effect. (With "private goods," neither condition is in effect.) The
concept of merit goods gives governments a basis to provide certain
goods and services, such as health care, "in quantities greater than
consumers would wish to purchase at market prices."[33]

To apply the concept of merit goods to the arts, it helps to dis-
tinguish a general argument from specific ones. Throsby points to
the need for both general and specific arguments when he asks: "Are
there aspects of a normative case for intervention in arts markets
that...lie beyond the standard welfare analysis based on rational
action in accordance with well-informed individual preferences?" He
thinks there are, and mentions two relevant conditions: first, if "indi-
viduals lack the necessary information on which to base their market
choices, or...are ignorant of their own welfare" and, second, if there
are "significant cases where the observed behavior of individuals is
inconsistent with their underlying values, for reasons such as misper-
ception, weakness of will, or fluctuations in preferences over time."[34]
Although Throsby seems to attribute such conditions to the arts in a
general way, one could easily apply them to certain art forms and not
to others.

The general merit good argument would be that the relevant polit-
ical community regards the arts as having an intrinsic worth that the
market does not adequately reflect, and this discrepancy makes them
deserving of government funding. Although the argument does not
tell us which activities and organizations deserve direct state subsidy

[32] Richard A. Musgrave, "Merit Goods," in *The New Palgrave: A Dictionary of Economics*,
 vol. 3, ed. John Eatwell et al. (London: Macmillan, 1987), pp. 452–3.
[33] Heilbrun and Gray, *The Economics of Art and Culture*, p. 219, summarizing Richard A.
 Musgrave, *The Theory of Public Finance* (New York: McGraw-Hill, 1959).
[34] Throsby, "The Production and Consumption of the Arts," pp. 23–4.

and how much they should receive,[35] it does tell us in general that activities and organizations of this sort are worthy of consideration for government funding.

There are also specific merit good arguments for direct subsidies. Netzer mentions two: that private demand for certain art forms such as poetry is so small that, without subsidy, little would be produced, and valuable talents would be wasted; and that subsidies are needed to counter the tendency of unsubsidized museums and performing arts to be strongly centralized, such that people outside the largest cities cannot enjoy "professional quality art production." These serve as arguments for subventions to publishers, for example, and for subsidies to support traveling exhibitions and touring performance companies.[36] Such arguments are not pure merit good arguments, however. The first appeals to a notion of efficiency, and the second to one of equity.

Indeed, according to James Heilbrun and Charles Gray, both general and specific merit good arguments have "an annoying tendency to overlap with [economic] arguments made for public subsidy on other grounds."[37] Yet I would submit the converse as well: efficiency and equity arguments tend to overlap both each other and merit good arguments. These tendencies toward overlap are annoying only if one thinks that one argument or one type of argument suffices to make the case for government arts funding. I doubt that this is so within the general category of economic justifications. I also doubt that all economic arguments combined will suffice in the absence of political justifications, which the next chapter considers.

Heilbrun and Gray are in fact highly skeptical toward merit good arguments. They give two reasons why one might think the arts deserve government funding as merit goods. One is that the arts offer people something more worthwhile than they realize and that they therefore underconsume – a reason indicated by Throsby's first condition. The other reason is that the arts have some "intrinsic worth," which "distinguishes them from ordinary consumer goods," and thus the arts deserve wider distribution than the market allows – a reason suggested by Throsby's second condition. But Heilbrun and Gray dismiss both of these potential merit good justifications. The

[35] Netzer, *The Subsidized Muse*, p. 16.
[36] Ibid., p. 26–7.
[37] Heilbrun and Gray, *The Economics of Art and Culture*, p. 220.

first comes down to a matter of "market failure due to lack of information," they say, and the second "is not so much an explanation in economic terms as it is a value judgment...that lies outside the realm of economic discourse."[38]

Yet neither of the reasons they reject touches the core of Musgrave's concept of merit goods, namely, the way in which community values *override* consumer sovereignty. By saying that the second justification relies on a "value judgment" outside economic discourse, Heilbrun and Gray not only discount the core of Musgrave's concept but also simply reaffirm their own attachment to the value of consumer sovereignty. Throsby, by contrast, raises the possibility that "a traditional social welfare function that admits only individual utilities as its arguments may be too restrictive in the context of socially meritorious goods such as the arts." Such goods might "contain some element of benefit that cannot ultimately be attributed to some individual." To take this possibility seriously, he says, would stretch "conventional economic thinking" to "encompass ideas of culture and civilization drawn from philosophy, aesthetics, and political and social theory."[39] Perhaps the larger "merit" of merit good arguments, then, lies in their pointing up a cultural deficit in standard welfare economics.

2.2 CULTURAL DEFICIT

Whether mainstream economists are open to the possibility raised by Throsby remains to be seen. So long as they approach the arts within the framework of Paretian welfare economics, they will either ignore or suppress what distinguishes the arts as cultural endeavors. The arts are not simply consumer goods satisfying the self-interests of competing individuals. Even the concept of merit goods, which lets community "values" or "preferences" override the norm of "consumer sovereignty," does not get at the specifically cultural character of the arts. For "values" and "preferences" are still thought along the lines of consumer satisfactions. To regard the arts as mere objects of consumer satisfaction, whether individual or communal, is to miss their cultural character. Standard economic justifications for government arts funding suffer from a cultural deficit.

[38] Ibid.
[39] Throsby, "The Production and Consumption of the Arts," pp. 23–4.

Along with this cultural deficit goes a lack of normative self-reflection. Mainstream economists ignore the extent to which all of their arguments for government arts funding presuppose normative notions not merely of "goods" but of "the good."[40] In emphasizing external benefits, efficiency arguments presuppose that it is good to meet widespread wants of individual consumers, regardless of whether their wants are worthwhile on other grounds. They presuppose the norm of maximal individual gratification. So too, equity arguments implicitly appeal to a normative notion of public justice. They presuppose a political consensus that relatively equal access is a worthy goal and then ask whether, as public goods having external benefits, the arts are sufficiently accessible to various populations in light of this goal. Similarly, merit good arguments depend upon a normative notion of collective value. They claim that the arts, or the experiences the arts afford, are accorded value (i.e., are considered intrinsically good) by the relevant community and therefore deserve state support. Indeed, the closer a justificatory argument comes to regarding culture as something irreducible to economic considerations and as good in its own way, the more problems such an argument poses to mainstream economics. All of the standard economic justifications fall short precisely because their underlying assumptions are incompatible with a robust notion of culture. Moreover, to the extent that arts organizations do not articulate art's cultural character in ways that make sense outside their own walls, they inadvertently support this cultural deficit.

Market Boundaries

The cultural deficit in economic justifications points to a misalignment of culture and economy under conditions of consumer capitalism. To envision better economic justifications, one must address this misalignment. That is what Russell Keat attempts in *Cultural Goods and the Limits of the Market*. Keat argues that there is "something fundamentally wrong" with an "expansion and intensification of the market" that undermines "the integrity of cultural institutions and

[40] For a detailed critical examination of the purported value-neutrality in mainstream economics with respect to consumer goods, see Alan Storkey, *Foundational Epistemologies in Consumption Theory* (Amsterdam: VU University Press, 1993).

reduce[s] their potential contribution to human well-being."[41] Hence, state subsidies and government regulations are needed to protect cultural activities, and the institutions where they occur, from "the operation of the market."[42]

The central issue for Keat is not one of injustice or of commodification but rather one of inappropriate market boundaries with respect to cultural activities and institutions. Keat understands cultural activities such as the arts, broadcasting, and academic research using Alasdair MacIntyre's concept of "social practices." Such practices are "governed by their own *standards of excellence*," and they subordinate "the *external goods* of money, power and status" to their own "specific *internal* goods."[43] In a market understood by mainstream economists to be governed by consumer sovereignty, conflict arises between "the judgements on which consumer preferences are based" and "the standards embedded in the practices concerned."[44] In this environment, competition for necessary financial resources forces cultural institutions to sacrifice the integrity of the practices for which they are established. When accompanied by skepticism about the legitimacy of institutionally embedded "value judgements" and by "illicit transfers of meanings" from the market to cultural contexts, market pressures jeopardize social practices that have their own standards and internal goods.[45]

Is this conflict between the market and cultural institutions inevitable, and is it always necessarily to the detriment of cultural institutions? Keat suggests that the conflict would be inevitable if the market itself were "inherently incompatible with social activities being conducted as practices," as MacIntyre seems to think. Against MacIntyre, however, Keat argues that even production in a market economy "displays at least practice-*like* characteristics."[46] It also contributes to the well-being

[41] Russell Keat, *Cultural Goods and the Limits of the Market* (London: Macmillan; New York: St. Martin's Press, 2000), p. 2. My summary of Keat's argument ignores the fact that part II of his book rejects some of the claims he makes in part I. The summary remains at a level where these incompatibilities play little role.

[42] Ibid., p. ix. Although Keat intends his argument to apply to all markets, and not simply to capitalist markets, it is prompted by government-promoted incursions of commercial practices and strategies into British universities and other public-sector organizations where the dominant market is capitalist.

[43] Ibid., p. 5.

[44] Ibid., p. 6.

[45] Ibid., pp. 7–10.

[46] Ibid., pp. 11–12.

of consumers in ways that are significantly superior to nonmarket pro-
duction. So the problem does not lie in the fact that production has
become market-organized and market-driven. Rather, the problem lies
in how the market is structured to give priority to consumer benefits
(such as incomes and consumer goods) over production benefits (such
as satisfying work and the development of human potential) whenever
conflicts arise between the two types of benefits.[47] This structure gets
reinforced when cultural institutions are subjected to market pressures
that privilege economic consumer benefits.

Cultural Meta-Goods

Nor would it suffice for complacent neoconservatives to exclaim, So
much the worse for cultural institutions! For, says Keat, the market
itself needs intact cultural institutions "to succeed 'in its own terms,'
in enhancing people's well-being through the production of con-
sumer goods." The market needs cultural institutions to provide cul-
tural activities such as art and academic research that "explore the
nature and possibilities of human well-being." In the absence of such
"cultural meta-goods," consumers would be less able "to make sound
judgements about the value for them of the various goods they might
purchase."[48] Beyond this specific market-supporting role, certain cul-
tural goods can also help one reflect in general on the appropriate
role of consumption in one's life. "Thus cultural goods enhance both
the benefits available through the market *and* one's ability to keep
these in proper perspective."[49] Indeed, by thematizing "the nature
and conditions of human well-being," cultural goods enable one to
recognize the market's limitations "as a source of such well-being,
and the need to sustain relationships and activities [such as friend-
ships and hobbies] characterized by the absence both of market insti-
tutions and market meanings."[50]

Given the market-supporting role of cultural meta-goods, Keat
claims that one could make a standard "market-failure" argument
for government involvement: the market's underproduction of

[47] Ibid., p. 13.
[48] Ibid., p. 14.
[49] Ibid., p. 160.
[50] Ibid., p. 161.

economically crucial meta-goods could justify state subsidies for
nonmarket cultural institutions as well as government regulation of
their commercial counterparts. Moreover, addressing the concern
for state neutrality in liberal political thought, Keat argues that a
nonprotecting state would not be neutral with respect to different
conceptions of the human good. Rather, it would privilege market-
based conceptions of the good, which are not neutral with respect
to nonmarket goods, practices, and institutions. *Not* to regulate the
market in this regard, and *not* to subsidize appropriate cultural
institutions, would violate the liberal principle of state neutrality
by privileging market-based conceptions of the good: "Indeed, the
principle of neutrality may itself require the state to intervene."[51]

Hence, contrary to both welfare economics and liberal politics, Keat
argues for "a politics of common goods." In this politics, the citizens
of a democratic society, who share a limited plurality of values beyond
the shared value of consumption, will want to ensure that the market
does not "damage or undermine...other sources of their well-being,"[52]
whether such sources be the natural environment or nonmarket
spheres of social life. Such a politics presupposes both that people are
motivated by more than consumption-oriented self-interest and that,
although they differ "in the particular conceptions of the good which
they *choose to pursue*," they can nevertheless jointly recognize "whether
these are indeed conceptions of the *good*."[53] When it comes to the mar-
ket's place in people's pursuit of the good, "collective decisions have to
be made, and it is hard to see how one can avoid their being based on
substantive – 'perfectionist' – judgements about the respective value of
different goods." Just as neutralist liberalism is inadequate as a political
theory, so setting aside substantive conceptions of the good is inad-
equate as a mode of democratic politics, for which a philosophical
conception of society and human well-being "is an important cultural
resource."[54] In the end, state support of nonmarket cultural institu-
tions is "a crucial requirement for a flourishing democracy."[55]

[51] Ibid., p. 165.
[52] Ibid., p. 166.
[53] Ibid., p. 169.
[54] Ibid., p. 170. Keat mentions Hegel's *Philosophy of Right* as a prime example of such
a philosophical conception; see p. 203n41.
[55] Ibid., p. 171.

Culture and Economy

I share Keat's intuition that the warrant for government arts funding
lies in art's cultural character and not merely in its more directly eco-
nomic or political contributions. More precisely, whatever economic
and political contributions the arts afford need a firm anchor in art's
cultural character in order properly to serve as justifications for state
subsidies. Keat gets at this relationship by portraying the arts as social
practices made possible by cultural institutions for which external
goods must remain subordinate to specific cultural standards. His
emphasis on art's cultural character marks a notable step beyond
mainstream economic justifications of government arts funding. Yet
Keat has not clarified sufficiently the relationship between art's cul-
tural character and its economic and political roles.

The foggy patch in Keat's otherwise lucid and nuanced argument
arises from his attempt to beat welfare economics at its own game.
He argues that the market needs intact cultural institutions to gener-
ate cultural meta-goods. Left to its own devices, the market tends to
underproduce the cultural meta-goods it needs and to overproduce
"non-credible cultural goods."[56] Hence, government intervention
into the market is required and justified. But it is difficult to see why
a market structured to give priority to consumer benefits would need
cultural meta-goods in any sense strong enough to justify state inter-
vention. Would the consumer capitalist market economy slow down
or become dysfunctional if noncommercial art or academic research
in the humanities was abandoned or was "outsourced" to commercial
firms? I hardly think so. People's lives might be poorer, and their abil-
ity to make wise choices might diminish, but perhaps then the market
would thrive even more in its consumption-biased way.

It is also hard to see what would motivate people to prefer cultural
meta-goods strongly enough to endorse state support for cultural
institutions. Keat gives the partly hypothetical example of people rec-
ognizing that the market-driven elimination of substantial news pro-
gramming on television damages "the health of the democratic system
to which they are politically committed." Hence, they might support
state regulation of commercial television in this regard.[57] Even if this

[56] Ibid., p. 159.
[57] Ibid., p. 158.

example were plausible, which I doubt, it would not show that people are motivated to value cultural meta-goods *as meta-goods* – that is, as goods that help them sort out the context and priorities of their own consumption. The example simply shows that people might have other values (political values, in this case), in addition to consumer preferences, that might prompt them to curb their consumer preferences, thereby turning substantial news programming into a "merit good." In fact, Keat's argument seems to land in a "catch-22": to value cultural meta-goods strongly enough to endorse state support, people would already have to enjoy wide and substantial exposure to the cultural meta-goods that the market purportedly underproduces.

In my view, the "need" for cultural meta-goods is not intrinsic to the market. Rather, it is a cultural need that people have, their need to achieve market-independent or market-resistant orientations. Consequently, the case for state subsidies must appeal to people's cultural well-being, not simply to the market's "well-being." In calling upon governments to protect cultural meta-goods from market forces, Keat limits the cultural character of art products and events to the potentially corrective role they could play in a consumerist economy. Conversely, by viewing the market as having its own inherent "conceptions of the good" that oppose nonmarket conceptions of the good, Keat treats the market as a cultural institution having its own standards and internal goods. But this flies in the face of a large literature that says the market is a system that has become disembedded from cultural practices and social institutions, such that its only "standard" is that of exchange and its primary "good" is the medium of money.[58] Although I share Keat's unease at this system's dominance over cultural organizations, challenging its dominance requires a normative critique of the economy as such and not simply recasting it as a cultural institution.

Part of the problem seems to lie in Keat's equating the identity of something with one of its functions, as if the ability of artworks to help orient the consumer, for example, defines their "proper" identity in modern societies. It seems to me that having such ability does

[58] See especially Jürgen Habermas, *The Theory of Communicative Action*, vol. 2, *Lifeworld and System: A Critique of Functionalist Reason*, trans. Thomas McCarthy (Boston: Beacon Press, 1987).

not mean that artworks are not simultaneously economic commodities or legal possessions. Whenever they are purchased or sold, their economic function leaps clearly into view. So it is too simple to describe them as "cultural meta-goods" that help reorient or disorient consumers in the market. They are also straightforward economic goods, even when their production and distribution occurs within noncommercial cultural organizations. Indeed, this commodity status helps make possible their role as cultural meta-goods. But so do, say, their hermeneutical functions. Like the cultural organizations that make them possible, artworks are multidimensional. Because they are multidimensional, their metafunction in the market is too thin a basis for justifying state support.

The challenge, then, is to acknowledge the multidimensional and cultural character of the arts without either overextending the notion of culture to include a market economy or ignoring the cultural deficit in both the market economy and welfare economics. Although Keat offers better culturally inflected reasons for state support than do mainstream economic justifications of government arts funding, he has not overcome the cultural deficit.

2.3 SOCIOCULTURAL GOOD

Irreducibly Social Goods

My alternative develops the intuition that the arts are, in Charles Taylor's terms, "irreducibly social goods." We cannot adequately understand them employing the "consequentialism" and "atomism" that underlie welfare economics. It is a mistake to regard them as merely "decomposable" public goods, as being good only because they deliver satisfactions to individuals. Nor can their measure of goodness lie in subjective satisfactions or "preferences."[59] Rather, as Taylor insists, and as Keat recognizes, cultural products and events such as artworks and artistic performances inhabit "the domain of meaning, the domain in which 'counting as' and 'validity' play an

[59] Charles Taylor, "Irreducibly Social Goods," in *Philosophical Arguments* (Cambridge, Mass.: Harvard University Press, 1995), pp. 127–45; quotations are from pp. 127–30.

essential role."[60] In the domain of meaning, "goods" can be good, and be regarded as good, only against the background of meanings they both presuppose and require. This background exists because of shared normative practices.

Taylor provides two approaches to defining cultural matters as irreducibly social goods, rather than as individual consumer goods. First, a "background of practices, institutions, and understandings" that forms an intrinsically good culture makes them possible: "To say that a certain kind of self-giving heroism is good, or a certain quality of aesthetic experience, must be to judge the cultures in which this kind of heroism and that kind of experience are conceivable options as good cultures. If such virtue and experience are worth cultivating, then the cultures have to be worth fostering, not as contingent instruments, but for themselves."[61] Being "an irreducible feature of the society as a whole," a valuable culture, unlike the "public goods" of welfare economics, could never *not* be "supplied" to everyone in the society.[62] Second, as irreducibly social goods, cultural matters are enveloped in "common understandings" that are "undecomposable." This means that their very goodness depends on their being acknowledged as good "not just for me and for you, but for *us*." In this second sense, a good is irreducibly social "where it is essential to its being a good that its goodness be the object of a common understanding."[63]

It is to Keat's credit that he challenges Paretian welfare economics, which can only admit of individual consumer goods and thereby, as Taylor puts it, "pretends to a neutrality it doesn't really enjoy."[64] Keat challenges welfare economics by appealing to the first sense in which cultural matters can be defined as irreducibly social goods. Because cultural "meta-goods" provide perspectives within which to evaluate other goods, their own goodness exceeds market measures. It goes back to a culture, or perhaps a set of cultural institutions, that should be regarded as intrinsically good.[65] But Keat does not identify clearly

[60] Ibid., p. 132, writing specifically about "thoughts."
[61] Ibid., p. 136–7.
[62] Ibid., p. 138.
[63] Ibid., p. 139.
[64] Ibid., p. 145.
[65] Keat does not say this explicitly, however, nor does he revert to the sort of cultural nationalism that Taylor associates with a heavy emphasis on the intrinsic worth of a culture.

what is culturally specific to the arts, nor does he explain adequately their economic and political underpinnings as irreducibly social goods. Neither does Taylor, for that matter. So let me sketch my own alternative.

Art and Culture

To begin, I employ both a generic notion of *culture* and a specific notion of *a culture*. These two notions are roughly parallel to David Throsby's dual usage of "culture" in *Economics and Culture*. Throsby uses it in a "functional" sense (generic sense, in my terms) to denote human activities and products that "have to do with the intellectual, moral and artistic aspects of human life." Such activities and products involve creativity, symbolic meaning, and the potential for becoming intellectual property. Throsby also uses "culture" in a "broadly anthropological or sociological" sense (specific sense, in my terms) "to describe a set of attitudes, beliefs, mores, customs, values and practices which are common to or shared by any group."[66] The connection between these two senses remains vague in Throsby's book, however, and his functional definition seems more narrowly circumscribed than is warranted.

My own distinction between a generic and a specific notion of culture tries to avoid these problems. Generically, *culture* is a dynamic network of human practices, relationships, and products or events. Through this network, traditions take shape and get transmitted, social connections solidify and are contested, and personal identities develop and are embraced. Art, language, and education are among the many nodes to culture as a dynamic network in contemporary societies. By contrast, *a culture* (or a subculture) is a relatively cohesive and complex configuration of practices, relationships, and products or events where certain habits, sensibilities, and self-understandings are characteristic. It is in this specific sense that one speaks of "Canadian culture," for example, or "a democratic culture." This is also the sense in which Seyla Benhabib, arguing for the hybrid and polyvocal character of contemporary cultures, defines them as "complex human practices of signification and representation, of

[66] Throsby, *Economics and Culture*, pp. 3–4.

organization and attribution, which are internally riven by conflicting narratives. Cultures are formed through complex dialogues with other cultures."[67] Although I agree with Benhabib's insistence on the internal complexity and dialogical character of contemporary cultures, I would also emphasize that, to be "a culture" in the proper specific sense, a certain configuration of practices and the like needs to be relatively cohesive and not simply complex.

I have argued elsewhere that, as a node of culture in the generic sense, the arts today are societal sites for imaginative disclosure. This gives the arts a very important role in society. People in the contemporary West turn to the arts in order to find cultural orientation. "Cultural orientation" refers to the ways in which "individuals, communities, and organizations find their direction both within and by way of culture."[68] It has to do both with discovering purpose and meaning and with learning why purpose and meaning are absent. We look to the arts for this because they have developed in the West as organized settings for exploring, presenting, and creatively interpreting multiple nuances of meaning. They are societal sites for imaginative disclosure.

This implies that aesthetic judgments are not simply about the formal qualities of self-contained products. Aesthetic judgments about art phenomena pertain in the first instance to the authenticity of artistic practices, the integrity of artworks as self-referential signs, and the significance of the experiences that participation in art affords. Authenticity, integrity, and significance, in turn, make it possible for art products and art events either to articulate nuances of personal and social worlds or to disturb the personal and social worlds we already inhabit. That is why "artworks elicit interpretations not only of themselves but also the worlds to which they point, which exceed either the world of the artist or the world of the interpreter."[69]

Viewed in this way, the aesthetic worth of the arts is not asocial or antisocial. Rather, aesthetic worth is intrinsic to their being

[67] Seyla Benhabib, *The Claims of Culture: Equality and Diversity in the Global Era* (Princeton, N.J.: Princeton University Press, 2002), p. ix.

[68] Lambert Zuidervaart, *Artistic Truth: Aesthetics, Discourse, and Imaginative Disclosure* (Cambridge: Cambridge University Press, 2004), p. 132.

[69] Lambert Zuidervaart, *Social Philosophy after Adorno* (Cambridge: Cambridge University Press, 2007), p. 44.

"irreducibly social goods": the arts have aesthetic worth *as* "dedicated societal sites for imaginatively pursuing cultural orientation." They are, we could say, not simply *social* goods but *sociocultural goods*, and irreducibly so. Nor is the importance of the arts in society somehow detached from their aesthetic worth. Rather, "intersubjective imaginative processes within the arts both complement and disrupt other societally constituted sites in which cultural orientation occurs."[70]

This suggests, in turn, that the distinction between intrinsic merits and instrumental benefits, as it informs standard economic justifications for government arts funding, cannot be accepted at face value. The aesthetic worth of the arts is not peculiar to them: many other products and events have aesthetic worth. But neither is the aesthetic worth of the arts somehow instrumental to nonaesthetic ends: whatever the arts can contribute to other institutions in society will occur *in the process of* imaginative disclosure, not *by means of* imaginative disclosure. If we take seriously the hermeneutical character of the arts, as Taylor suggests, then the model of intrinsic and instrumental value, of ends and means, will yield to a model of cultural mediation. Similarly, if we take seriously the institutional character of the arts, as Keat proposes, then the model of consumer goods and meta-goods, of market and culture, will give way to a model of mutual societal constitution. The requisite model will do justice to the arts as imaginatively disclosive, sociocultural goods to which people turn in order to find cultural orientation.

On my model, the focus of state subsidies for the arts, and of the requisite justification, does not lie in generic "external benefits." Nor does it lie in "intrinsic merits" as such. Rather, it occurs at certain intersections among economy, polity, and civil society where significant contributions and pressures arise. They arise there because of the societally important aesthetic worth of arts that have a specific form of economic organization and perform a specific type of political role. The primary form of economic organization in question is that of the legal or customary not-for-profit association; the political role is that of public communication.[71] The question of state subsidies

[70] Zuidervaart, *Artistic Truth*, p. 215.

[71] Although in the current context I am primarily interested in the economic role of civic-sector organizations, a more comprehensive analysis would need to include their role in democratic communication and deliberation. See in this connection the groundbreaking study by Mark E. Warren, *Democracy and Association* (Princeton, N.J.: Princeton University Press, 2001).

arises most pertinently with respect to the sociocultural importance of civic-sector organizations dedicated to fostering what I call "art in public."[72] Examples of such organizations could include public art museums, not-for-profit theater groups, and community-based choirs.

Economic Dialectic

The question concerning state subsidies for arts organizations arises in part from an economic dialectic. This dialectic unfolds where civil society links up with the economic system and the administrative state. The economic link lies in what I call the civic sector – an economic zone of cooperative, nonprofit, and mutual benefit organizations. On the one hand, arts organizations in the civic sector foster a sociocultural good that society needs but neither the capitalist marketplace nor the administrative state can adequately provide. It is not simply that such organizations offer the "external benefits" identified by economic efficiency arguments, nor can we capture what they offer in the notion of "merit goods." Rather, civic-sector arts organizations, being set up to promote societally important aesthetic worth, offer a *real economic alternative*. They pursue and provide practices, relationships, and products or events that open up cultural pathways in an imaginative fashion and relatively free from the systemic constraints of marketplace and state. And they do this within a social economy where solidarity among participants outweighs considerations of efficiency and control. Moreover, for-profit firms need this alternative, not merely as providing an inexpensive avenue to creative talent and corporate self-promotion, but more significantly as holding open possibilities for doing business differently and for different reasons.

On the other hand, the most dramatic threats to civil society, and to art as a sociocultural good, come from the financial imperatives of a global capitalist economy dominated by transnational corporations. Following its own logic of money, global capitalism threatens to wipe out any form of economic organization that does not make monetary objectives primary and does not fully embrace commercial

[72] I explain the concept of "art in public" in Chapter 3 and the concept of "civic sector" in Chapter 5.

strategies. Hence, in the interests of preserving creative economic alternatives to a hegemonic economic system that also conflicts with state imperatives, governments do well to protect and subsidize arts organizations in the civic sector. Because such arts organizations also strengthen the social-economic fabric of society, without which the capitalist market itself would implode,[73] they warrant government support.

Although my economic argument retains some of Keat's worry about market boundaries, I introduce distinctions internal to the economy that eliminate the need to pit cultural meta-goods against consumer goods. The contest over market boundaries does not occur between the market and cultural institutions as such. Rather, it occurs among three sectors of a mixed economy: for-profit, government, and civic sectors. Whereas the first two economic sectors are systemic and formal, the third sector is sociocultural and informal. Accordingly, arts organizations having a not-for-profit form are simultaneously vulnerable to systemic economic pressures and crucial as participants in an alternative economic modality. To the extent that they are institutionally shielded from the systemic pressures of a capitalist market and the administrative state, endeavors sponsored by civic-sector arts organizations are more likely than commercial or state-sponsored art to concentrate on processes of imaginative disclosure. Because imaginative disclosure is central to art's societal importance, even as it makes up art's aesthetic worth, a case can emerge for government measures to protect civic-sector arts from commercialism and to promote their flourishing via state subsidies.

From this discussion of economic justifications, we begin to see why the debate between advocates and opponents of government arts funding has been poorly framed. By pitting state subsidies against a supposedly free market, it overlooks the internal complexity of a three-sector economy. The debate also misconstrues the character of arts organizations in the civic sector, which are not simply business enterprises. And it fails to recognize the sociocultural reasons why the arts are important to society in general and to a capitalist

[73] This strikes me as a preferable way to articulate Russell Keat's point about the market's need for "cultural meta-goods." On the importance of civil society to a market economy, see John Keane, *Global Civil Society?* (Cambridge: Cambridge University Press, 2003), pp. 75–88.

economy in particular. These reasons will become more substantial when Chapter 5 explicates the role of organizations in the economy's civic sector.

Arts organizations in North America face a cultural deficit. The deficit occurs in the societal structures that sustain them. But it also occurs within the explanations that arts organizations give for the societal importance of the arts. This cultural deficit receives forceful expression in standard economic arguments for government arts funding: such arguments misinterpret the character of cultural practices. They also misconstrue the role of arts organizations in a democratic society. The standard arguments are like canaries in the sociocultural mine: they fall silent precisely where internal deficits hinder arts organizations from fostering a democratic culture. The arguments, like the organizations, fall silent before the question, what good is art? I have attempted to show this with respect to mainstream economics and have begun to offer an alternative. Now we must consider political justifications for government arts funding.

3

Just Art?

I see little of more importance to the future of our country and our civilization than full recognition of the place of the artist.

John F. Kennedy[1]

President John F. Kennedy's remarks at Amherst College one month before his assassination in 1963 capture the high aspirations that surrounded the establishment of the National Endowment for the Arts. Artists, he suggested, have a central role to play in public discourse. Their sensitivity and concern for justice make artists important social critics: "If sometimes our great artists have been the most critical of our society, it is because their sensitivity and their concern for justice, which must motivate any true artist, makes [them] aware that our Nation falls short of its highest potential." A prime example, President Kennedy said, is the poet Robert Frost, to whom Amherst College dedicated the Robert Frost Library that same day. Frost "saw poetry as the means of saving power from itself....When power corrupts, poetry cleanses. For art establishes the basic human truth which must serve as the touchstone of our judgment."[2] That is why a great nation will fully recognize the place of artists in society.

[1] John F. Kennedy, "Remarks at Amherst College upon Receiving an Honorary Degree, October 26, 1963," in *Public Papers of the Presidents of the United States: John F. Kennedy, 1963* (Washington, D.C.: U.S. Government Printing Office, 1964), p. 817.
[2] Ibid.

Kennedy had few doubts that art is a sociocultural good, as was argued in the previous chapter. He also assumed that people have a right to participate in the arts, that those who attend schools such as Amherst have "a responsibility to the public interest," and that the artists among us make an indispensable contribution to a country's "spirit."[3] Today, none of these assumptions can be taken for granted. The optimism and public-mindedness that President Kennedy exuded have long since dissipated in both the United States and Canada. Mainstream economists have little use for the notion of art as a sociocultural good. And mainstream political theorists are not so sure that art is important for the pursuit of public justice or that people have a right to participate in the arts.

Questions concerning "good" and "right" are not unrelated. In fact, debates among contemporary political theorists revolve around disagreements concerning the relative priority of the good and the right, with political liberals preferring the right and their opponents preferring the good. Not surprisingly, mainstream political justifications of direct state subsidies for the arts also divide into two camps, namely, instrumentalism and perfectionism.[4] Instrumentalists usually are political liberals, and perfectionists usually oppose political liberalism. The two camps disagree in general about the proper role of the state in a pluralist and democratic society. Should the state restrict its efforts to promoting and ensuring justice, as instrumentalists hold? Or should it have the more expansive role assigned by perfectionists of furthering human flourishing within its jurisdiction? One will have a different view of government funding depending on how one answers such questions about the state's proper role in society.

The economic arguments discussed in Chapter 2 both parallel and intersect mainstream political arguments. Merit good arguments have their political counterpart in perfectionist justifications of government arts funding, which turn on a notion of intrinsic

[3] Ibid., pp. 815–16.

[4] I adopt the terms "instrumental" and "perfectionist" from David T. Schwartz, *Art, Education, and the Democratic Commitment: A Defense of State Support for the Arts* (Dordrecht: Kluwer, 2000). Although Schwartz describes his own approach as a type of instrumental justification, it differs significantly from mainstream instrumentalism. I discuss it later as an alternative to liberal political theory.

worth. Political liberals counter with instrumental justifications. These either resemble or employ the efficiency and equity arguments already considered. Instrumental justifications do not deny that art has intrinsic worth, but they claim intrinsic worth cannot serve as a basis for government arts funding.

As we have seen, a central question for economic justifications of government arts funding is, what good is art? In addressing this question, the previous chapter challenges a standard distinction between intrinsic merits and instrumental benefits and insists on the sociocultural character of the arts. A similar distinction shows up in political justifications, for which a central question is, what right do people have to participate in the arts? To address this question, the present chapter renews my critique of the intrinsic-extrinsic distinction and elaborates the role of art in public communication. First I consider three mainstream political justifications of direct state subsidies for the arts: a perfectionist argument (Joel Feinberg), a minimal instrumental argument (John Rawls), and a robust instrumental argument (Ronald Dworkin). Next I uncover a democratic deficit in such justifications, and I discuss one attempt to overcome this deficit. Then I sketch a conception of art in public that points toward an alternative case for government arts funding.

3.1 POLITICAL JUSTIFICATIONS

Perfectionism

In contemporary political-theoretical debates about the relative priority of the good and the right (or justice), political perfectionists take the side of the good. The perfectionist claims that some forms of life are intrinsically better than others, better in the sense that they are more conducive to human flourishing. The perfectionist also argues that the state has a legitimate and necessary role in promoting better forms of life and discouraging worse ones. Accordingly, the perfectionist justifies direct subsidies for the arts as ways to carry out the state's life-perfecting role, because of the intrinsic worth either to artistic endeavors or to the experiences that the arts afford. Perfectionism, or what Ronald Dworkin calls the "lofty" approach to state subsidies, "assumes that art allows citizens to achieve a level of

flourishing otherwise unobtainable. And...it assumes that promoting human flourishing is a proper and justifiable item on the state's agenda."[5] As David Schwartz points out, a perfectionist argument figures prominently in the charter of the National Endowment for the Arts (NEA).[6] The same applies to the charter of the Canada Council for the Arts (CCA). Nor is this surprising, given the frequency of economic merit good arguments, with their emphasis on art's intrinsic worth, in political discourse before the neoconservative "revolution."[7]

Joel Feinberg takes care not to state in detail what the intrinsic worth of the arts might be. Yet his case for government arts funding follows a perfectionist strategy. Feinberg says that the advocate of government arts funding must persuade "the indignant taxpayer." The indignant taxpayer thinks it is unfair to use "government funds derived from mandatory taxation of all citizens in order to promote the esoteric projects of a small number of people." This indignant taxpayer invokes the following "benefit principle": "Justice requires that persons pay for a facility in proportion to the degree they benefit from it."[8] Because Feinberg thinks that indirect subsidies and users' fees would not suffice as means to support the arts, and because he also thinks that public good arguments will not satisfy indignant taxpayers who never attend, say, the opera, he proposes a noninstrumental justification for direct state subsidies. The central concept in Feinberg's proposal is that of "benefit-less" or "intrinsic" value.[9]

[5] Ibid., p. 18. Schwartz's chapter on "The Tradition of Subsidy" (pp. 13–44) gives a lucid account of perfectionist justifications and of both their political and aesthetic deficiencies.

[6] Ibid., pp. 13–14.

[7] For perfectionist and merit good arguments supporting the CCA and NEA, see *Report of the Royal Commission on National Development in the Arts, Letters and Sciences, 1949–1951* (Ottawa: Edmund Cloutier, 1951), pp. 3–10, and *Compilation of the National Foundation on the Arts and the Humanities Act of 1965, Museum Services Act, Arts and Artifacts Indemnity Act, as Amended through December 31, 1991*, prepared for the use of the Committee on Education and Labor, U.S. House of Representatives, 102nd Cong., 2nd sess. (Washington, D.C.: U.S. Government Printing Office, 1992), pp. 1–2.

[8] Joel Feinberg, "Not with My Tax Money: The Problem of Justifying Government Subsidies for the Arts," *Public Affairs Quarterly* 8 (April 1994): 102.

[9] Feinberg (ibid., pp. 104–6) does consider a mode of instrumental justification, a scheme of "rotational justice" in which the entire "complex institutional practice" of the arts, rather than any specific project or art form, is the object of universal

First Feinberg sketches how something "can be truly valuable for some reason other than that it benefits someone" and indicates how subsidizing it "can be the proper business of the state, using tax funds extracted in part from the unbenefitted."[10] Then he explicates a concept of "intrinsic value," applies it to art, and argues on that basis for state subsidies.[11] To distinguish "benefit-less" or "intrinsic" value from the concept of benefit or instrumental value, Feinberg says that "to be valuable" is "to be worthy of being valued" in the sense of being held in high regard or even cherished or treasured. Something can be valuable either as worthy of being valued for its own characteristics and properties (i.e., intrinsically valuable) or as worthy of being valued "for what can be done with it" (i.e., instrumentally valuable) or both.[12] The crucial point for Feinberg is that we cannot explain the value of an intrinsically valuable thing "by reference to the states of mind it produces." Rather, we can explain such states of mind, at least in certain cases, only by reference to an "independently grounded value," and they might arise only when we understand this value.[13] Citing several examples, including an esoteric mathematical proof, an atonal sonata, and an endangered species, Feinberg concludes that there are intrinsically valuable things.

Among these intrinsically valuable things are artworks, whose "aesthetic value...is not reducible to [their] beneficial properties." For example, the market value of a painting, while beneficial to its owner, "can hardly be the whole of its value, else it would be impossible to explain how it could have any monetary value at all."[14] Worthiness of being intrinsically valued is reason enough "for requiring people to protect or support" what has intrinsic value. And this reason has

and equal benefit. This approach, which resembles Dworkin's appeal to a rich cultural structure, may be "the best we can hope to do if we restrict ourselves to the concepts of benefit and harm in our attempts to justify subsidies. On that level, it provides the best answer to the challenge of the taxpayer who disapproves in a particular case the uses for which his money is employed, who doesn't want his money used in that way, and who is unbenefitted himself by that use of it" (ibid., p. 105). But he thinks his own noninstrumental approach is better.

[10] Ibid., p. 106.

[11] My summary omits Feinberg's attempt (ibid., pp. 114–18) to distinguish "intrinsic" from "inherent" value. While important in its own right, the distinction does little to advance his argument for state subsidies.

[12] Ibid., p. 108.

[13] Ibid., p. 111.

[14] Ibid., p. 114.

relevance and cogency, even for "the egoistic philistine taxpayer," because "the judgment of [intrinsic] value is an appeal not to the taxpayer's actual attitudes and wants..., but rather to the worthiness and propriety of attitudes that he [or she] might not in fact share."[15]

Whatever one thinks of the distinction between benefit and intrinsic value, there are two problems internal to Feinberg's argument, both of them highlighted by Richard Manning. First, Feinberg does not show that the "aesthetic value" which makes art intrinsically valuable is itself intrinsically valuable. The problem stems in part from the fact that he provides no content for the notion of aesthetic value. Second, Feinberg fails to answer the indignant taxpayer's objection with which he began. Manning states the issue as follows: "Since the benefit principle is [indifferent] to intrinsic value, a showing that art objects are intrinsically valuable is simply [irrelevant] to challenges based on that principle. What we need to defeat the taxpayer challenge... is either an argument showing that the benefit principle may in fact be satisfied even where the taxpayer is unable or unwilling to appreciate the value in a subsidized project, or an argument that shows the benefit principle itself to be false."[16] Manning offers both sorts of argument. First, he argues that satisfaction of the benefit principle can be demonstrated once we slaughter the "sacred cow of classic, rights based liberalism" that "the individual is the [only] proper judge of her own good."[17] Then, he rejects the benefit principle altogether, claiming that "the benefit principle is false. Justice simply does not demand that I receive quid pro quo from each project funded with my tax dollars."[18]

There is much to commend Manning's response to the second problem. Yet, like Feinberg's approach, it has the unfortunate consequence that it too does not answer the indignant taxpayer. Schwartz puts matters like this: "While both philosophers seek to answer the indignant taxpayer's challenge, neither takes this challenge seriously, for neither responds to the indignant taxpayer on her own terms. Feinberg and Manning each start their arguments using one model of political justification – satisfying the benefit principle – but then

[15] Ibid., p. 120.
[16] Richard Manning, "Intrinsic Value and Overcoming Feinberg's Benefit Principle," *Public Affairs Quarterly* 8 (April 1994): 134.
[17] Ibid., p. 135.
[18] Ibid., p. 139.

each slides into a very different model of political justification – demonstrating the existence of objective value." They must make up their minds, he says, whether "the task of justifying arts subsidies is one of persuading the philistine taxpayer."[19]

At a more general level, the political difficulty[20] with perfectionist justifications such as Feinberg's is that they violate state neutrality with respect to particular conceptions of the good, a fundamental tenet of political liberalism. As a justificatory strategy,[21] perfectionism unavoidably privileges one particular conception of the good (such as one that regards beauty or aesthetic value as central to human flourishing) over others (such as one that regards aesthetic value as the province of elite culture or one that regards beauty as an ideological distraction from oppressive relations).[22] Because political liberalism

[19] Schwartz, *Art, Education, and the Democratic Commitment*, p. 122. For his own part, Schwartz sees the justificatory task as not requiring "that we actually *persuade* the indignant taxpayer to acquiesce to the needed taxation" but only "the weaker requirement that we *respond* to the taxpayer's complaint by providing good and adequate reasons in favor of subsidy" (ibid., p.11n8).

[20] There is also an art-philosophical difficulty, which Schwartz elaborates. Perfectionist views of art, with their emphasis on beauty or aesthetic appreciation, receive little support from contemporary artists and art critics, and the alternative of appealing to "cultural excellence" rather than "beauty" introduces another set of problems. See ibid., pp. 33–41.

[21] I focus on "neutrality of reasons" (what Will Kymlicka calls justificatory neutrality) and leave aside concerns about "neutrality of outcomes" (what Kymlicka calls consequential neutrality) because, as Schwartz puts it, holding that public policies should not have effects that benefit one particular conception of the good "makes the neutrality ideal too stringent to be workable" (ibid., p. 42n16).

[22] There is an economic basis for concerns along these lines if one considers outcomes and not simply reasons. Numerous studies show that federal arts funding in countries like the United States and Canada has overwhelmingly supported mainstream organizations and activities controlled and enjoyed by those who are wealthier and "better educated." Because every citizen is subject to the income taxes and property taxes that make this funding possible, government arts funding with such outcomes amounts to a state-sponsored transfer of wealth away from those who are less well off. This gives some credence to the charge of "elitism" leveled at federal funding agencies in these countries. Commenting on this pattern in Britain in the early 1990s, Ruth Towse writes: "Subsidised art forms clearly only appeal to a minority of the population, even to only a minority of upper socio-economic groups.... Yet the tax system in Britain ensures that working-class people bear the brunt of taxation. Hence the...claim that subsidy to the arts is highly inequitable." Ruth Towse, "Achieving Public Policy Objectives in the Arts and Heritage," in *Cultural Economics and Cultural Policies*, ed. Alan Peacock and Ilde Rizzo (Dordrecht: Kluwer, 1994), p. 156. See also John W. O'Hagan, *The State and the Arts: An Analysis of Key Economic Policy Issues in Europe and the United States* (Cheltenham, U.K.: Edward Elgar, 1998), pp. 53–63.

has been the dominant political philosophy in North America, this apparent violation of state neutrality throws a significant hurdle into the perfectionist path. The assumption of state neutrality has steered leading political liberals away from perfectionist arguments concerning intrinsic value toward instrumental justifications on the basis of what Feinberg calls "benefits."

Minimal Instrumentalism

In *A Theory of Justice*, a classic of liberal political philosophy, John Rawls concludes that state subsidies for cultural goods cannot be justified on perfectionist grounds, and they can receive only a very weak justification on instrumental grounds. The reasons for rejecting perfectionist justifications stem from what Harry Brighouse calls the "neutrality constraint," which we have already considered: the principles of justice require that the state remain neutral with respect to particular conceptions of the good. The reasons for allowing only a very weak instrumental justification stem from the claim that state subsidies for cultural goods not only are not required by the principles of justice but also tend to violate the principles of justice. More specifically, state subsidies for the arts and culture tend to violate what Brighouse calls "the publicity constraint": the principles of justice require "that the actual reasons for government action must be understandable to, and available for scrutiny by, reasonable citizens, and that it must be manifest that the requirements of justice are met."[23]

Against perfectionism, Rawls claims that "the principles of justice do not permit subsidizing universities and institutes, or opera and the theater, on the grounds that these institutions are intrinsically valuable, and that those who engage in them are to be supported even at some significant expense to others who do not receive compensating benefits."[24] Although his including universities in this list may be surprising, given the sizable state subsidies they have in fact received in North America, Rawls thinks that "human perfections" should be pursued "within the limits of the principle of free association" and

[23] Harry Brighouse, "Neutrality, Publicity, and State Funding of the Arts," *Philosophy and Public Affairs* 24 (Winter 1995): 41.
[24] John Rawls, *A Theory of Justice* (Cambridge, Mass.: Harvard University Press, 1971), p. 332.

should not rely on "the coercive apparatus of the state" to gain advantages: "Thus the social resources necessary to support associations dedicated to advancing the arts and sciences and culture generally are to be won as a fair return for services rendered, or from such voluntary contributions as citizens wish to make, all within a regime regulated by the two principles of justice."[25] So if state subsidies for the arts can be justified at all, this will be an exception to the general rule.

Why does Rawls take such a minimalist approach, one at odds with prevailing policies and practices in the very governments for which he seeks to provide a political philosophy? Two Rawlsian premises help explain this. One is the priority given to individual rights, which Samuel Black calls "the constitutional orientation": in a just society individual rights take priority over other claims, including collective aims and aspirations, and those rights should be constitutionally secured.[26] The second premise is the presumption of "mutual disinterest" among the members of a just society: those who enter the social contract are presumed to do so as individuals whose primary interests are asocial. As Black puts it, these interests are "pursuits people might have as perfect strangers, or lone individuals, rather than the goods that may matter to them as members of a vibrant and robust culture." Accordingly, the primary goods to which the state can legitimately attend come down to "claims for negative liberties and an income share."[27] They do not include cultural goods.

Combined with the neutrality constraint and the publicity constraint, individualism and the presumption of mutual disinterest leave little room and provide little impetus for direct state subsidies of the arts and other cultural goods. Unlike primary goods such as transportation infrastructure or national defense, artistic activities and products embody and advance particular conceptions of the good that not all citizens share. If one adds to such nonneutrality "the fact that many persons do not value – and are sometimes offended by – much contemporary art," then "a compelling case emerges against classifying

[25] Ibid., p. 329. The two principles of justice are equality in the assignment of basic rights and duties and fairness in the arrangement of social and economic inequalities. For an explication of these principles, see ibid., pp. 54–117 and 302–3.

[26] Samuel Black, "Revisionist Liberalism and the Decline of Culture," *Ethics* 102 (January 1992): 245–6.

[27] Ibid., p. 249.

art as a primary good.["28] If art is not a primary good, then on a liberal political philosophy it is an unlikely candidate for legitimate state subsidies. In fact, a general tax to support such nonneutral and contested goods is prima facie unjust within a Rawlsian framework.

Nevertheless, Rawls does provide one instrumental reason for cultural subsidies, namely, the requirement of intergenerational equity. In the passage quoted earlier, where Rawls rejects perfectionist grounds for awarding cultural subsidies, he adds: "Taxation for these purposes can be justified only as promoting directly or indirectly the social conditions that secure the equal liberties and as advancing in an appropriate way the long-term interests of the least advantaged."[29] This comes to bear on the arts via Rawls's claim that each generation is obligated to replace the stock of capital goods that it has inherited.[30] Insofar as education and other cultural goods are essential to economic well-being both today and in the future, this obligation also includes the arts.

Yet, as Black comments, the cultural obligation here is purely instrumental: "whatever value Rawls assigns to 'knowledge and culture,' this is clearly derivative from their role in preserving just institutions and in particular from their instrumental capacity to raise the economic expectations of future generations. What his view excludes is the idea that knowledge and culture should be transmitted to posterity on account of either their intrinsic value or, alternatively, because people can naturally be presumed to take a vital interest in their culture."[31] Accordingly, and in keeping with an emphasis on individual rights and on equity in the distribution of neutral primary goods, Rawls suggests that one can justify direct state subsidies for the arts only insofar as they help "preserve general knowledge and culture as part of [each generation's] bequest to the next generation."[32] For presumably individuals in a future generation who receive an impoverished culture will also be economically disadvantaged thereby, and those who have the fewest cultural opportunities may well be even further disadvantaged and less free to pursue their own (economic) interests.

[28] Schwartz, *Art, Education, and the Democratic Commitment*, p. 22.
[29] Rawls, *A Theory of Justice*, p. 332.
[30] See ibid., pp. 284–93, and Black, "Revisionist Liberalism and the Decline of Culture," pp. 254–5.
[31] Black, "Revisionist Liberalism and the Decline of Culture," p. 255.
[32] Michael Rushton, "Public Funding of Artistic Creation: Some Hard Questions" (Regina: University of Regina, Saskatchewan Institute of Public Policy, 2002), p. 6.

So Rawls permits only a minimal instrumental justification of cultural subsidies, one that combines selected features of the efficiency and equity arguments familiar to economists. To defend actual state subsidies for the arts on this basis, however, one would have to demonstrate that the next generation faces artistic impoverishment – and hence economic disadvantages – in the absence of state subsidies. Such a case is notoriously difficult to make. For this reason a Rawlsian justification on the basis of intergenerational equity probably works better as a case for subsidizing *education* in the arts than as a case for subsidizing the activities of *artists and arts organizations*. This observation is consistent with Rawls's view, noted earlier, that cultural goods should normally be promoted through independent associations and not through coercive taxation.

In general, as Black states, "Rawls's rights-based constitution leaves virtually no room for state involvement in support of culture. Rather, his theory effectively relegates those goods to a position where they are certain to suffer systematic neglect." Like Black, I consider this position "both unduly restrictive and at variance with our current practices," a not altogether welcome result for a theory that claims to honor "our considered convictions on matters of justice."[33]

Robust Instrumentalism

Ronald Dworkin, who endorses much of Rawls's political philosophy, is not happy with this outcome. Like Rawls, he rejects perfectionist justifications, finding them "elitist" and "paternalistic."[34] Dworkin

[33] Black, "Revisionist Liberalism and the Decline of Culture," p. 253. Before reaching this conclusion, Black considers a public good justification that could be consistent with Rawls's "revisionist liberalism." But Black argues that policies so justified would be nearly impossible to implement and also incompatible with the presumption of mutual disinterest. See ibid., pp. 252–3.

[34] Ronald Dworkin, "Can a Liberal State Support Art?" in *A Matter of Principle* (Cambridge, Mass.: Harvard University Press, 1985), p. 222. Black, "Revisionist Liberalism and the Decline of Culture," pp. 253–4, points out that the charge of "paternalism" reflects "the rights-based constitutional orientation," which holds "that no individual can be deprived of his income share for the purposes of some common enterprise, without his consent." The charge of "elitism" reflects the neutrality constraint, which implies "that government is not permitted to levy taxes or otherwise intervene in promoting perfectionist ideals."

also goes to some length to show why the economists' public good arguments are unsatisfactory. His alternative is a more robust version of the Rawlsian appeal to intergenerational equity, one that justifies state subsidies for arts organizations and artistic creation, and not simply for education in the arts.

Objections

Before we turn to Dworkin's alternative, it will be useful to rehearse his objections to public good arguments. According to Dworkin, if we can find out how much citizens would spend collectively for the external benefits the arts offer, then we can regard art as a partial public good (his own term is "mixed public good"). But justifications that appeal to external benefits do not go far enough, he says, for two reasons. First, the sum of such benefits "would not be high enough to justify any substantial level of public support for that reason alone." Second, and more important, such a justification "demeans the suggestion that art is a public good" because it overlooks "our sense that art makes a general contribution" that is intrinsically "aesthetic and intellectual."[35] In other words, as was claimed in the previous chapter, the economists' public good arguments give insufficient attention to art's sociocultural character.

Next Dworkin proposes a type of public good justification that appeals to the "intrinsic benefits" that art has "for the public as a whole." Let me label this the "intracultural benefits argument." On the assumption that "culture is a seamless web," Dworkin posits a reciprocal influence between "high culture and popular culture." Of particular significance here is the influence of high culture, which provides popular culture with form (e.g., dramatic genres), reference (e.g., cultural allusions), and resonance (e.g., aesthetically articulated ideas). To the extent that high culture provides such cultural "spill-over benefits to the public at large, most of whom do not engage in the specific commercial transactions that finance it," state support seems

[35] Dworkin, "Can a Liberal State Support Art?" p. 225. Although I share Dworkin's intuitions on the second point, I think the economic literature proves him wrong on the first. Even the purely external benefits of the arts are high enough to warrant significantly increased subsidies in North America, provided, of course, that public good justifications are acceptable arguments.

"necessary to prevent the community's having less than it really wants of high culture because of the free-rider...problem."[36]

Despite Dworkin's sympathies for this approach, he finds it fatally flawed in two respects.[37] First, it is impossible to predict what cultural spillover benefits (high) art will actually have. This "problem of indeterminacy" makes it extremely difficult to justify a subsidy program as "helping to give [people] what they really want."[38] The second problem is one of incoherence. To determine what the public would be willing to spend in support of high culture, one would need to ask people what sort of popular or general culture they want. But the culture they already inhabit shapes their current cultural preferences, and they cannot step outside that culture to say what they really value and to what extent.[39] Dworkin calls this "the final blow to efforts to construct a public-good argument on the [cultural] spillover effects of high culture. That argument cannot work without some way to identify, or at least make reasonable judgments about, what people – in the present or future – want by way of culture; and culture is too fundamental, too basic to our schemes of value, to make questions of that kind intelligible."[40] From this he draws two conclusions: public good justifications do not work, even when they rest on art's cultural benefits, and "the economic approach is simply unavailable...as a test of whether art should be publicly supported or at what level. The issue of public support lies beneath or beyond the kinds of tastes, preferences, and values that can sensibly be deployed in an economic analysis."[41]

[36] Ibid., p. 225.

[37] Dworkin mentions a third flaw, namely, the problem of time lag between the public's being taxed and the enjoyment of the benefit. As Brighouse mentions, however, this "would be a problem for almost every expenditure policy," and it is not crucial to Dworkin's argument. Brighouse, "Neutrality, Publicity, and State Funding of the Arts," p. 49n20.

[38] Dworkin, "Can a Liberal State Support Art?" p. 226.

[39] Brighouse, "Neutrality, Publicity, and State Funding of the Arts," p. 49, frames this problem as one of asking people to compare "incommensurable values." But Dworkin's more fundamental point is that values are deeply embedded in the very culture about which people are being asked to rank their values with a view to public expenditures on culture.

[40] Dworkin, "Can a Liberal State Support Art?" p. 228.

[41] Ibid., p. 229.

Rich Cultural Structure

As an alternative not only to public good justifications but also to both perfectionism and Rawlsian minimalism, Dworkin proposes a version of what I label "robust instrumentalism." His justification is instrumental because it locates the basis for state subsidies in a type of instrumental value. It is robust in the sense that this instrumental value pertains to the "aesthetic and intellectual" contribution the arts make and not simply to the political or economic benefits the arts afford. And this contribution is not simply a matter of intracultural spillover benefits.

Dworkin's justification of government arts funding relies on the notion of a "rich cultural structure." A rich cultural structure is one that "multiplies distinct possibilities or opportunities of value." Art can contribute to this structure. The arts, he says, provide a "structural frame" that both makes aesthetic values possible and "makes them values for us."[42] They are like a community's "shared language," which our "daily transactions in language" either enrich or debase: "We are all beneficiaries or victims of what is done to the language we share." Similarly, "the structural aspect of our artistic culture is...a special part of the language we now share. The possibilities of art, of finding aesthetic value in a particular kind of representation or isolation of objects, depend on a shared vocabulary of tradition and convention." Like language in general, the cultural structure to which the arts contribute can be either enriched or impoverished by daily transactions, in two ways: first, by gaining or losing the "historical and cultural continuity" in which we find aesthetic value; second, by gaining or losing possibilities of innovation in art, both as "a tradition *of* innovation" and as the artistic preservation of cultural continuity "*through* innovation."[43] The rich cultural structure to which daily transactions in the arts can contribute would be one that multiplies possibilities for the cultural continuity and innovation in which people find aesthetic value.[44]

[42] Ibid.

[43] Ibid., pp. 230–2.

[44] Although Dworkin does not explicitly define this notion of an artistically generated and rich cultural structure, it is strongly implied by his description of art as part of a shared language.

Employing this notion of rich cultural structure, Dworkin's justification for government arts funding goes as follows:[45]

1. It is better for people to have a rich cultural structure – "to have complexity and depth in the forms of life open to them"[46] – than to have an impoverished cultural structure.

2. Everyone in a culture benefits from a rich cultural structure, not simply those who directly carry out the arts-related transactions that build and maintain this structure.

3. The (political?) community as a whole has an obligation to "act as trustees for the future of the complexity of our own culture."[47]

4. This obligation belongs to the "elementary obligation of justice to ensure that future generations inherit a fair share of social resources."[48]

5. The state has the legitimate task of maintaining such intergenerational equity by protecting the (political?) community's cultural structure.

6. Therefore, on the assumption that direct subsidies are an effective means to ensure intergenerational equity, state subsidies for the arts are justified. By "the arts" in this context, Dworkin means high art.[49]

Clearly Dworkin's robust instrumentalism revolves around an enhanced understanding of intergenerational equity: "We have inherited a cultural structure," he writes, "and we have some duty, out of simple justice, to leave that structure at least as rich as we found it." By the same token, his case restricts legitimate state subsidy to

45 For a different but not incompatible reconstruction of Dworkin's argument, see Black, "Revisionist Liberalism and the Decline of Culture," p. 254.

46 Dworkin, "Can a Liberal State Support Art?" p. 229.

47 Ibid., p. 232.

48 Black, "Revisionist Liberalism and the Decline of Culture," p. 254. Although Dworkin does not state this Rawlsian premise of intergenerational equity here, he had introduced it as an assumption in the public good arguments he rejected earlier. There he wondered how intergenerational equity could be implemented on an economic approach, but he did not question its legitimacy as a fundamental political principle.

49 In other words, Dworkin retains the "trickle down" thesis advanced earlier concerning the influence of high culture on popular culture. His criticism of the intracultural benefits argument assumed and did not challenge this thesis.

that which "is designed to protect structure rather than to promote any particular content for that structure at any particular time. So the ruling star of state subsidy should be this goal: it should look to the diversity and innovative quality of the culture as a whole rather than to...excellence in particular occasions of that culture."[50] This approach is not paternalistic, he suggests, because it does not assume that certain particular preferences, tastes, or ways of life are better than others. Nor is it elitist, because it aims at a structure that "affects almost everyone's life...in fundamental and unpredictable ways."[51]

More than any of the other economic and political arguments already considered, Dworkin's robust instrumentalism reduces the cultural deficit in mainstream justifications for government arts funding. For he recognizes that to justify such funding, the cultural contributions of the arts, and the state's role in supporting and protecting those contributions, need to be front and center. Yet this reduction of the cultural deficit amplifies a democratic deficit in mainstream political justifications, and it comes at the price of internal inconsistencies in his philosophy. His critics have noted three areas of inconsistency: economic anthropology, cultural philosophy, and political theory. When combined, these inconsistencies render his approach problematic.

Internal Inconsistencies
The inconsistency in economic anthropology occurs between two different views of the individual within Dworkin's argument. Political liberals share with welfare economists the view that individuals are rational maximizers of utility whose freedom consists in the unimpeded satisfaction of their own wants and preferences. This individualistic view underlies the constitutional orientation and neutrality constraint with which both Rawls and Dworkin begin their reflections on state subsidies for the arts. It strongly motivates their rejection of perfectionist justifications, and it governs their definition of "primary goods." Yet, as Samuel Black has shown, Dworkin's assumption that future generations will want a rich cultural structure and his claim that the present generation has an obligation to preserve this structure implicitly

[50] Dworkin, "Can a Liberal State Support Art?" p. 233.
[51] Ibid., p. 232.

employ quite a different view. They imply a more collective view of individuals as participants in a common culture for whom shared participation matters: "Dworkin appears to be assuming that the members of a society, including its future generations, have a very basic, noninstrumental interest in participating in a rich cultural life."[52]

In other words, Dworkin makes an unelaborated assumption that individuals, on behalf of whom the state acts, are fundamentally members of a cultural community who share a common cultural structure even as they share a common language. And this assumption cannot be compatible with the economic individualism that undergirds his account of the state's legitimate role in maintaining intergenerational equity and protecting individual rights. On this score Rawls is the more consistent of the two when he refuses to treat cultural matters as primary goods.

A closely related problem occurs in Dworkin's philosophy of culture. On the one hand, his case for state subsidies appeals to the need for a cultural structure that is common to all. Hence, he singles out the contributions that high culture makes to "general or popular culture."[53] On the other hand, even though Dworkin acknowledges *reciprocal* influence between high culture and popular culture, his case exclusively concerns subsidies for high culture. It does not even ask what contributions popular culture might make either to high culture or to the cultural structure that state subsidies should maintain. Despite his desire to avoid paternalism and elitism, it is hard to see how his case can succeed in that regard. As Black puts it, robust instrumentalists "enlist our support for high culture not because of its alleged intrinsic value or democratic support but on the grounds of its objectively fecund properties. This, however, is a bad argument. It has the rather strange implication that the members of society, including its poorest members, should be compelled to sacrifice part of their income share in order to subsidize cultural options for posterity, to which they themselves purportedly assign no value."[54]

[52] Black, "Revisionist Liberalism and the Decline of Culture," p. 256.
[53] Dworkin, "Can a Liberal State Support Art?" p. 225. I note in passing that Dworkin seems undecided whether to equate popular and general culture or to regard popular culture as one component of general culture, of which high culture would be another component.
[54] Black, "Revisionist Liberalism and the Decline of Culture," p. 258.

Behind Dworkin's argument stands "a strongly normative and covert theory of interests"[55] that in fact jars with the presumption of mutual disinterest with which liberals begin. For Dworkin has posited a shared interest in cultural values, specifically in aesthetic value, that individuals "in the state of nature" are presumed not to have, or are presumed to leave aside, when they enter "the social contract." Until Dworkin actually establishes that all of them have a shared and central interest in the cultural life of their community or polity, which as a good liberal he should not do, his robust instrumentalism cannot succeed. Moreover, if Dworkin had established such a shared and central interest, then, as Black says, it would make more sense to justify state subsidies directly, on the basis of this existing shared interest, "rather than rerouting it through an obligation to the future." But then the case for subsidies would run up against the "unmitigated undemocratic bias" of Dworkin's account: the likely desire for more than minimal state support, even if it were the will of the majority, could never overcome "the familiar unanimity constraint dictated [in political liberalism] by the priority of individual rights."[56]

In addition to employing a view of persons at odds with the neutrality constraint and a view of culture in conflict with the presumption of mutual disinterest, Dworkin's robust instrumentalism runs into political-theoretical problems with the publicity constraint. Recall that, as formulated by Harry Brighouse, political liberalism's publicity constraint implies that the state's subsidizing the arts should have accessible and understandable reasons and should be manifestly just.[57] Although Dworkin, like Rawls, subscribes to this constraint, the appeal to a rich cultural structure violates it, because of indeterminacy. Just as it is impossible to predict what cultural spillover benefits high art will actually have, so it is very difficult to say in advance how either supporting artistic innovation or maintaining traditional high art will actually contribute to the structure of culture. Dworkin touches on this when he says that "we lack the conceptual equipment to measure who benefits most" from the ways in which the cultural

[55] Ibid., p. 259.

[56] Ibid., p. 263.

[57] Brighouse, "Neutrality, Publicity, and State Funding of the Arts," p. 42, glosses "manifestly just" to mean "that there should be little room for reasonable doubt that the requirements of justice have been met."

structure affects people.[58] He does not seem to recognize, however, that the problem is not simply one of measuring relative degrees of benefit but of making any predictive measurements at all. Unlike, say, a proposal to nationalize railroads, where well-tested economic theory allows economic benefits to be predicted and debated, no currently established theory allows us to predict the effects on cultural structure of subsidizing high art. Hence, says Brighouse, "the opponent of funding for the arts who denies or doubts that the purported benefit will ever accrue is being perfectly reasonable. The fact of indeterminacy makes it impossible to demonstrate publicly that the expenditure has the intended effects."[59]

This violation of the publicity constraint actually heightens once the purported benefit gets located in a "cultural structure" that is even more diffuse and unpredictable than alleged cultural spillover benefits. Add to this the extreme difficulty in showing "that the actual justification for interrupting the existing distribution of resources is in fact neutral, even when it is,"[60] and one must conclude that robust instrumentalism violates the publicity constraint to which a political liberal such as Dworkin subscribes. Not only does it fail to provide publicly accessible and understandable reasons for subsidies but it also leaves ample room for reasonable doubt that such subsidies are just.[61]

3.2 DEMOCRATIC DEFICIT

The problems internal to Dworkin's position point toward two closely related deficiencies in mainstream political justifications of government arts funding. One is the cultural deficit that we already noted in mainstream economics. The other is a democratic deficit. To the extent that Dworkin's argument combines the best features of

[58] Dworkin, "Can a Liberal State Support Art?" p. 232.
[59] Brighouse, "Neutrality, Publicity, and State Funding of the Arts," pp. 51–2.
[60] Ibid., p. 53.
[61] In fact, Brighouse (ibid., p. 36) thinks that a similar problem besets all political liberals, whether their instrumental justifications for arts subsidies are weak or robust: "[A]rts funding is always liable to be a target of reasonable suspicions about nonneutrality, because it is especially difficult to show that the projects which are funded have the kinds of public benefits on which a liberal justification depends."

Feinberg's perfectionism and Rawls's minimal instrumentalism, his robust instrumentalism shows that mainstream political justifications can reduce these deficits only at the expense of internal inconsistencies with respect to culture, the economy, and political discourse. Nor is this surprising, given the need to take a stance on art's cultural character and democratic potential when one tries to argue for state subsidies. By way of review, let me briefly comment on the cultural deficit before I demonstrate a democratic deficit in mainstream political justifications.

Recalling the many different reasons given to justify government arts funding, we can see that all of them turn on what sort of good the arts provide in a cultural context. Either implicitly or explicitly, each type of justification not only stipulates the conditions that art must meet in order to be a good that deserves state support but also appeals to a normative notion of the good. Two sorts of conditions have come to the surface: benefit and intrinsic worth.

The concept of benefit figures prominently both in the economists' efficiency arguments over the arts as "public goods" providing external benefits and in the instrumental justifications offered by political liberals such as Rawls and Dworkin. The concept of benefit allows a wide range of effects to count as reasons for government funding, including cultural, political, and economic outcomes. All of these benefits share two features: they meet wants or needs that are presumed to be widespread and highly valued, and they arise as effects of interaction in the arts. Accordingly, challenges to specific arguments from benefit usually ask how effective the arts are in generating the alleged effect and whether this effect is of the sort that government should protect or promote. An underlying assumption in all such arguments is that government should intervene only where the market fails to provide enough of the desired benefit. They also presuppose the norm of maximal individual gratification.

The concept of intrinsic worth also depends upon a normative notion of the good. The argument from intrinsic value proposed by Feinberg claims that arts-generated "aesthetic value" is intrinsically good and therefore worthy of state support. Similarly, economic merit good arguments claim that the arts or experiences of the arts deserve state support because the relevant community considers them intrinsically good. Elements of intrinsic worth also enter Dworkin's robust

instrumentalism, insofar as he postulates a rich cultural structure as something worth maintaining and fostering for its own sake, and not simply because of the support it lends to people's economic prospects and individual liberties.

As we noted in connection with mainstream economic justifications, the closer one of these concepts comes to a notion of culture as something irreducible to economic and political considerations, the more problems it poses to mainstream political justifications for government arts funding. All the justifications already considered appear to fall short precisely because their underlying assumptions are incompatible with the sociocultural character of art. They suffer from a cultural deficit.

Public Justice

Mainstream political justifications also display a democratic deficit. This becomes evident when we consider the normative notions of public justice to which all of them appeal. Whereas economic equity arguments presuppose a political consensus concerning the value of relatively equal access to the arts but do not spell out a normative notion of justice, both political perfectionism and political instrumentalism try to articulate what justice requires of the state with respect to artistic endeavors. On Feinberg's perfectionist argument, justice requires that all taxpayers protect and support art that has intrinsic aesthetic value, even if they do not intrinsically value it or do not find it extrinsically beneficial. Rawls's minimal instrumentalism claims that the two principles of justice – political-legal equality and socioeconomic fairness – permit direct state subsidies for art but only as a way to promote intergenerational equity. Dworkin's robust instrumentalism, which appeals to the same two principles, holds that justice not only permits but also requires such subsidies in order to maintain a rich cultural structure and thereby to promote intergenerational equity.

Unfortunately, the normative notions within all three mainstream political justifications omit crucial elements of public justice. This becomes clear if we consider the primary normative task of the constitutional democratic state. The state's primary normative task is, through legislation, administration, and judicial decisions, to achieve

and maintain public justice for all the individuals, communities, and institutions within its jurisdiction. When the state lives up to its normative task, it is the most important institutional framework within which matters of public justice can be addressed.[62]

Matters of public justice occur in three domains. One is the plurality of distinctive institutions – religious, ethical, economic, educational, and the like – that need societal room to pursue their own legitimate tasks and that have a claim to state protection from illegitimate incursions by other institutions. I call this the domain of institutional pluralism. The second domain of public justice is that of cultural pluralism. Many different cultural communities have claims to public recognition from other communities. Such claims need to be adjudicated within the context of statewide legislation. The third domain of public justice pertains to the diverse needs and concerns of all the individuals who live within a state's jurisdiction. The state must protect persons from gross injustices at the hands of others, and they can expect a rightful share in the benefits afforded by government policies and programs.

It is not easy to reconcile this normative conception of the constitutional democratic state with the fact that national governments today take the shape of an administrative system – a system of governance in which the primary political power resides not in the legislature or judiciary but in a complex and self-regulating bureaucracy largely impervious to influence from citizens.[63] The administrative system makes it more difficult to see how the state can be an institutional framework for public justice and not simply a hegemonic center of political power. Yet the power of the administrative state is not unlimited, nor is the task of achieving and maintaining public justice unconstrained. Rather, the state's power is always subject to the requirement of public justification. State power needs to prove justifiable before the court of public opinion if it is to be sustained. Moreover, matters of public justice come into the state's purview only insofar as enforceable laws and policies, themselves subject to the requirement of public justification, can address such matters. Like Jürgen Habermas, I believe that democratic communication is the

[62] Jonathan Chaplin, "'Public Justice' as a Critical Political Norm," *Philosophia Reformata* 72 (2007): 130–50.

[63] Jürgen Habermas, *Between Facts and Norms: Contributions to a Discourse Theory of Law and Democracy*, trans. William Rehg (Cambridge, Mass.: MIT Press, 1996), p. 505.

source of public justification. Even as an administrative system, then, the state's task is to pursue enforceable public justice on the basis of publicly justifiable force and thereby to provide political and legal integration in a pluralist society.

Be that as it may, mainstream political justifications of government arts funding simply overlook questions of justice pertaining to both institutional and cultural pluralism. They fail to consider the state's obligation to ensure that no region of organizations and practices in a differentiated or structurally pluralist society dominates another. Hence, for example, the state should not allow commercial business interests to overwhelm the endeavors of noncommercial cultural organizations – a concern directly registered by Russell Keat's argument concerning market boundaries. Mainstream justifications also fail to address the state's obligation to protect the right of all cultural communities within a multicultural society to receive reciprocal recognition. So, for example, the state should not permit cultural advantages enjoyed by a majority population to come at the expense of racial or ethnic minorities – a concern indirectly registered by the notion of multicultural equity, which economists have been slow to articulate.

Both of these missing elements of public justice have to do with the rights of people to participate in the full range of human activities, to do so in ways that foster mutual recognition and substantial freedom, and to pursue these activities within communities and institutions that allow their members to flourish. Insofar as participation, recognition, and freedom are central to the idea of democracy, as I suggest in Chapter 9, the two missing elements are matters of democracy. In other words, mainstream political justifications, by virtue of their insufficiently nuanced normative notions of public justice, suffer a democratic deficit. To the extent that they employ the normative idea of a right to participate in culture, they restrict this notion to the cultural rights of individuals and ignore the cultural rights of institutions and communities.

Concern about this democratic deficit goes beyond the worries about elitism and paternalism already noted. It is so, of course, that a perfectionist argument such as Feinberg's unavoidably privileges the interests of aesthetic experts and of participants in high art above those of "the egoistic philistine taxpayer."[64] Not surprisingly, on the

[64] Feinberg, "Not with My Tax Money," p. 120.

contentious question of who should determine whether the state should subsidize experimental artworks in the category of intrinsically valuable things, Feinberg is happy to trust the judgment of expert practitioners (e.g., in peer review panels): "[O]nce we have determined that an area of human activity, like art, (at its best) has a value beyond its benefits, then the projects in that area most deserving of support had best be determined by committees of leaders in the field in question."[65] It is also so that the "trickle down" thesis assumed by Dworkin's notion of a rich cultural structure excludes popular culture from the range of the state's obligations in cultural matters. Not even the more evenhanded or, better, hands-off approach advocated by Rawls would ensure that the state's support goes beyond high art. All three approaches are vulnerable to populist objections.

Yet the democratic deficit is not merely a matter of which art gets funded and at whose expense. It is more fundamentally a matter of how we envision public justice in the first place. Is public justice simply the state's duty to uphold the rights of discrete individuals and to mitigate economic disparities among them? Or does public justice include the state's obligations toward various social institutions and cultural communities? If it includes these obligations, then the political justification for government arts funding must take them into account. Direct state subsidies must be appropriate and effective ways to ensure that the institution of art has room to flourish amid structural pluralism. Art subsidies must also be appropriate and effective ways to uphold the cultural rights of diverse communities in a multicultural setting. Otherwise the political justification for direct state subsidies, perhaps like the governments for which political justifications hold, will suffer from a democratic deficit.

Democratic Education

That is not to say no one has attempted to address this deficit. As we discovered in Chapter 2, Keat claims that state support of nonmarket cultural institutions is "a crucial requirement for a flourishing democracy."[66] David Schwartz reaches a similar conclusion in

[65] Ibid., p. 119.

[66] Russell Keat, *Cultural Goods and the Limits of the Market* (London: Macmillan; New York: St. Martin's Press, 2000), p. 171.

Art, Education, and the Democratic Commitment, but by a different route. Addressing political justifications of government funding for the arts, rather than economic threats to cultural institutions, Schwartz rejects both the perfectionist stance toward which Keat leans and the instrumentalism favored by neutralist liberals such as Rawls and Dworkin. Yet Schwartz describes his own approach as "an instrumental strategy of justification."[67] He locates the instrumental value that justifies government arts funding in the contributions art makes to democratic education. He intends this strategy not only to provide a normative response to the most common objections raised by disgruntled taxpayers[68] but also to avoid the most prominent shortcomings of other instrumental justifications.[69]

Reconstructed, Schwartz's instrumental case for government arts funding goes as follows. Citizens in a democratic society share a widespread commitment to democratic self-rule, he claims. This commitment, "perhaps our most widely-held public value,"[70] "rests upon the belief that self-rule is constitutive of respecting persons as autonomous agents." In other words, "human dignity requires we respect citizens as self-directing agents," and democracy best honors such self-directedness "in its unavoidably political dimension."[71] Moreover, to be committed to democracy on the basis of a commitment to autonomy entails a further commitment to *deliberative* democracy, in which citizens must exercise "sound political judgment." Unlike atomistic choices made by consumers in the marketplace, sound political judgment involves both engaging in rational discussion and "discerning the *meaning*" of

[67] Schwartz, *Art, Education, and the Democratic Commitment*, p. 7.

[68] Ibid., pp. 2–3, identifies two such objections: that government should not finance artworks that offend taxpayers' "moral convictions," and that "supporting the arts is not a legitimate government function."

[69] Ibid., pp. 6–7, says that other instrumental justifications tend to cast the subsidy net too widely and fail to single out art as what merits state subsidies. To justify state subsidies on the ground that the arts promote tourism, for example, raises the question whether everything that promotes tourism deserves subsidies, while also leaving the door open to eliminating government arts funding when another activity proves to be more effective at promoting tourism.

[70] Ibid., p. 45. On subsequent pages Schwartz is careful to distinguish the commitment to democracy from a commitment to liberal ideals such as free speech and equal opportunity. He suggests that democratic citizens are committed to democratic procedures in their own right and not simply as means to secure liberal ideals.

[71] Ibid., pp. 49, 56.

political events and strategies through reflection, imagination, and interpretation.[72] But citizens must *learn* to exercise political judgment and must *develop* the character to sustain this. Hence a commitment to democracy "implies a commitment to educating citizens for demo-cratic life," a commitment to what Amy Gutmann labels "democratic education." Indeed, citizens committed to deliberative democracy have "a *prima facie* obligation" to foster the attitudes and skills that enable current and future citizens to exercise political judgment.[73]

Here the question of subsidizing art arises. For "engaging artworks can foster the mental preconditions of [political] judgment." To the extent that art can do this, democratic citizens have a common inter-est in encouraging participation in the arts.[74] As "metaphorical repre-sentations" with an indefinite "semantic richness," artworks require interpretation in order for their meaning to be "constituted."[75] And such interpretation requires the same attitudes and skills of interpre-tation, empathy, and reflective imagination that citizens need in order to exercise sound political judgment.[76] Hence art offers "rich oppor-tunities" for practicing the skills of political judgment, and it does so in contexts where "mistakes in judgment can cause little to harm others."[77] Moreover, engaging artistic content serves to "enlarge our mentality" by offering new ways of seeing others. Schwartz thinks such enlargement is "of obvious political benefit."[78] Insofar as "engaging

[72] Ibid., pp. 58–9.

[73] Ibid., pp. 59–62. See also pp. 112–13, 136–7, and 141–3 for Schwartz's further discussion of Amy Gutmann, *Democratic Education* (Princeton, N.J.: Princeton University Press, 1987).

[74] Schwartz, *Art, Education, and the Democratic Commitment*, p. 62. This is my formula-tion of what I think Schwartz intends. His own initial description is more com-pressed and a little vague: "Then the case for arts subsidies would share in the force of our commitment to perpetuating democratic sovereignty" (p. 62).

[75] Ibid., pp. 69–72.

[76] On the political significance of "empathy," see Martha Nussbaum, *Poetic Justice: The Literary Imagination and Public Life* (Boston: Beacon Press, 1995), which Schwartz cites on pp. 101–2.

[77] Schwartz, *Art, Education, and the Democratic Commitment*, p. 80.

[78] Ibid., p. 106. Earlier Schwartz gives the following summary of his claims about the political relevance of participation in the arts: "[A]rt and politics utilize a common set of skills and attitudes that together constitute the faculty of judg-ment. Practitioners of either democratic deliberation or artistic appreciation both benefit from keen perception, sustained and imaginative reflection, an ability to construct and defend interpretations, a propensity to empathize with unfamiliar characters and situations, and an awareness that sound judgment requires disen-gaging personal bias and assuming a broadened perspective" (p. 8).

artworks is *itself* a form of democratic education,"[79] and insofar as government has a legitimate interest in furthering the democratic education of its own citizens, government funding for the arts is justified.

Schwartz argues that his case can answer taxation-based objections to arts subsidies. It establishes that government arts funding is no less justified than "public funding of education"; that the force of its justification stems from "something virtually everyone values – democratic self-rule"; and that the mode of its justification does not preclude public deliberation about what sort of art is most deserving of government funding.[80] His case can also answer neutralist liberal objections concerning proper functions of the state, he claims. Because the case does not appeal to the intrinsic value of either art or democracy, it does not violate the neutrality constraint on proper state functions. Moreover, if the case "privileges democracy over other forms of government" and "sanctions state action aimed at improving citizens' performance within such a system," then it simply embodies a long-standing "tension between the [paternalistic] nature of education and the nature of the liberal state." At most the case represents a weak and "relatively benign" form of paternalism, because citizens remain free to ignore the subsidized art, and such subsidies simply promote existing preferences and do not impose or create them.[81] Indeed, if citizens value democracy strongly enough, they "may even have a moral obligation to subsidize art!"[82] At a minimum, and in analogy with economic public goods, perhaps art is a "political public good" whose engagement tends to foster "robust democratic participation and sound democratic procedures."[83]

To the empirical question whether engaging art will "really improve a person's political judgment,"[84] Schwartz has a triple response. First,

[79] Ibid., p. 113.
[80] Ibid., pp. 117, 123. In my summarizing sentence, the first clause gives Schwartz's response to libertarian arguments against art subsidies as violating individual property rights (e.g., Robert Nozick and Edward Banfield); the second, his response to "indignant taxpayers" who object to the absence of universal benefits (cf. the formulation by Joel Feinberg); and the third, his response to "offended taxpayers" who object to having their taxes finance artworks they find morally offensive.
[81] Ibid., pp. 134–6.
[82] Ibid., p. 137.
[83] Ibid., p. 159.
[84] Ibid., p. 150.

he gives evidence that people can and do engage art in the requisite manner. Then, he proposes two reasons why it is not unduly ineffi-cient to subsidize art for the purposes of democratic education: this may be no less efficient than other education subsidies, and engaging art "may well be the *only* means of practicing reflective judgment out-side political participation itself."[85] Finally, he lists the ways in which engaging art can develop "the hermeneutic preconditions...of citi-zenship" and cites a major study of twenty-five thousand secondary students as lending support to this claim.[86]

Art and Democracy

Despite different foci, with one addressing market boundaries and the other addressing political education, Keat and Schwartz share the correct intuition that the proper basis for justifying state sub-sidies lies in the cultural character of the arts and in their contri-butions to democracy. Although Schwartz emphasizes the similarity between aesthetic and political judgment, it is the metaphorical char-acter of art, requiring cultural interpretation, that makes engaging the arts an indispensable propaedeutic to democratic citizenship. This takes his argument beyond mainstream political justifications of government arts funding. For, like Keat, Schwartz recognizes that art's political contributions must have a direct tie to its cultural char-acter in order to serve justificatory purposes. Yet he too has not clari-fied sufficiently the relationship between art's cultural character and its economic and political roles. In the absence of sufficient clarity, pressure will mount either to downplay art's cultural character or to exaggerate its economic and political roles.

Schwartz argues that democratic governments need democratically educated citizens and that the arts are a primary means of such educa-tion. Hence, government funding is no less justified for the arts than it is for education in general. There are two flaws with this argument. The first flaw is that it does little to establish the economic necessity and priority of arts subsidies. One could grant that art is intrinsically metaphorical and that art calls for political-judgment-enhancing

[85] Ibid., p. 154.
[86] Ibid., pp. 156–7.

interpretation but still ask why the government needs to intervene. Why could not governments simply say, yes, the arts are important, and it is very fortunate that the market and nonprofit organizations provide them in such abundance? Moreover, even if additional information were added to show the economic need for government intervention, the question would still remain whether arts subsidies are a priority, and what sort of priority, relative to other means of democratic education. Although Schwartz suggests that engaging art may be "the *only* means of practicing reflective judgment outside political participation itself,"[87] this seems implausible at first glance. Most education, both in the context of schooling and in other contexts, offers many such means, even when the arts are not engaged.

The second and more serious flaw is that the argument does not establish the centrality of the arts to democratic education. Rather, it establishes an analogy between the sort of political judgment normatively required to sustain deliberative democracy and the sort of aesthetic judgment elicited by sufficiently nuanced and meaningful artworks. But there is an important disanalogy too. Whereas nuanced and meaningful artworks would continue to invite reflective aesthetic judgments even when few people are prepared to make such judgments, deliberative democracy would simply disintegrate in the absence of reflective political judgments. In other words, political judgments are constitutive for a democratic political condition in ways that aesthetic judgments are *not* constitutive for an artwork. Moreover, an analogy does not guarantee transfers of learning from one process to another. It is not hard to imagine a society where citizens have become highly adept at judging art but are so committed to the power and wealth of their own country, as protected by a strong military and national security apparatus, that they willingly surrender the exercise of sound political judgment. There is no necessary link between the opportunity for reflection offered by art and the actual exercise of political judgment. Hence, I do not think that Schwartz has in fact established that art is a "political public good": in his account, the external benefits of democratic participation and procedures are at best contingent by-products, not necessary outcomes of engaging the arts.

[87] Ibid., p. 154.

Despite attempts to correct the cultural and democratic deficits in mainstream economic and political justifications, neither Keat nor Schwartz sufficiently closes the gap. Keat calls upon governments to protect cultural meta-goods from market forces, but he thereby limits the cultural character of the arts to their potentially corrective role in a consumerist economy. Schwartz calls upon governments to support the arts as means of democratic education, but he thereby restricts their contribution to being contingent pathways toward political judgment. Although Schwartz offers more culturally inflected and democratically attuned reasons for state subsidies than do mainstream political justifications, he has not overcome a democratic deficit. Specifically, he has not addressed the state's obligations with respect to cultural rights and structural pluralism.

3.3 PUBLIC COMMUNICATION

Yet Schwartz's case does point in potentially fruitful directions. To explore these directions, and to lay additional groundwork for an alternative justification of government arts funding, let me now explain the concepts of "art in public" and "civil society."

Art in Public

We commonly use the term "public" with reference to art in one of three ways. First, "public" can mean that the art in question has been sponsored by local, regional, or national governments or is in fact owned and administered by the state. This is one sense in which one can call the Vietnam Veterans Memorial in Washington, D.C., a work of "public art." Although its creation was funded by nongovernmental donations, it is managed and maintained by the U.S. National Park Service. A second usage of "public" calls attention to art that is subsidized by the state, whether at the local, regional, or national level. Most often we use the term in this sense to identify art that receives direct state subsidies, such as an exhibition or performance supported by grants from the NEA or CCA, and speak then of "publicly funded art." There is a third sense in which art can be called public, namely, that it occurs in public media or public places – for example, concerts presented by public broadcasters such as the Canadian Broadcasting

Corporation (CBC) and National Public Radio (NPR) in the United States. We can speak in this connection of "publicly presented art." Here, however, the term "public" can lose direct links to state control or funding, for we often use "public" to talk about media and places that are not sponsored, owned, or directly subsidized by the state – commercial television, for example, or nonprofit museums that do not receive government funding.

To these three well-established usages we can add a more recent one, namely, the term "new genre public art." Although some of the projects given this label receive government sponsorship or funding, that is not what characterizes them as "public." Rather, their public character has to do with their aiming to engage a wide and diverse audience with respect to issues that matter to them and to do so in a collaborative fashion.[88] This usage makes the link between state and "public" even less direct.

A further complication arises from the fact that in North America the bulk of government support for the arts occurs by way of *indirect* subsidies. Governments indirectly subsidize the arts via tax concessions for donors to both state-owned and nonprofit arts organization, via property tax exemptions for certain arts organizations, and, in some jurisdictions, via income tax exemptions for working artists. Moreover, the state establishes and administers the regulatory framework within which artists and arts organization operate, the most notable areas of regulation being copyright, international trade, and guarantees of the freedom of expression.[89]

Once one notices how complex the relation is between the state and the arts, and how elastic the usage of "public" in connection with the arts, very little of the art intended for some audience appears "private" in the strict sense. In fact, the traditional distinction between "public" and "private," which is problematic in any case, seems ever less applicable to the arts.[90] To recognize such complexity and elasticity,

[88] Suzanne Lacy, "Cultural Pilgrimages and Metaphoric Journeys," in *Mapping the Terrain: New Genre Public Art*, ed. Suzanne Lacy (Seattle: Bay Press, 1995), pp. 19–20.

[89] On the topics of regulation and taxation, see O'Hagan, *The State and the Arts*, pp. 73–130.

[90] Hilde Hein, *Public Art: Thinking Museums Differently* (Lanham, Md.: AltaMira Press, 2006), notes this tendency yet continues to use a distinction between "private art" and "nonprivate art" (which includes "public art"). I take up her discussion in the next chapter.

I have coined the phrase "art in public." By "art in public" I do not mean simply state-sponsored, state-owned, directly state-subsidized, or indirectly state-presented art, even though art in public can and usually does include "public art," "publicly funded art," and "publicly presented art." I use "art in public" to refer to any art whose production or use presupposes government support of some sort and whose meaning is available to a broader public – broader than the original audience for which it is intended or to which it speaks. Given the ubiquity of state involvements in culture, the dissemination of new genre public art, and the proliferation of computer-based technologies for creating and experiencing art, much of contemporary art has become art in public, regardless of how direct or indirect are its links to the state.[91]

The concept of art in public has immediate relevance for political justifications of direct state subsidies. The standard justifications, whether perfectionist or instrumentalist, presuppose a static and fixed boundary between artistic creation and experience, on the one hand, and matters of state, on the other. They also assume that for the most part atomic individuals privately create or experience discrete works of art either to satisfy their aesthetic needs or to achieve some other end. Even when inconsistently modified by Dworkin's emphasis on a "rich cultural structure," the dominant framework is individualist with respect to who participates in art, privatist with respect to where their participation occurs, and instrumentalist with respect to how. Although David Schwartz's "democratic education" points beyond this framework, his background picture also remains one of private individuals judging discrete art objects and thereby learning attitudes and skills that would make them better citizens.[92]

"Art in public" challenges these mainstream assumptions. On the one hand, it suggests that the state is always already present in the societal constitution of contemporary art and that very little artistic creation and experience would occur without the state's fiscal and

[91] Not all of contemporary art is obviously public in this sense. A homemade birthday card, for example, or a liturgical banner for local use may not fit my description. But these are not the sorts of art that come up for consideration when we debate government funding for the arts.

[92] Although, like Schwartz, I endorse the commitment to autonomy that underlies a commitment to democracy, I give the notion of autonomy a postindividualist construal – see Chapter 7.

regulatory involvement. On the other hand, because much of con-
temporary art is public in orientation, we can no longer regard art as
a field in which unattached individuals carry out private transactions
with discrete objects that either have intrinsic value or give rise to
external benefits. Rather, we need to devise a postindividualist, non-
privatist, and communicative framework for understanding both the
recipients and the rationale of government arts funding. Specifically,
as the next chapters explain in greater detail, we must identify the
role of the arts in civil society and discover both how and why direct
state subsidies can and should strengthen this role. To be sure, there
will be some continuity between the role the arts play in civil society
and concepts such as Rawls's "intergenerational equity," Dworkin's
"rich cultural structure," and Schwartz's "democratic education."
Yet the framework surrounding these concepts will change, thereby
altering the concepts themselves.

The new framework will recast the by-now hackneyed debate
between advocates and opponents of government arts funding. That
debate sets up an opposition between advocating state subsidies and
embracing a supposedly free market. The debate thereby ignores
just how important a role the state plays in art's societal constitution,
regardless of whether direct state subsidies are involved. The debate
also overlooks entirely the public orientation of much contemporary
art, which does not simply occur in some private domain. And the
debate fails to recognize the sociopolitical reasons why the arts are
important to both civil society and the state.

Civil Society

To uncover such reasons, in anticipation of the chapters that follow, I
need to say something about civil society. "Civil society" is a contested
concept in the social scientific literature. I do not have space here to
review the relevant debates. Instead, let me simply describe my own
conception.[93] I regard civil society as one of three macrostructures in

[93] My conception of civil society owes most to the writings by Jürgen Habermas, Seyla
Benhabib, Nancy Fraser, and Jean Cohen and Andrew Arato discussed in the next
chapter. The most important nineteenth-century sources for this conception are G.
W. F. Hegel, *Elements of the Philosophy of Right* (1821), ed. Allen W. Wood, trans. H. B.
Nisbet (Cambridge: Cambridge University Press, 1991), and Alexis de Tocqueville,

82

Double Deficit

contemporary Western societies. The other two macrostructures are the for-profit (or proprietary) economy and the administrative state. Whereas the economy and the state are highly integrated systems that operate according to their own logics, civil society is a more diffuse array of organizations, institutions, and social movements. It is the space of social interaction and interpersonal communication where economic alternatives can thrive and where informal political publics can take root.

The intersections between civil society and the proprietary economy, on the one hand, and between civil society and the administrative state, on the other, have special significance for the role of the arts in civil society. I call the first of these intersections "the civic sector." The civic sector is the economic zone of cooperative, nonprofit, and mutual benefit organizations within national and international economies. It is the primary way in which civil society achieves and maintains both economic differentiation from and economic integration with the proprietary economy and the administrative state. Conversely, civil society is not purely noneconomic. It has, among other aspects, an economic dimension whose primary articulation occurs in the civic sector.[94] The

Democracy in America (1835, 1840), ed. and trans. Harvey C. Mansfield and Delba Winthrop (Chicago: University of Chicago Press, 2000). In addition, I have found the following publications instructive, listed in chronological order: Michael Walzer, "The Civil Society Argument," in *Dimensions of Radical Democracy: Pluralism, Citizenship, Community*, ed. Chantal Mouffe (New York: Verso, 1992), pp. 89–107; Adam B. Seligman, *The Idea of Civil Society* (Princeton, N.J.: Princeton University Press, 1995); Charles Taylor, "Invoking Civil Society," in *Philosophical Arguments* (Cambridge, Mass.: Harvard University Press, 1995), pp. 204–24; Frank Hearn, *Moral Order and Social Disorder: The American Search for Civil Society* (New York: Aldine de Gruyter, 1997); John Keane, *Civil Society: Old Images, New Visions* (Cambridge: Polity Press, 1998); John Ehrenberg, *Civil Society: The Critical History of an Idea* (New York: New York University Press, 1999); Robert K. Fullinwider, ed., *Civil Society, Democracy, and Civic Renewal* (Lanham, Md.: Rowman & Littlefield, 1999); Don E. Eberly, ed., *The Essential Civil Society Reader* (Lanham, Md.: Rowman & Littlefield, 2000); Mark E. Warren, *Democracy and Association* (Princeton, N.J.: Princeton University Press, 2001); and Simone Chambers and Will Kymlicka, eds., *Alternative Conceptions of Civil Society* (Princeton, N.J.: Princeton University Press, 2002).

[94] This formulation aims to avoid the "civil society purism" rightly criticized by John Keane, *Global Civil Society?* (Cambridge: Cambridge University Press, 2003), 57–65, but without duplicating his mistake of including proprietary organizations in civil society. I comment on Keane's approach at greater length in Lambert Zuidervaart, *Social Philosophy after Adorno* (Cambridge: Cambridge University Press, 2007), pp. 171–5.

civic sector is the space in society that is most conducive to what some have labeled a "social economy" – an economy in which considerations of solidarity take precedence over efficiency, productivity, and maximal consumption.

I call the second intersection – that between civil society and the state – "the public sphere." The public sphere is a continually shifting network of discourses and media of communication that supports wide-ranging discussions about social justice and the common good. It sustains widespread participation in the shaping of societal structures. It facilitates challenges to the operations of the economic system and the administrative state. And, within civil society itself, it serves to promote democratic communication. Hence, the public sphere can enable and modify democratic potentials in economic and political macrostructures while fostering a democratic culture. More specifically, it allows cultural rights – individual, communal, and institutional – to be articulated and claims for their satisfaction to be communicated. In these ways the public sphere is essential to any modern democratic society.

Political Dialectic

Now I can provide a political supplement to the justification for government arts funding that began to emerge in the previous chapter. The case I wish to make pertains specifically to art in public insofar as it occurs within civil society, has a nonproprietary and nongovernmental form of economic organization, and circulates within the public sphere. I would argue that the focus of state subsidies for the arts, and of the requisite justification, does not lie in generic "benefits" such as intergenerational equity or in an "intrinsic value" such as aesthetic value per se. Rather, it lies in the roles that art in public has by virtue of both its sociocultural character and its location at the intersections among economy, polity, and civil society. These roles will acquire greater clarity and force when Chapters 4 and 5 consider art's place in the public sphere and the civic sector. But let me indicate their contours by describing a political dialectic that parallels the economic dialectic mentioned earlier.

According to the previous chapter, the question concerning state subsidies arises in part from an economic dialectic between civic-sector arts organizations and global capitalism. This has its counterpart

in a political dialectic between the communicative role of the arts and the imperatives of state power. On the one hand, art in public has a central role to play in the articulation of issues and interests that require government attention. Because this articulation occurs in the mode of imaginative disclosure, it affords access to public issues and interests in ways that open rather than close conversation and debate. On the other hand, the administrative state is organized as a relatively self-sustaining system. Following its own logic of state power, it puts enormous pressures on the public sphere in which such art participates. These pressures impede the imaginatively disclosive public communication that democratically elected governments nevertheless require. In the interests of preserving avenues for critique and redirection of the state's own power-driven operations, governments do well to protect and subsidize civic-sector arts organizations that sponsor art in public. In doing so, governments would create room for arts organizations to pursue their own mandates, and not simply to succumb to systemic pressures, as they often do. This would not only encourage more robust participation in the arts by various communities and individuals but also promote the pluralism of institutions required in a democratic society. In these ways direct state subsidies for the arts could further both democratic communication and public justice.

Construed in this way, the political dialectic can give rise to a political justification that retains Schwartz's democratic emphasis but dispenses with his analogy between political and aesthetic judgment. It matters a great deal to democratically elected governments whether issues and interests of public concern receive proper attention. But this consideration exceeds the question whether training in aesthetic judgment prepares citizens for political judgment. Arts-generated imaginative disclosure matters to democratic governments because, as an administrative system, the state resists nuanced consideration of public matters and becomes vulnerable to legitimation crises.[95] These crises arise in part from the state's

[95] Legitimation crises have to do with a lack of public support for the government in its attempts to steer the economy. Their origins are more complex than simply a lack of public support, however. Habermas sees them as intimately connected with concomitant crises in the economy and in administrative rationality as well as with "motivation crises" that occur when sociocultural changes undermine support for the state and the occupational system. See Jürgen Habermas, *Legitimation Crisis*, trans. Thomas McCarthy (Boston: Beacon Press, 1975), pp. 33–94.

own cultural tone-deafness. Among the institutions of contemporary society, it is the arts, and specifically civic-sector arts in public, that are set up to emphasize nuanced consideration of public matters, not as a mere side effect, but as intrinsic to their mediated hermeneutical character and societal constitution. Because government needs what these arts offer, and because what they offer often has the additional advantage of not being overtly political in the formal sense, civic-sector arts in public merit government support. The case for this support's taking the form of direct subsidies requires additional economic premises, however, of the sort that Schwartz never provides.

Let me briefly summarize the case for direct state subsidies that I have begun to develop in Chapters 2 and 3. (See also Table 3.1, which schematizes the various arguments considered as well as my own alternative.) My alternative to mainstream justifications for government arts funding highlights the political and economic structures to which the arts contribute and on which their flourishing depends. I argue that civic-sector art in public needs government protection and support precisely because an administrative state and a capitalist market economy pose threats to civil society, even as both systems require a robust civil society to continue. Contemporary arts need government regulations and subsidies that protect the public sphere to which they contribute and that strengthen the social economy in which they participate. Both as elements and as agents of civil society, civic-sector arts in public are sociocultural goods that merit and require government support.

Reduced to its underlying structure, my case has three components: cultural, political, and economic. Culturally, it claims that the arts are an institutional setting for imaginative disclosure that is societally important. Politically, it claims that, to promote public justice, democratically elected governments need to protect and support art's creative articulation of issues and interests in the public sphere. Economically, it claims that arts organizations in the civic sector provide important social-economic alternatives both needed and threatened by the capitalist market and the administrative state. No one component in itself would justify direct state subsidies. Only when the three components come together does a case for direct state subsidies begin to emerge.

TABLE 3.1. *Summary of Justifications for Government Arts Funding*

Basis for Justification	Purely Extrinsic	Partially Extrinsic	Intrinsic
Field of discourse			
Mainstream economic	Efficiency: Public good (Baumol and Bowen)	Equity: Public good (O'Hagan)	Intrinsic value: Merit good (Throsby)
Mainstream political	Minimal instrumentalist: Intergenerational equity (Rawls)	Robust instrumentalist: Rich cultural structure (Dworkin)	Perfectionist: Aesthetic value (Feinberg)
Three alternatives	Democratic education (Schwartz)	Cultural meta-good (Keat)	Social good (Taylor)
Proposed framework[a]	Participation in the public sphere and the civic sector	Culturally mediated and societally constituted sociocultural good	Imaginatively disclosive art in public

[a] The proposed framework in this row, unlike the rows above, does not employ the standard distinction between extrinsic and intrinsic goods.

This sociocultural and sociopolitical approach does not pretend to satisfy indignant taxpayers. Instead, it rejects the truncated vision of art and civil society that informs their "benefit principle" and misdirects every mainstream response. Alongside, however, a worry arises that direct state subsidies, if improperly procured or provided, could undermine what they are supposed to support. This worry stems in part from cultural and democratic deficits in economy and polity that match the deficits in mainstream justifications of government arts funding. For, as systems, the capitalist market and the administrative state seem relatively impervious to arts-generated alternatives to their own systemic logics. Hence, one worries that state subsidies will enable culturally impoverished and democratically deficient systems to impose their imperatives on the arts and not actually secure room for economic and political alternatives. Yet the absence of subsidies would make civic-sector arts in public even more vulnerable to systemic pressures. Perhaps, then, the worry that accompanies state subsidies is not too high a price for protection and support whose justification and intent would correct deficits that undermine civil society. Although we shall return to this topic in Chapter 6 after I give a more detailed account of civil society's public sphere and civic sector, my full-scale justification of direct state subsidies must wait until Chapter 10.

PART II

CIVIL SOCIETY

4

Public Sphere

Any public [that] denies artistry its rightful place under the sun forfeits
a rich source of imaginative knowledge.

Calvin Seerveld[1]

Part I showed why public debates between advocates and opponents of
government arts funding so frequently misfire. These debates ignore
both the internal complexity of a three-sector economy and the role
of the state in the societal constitution of art. They misconstrue the
sociocultural character and the public orientation of contemporary
art. And they fail to recognize the sociocultural and sociopolitical rea-
sons why the arts are societally important. I have also criticized main-
stream justifications of government arts funding and pointed to both
an economic and a political dialectic among capitalism, the state, and
civil society. To lay groundwork for an alternative case, I introduced
two concepts that need further elaboration: civic sector and public
sphere. Completing this groundwork, the next three chapters provide
a more detailed account of the roles of art in civil society and the
dialectical tensions they involve.

Three events in 1989, at the height of North American controver-
sies about government arts funding, mark a new phase in the devel-
opment of theories about civil society and the public sphere: the

[1] Calvin Seerveld, *Bearing Fresh Olive Leaves: Alternative Steps in Understanding Art*
(Carlisle, U.K.: Piquant, 2000), p. 58.

$14 billion merger of Time and Warner Communications; the fall of the Berlin Wall; and the publication in English of Jürgen Habermas's book on the public sphere.[2] Whereas the creation of Time Warner Inc. confirmed the increasingly global and hypercommercialized character of many cultural media, the reunification of Germany signaled new opportunities for democratic discourse in Eastern European countries where the state had long controlled such media. Appearing at this juncture, Habermas's book immediately entered a growing debate over prospects for the public sphere.[3] The outbreak of old ethnic hostilities in Eastern Europe and the continuation of new culture wars in the West increased the debate's significance.

This debate raises three theoretical questions of particular relevance for understanding what the arts contribute to civil society. What is the public sphere? How does it relate to the economy and the state in modern democratic societies? And what is the role of art in the public sphere? To address these questions, this chapter examines appropriations of Habermas's work by sympathetic critics of his approach: Seyla Benhabib, Nancy Fraser, and Jean Cohen and Andrew Arato. Their appropriations represent versions of social democratic and feminist theory that are close to my own social philosophy.

My starting point is Habermas's original account of the public sphere and Cohen and Arato's theory of civil society. I claim first that the public sphere represents an essential structure and principle within any modern democratic society. I argue that we can best conceive of the public sphere as a social nexus accommodating diverse publics and encompassing both political and cultural organizations – including publics and organizations that make up the contemporary art world. Next I consider the strengths and weaknesses of revisions to Habermas's account proposed by Nancy Fraser and Seyla Benhabib.

[2] The original work, published as *Strukturwandel der Öffentlichkeit* (Darmstadt and Neuwied: Hermann Luchterhand Verlag, 1962), was an expanded version of a *Habilitationsschrift* presented to the Philosophical Faculty at Marburg. Citations are from Jürgen Habermas, *The Structural Transformation of the Public Sphere: An Inquiry into a Category of Bourgeois Society*, trans. Thomas Burger and Frederick Lawrence (Cambridge, Mass.: MIT Press, 1989).

[3] See in particular the anthologies *Habermas and the Public Sphere*, ed. Craig Calhoun (Cambridge, Mass.: MIT Press, 1992), and *The Phantom Public Sphere*, ed. Bruce Robbins (Minneapolis: University of Minnesota Press, 1993).

Then, in response to a book on "public art" by Hilde Hein, I offer a
new way to envision the role of the arts in the public sphere.

4.1 CRITICAL THEORIES

Jürgen Habermas

In *The Structural Transformation of the Public Sphere*, Jürgen Habermas
argues that modern *Öffentlichkeit* emerged in European societies of
the seventeenth and eighteenth centuries. As the translator Thomas
Burger points out, the term *Öffentlichkeit* "may be rendered variously
as '(the) public,' 'public sphere,' or 'publicity.'"[4] For the most part I
use the translation "public sphere" and discuss it as involving both an
institutionally secured societal *structure* and an institutionally prom-
ised normative *principle*. Sometimes I refer to these two axes of the
public sphere as "the structure of publicity" and "the principle of pub-
licity." According to Habermas, the modern public sphere emerged
in conjunction with a growing separation between civil society and
the state, the increasing power of the bourgeoisie, and the develop-
ment of relatively independent literary and cultural institutions. In
the words of Thomas McCarthy, Habermas claims that this new struc-
ture and principle – *Öffentlichkeit* – constituted "a sphere between civil
society and the state, in which critical public discussion of matters of
general interest was institutionally guaranteed."[5]

Habermas's encyclopedia article of 1964 defines the public sphere
as "a realm of our social life in which something approaching pub-
lic opinion can be formed." Public opinion refers to "the tasks of
criticism and control which a public body of citizens...practices *vis-
à-vis* the ruling structure organized in the form of a state."[6] His book
argues that the bourgeois public sphere underwent a structural trans-
formation in the nineteenth century. With the twentieth-century rise
of mass media and the welfare state, this transformation led to the
public sphere's disintegration.

[4] Thomas Burger, "Translator's Note," in Habermas, *Structural Transformation*, p. xv.
[5] Thomas McCarthy, introduction to Habermas, *Structural Transformation*, p. xi.
[6] Jürgen Habermas, "The Public Sphere: An Encyclopedia Article" (1964), trans.
 Sara Lennox and Frank Lennox, *New German Critique*, no. 1 (Fall 1974): 49–55; the
 quotes are from p. 49. This article originally appeared in the Fischer Lexicon, *Staat
 und Politik*, new ed. (Frankfurt am Main: Fischer Bücherei, 1964), pp. 220–6.

Although highly illuminating, Habermas's original account of the public sphere suffers from methodological, theoretical, and conceptual problems. The methodological problem arises because his book traces the history of both specific institutions and a general societal structure. On the one hand, critics have charged that his book reads too much into the development of specific legal, constitutional, and cultural arrangements in England, France, and Germany. On the other hand, they have criticized him for not recognizing sufficiently how the public sphere outlives the demise of specific arrangements and shapes the institutions that replace them. The two criticisms are polar expressions of an unresolved tension in Habermas's own methodology. One can call this tension the problem of phenomenological specification.

Another, more theoretical problem stems from the way in which *Structural Transformation* ties the viability of the principle of publicity (*Öffentlichkeit*) to the fate of the public sphere as a structure (*Öffentlichkeit*). By "the principle of publicity," I mean the normative expectation that judgments and decisions on matters of public concern should be reached by way of democratic communication – in Calhoun's words, by "reasoned discourse in which arguments, not statuses or traditions, [are] decisive."[7] By "the public sphere as a structure" or "the structure of publicity," I mean the network of institutions, organizations, and practices that allow such judgments and decisions to be attempted.[8] In Habermas's book, the principle of publicity looks increasingly unattainable as the structure of publicity seems to disintegrate. At the same time, the normative point of his entire historical-sociological account is to envision the enactment of democratic communication in a reconstituted public sphere under late capitalist conditions. *Structural Transformation* is pervaded by what Cohen and Arato describe as "the antinomy of normative

[7] Craig Calhoun, introduction to *Habermas and the Public Sphere*, p. 2. In the same anthology, Seyla Benhabib's essay on "Models of Public Space," quoting Habermas, describes the principle of publicity as "the normative principle of 'free and unconstrained dialogue among reasoning individuals'" and says it is "the *principle of democratic legitimacy for all modern societies*" (p. 88).

[8] As Calhoun points out in the introduction to *Habermas and the Public Sphere*, the adequacy of the public sphere as a structure at any particular stage of its development will depend upon "both the quality of discourse and quantity of participation" (p. 2).

development and institutional decline."⁹ One can call this the problem of dialectical closure. Because of dialectical closure and the problem of phenomenological specification, *Structural Transformation*, like some of Theodor W. Adorno's later writings, comes across as desperate about the prospects for genuine democracy.¹⁰

While the first two problems indicate the difficulty of theorizing late capitalist society, they also reflect conceptual conflicts in the intellectual tradition Habermas claims as his own. Of particular importance are the contributions of Kant, Hegel, and Marx, as summarized by Habermas.¹¹ Habermas's summary moves from Kant's tendency to treat *Öffentlichkeit* as a normative principle, in abstraction from any specific societal arrangements, to Marx's tendency to treat it as an ideological mask of current bourgeois class interests. Whereas Kant tends "to turn politics into a question of morality,"¹² Marx tends to reduce the public sphere to contemporary machinations of power.

Hegel's political philosophy mediates these two extremes and establishes the categories of civil society and *Öffentlichkeit* that are so important for Habermas's analysis. Yet Hegel also tends both to turn politics into a question of ethics (of a universal communitarian sort) and to reduce publicity to the machinations of power (as the political expression of a disorganized, individualistic, and antagonistic society that nevertheless attunes people to the spirit at work in the state). Habermas's challenge is to extricate a viable concept of the public sphere from this intellectual legacy, even as he uses the formulations of Kant, Hegel, and Marx to map the societal formation within which the structure and principle of *Öffentlichkeit* first crystallize.

⁹ Jean Cohen and Andrew Arato, *Civil Society and Political Theory* (Cambridge, Mass.: MIT Press, 1992), p. 395.

¹⁰ For a description of Adorno's approach as a "critical phenomenology," see Lambert Zuidervaart, *Adorno's Aesthetic Theory: The Redemption of Illusion* (Cambridge, Mass.: MIT Press, 1991), pp. 53–64. For a discussion of Adorno's "objectification of transformative hope," see Lambert Zuidervaart, *Social Philosophy after Adorno* (Cambridge: Cambridge University Press, 2007), pp. 66–76 and 107–31. In subsequent writings, Habermas abandons the approach of ideology critique that he inherited from Adorno, and he anchors the principle of publicity in what Calhoun's introduction describes as "a transhistorical capacity of human communication" (*Habermas and the Public Sphere*, p. 31).

¹¹ Habermas, *Structural Transformation*, pp. 102–29.

¹² Ibid., p. 111.

The conceptual problems in Habermas's book largely arise from incompatibilities among these formulations.

Like Habermas's own subsequent revisions,[13] most criticisms of his original account respond to the problems I have just reviewed. Insofar as such criticisms make valid points, articulating a viable conception of the public sphere in response to Habermas becomes endlessly complex. Rather than rehearse the entire range of criticisms,[14] let me examine one instructive attempt to revise Habermas's approach. This attempt builds on the discourse ethic developed by Habermas in subsequent years; reappropriates the legacy of Kant, Hegel, and Marx; and addresses criticisms articulated within other traditions of social and political philosophy. I refer here to Jean Cohen and Andrew Arato's treatise on the concept of civil society.

Cohen and Arato

In their book *Civil Society and Political Theory*, Cohen and Arato develop a three-part model of modern society. This model aims to bypass the polarity of society versus state that informs the approaches of Kant and Marx and that still shapes Habermas's more differentiated account.[15] The model derives from a reconstruction of Hegel's philosophy of

[13] See especially Jürgen Habermas, "Further Reflections on the Public Sphere" and "Concluding Remarks," in Calhoun, *Habermas and the Public Sphere*, pp. 421–61 and 462–79, respectively, and the chapter titled "Civil Society and the Political Public Sphere," in his *Between Facts and Norms: Contributions to a Discourse Theory of Law and Democracy*, trans. William Rehg (Cambridge, Mass.: MIT Press, 1996), pp. 329–87. I refer to his two essays later in this chapter and take up *Between Facts and Norms* in Chapter 7. All of these writings presuppose the theoretical framework provided by Jürgen Habermas, *The Theory of Communicative Action*, trans. Thomas McCarthy, 2 vols. (Boston: Beacon Press, 1984, 1987).

[14] From my brief review of the problems in Habermas's original account, one can predict the main lines along which his critics will proceed. Kantian political liberals will fault him for contaminating normative principles with sociological and historical considerations. Poststructuralists, especially those of the Foucaultian stripe, will criticize him for idealizing the discourses of power and for overlooking the counterpublics systematically excluded by the bourgeois public sphere. Communitarians will question his confidence in the procedural norms of the constitutional state and modern jurisprudence. And feminist critics of various political leanings will reject his apparent acceptance of the public-private split seemingly presupposed by the concept of a public sphere.

[15] Cohen and Arato, *Civil Society*, p. 410.

law and politics.[16] It distinguishes civil society from both state and economy, and it adds further distinctions between the administrative state and political society as well as between the economic system and economic society. Political society (political parties, political organizations, and political publics such as parliaments) arises from civil society and mediates between civil society and the state. Similarly, economic society (e.g., firms, cooperatives, partnerships) arises from civil society and mediates between civil society and the market system. In this context Cohen and Arato define civil society as "a sphere of social interaction between economy and state, composed above all of the intimate sphere (especially the family), the sphere of associations (especially voluntary associations), social movements, and forms of public communication."[17]

To the extent that Habermas's original account of the public sphere tied it to voluntary associations and public communication, Cohen and Arato's model treats the public sphere as a crucial component of a relatively autonomous civil society. There the public sphere, like the rest of civil society, can exert political and economic influence without following the dictates of either the state or the economy. The model also assigns some dimensions of the public sphere to political and economic society. By refusing to accent the public sphere's bourgeois character, Cohen and Arato avoid both Habermas's (Marxian) tendency to criticize the public sphere's original exclusivity and his (Hegelian) tendency to bemoan the effects of the public sphere's democratization in the nineteenth and twentieth centuries.[18] By more clearly distinguishing civil society from political society and economic society, they try to defuse the tension in Habermas's approach between his (Kantian) insistence on liberal norms[19] and an (Hegelian) embrace of solidarity and mutual recognition.

Cohen and Arato detect both statist and antistatist positions in Hegel's *Rechtsphilosophie*.[20] Hegel regards civil society as both ethical

[16] G. W. F. Hegel, *Elements of the Philosophy of Right*, ed. Allen W. Wood, trans. H. B. Nisbet (Cambridge: Cambridge University Press, 1991).

[17] Cohen and Arato, *Civil Society*, p. ix.

[18] See ibid., pp. 210–31.

[19] According to Cohen and Arato (ibid., p. xiii) liberal norms include "individual rights, privacy, voluntary association, formal legality, plurality, publicity, [and] free enterprise."

[20] Ibid., pp. 89–116.

and counterethical (i.e., as having moments of both *Sittlichkeit* and *Gegensittlichkeit*), they say: although corporate organizations, the estate assembly, and public opinion generate "societal solidarity, collective identity, and public will" in civil society as a whole,[21] egoistic individualism and anonymous interdependence prevail within civil society as a capitalist economy, which in turn requires paternalistic state intervention. On their own antistatist reconstruction, civil society, being distinct from the economy and state, becomes "the central terrain of social integration and public freedom."[22]

Yet Cohen and Arato do not seem to fully recognize how Hegel's duality poses difficulties for their attempt to reconstruct his political philosophy. For their reconstruction papers over the *Gegensittlichkeit* of civil society, not only as portrayed by Hegel's perceptive, albeit confused, critique, but also as reconceptualized in their own book. Even if one distinguishes civil society proper from economic society and political society and from their correlative subsystems of the economy and state, the fact remains that individualism and anonymity have permeated contemporary voluntary associations and public communication even more than they had in Hegel's day.[23] This fact does not preclude the potential of civil society to generate social integration and public freedom. But it does require the characterization of this potential to be more dialectical and makes its achievement more difficult than Cohen and Arato suggest.[24]

Their reconstruction involves two departures from Hegel's political philosophy. First, Cohen and Arato's model is "society-centered" rather than "state-centered" (Hegel) or "economy-centered" (Marx). Civil society, as distinct from the state and economy, is the matrix of emancipation. Second, the central institutions of civil society are not Hegel's corporate organizations, estate assembly, and public opinion, nor are they the family, which Cohen and Arato include in civil society

[21] Ibid., p. 100.
[22] Ibid., p. 116.
[23] The pervasiveness of individualism and anonymity has helped motivate communitarian politics on both sides of the American political spectrum, despite the obvious differences in emphasis between, for example, Amitai Etzioni and Michael Lerner. See in this connection Robert D. Putnam, *Bowling Alone: The Collapse and Revival of American Community* (New York: Simon & Schuster, Touchstone, 2000).
[24] I return to this topic in the next chapter, where I discuss the social economy of the civic sector.

but Hegel does not. Rather, the central institutions are "the public spheres of societal communication and voluntary association."[25]

Hence, civil society and particularly the public sphere within civil society become the key to Cohen and Arato's political ethic, itself a modification of Habermas's discourse ethic. They insist that civil society and representative democracy in political society presuppose one another.[26] The two "societies" share the public sphere (e.g., communications media in civil society and parliamentary debate in political society). Both of them presuppose communication rights, and both contribute to the assertion and legal procurement of various other rights.[27] Because of such relationships, modern civil society can encourage further democratization of the political and the economic spheres (e.g., direct participation in local policy making and establishment of representative workers' councils). It also helps create space in these spheres for a plurality of democratic forms (e.g., representative, direct, federal, centralist).[28] There is a limit to the degree in which such democratization can and should be carried, however. In agreement with Habermas's *Theory of Communicative Action*, Cohen and Arato hold that a modern differentiated society requires the logics of power and money to prevail, respectively, in the administrate state and economic system.

Cohen and Arato's "central thesis," then, is that "democracy can go much further on the level of civil society than on the level of political or economic society, because here the coordinating mechanism of communicative interaction has fundamental priority." Indeed, it is in civil society's voluntary associations and public communication, as well as in families and cultural institutions, that "egalitarian, direct

[25] Cohen and Arato, *Civil Society*, p. 411. Like Hegel, and unlike Cohen and Arato, I do not include families, friendships, marriages, and other affectional relations within civil society – see Zuidervaart, *Social Philosophy after Adorno*, p. 174.

[26] Cohen and Arato, *Civil Society*, pp. 412–14.

[27] In Chapter 8 of *Civil Society* ("Discourse Ethics and Civil Society," pp. 345–420), Cohen and Arato distinguish three classes of rights, namely, privacy rights (negative liberties and personality rights having to do with personal autonomy), political rights (socioeconomic rights and the right to have rights – to participate in democratic decision making), and communication rights (free speech, assembly, association, and expression, and all citizenship rights). They argue that the first and third classes are "fundamental to the institutional existence of a fully developed civil society" (p. 403), and are also "required as preconditions of democratic legitimacy" (p. 404).

[28] Ibid., pp. 414–17.

participation and collegial decision making" have the greatest room
to thrive. Here a "democratic political culture" can take root and
flourish.[29] Accordingly, Cohen and Arato's political ethic has a two-
fold imperative: to protect civil society from encroachments and dis-
tortions at the hands of the administrative state and a late capitalist
economy; and to further democratize civil society, especially in its
public sphere(s) of communication and voluntary association.[30]

In my judgment, Cohen and Arato's conception establishes the
public sphere as essential to any modern democratic society and elu-
cidates its political significance. I propose to characterize the public
sphere as a societal structure whose existence is secured by various
political and cultural institutions, organizations, and practices and
whose normative principle is promised by the premises on which
these operate. The public sphere is a continually shifting network of
discourses and media of communication within which and through
which social groups and individuals seek wider recognition, social
movements and social classes struggle for liberation, and cultural
practices and products achieve general circulation. Although the
public sphere transects various differentiated spheres of contempo-
rary society such as the economic, the political, the ethical, and the
religious, its primary location is within "the social" (Nancy Fraser)
or "civil society" (Cohen and Arato). More specifically, it lies at the
intersection between civil society and the state.

Because the public sphere provides locations and procedures for
open-ended conversations and debates about social justice and the
common good, and because it can generate and sustain widespread
participation in the shaping of societal structures that affect every-
one, the public sphere is essential to any modern democratic society.
It acquires significance by way of its functions within various dimen-
sions of contemporary societies. Normatively considered, the primary
functions of the public sphere with regard to the economic and polit-
ical spheres are to challenge the operations of the economic system
and the administrative state and to open these to nonmonetary and

[29] Ibid., p. 417.
[30] A crucial question here is whether this political ethic and the concept of civil soci-
 ety behind it are viable under current conditions, a question Cohen and Arato
 address in chapter 9 of *Civil Society and Political Theory*. I take up aspects of this
 question in Chapters 6 and 9.

nonadministrative considerations. Again, normatively considered, the primary functions of the public sphere within civil society are to promote democratic communication and to encourage discursive will formation. Hence, the public sphere has broad political significance in two respects: it can serve as a precondition and modifier of democratic potentials in the political and economic spheres, and it can further the creation of a democratic culture within civil society.

4.2 FEMINIST REVISIONS

The proposed conception of the public sphere faces significant objections from practitioners and theorists of cultural politics who question the adequacy of Habermas's original account.[31] Among attempts by sympathetic critics to revise Habermas's model of the public sphere, the proposals of Nancy Fraser and Seyla Benhabib are particularly relevant to my own conception. Whereas Fraser would replace the principle of publicity with a multiplicity of competing publics, Benhabib would turn the structure of publicity into a continual process of practical discourses. I hope to show that both proposals suffer from institutional deficits, in order to suggest how addressing their institutional deficits can help clarify the political role of art in public.

Equality and Diversity

Nancy Fraser argues in "Rethinking the Public Sphere"[32] that Habermas's *Structural Transformation* fails to provide "a conception that is sufficiently distinct from the liberal model of the bourgeois

[31] Among the inadequacies of *Structural Transformation* identified by various contributors to *Habermas and the Public Sphere* and summarized by Craig Calhoun, at least three have to do with cultural politics: (1) the lack of attention to matters of culture and identity, leading to a misunderstanding of the public sphere's legitimate roles in consciousness-raising and need-interpretation; (2) a neglect of the role of social movements in redefining the issues and rearranging the voices in public debates; (3) a failure to analyze the internal organization of the public sphere, leading to a neglect of proletarian, ethnic, and subaltern publics. See Calhoun's introduction to *Habermas and the Public Sphere*, pp. 33–9. These criticisms are echoed in Robbins, *The Phantom Public Sphere*.

[32] Chapter 3 in Nancy Fraser, *Justice Interruptus: Critical Reflections on the "Postsocialist" Condition* (New York: Routledge, 1997), pp. 69–98. Earlier versions appeared in Calhoun, *Habermas and the Public Sphere*, pp. 109–42, and in Robbins, *The Phantom Public Sphere*, pp. 1–32. Citations are from *Justice Interruptus*.

public sphere to serve the needs of critical theory today."[33] Drawing on
the work of feminist historians such as Joan Landes and Mary Ryan,
Fraser claims that "Habermas's account idealizes the bourgeois pub-
lic sphere," ignores how it was constituted by significant exclusions,
and fails to examine "other, nonliberal, nonbourgeois, competing
public spheres."[34] Her response is to challenge several assumptions
of what she calls the "*bourgeois, masculinist, white-supremacist*" concep-
tion of the public sphere described by Habermas. She starts with the
bourgeois public sphere's "claim to be open and accessible to all,"[35]
points out that in fact it is exclusionary toward subordinated social
groups such as women, workers, peoples of color, and gays and lesbi-
ans, and then proposes a more inclusive conception.

Fraser's alternative revolves around four claims.

1. For there to be "a public sphere in which interlocutors can
 deliberate as peers," economic, cultural, and sociosexual "rela-
 tions of dominance and subordination" must be eliminated.[36]
2. Participatory parity is better achieved by a "multiplicity of pub-
 lics" than by a single, comprehensive public sphere.[37]
3. The topics of public discourse must not be restricted to "the
 common good" but must include so-called private interests and
 issues.[38]
4. An adequate conception of the public sphere should theorize
 the relation between "strong publics" such as parliaments,
 "whose discourse encompasses both opinion formation and
 decision making," and "weak publics" such as voluntary associa-
 tions in civil society, "whose deliberative practice consists exclu-
 sively in opinion formation."[39]

Let me restrict my remarks to the first two claims, which are the most
problematic.

Even though I agree that a more inclusive conception of the pub-
lic sphere is needed, I think there are three problems with Fraser's

[33] Fraser, *Justice Interruptus*, p. 71.
[34] Ibid., pp. 74, 75.
[35] Ibid., p. 76.
[36] Ibid., pp. 77–80.
[37] Ibid., pp. 80–5.
[38] Ibid., pp. 85–9.
[39] Ibid., pp. 89–92.

alternative. First, there is an unaddressed and perhaps irresolvable tension between the prerequisite of social equality (claim 1) and a strong preference for multiple publics (claim 2). Second, insistence on social equality as a prerequisite (claim 1) turns political democracy into a mere ideal even further removed from existing society than is the bourgeois norm of publicity. Third, the preference for multiple publics over a single public sphere (claim 2) rests on confusion between "a public" and "the public sphere." Let me briefly explain each problem before commenting more extensively on the third.

Democracy and Difference
The tension between the first and second claims is as follows. On the one hand, the exposure of social inequality, to be effective, seems to presuppose the existence of a public forum sufficiently accessible that the voices of oppressed groups can be heard and their claims adjudicated. On the other hand, the promotion in stratified societies of "arrangements that accommodate contestation among a plurality of competing publics"[40] seems to presuppose that the exposure of social inequality cannot be effective. Perhaps one can style this tension as one between the Habermasian and the Foucaultian sides to Fraser's theory. Are the openness and accessibility of the public sphere (or of multiple publics) normative desiderata at work in existing institutions and discourses? Or are they simply rhetorical instruments to be wielded in the ongoing struggle for power? Is diversity to be promoted as something good in itself? Or is it simply a means to advance the interests of disadvantaged groups?[41]

By claiming that a properly constituted public sphere presupposes social equality, Fraser challenges the liberal assumption that a society can achieve political democracy in the absence of economic and gender equality. Unfortunately, the antiliberal claim that social equality *is* a necessary condition for participatory parity in specifically political institutions is no less abstract than the liberal assumption that

[40] Ibid., p. 81.
[41] Fraser takes up these issues at greater length in her groundbreaking essay "From Redistribution to Recognition? Dilemmas of Justice in a 'Postsocialist' Age," in ibid., pp. 11–39. See also her debate with Honneth in Nancy Fraser and Axel Honneth, *Redistribution or Recognition? A Political-Philosophical Exchange*, trans. Joel Golb, James Ingram, and Christiane Wilke (London: Verso, 2003).

social equality is *not* a necessary condition for political democracy.[42] Fraser argues that participatory parity would be better served by thematizing social inequalities in public deliberation than by acting as if these do not exist. She also suggests that the dominant culture and corporate media marginalize the cultural styles of subordinated groups. One wonders, though, how social inequalities could be thematized if some level of participatory parity did not already pervade political and legal institutions. Equally puzzling is how the marginalization of subcultures could be challenged without an appeal to democratic assumptions in the dominant culture and without a legal framework that secures a public role for media that are privately owned and operated for private profit. Here, it seems to me, one can learn instructive lessons from both feminism and the American civil rights movement. My point, however, is not to defend liberalism, but to suggest that both liberalism and antiliberalism are insufficiently nuanced. Whereas liberalism tends to assume that democratic political forms are sufficient to guarantee genuine publicity, Fraser's critique tends to assume that no public sphere will ever be sufficiently democratic until the entire society is egalitarian. In her own words, "political democracy requires substantive social equality."[43] This totalizing approach makes political democracy seem unattainable for the foreseeable future.

Counterpublics and Public Sphere

Fraser gives two reasons for claiming that participatory parity is better achieved by a multiplicity of publics than by a single, comprehensive public sphere.[44] First, in societies having only a single, comprehensive public sphere, "members of subordinated groups would have no

[42] In this connection, see Habermas's comments on Rousseau in "Further Reflections on the Public Sphere" in Calhoun, *Habermas and the Public Sphere*, pp. 444–6, as well as his response in "Concluding Remarks" in the same anthology to the following question from Nancy Fraser: "Isn't economic equality... the condition for the possibility of a public sphere, if we are really talking about what makes it possible for people to participate?" (p. 469).

[43] Fraser, *Justice Interruptus*, p. 80.

[44] Here I restrict myself to Fraser's argument pertaining to *stratified* societies. She also argues that a multiplicity of publics would be preferable in "egalitarian, multicultural societies" – "classless societies without gender or racial divisions of labor" that are not culturally homogeneous (ibid., p. 83). The latter best approximate Fraser's projection of utopia.

arenas for deliberation among themselves" and hence would be "less able than otherwise to articulate and defend their interests in the comprehensive public sphere."[45] Second, when subordinated social groups constitute "subaltern counterpublics,"[46] this helps to "expand discursive space," widen "discursive contestation," and offset "the unjust participatory privileges enjoyed by members of dominant social groups."[47] In other words, a multiplicity of publics better promotes both intragroup and intergroup parity of participation.

It is not clear, however, why the existence of a single, comprehensive public sphere would prevent intragroup deliberation. If one means by "the public sphere" something like "a theater in modern societies in which political participation is enacted through the medium of talk,"[48] why would the existence of only one theater prevent groups from gathering in other spaces to sort out their own "needs, objectives, and strategies"?[49] Nor is it clear how in itself the constituting of subaltern counterpublics increases discursive space and contestation.

As Fraser herself points out, the potential of a multiplicity of publics for participatory parity depends on two factors: the counterpublics must have "an orientation that is *publicist*" such that they aim to disseminate their discourses into "ever-widening arenas," and they must actually engage in contestation with other publics. Accordingly, she endorses Geoff Eley's suggestion that we think of the public sphere in stratified societies as "the structured setting where cultural and ideological contest or negotiation among a variety of publics takes place."[50] But this suggestion, along with the two factors just noted, indicates that something like a single, comprehensive public sphere is required in order for groups to constitute themselves not simply as groups but as *publics*, and in order for such groups to engage in *interpublic* discourse.

[45] Ibid., p. 81.
[46] Fraser describes subaltern counterpublics as "parallel discursive arenas where members of subordinated social groups invent and circulate counterdiscourses, which in turn permit them to formulate oppositional interpretations of their identities, interests, and needs" (ibid., p. 81).
[47] Ibid., p. 82.
[48] Ibid., p. 70.
[49] Ibid., p. 81.
[50] Ibid., pp. 82–3.

Power and Principle

It seems to me that Fraser's argument confuses the concept of "a public" with the concept of "a public sphere." The confusion shows up when her language switches back and forth between "a single, comprehensive *public*" and "a single, comprehensive *public sphere*." To argue that a multiplicity of publics is preferable to a single public sphere involves a category mistake. I would suggest instead that a multiplicity of publics is preferable to a homogeneous *public*, and that a flexible and open public sphere is preferable to either a rigid and closed *public sphere* or a disparate array of enclaved subaltern *arenas*. In other words, the relevant choice is not between a single, comprehensive public sphere and a multiplicity of publics, but between a public sphere that functions properly and one that either malfunctions or does not exist at all. One mark of a properly functioning public sphere would be that it encourages the formation and maintenance of multiple publics. In the absence of such a public sphere, the state would be hard pressed to pursue public justice for the diverse institutions, communities, and individuals within its jurisdiction.

The flaw in the way Fraser poses the choice becomes apparent when she describes how multiple "public spheres" would operate under utopian conditions – that is, in "egalitarian, multicultural societies." They would function primarily as "arenas for the formation and enactment of social identities" through group-specific idioms and styles.[51] The obvious concern here is that such groups might not be able to talk "across lines of cultural diversity"[52] in order to deliberate over policies and issues affecting everyone.[53] To this, Fraser replies that she sees no conceptual barriers "to the possibility of a socially egalitarian, multicultural society that is also a participatory democracy," and that such a society would necessarily include "at least one public in which participants can deliberate as peers across lines of

[51] Ibid., p. 83.
[52] Ibid., p. 84.
[53] In other words, Fraser's account of the public sphere risks endorsing what Benhabib criticizes as "cultural enclavism" in Seyla Benhabib, *The Claims of Culture: Equality and Diversity in the Global Era* (Princeton, N.J.: Princeton University Press, 2002), pp. 49–81. Here, however, Benhabib endorses Fraser's argument about "bivalent collectivities" such as race and gender (in the first chapter of *Justice Interruptus*) as a worthy alternative to Charles Taylor's "politics of recognition" and Will Kymlicka's conception of a right to culture.

difference about policy that concerns them all."⁵⁴ But this is both to admit that there would have to be one shared public sphere and to avoid the question of how such a public sphere would be constituted. Even though Fraser does not intend her argument "as a simple postmodern celebration of multiplicity,"⁵⁵ it is hard to see how her conclusions avoid turning interpublic discourse into a carnival of expressive particularism. Cultural diversity seems to define what counts as social equality and participatory democracy.

Fraser's approach suffers from a failure to show that existing political institutions, despite their distortions and failures, nevertheless must promise equal access and open participation in order to exist. Few theorists today would deny that existing parliaments and political parties are exclusionary both in their origins and in their current operations. To point out these exclusionary tendencies, however, is to engage in a form of immanent critique that appeals to normative principles promised by the organizational premises of such institutions. Supposedly democratic political institutions purport to be egalitarian and participatory, and one task of "subaltern counterpublics" is to hold such institutions to their own premises.

To think of counterpublics as primarily engaged in formulating "oppositional interpretations of their identities, interest, and needs"⁵⁶ is to surrender the central institutions of the political public sphere to the forces of hegemony. Although Fraser's call for a theory of the relations between "strong" and "weak" publics goes some way to address this problem (see claim 4), it also tends to reinscribe the gap between political institutions and identity politics. In that sense, Fraser's approach can be said to suffer from a political-institutional deficit reminiscent of early Marx's critique of liberalism.⁵⁷

More crucial, however, is her failure to give a normative account of the public sphere. This, it seems to me, provides the common thread connecting the problems I have with her argument. The friction in her conception between social equality and multiple publics arises

⁵⁴ Fraser, *Justice Interruptus*, p. 85.
⁵⁵ Ibid.
⁵⁶ Ibid., p. 81.
⁵⁷ Fraser's argument that social equality is a necessary condition for participatory parity in political institutions is self-consciously indebted to Marx's "On the Jewish Question." See ibid., p. 96n21.

because she does not locate openness and accessibility as norms within an existing public sphere. Similarly, Fraser's insistence on economic equality as a prerequisite for political democracy seems to ignore the normative expectations of parity and participation already built into an existing public sphere. Again, her pitting of multiple publics against a single public sphere assumes, without sufficient argument, that dissension and difference are preferable ways to actualize democratic principles rather than, say, consensus and collaboration.[58] Fraser seems to hold that the ability of oppressed and marginalized groups to gain and exercise discursive power is to be preferred in and of itself. The crucial normative question, however, is whether and why this is preferable according to democratic principles.

This question becomes relevant for the arts in the following way. Many innovative and provocative art projects and organizations in recent decades have links to feminism, to gay and lesbian liberation, and to other new social movements. The harshest and most attention-grabbing criticisms of such art come from fundamentalist groups. The two sides, despite their conflicts, often "share" a dislike for political liberalism and a need to advance their causes in public. If these opponents do not understand and accept the democratic principles built into the political and cultural institutions that make up the public sphere, then their ongoing struggles quickly reduce to power politics pure and simple and lose their character as attempts to call for public justice. At that point both sides lose their legitimacy and their right to be heard. In other words, with the right to have a public voice comes the challenge to uphold the opponent's right to have a public voice. That challenge can be grasped only on normative grounds, a point that has been articulated well by Seyla Benhabib.

Respect and Reciprocity

Like Fraser, Seyla Benhabib examines the adequacy of Habermas's model for the purposes of feminist theory and praxis. Whereas Fraser

[58] Matthew Klaassen has traced this assumption to problematic notions concerning epistemological incommensurability that recall the classical problem of the One and the Many, in an unpublished seminar paper titled "Critical Theory, Feminism, and the Public Sphere" (Toronto: Institute for Christian Studies, 2006).

insists on the strategic importance of multiple publics, Benhabib is most concerned with the normative legitimacy of practical discourses. Her book *Situating the Self* argues for an ethical universalism that is interactive, gender-cognizant, and contextually sensitive. Accordingly, her chapter on "Models of Public Space"[59] advocates a "radically proceduralist model of the public sphere, neither the scope nor the agenda of which can be limited a priori, and whose lines can be redrawn by the participants in the conversation."[60] Benhabib compares Habermas's "discursive model" with the "agonistic model" of the civic republican Hannah Arendt and the "legalistic model" of the liberal Bruce Ackerman. She concludes that only the discursive model comports well with both contemporary social trends and "the emancipatory aspirations of new social movements like the women's movement."[61] What makes the discursive model superior is its dual emphasis on public participation and on normative procedures. On this model, no groups are excluded, but only certain types of procedures can be legitimate.

According to Benhabib, all of Habermas's writings from *Structural Transformation* on pursue an interest in "extending the principle of modernity, namely the unlimited and universally accessible participation of all in the consensual generation of the principles to govern public life."[62] The modern differentiation of societal structures and value spheres makes it possible to extend this principle in both political society and civil society.[63] Her reworking of Habermas's model ties the existence of public space (or the public sphere) to participation in practical discourses. In a practical discourse, general norms of action are evaluated by all affected, subject to the moral principles of universal respect and egalitarian reciprocity. Benhabib defines the principle of universal moral respect as the recognition of "the right of all beings capable of speech and action to be participants

[59] In Seyla Benhabib, *Situating the Self: Gender, Community and Postmodernism in Contemporary Ethics* (New York: Routledge, 1992), pp. 89–120. An earlier version appears under the same title in Calhoun, *Habermas and the Public Sphere*, pp. 73–98. Citations are from Benhabib's book, unless specifically noted otherwise.

[60] Benhabib, *Situating the Self*, p. 12.

[61] Ibid., p. 113.

[62] Ibid., p. 81.

[63] Ibid., p. 104.

in the moral conversation." She defines the principle of egalitarian reciprocity as the symmetrical rights of all participants "to various speech acts, to initiate new topics, to ask for reflection about the pre-suppositions of the conversation, etc."[64] People can challenge these two principles but only from within a practical discourse. Benhabib's model acknowledges "a plurality of public spaces emerging...around contested issues of general concern."[65]

This approach has a couple of advantages for feminists, she says. Because the scope and agenda of public conversations are not prede-termined, Benhabib's model acknowledges and encourages struggles over what Fraser calls "the sociocultural means of interpretation and communication."[66] Also, Benhabib's normative emphasis provides a way to "distinguish between the bureaucratic administration of needs and collective democratic empowerment over them,"[67] without recourse to a traditional public-private split that overlooks asymmet-rical power relations in the intimate sphere.

Her approach also challenges some feminists' assumptions. Whereas Fraser would have us evaluate interpretations of need according to the inclusiveness of their procedures and the fairness of their outcomes,[68] Benhabib's approach suggests that even the most inclusive and fair interpretations, when presented in public, are subject to the normative principles of universal respect and egal-itarian reciprocity. Although primarily directed at bigotry, racism, sexism, and religious fundamentalism, Benhabib's insistence that the

[64] Benhabib gives these definitions in the first chapter in *Situating the Self* (titled "In the Shadow of Aristotle and Hegel"), p. 29. An earlier version of this chapter appears as the afterword to *The Communicative Ethics Controversy*, ed. Seyla Benhabib and Fred Dallmayr (Cambridge, Mass.: MIT Press, 1990), pp. 330–69. Citations are from the version in *Situating the Self*.

[65] Benhabib, *Situating the Self*, p. 105.

[66] Nancy Fraser, *Unruly Practices: Power, Discourse, and Gender in Contemporary Social Theory* (Minneapolis: University of Minnesota Press, 1989), p. 164. Fraser defines the sociocultural means of interpretation and communication as "the historically and culturally specific ensemble of discursive resources available to members of a given social collectivity in pressing claims against one another" (p. 164). These resources include officially recognized idioms, available vocabularies, paradigms of argumentation, narrative conventions, and modes of subjectification (how vari-ous discourses position their addressees "as specific sorts of subjects endowed with specific sorts of capacities for action," p. 165).

[67] Benhabib, *Situating the Self*, p. 113.

[68] See Fraser, *Unruly Practices*, p. 182.

principles of right must "trump" particular conceptions of the good[69]
would apply to various programs of radical feminism, eco-activism,
and political anarchism as well.[70]

While I agree that a discursive model is better than the agonis-
tic and legalistic models, there are several problems in Benhabib's
approach. First, there is an acknowledged but unresolved tension
between an insistence on political-legal neutrality and her stance of
moral commitment. Second, she articulates the stance of moral com-
mitment in a way that potentially violates the principle of universal
respect. Third, Benhabib's emphasis on the *process* of practical dis-
course comes at the expense of an institutionally secured *structure*
of publicity. Let me comment briefly on the first two problems and
devote more attention to the third.

Neutrality and Commitment

The first chapter of *Situating the Self* clearly states that Benhabib's ver-
sion of communicative ethics is not morally neutral: it privileges "a
secular, universalist, reflexive culture in which debate, articulation
and contention... have become a way of life."[71] At the same time, how-
ever, it embraces "political-legislative neutrality," holding that "the
norms embodied in the legal and public institutions of our societ-
ies should be so abstract and general as to permit the flourishing of
many different ways of life and many different conceptions of the
good." Such neutrality encourages "plurality, tolerance and diversity
in culture, religion, lifestyles, aesthetic taste and personal expres-
sion." When a clash occurs between universal rights and the norms
of a specific ethical community, however, "universal human and citi-
zen's rights take precedence."[72]

Benhabib acknowledges a tension between the stance of moral
commitment and her insistence on political neutrality, but she leaves
it unresolved. On the one hand, like Bruce Ackerman, she thinks
that traditional or conventional views of morality "cannot serve as

[69] Benhabib, *Situating the Self*, pp. 45, 97, 116n22.
[70] See, for example, *Situating the Self*, p. 113, where Benhabib expresses her impa-
tience with the "political and moral authoritarianism" of radical feminists such as
Catharine MacKinnon.
[71] Ibid., p. 42.
[72] Ibid., pp. 44–5.

the moral foundations of a liberal-democratic state." They are not
sufficiently impartial and comprehensive "to allow the public coex-
istence of differing and competing conceptions of the good life."[73]
Hence, her moral commitment to universal respect and egalitarian
reciprocity excludes the state-founding role of legal and political phi-
losophies that claim to express conventional moralities – "Christian"
Reconstructionism, for example. On the other hand, she does not
wish to push any conceptions of the good life off the agenda of pub-
lic debate. Even conventional views of morality must be allowed "as
partial conceptions of the good which enjoy an equal public forum
with other more comprehensive views."[74] Hence, her insistence on
political-legal neutrality seems to allow public space for homophobic
rhetoric and racist agendas. There is a tension, then, between wel-
coming all moral and ethical viewpoints into the public forum and
permitting only postconventional views to provide moral grounding
for the liberal-democratic state.[75]

Benhabib's extended footnotes indicate that she takes this tension
seriously, but also that she does not resolve it. In one note, for exam-
ple, she entertains the suggestion that "restraining public dialogue
may be a morally desirable option" in certain situations but argues
"the moral burden of proof" in such situations "is almost always on
the shoulders of the advocates of 'gag rules.'"[76] One wonders, how-
ever, whether this burden would shift to those who oppose restraints
if, for example, recent civil rights legislation and jurisprudence came
under a concerted and inflammatory attack by latter-day fascists who
had captured control of the electronic media. My intent here is not to
slip the liberals' "conversational restraint" through the back door but
rather to highlight an unresolved tension in Benhabib's approach. In

[73] Ibid., p. 97.
[74] Ibid.
[75] In a note that comments on Ackerman's position, Benhabib distinguishes between
the neutrality required of the modern legal system as the guarantor of constitu-
tional rights and the nonneutrality to be permitted and encouraged in the media
and other public fora. "As long as this agonistic conversation does not lead to the
imposition of one understanding of the good upon all others as the officially sanc-
tioned way of life," she writes, "there is no reason why these partial conceptions
of the good cannot be out there, competing and arguing with each other, in the
public space of the liberal state" (ibid., pp. 116–17n22).
[76] Ibid., p. 117n23.

a sense, she would like to eat a liberal pie and have it postliberally too. I am not convinced this can be done in the way she proposes.[77]

Reflexivity and Respect

The second problem in Benhabib's approach has to do with the way in which she formulates her stance of moral commitment. Her formulation smacks of an arrogance that seems incompatible with the principle of universal moral respect. Benhabib argues that communicative ethics is superior to "systems of conventional morality," for it has the "singular cognitive virtue" of "comprehensive reflexivity." By "comprehensive reflexivity" Benhabib means something like the capacity and the inclination to submit all ethical practices and claims, including one's own, to the test of universalizability. For the communicative ethicist, "no way of life is prima facie superior to another and the prima facie validity [a way of life] confers upon certain normative practices cannot be taken for granted if one cannot demonstrate with reasons to others who are not members of this way of life and even to skeptics among one's way of life as to why these practices are more just and fair than another." To be truly comprehensive, a reflexive ethic must also be able to "radically question all procedures of justification, including its own."[78]

Conventional systems, because they lack the virtue of comprehensive reflexivity, suffer from a "rationality deficit," she claims. They are inadequate in two respects. First, such systems cannot consistently support "a mode of collective existence" that is "tolerant and pluralistic enough to support the right of those who opt out of it." Second, advocates of conventional morality at some point must "withdraw from the process of reflexive justification in order not to let their world-view crumble." Communicative ethics, by contrast, can support a tolerant and pluralistic way of life, and its advocates

[77] Another example of the unresolved tension occurs in Benhabib's comments on the issue of pornography. She suggests that unconstrained public dialogue must be allowed to run its course if "we" are to learn whether it is primarily a First Amendment issue, or "a private, moral issue concerning...sexual taste," or a matter of aesthetic sensibility and artistic fantasy (ibid., p. 99). If one were to add to this list the view of religious fundamentalists that pornography is an issue of *public* morality about which unconstrained dialogue is *immoral* and should be illegal, however, the limitations of Benhabib's suggestion would soon become apparent.

[78] Ibid., pp. 42–3.

do not have to withdraw from the process of reflexive justification. Indeed, adherents of communicative ethics (or of another type of postconventional morality) can even "respect a way of life which considers that the game of moral justification has its limits, and that the point is not to argue about the good incessantly but to do the good."[79]

This formulation first stacks the deck against conventional systems of morality and then faults them for not playing according to the rules of communicative ethics. Benhabib assumes, for example, that comprehensive reflexivity is not only a *cognitive* virtue but also a *moral* virtue and even the *supreme* or the *sole* virtue. No conventional system could ever agree to that assumption and remain a conventional system. Benhabib also assumes that the prevailing culture of modern societies both is and ought to be "secular, universalist, [and] reflexive" – surely a major point of contention between conventionalists and postconventionalists. She also fails to recognize that a postconventionalist appeal to the force of the better argument, no less than a conventionalist appeal to tradition or sacred writings or revelation, can tend to "divide the participants of the moral conversation into insiders and outsiders."[80]

In fact, one wonders what it actually means for a postconventionalist to "respect" a conventionalist way of life. If "respect" means that conventionalists can enter the conversation but only so long as they play by postconventionalist rules, then respect means little more than liberal tolerance: that is, conventionalist interlocutors gain admittance to the game, but they must be ready to check their deepest convictions at the door.[81]

Process and Structure

The third problem stems from Benhabib's emphasis on practical discourse as the key to understanding and constituting a public sphere, an emphasis that prompts her plea for a radically proceduralist

[79] Ibid., pp. 43–4.
[80] Ibid., p. 43.
[81] Such incongruities are part of the motivation for Albrecht Wellmer, Agnes Heller, and others to argue that Habermasian discourse ethics "formulates a model of *political legitimacy* rather than one of *moral validity*" (ibid., p. 38). Discourse ethics is less problematic as a model of political legitimacy.

model. Her proceduralist model tends to reduce the public sphere from a societal structure encompassing specific groups and organizations to a continual process of open-ended conversation among relatively autonomous individuals. The tendency toward reduction becomes apparent in the following claim: "The public sphere comes into existence whenever and wherever all affected by general social and political norms of action engage in a practical discourse, evaluating their validity."[82] This claim is questionable in two respects. On the one hand, it is nearly impossible in a complex modern society for *all* who are so affected to undertake a practical discourse. On the other hand, it is unlikely that practical discourses of the specified sort can be undertaken unless appropriate organizations and publicly constituted groups already exist within a public sphere. A public sphere that would come and go as practical discourses ebb and flow could neither carry the traffic of long-term social struggle nor provide a significant counterweight to the systems of state and economy.

This problem is not unrelated to the unresolved tension between legal neutrality and moral nonneutrality or to a conflict between the moral commitment to a reflexive culture and the normative principle of universal moral respect. When Benhabib insists on political-legal neutrality, for example, she seems to assume that major institutions of the modern state either do accord or ought to accord with the strictures of moral conversation and discourse. To the political charge that such an approach is either anti-institutional or completely utopian, she replies that communicative ethics does not pretend to be a theory of institutions, although it does help ferret out exclusionary mechanisms and encourages "cooperative and associative methods of problem solving."[83] One wonders, though, how a social philosophy can insist on morally bound political-legal neutrality without proposing a theory of political institutions. A similar question about cultural institutions arises because of Benhabib's apparent reduction of the public sphere to a process of practical discourses.

[82] Ibid., p. 105.
[83] Ibid., p. 49.

Institutional Deficits

Benhabib's plea for a proceduralist model derives from her understanding of universalizability as primarily a procedure for testing "the intersubjective validity of moral principles and norms of action."[84] As a test, universalizability has three components: the normative principles of universal moral respect and egalitarian reciprocity, which are built into any argument situation in a modern society; the basic premise that "only those norms can claim to be valid that meet (or could meet) with the approval of all concerned in their capacity as participants in a practical discourse"; and certain "rules of argument governing discourses."[85] So construed, the requirement of universalizability emphasizes the process more than the result of reaching reasonable agreement. What is crucial is less the agreement per se and more the sustaining of practices and relationships that let open-ended moral conversation flourish as a way of life. In Benhabib's own words, universalizability involves "the utopian projection of a way of life in which respect and reciprocity reign."[86]

The upshot of all this is that Benhabib's model of the public sphere displays a culture-institutional deficit[87] not unlike the political-institutional deficit in Fraser's model. Where Fraser emphasizes strategic questions at the expense of normative reflections, Benhabib stresses normative reflections at the expense of strategic questions. There is something peculiar about Benhabib's institutional deficit, however, because Habermas's original account regarded the emergence of relatively autonomous cultural institutions as crucial for the constitution of a public sphere. Moreover, as Habermas has pointed out in response to his critics,[88] the central topic of the second half of his book was a structural transformation manifested in cultural

[84] Ibid., p. 34.
[85] Ibid., p. 37.
[86] Ibid., p. 38.
[87] Benhabib subsequently addresses this institutional deficit in *The Claims of Culture*, where she calls attention to "the civil, cultural, religious, artistic, and political associations of the *unofficial* public sphere" (p. 21).
[88] Jürgen Habermas, "Further Reflections on the Public Sphere," in Calhoun, *Habermas and the Public Sphere*, pp. 421–61. On p. 436, Habermas specifically mentions professionalized book production, the mass-circulation press, "the rise of the electronic mass media, the new relevance of advertising, the increasing fusion of entertainment and information." For Habermas's original account of the transformation in cultural institutions, see *Structural Transformation*, pp. 159–95.

institutions. Habermas also suggests that his book's primarily nega-
tive assessment of this transformation needs to be modified by more
nuanced inquiries in political sociology (e.g., studies of political
behavior and political culture) and cultural studies (e.g., the impact
of formal schooling, the institutional context of the media, and the
cultural context of media reception).[89]

In presenting his "modified theoretical framework," however,
Habermas focuses on questions concerning a "political public
sphere" and says very little about what could be called a "cultural
public sphere." He does acknowledge the potential importance of
churches, cultural associations, academies, independent media, and
leisure clubs for institutionalizing support of a critical political public
sphere, and he does point out the contradictory effects of the mass
media. Yet he seems doubtful that "a public sphere dominated by
mass media provides a realistic chance for the members of civil soci-
ety, in their competition with the political and economic invaders'
media power, to bring about changes in the spectrum of values, top-
ics, and reasons channeled by external influences, to open it up in an
innovative way, and to screen it critically."[90]

The closest Habermas comes in this essay to reconceptualizing
the cultural public sphere occurs when he talks about the necessary
interplay "between a constitutionally instituted formation of the polit-
ical will and the spontaneous flow of communication unsubverted by
power, within a public sphere that is not geared toward decision mak-
ing but toward discovery and problem resolution and that in this sense
is *nonorganized*."[91] But he does not tie this flow of public communica-
tion to actual cultural institutions and organizations, thereby dodg-
ing the question, left hanging by *Structural Transformation*, of exactly
how, under late capitalist and administrative state conditions, such
communication can counter the flow of consumerist publicity. Hence,
the culture-institutional deficit, while peculiar when one compares
Benhabib's model to Habermas's *Structural Transformation*, is less odd
when one compares it to Habermas's more recent theoretical frame-
work, an important reference point for both Benhabib and Fraser.

[89] Habermas, "Further Reflections," pp. 438–9.
[90] Ibid., p. 455.
[91] Ibid., p. 451.

In fairness to Benhabib, one must also note that her discussion explicitly focuses on the political public sphere, to the exclusion of the "larger sense of the term *Öffentlichkeit*, which would include a literary, artistic and scientific public."[92] Nevertheless, I want to suggest that even as a model for the political public sphere, Benhabib's approach suffers from a culture-institutional deficit. Further, her approach diverts attention from the unresolved culture-institutional questions raised by Habermas's original account of the public sphere's transformation.

One way to get at these questions is to consider the potential of the commercial mass media for generating a critical publicity at odds with the consumerist publicity that seems nearly all-powerful in Habermas's original account. In the essay "Chatter in the Age of Electronic Reproduction," for example, several authors argued in the early days of talk shows that these exemplify a transformation in television as a medium. Talk shows challenge the separation between production and consumption, problematize the distinction between expert and audience, and thereby constitute "a 'contested space' in which new discursive practices are developed in contrast to the traditional modes of political and ideological representation."[93] Although I have doubts about the progressive political potential of televisual talk shows, a thorough reconsideration of the commercial mass media is crucial for identifying the cultural institutions, organizations, and practices that constitute the contemporary public sphere and provide openings for genuinely democratic communication.

A second way to address the culture-institutional questions left unanswered by Habermas's *Structural Transformation* is to rethink the public roles of art as an institution that frames the aesthetic dimension in modern societies. In "For a Practical Aesthetics," George Yúdice argues persuasively that right-wing attacks on the NEA in the 1980s and 1990s were part of an attempt to "reverse the gains made in the past two decades by gays and lesbians, racial and ethnic minorities, women, and other subordinated and subaltern groups." The

[92] Benhabib, *Situating the Self,* p. 89.
[93] Paolo Carpignano, Robin Andersen, Stanley Aronowitz, and William DiFazio, "Chatter in the Age of Electronic Reproduction: Talk Television and the 'Public Mind,'" in Robbins, *The Phantom Public Sphere,* pp. 93–120; the quote is from p. 96.

"relatively protected sphere of the aesthetic" became "a major terrain of political contestation," he says, because it provided "forums for addressing crucial ethical concerns in ways that the mass media are disinclined to adopt."[94] Now we must view the aesthetic not as the protected domain of purportedly autonomous works and organizations but rather as the open terrain of "aesthetic practices *by which group identity and ethos are formed*."[95] Despite reservations about the politics of identity that Yúdice recommends, I think his argument provides a new way to think about the public roles of art-related cultural institutions and organizations.

My point here is not to say what a theory of cultural institutions should look like but rather to suggest that such a theory is required for an adequate model of the public sphere. Also required is a theory of political institutions. In the absence of either theory, it becomes very difficult to say how the structure of publicity is secured and to specify how the principle of publicity is promised. Lacking such specificity, the public sphere, both as a concept and as an existing social nexus, threatens to vanish in a maelstrom of identity politics within an increasingly globalized economy. This, in turn, would undermine the role that art plays in the public sphere. To help circumscribe this role, I turn next to Hilde Hein's discussion of museums as "public art."[96]

4.3 ART IN THE PUBLIC SPHERE

Hilde Hein characterizes museums as public institutions that generate and legitimate private experiences: "I suggest that the museum is an agent that mediates experience, publicly presiding over and bringing into focus objects and ideas... to make them accessible as private experience."[97] She argues that museums should aspire to the "committed temporality and impermanence" of newer forms of public art and thereby become more dynamic, deliberative, and responsive in constructing multiple publics.[98]

[94] George Yúdice, "For a Practical Aesthetics," in Robbins, *The Phantom Public Sphere*, pp. 209–33; the quote is from p. 209.
[95] Ibid., p. 219.
[96] Hilde Hein, *Public Art: Thinking Museums Differently* (Lanham, Md.: AltaMira Press, 2006).
[97] Ibid., p. 3.
[98] Ibid., p. xiii.

"Public Art"

Hein considers "public art" to be a subset of what she classifies as "non-private art." Nonprivate art includes nearly every type of art other than what others have labeled "fine art" or "high art." It ranges from cave paintings at Lascaux and medieval altarpieces to folk art, popular art, mass art, and outsider or visionary art. "Private art," by contrast, designates "creations produced by an individual...for limited display/performance to be experienced by other individuals, not excluding oneself."[99] It is the art, one could say, of private experience, and it is the art that until recently art museums have used as the template for all art.

What distinguishes public art, according to Hein, is that it "presupposes the public sphere and produces a [specific] public in relation to that concept... by means of an aesthetic interaction."[100] Yet Hein does not seem to think that a genuine public exists: "'The public' exists today in fractionated form, dissociated as countless individuals. It is a fiction that has survived through centuries of redefinition."[101] Similarly, she claims that the public sphere "has disintegrated into an arena of competing private interests. It has become a rhetorical marketplace presided over by a government bureaucracy that answers to manipulated public opinion."[102] Yet her concept of the public sphere is not simply descriptive. It is a normative notion. This becomes evident when she distinguishes "public art" that "constructs a public" from "art in public places" whose main characteristics are "its location and bureaucratic legitimation" as well as from publicly situated "corporate baubles" that "pacify, but do not...promote affinity among the patrons." Public art, properly so called, "aims both to express and to affect its culture" and is held to standards of both "aesthetic merit and social or political acceptability."[103]

Moreover, the interaction by which public art constructs a public – or, better, multiple publics, according to Hein – is a two-way street. Ultimately it is the public that "legislates the public identity of art" as publics are "emboldened by art and wish to be heard."[104] Hein

99 Ibid., p. 34.
100 Ibid., p. 49.
101 Ibid., p. 42.
102 Ibid., p. 27.
103 Ibid., p. 53.
104 Ibid., p. 62.

claims this interaction becomes even more pronounced when new genre public art, indebted to how "happenings" in the early 1960s raised "performativity" to a central category of artistic creation, collaboratively includes its publics "in the creation of art": "The artwork [in new genre public art] may... *be* the relationship between and among artists and publics – a process, not a thing. This process is social or even political at a grass-roots level. It is designed to build community, not to assume it. It is also meant to teach and to expose the conditions that separate communities as much as the communities link their members."[105] Unlike more traditional public art, which "addresses itself to a public sphere," the newer public art "no longer claims to find that [public sphere] ready-made and instead is dedicated to creating small public enclaves."[106]

Hein singles out three characteristics of new genre public art as the most germane to envisioning a new paradigm for museums. First, it tends to "dematerialize" and "decommodify" the art object – what counts is the process of "contextualized interpretation" rather than the object to be interpreted. This suggests, she says, that "discussion" has become "the work of art": "Public debate, dialogue, and analysis are the 'substance' that purportedly outlasts artifacts and temporal events and may be renewed at will independently of authorial intention."[107] Second, newer forms of public art do not aim to address "the public" but to construct multiple publics. This is in keeping, she claims, with the fact that "the rational public sphere described by Habermas" likely no longer exists: "There are many publics. They are generated and quickly dissolved as circumstances warrant. They are composed of individual persons who affiliate according to habit, pressure, and choice, defining themselves in terms of the cluster of publics to which they adhere and the public-making issues that matter to them. Public art is one among other devices that recruit and construct publics, and as the character of publics changes, so must that of the art that convenes them."[108] Third, the role of the artist has become one of

[105] Ibid., pp. 73–5.
[106] Ibid., p. 76.
[107] Ibid., pp. 90–1.
[108] Ibid., pp. 97–9.

enabling others rather than originating an artwork, to the point that "[c]onceptually, artist and public merge, and the work of art comes about through a process of multiple enactments."[109]

"Private Experience"

Although these emerging characteristics do not entirely collapse the distinctions between art and nonart, between public and private, and between publics and markets, the boundaries certainly have become less definite. Hein's primary marker for maintaining such boundaries appears to be the notion of private experience. Even the most collaborative and processual example of new public art would be "private in the sense that it evokes experiences uniquely constructed by and adherent to the person who has them."[110] On her account, all public art "motivates individual engagement with a social organism perpetually in motion."[111] Accordingly, although Hein embraces the aspiration of new public art to be "transformative" and thinks that all art, even private art, shares this aspiration, she glosses this as a matter of the individual's transformation: "[I]t can change your life."[112]

Philosophically, Hein's approach seems to have two primary sources: Hannah Arendt and John Dewey. From Arendt, she inherits a jaundiced view of the contemporary public sphere, a normative notion of "the public" as an agonistic encounter, and an emphasis on the individual as the center of agency and experience.[113] From Dewey, Hein derives a processual view of experience, a normative endorsement of democratic communication, and an emphasis on interpersonal interaction in art.[114] This helps explain why her category of public art makes reference to the public sphere even though she does not think there is a genuine public sphere. It also sheds light on her tendency to challenge the distinction between private and public while continuing to use it nonetheless. Although Hein recognizes that experience can occur in public and collective contexts, she does not

[109] Ibid., p. 99.
[110] Ibid., p. 93.
[111] Ibid., p. 99.
[112] Ibid., p. 101.
[113] See ibid., pp. 24, 34–5, 39–40, 92–3.
[114] See ibid., pp. 2–3, 26–7, 93.

countenance public or collective experience. This puts her account at odds with the self-understanding of many new genre public artists, who assume something like class-, race-, or gender-consciousness and aim to help raise or articulate such consciousness through their collaborative projects. It also prompts questions about the sociological status of the "publics" that public art is said to construct.

What Hein's otherwise instructive account omits is precisely what Habermas's early work, which she cites, tried but failed to envision: a structure and principle of publicity (*Öffentlichkeit*) that can resist the pressures exerted upon democratic communication by a late capitalist economy and an administrative state. If in this sense a genuine public sphere no longer existed, then Hein's own account of "public art" would implode, and her recommendation that museums model themselves after the newer public art might in fact point them away from any meaningful public role. Indeed, if publics can convene just by virtue of individuals' affiliating and defining themselves as publics,[115] then the public character of their interlinkages would be gratuitous.

One way to address these issues is to ask what it would mean for art to "construct" a public and for a public to "legislate" the public character of art. By "construct" Hein seems to mean that art can gather people together: it can convene them as a group such that individuals discover the interests they have in common. By "legislate" she seems to mean that people who are not artists now have a say, and perhaps the final say, in whether and what sort of art gets produced.[116] On these construals, however, neither art's constructing a public nor a public's legislating art's public character would account for the public character of either the art or the public. Instead, we would be left with various interest groups that vie for control of the art being produced. This view jibes with Hein's description of the contemporary public's "fractionated form" and the public sphere's disintegration "into an arena of private interests."[117] But it is at odds with the normative view of publicity that, following Arendt and Dewey, she continues to employ. For Arendt and Dewey, and for Hein too, a constant

[115] Ibid., pp. 97–9.
[116] See ibid., p. 62.
[117] Ibid., pp. 42, 27.

struggle among ever-changing interest groups would not suffice to enrich experience, build communities, or carry out democratic communication.

Art Matters

Hence, I think Hein's account of public art needs to be supplemented via insights gleaned from the preceding discussion of Habermas, Fraser, and Benhabib. From Habermas I accept the claim that the public sphere is both a structure and a principle that is essential to any modern democratic society. Its complete demise into a bureaucratically superintended battleground among competing private interests would spell the end of any public properly so called and of any "public art" in Hein's sense of the term. Regardless of whether such art "constructs" a public, the latter presupposes the existence of a public sphere in which it can be a public.

It is so, of course, that the existing public sphere is not a land of sweetness and light. Rather, as Nancy Fraser rightly claims, it is exclusionary both in its origins and in many of its current operations. To acknowledge the public sphere's exclusionary tendencies, and to counter them, we must insist that it be open to a multiplicity of publics that include many disadvantaged groups. In other words, and in my own terms, we must hold the public sphere to its own principle of genuinely democratic communication. If this principle is not enacted and renewed by the institutions, organizations, and practices that compose the public sphere, the public sphere will not challenge the operations of the economic system and administrative state – operations that either generate or reinforce social injustice. Nor will the public sphere promote democratic communication and encourage discursive will formation within civil society. These are crucial roles to which art in public can and should contribute, and not simply to the formation and expression of group identities and the struggle for greater parity and power. It is in relation to the partially and unevenly embodied principle of democratic communication that art in public must address its publics and receive legitimation.

The mode of address and the manner of legitimation are important considerations. As Seyla Benhabib correctly argues, although no group should be excluded from participation in the public sphere,

only certain modes of participation can be legitimate. The normative key to legitimacy is whether a mode of participation is itself genuinely democratic. To be legitimate, according to Benhabib, the manner in which groups call attention to contested issues of general concern should follow the principles of universal respect and egalitarian reciprocity, and groups must be prepared to justify their procedures in that regard. If she is right – and, despite my earlier criticisms, I believe she is – then art in public cannot rest content with simply "creating small public enclaves."[118] Rather, it must address itself to audiences beyond its own affinity groups and try to do so in ways that do not prima facie disrespect them or preclude their response.

Clearly this formulation poses a high demand, one that becomes evident less often in the observance, perhaps, than in the breech. Yet it sheds light on many public controversies over art that have erupted in recent decades, whether an international dispute about cartoons of Mohammed, for example, or a more local battle over the siting of Richard Serra's *Tilted Arc*. Such controversies are not simply about either the appropriateness or the aesthetics of art. They also pertain to whether the creators and primary audiences of the art in question have shown respect and reciprocity in how their art addresses matters of general concern. Although it may seem odd to speak of an abstract piece like *Tilted Arc* as addressing matters of general concern, the siting of a large steel sculpture in the middle of a familiar urban plaza does in fact address such matters. It addresses questions about who occupies the space, how they experience it, and whether and to what extent they are allowed to help shape public space. Admittedly, a strictly formalist aesthetic would have difficulty considering such questions legitimate in connection with art. But that is just one indication of why formalism is inadequate for understanding art in public.

Not only does the expectation of genuinely democratic participation remain in effect in more overtly pluralistic societies, but it also helps explain why artists have turned to explicitly participatory and collaborative modes of art making. Often their projects solicit public recognition for the experiences and concerns of neglected or oppressed groups. They ask, in effect, for respect and reciprocity, and their request can be legitimate only if their mode of address

[118] Ibid., p. 76.

demonstrates the same. Participatory and collaborative art making does not aim simply to build self-respect and group identity. It also aims to enact the universal respect and egalitarian reciprocity that the art makers want from others. Whereas Hein claims that newer forms of public art no longer expect to find a ready-made public sphere and create small public enclaves instead, I think that such art makes more readily apparent the principles of respect and reciprocity that provide legitimacy for any project in the public sphere.

Indeed, all art in public – which includes not only both traditional and newer forms of public art but also much of what Hein labels "private" and "nonprivate" art – has an important role to play in the formation and renewal of a vital public sphere. A vital public sphere requires more than political institutions and weak and strong political publics or, in the terminology I prefer, informal and formal political publics. It requires cultural organizations and practices in which matters of general concern can be explored, presented, and interpreted. These organizations and practices include the ones that make up the field of art in public. The special contribution of art in public is to help people carry out their explorations and presentations and interpretations in an imaginative fashion, to help them disclose in fresh and insightful ways the felt quality and lived experience of concerns that merit public attention. Products and events of art in public that accomplish this sort of imaginative disclosure exemplify and foster critical and creative dialogue both within various publics and among them. Such art also presupposes that the publics addressed, either potentially or actually, are not mere collections of self-interested individuals. The publics of art in public are themselves internally connected and cross-connected by virtue of shared traditions, social positioning, and patterns of interpretation that exceed and inform the experience of any individual member.

Understood along these lines, art in public can have political relevance without being overtly political. The AIDS Memorial Quilt project, for example, mobilized countless individuals and families in the United States to remember in a public way the loved ones they had lost. On display in sections at many different locations over several years and eventually arrayed in 1996 as one huge tapestry on the Washington Mall, it neither harangued politicians nor directly criticized the medical establishment. Yet it reminded everyone who

experienced it, whether as a quilt maker or as a site visitor or as a member of the media public, of a widespread tragedy that needed political responses: informal responses of information gathering and advocacy as well as formal responses of legislation and public policy. The AIDS Memorial Quilt not only reminded us but also encouraged us to engage in political action. In these ways it supported and furthered democratic communication and discursive will formation with respect to matters that, although experienced in unique ways by many individuals and families, nonetheless are of general concern. It offered profoundly moving and politically relevant imaginative disclosure. One reason why it drew as much attention as it did, I would argue, is because it exemplified the principles of respect and reciprocity.

It is time to complete the quilt of this chapter. I have derived from Habermas and Cohen and Arato a conception of the public sphere as an essential structure and principle in modern democratic societies. Various political and cultural institutions secure the existence of this societal structure, and the premises on which they operate point to the normative principle of democratic communication. Located in civil society where civil society intersects government, and distinct from both a late capitalist economy and an administrative state, the public sphere's shifting discourses and media not only support struggles for recognition and liberation but also permit the general circulation of cultural practices and products. Through such struggles and circulation, multiple publics engaging in democratic communication and discursive will formation can mount challenges toward the economic system and administrative state.

While agreeing with Nancy Fraser about exclusionary tendencies in the contemporary public sphere, I take this to be a point of immanent critique, holding the public sphere to its own principle. And while agreeing with Seyla Benhabib about the normative centrality of universal respect and egalitarian reciprocity to practical discourses in the public sphere, I do not think that publics can meet these expectations outside the impure texture of existing political and cultural institutions.

Among such institutions is art in public. Unlike Hilde Hein, I do not accept the pessimistic prognosis in Habermas's original account of the public sphere. Rather, in attempting with others to recast his

account, I have come to the conclusion that art in public has a significant role to play in an existing public sphere, which itself helps constitute the public character of art in public. That role is one of imaginatively disclosing matters of general concern and thereby bringing them to the attention of both informal and formal political publics. In accomplishing this, artists and their publics not only challenge the logics of money and power but also strengthen the fabric of civil society. For this to occur, however, the arts need a form of economic organization that keeps them relatively independent of both the economic system and the administrative state. To have room to disclose matters of general concern, the arts must participate in the social economy of a civic sector.

5

Civic Sector

The *purely* economic man is indeed close to being a social moron.

Amartya K. Sen[1]

The civic sector is the most admired and least studied area within national and international economies. Perhaps inattention helps explain the admiration, it being easier to praise what has not been analyzed or harder to theorize what one admires. On standard economic measurements, the nonprofit and nongovernmental organizations making up this sector are not insignificant. According to a report released in 2003, such organizations in thirty-five countries had $1.3 trillion in expenditures as of the late 1990s, a figure that would rank the civic sector in these countries as the seventh-largest national economy in the world. Their civic sector employed more than 39 million full-time-equivalent workers, 57 percent of them paid workers and 43 percent of them volunteers (in full-time-equivalent numbers). The report estimated that 190 million people volunteered in these countries alone, or approximately 221 volunteers per 1,000 members of the adult population.[2] An earlier report released

[1] Amartya K. Sen, "Rational Fools: A Critique of the Behavioral Foundations of Economic Theory," *Philosophy and Public Affairs* 6 (1977): 336.

[2] Lester M. Salamon, S. Wojciech Sokolowski, and Regina List, *Global Civil Society: An Overview* (Baltimore: Johns Hopkins University Institute for Policy Studies Center for Civil Society Studies, 2003), pp. 13–15. Part of the Johns Hopkins Comparative Nonprofit Sector Project, this report is available online at http://www.ccss.jhu.edu/pdfs/Books/BOOK_GCS_2003.pdf. The 35 countries covered by the report

in 1998 said that civic-sector organizations worldwide provided more aid than the World Bank and offered services in areas that many governmental agencies hesitate to enter.[3]

Unfortunately, mainstream economic theories do not adequately capture the reasons why such organizations exist and thrive. These theories also provide little guidance amid signs of turmoil across the entire sector in North America: allegations of overcompensation and fraud among leaders in higher education and philanthropy; proposals to remove exemptions and other tax benefits from religious and cultural organizations; debates about the appropriateness of "commercial" and "political" ventures by nonprofit agencies; conflicts in the United States about federal funding directed at "faith-based initiatives"; and attempts to turn over an increasing share of schooling, research, and health care to for-profit enterprises. These struggles feed on deep-seated and questionable assumptions about the identity and function of civic-sector organizations relative to business and government. In the absence of adequate understanding, responses to the turmoil tend to be myopic and destructive toward an area in society where organizations can imagine and pursue alternatives to "business as usual."

This chapter proposes an alternative account of what it calls "the civic sector." I summarize and criticize three mainstream economic theories, all of them predicated on the notion of market failure; explore normative concerns affecting the economics of organizations in the civic sector; and examine the civic sector's social economy. My aim is to generate a normative and critical theory that supports enlightened public policies and transformational economic strategies for the civic sector. The theory would encompass a wide array of nonprofit and nongovernmental organizations in areas ranging from education and research, arts and culture, and advocacy and legal services to health care, religion, social services, and international assistance. But I explore only a few implications specific to arts organizations and government arts funding.

include "16 advanced, industrial countries in North America, Western Europe, and Asia; 14 developing countries in Latin America, Africa, the Middle East and South Asia; and five transitional countries of Central and Eastern Europe" (p. 4). The United States and Mexico are included, but Canada is not.
3 Lester M. Salamon and Helmut K. Anheier, *The Emerging Sector Revisited: A Summary* (Baltimore: Johns Hopkins University Press, 1999).

First, however, a word about terminology. Various writers have pointed out the lack of an adequate label for the complex area I have in mind.[4] Each of the most common labels – voluntary, philanthropic, independent, nonprofit, or third sector – has limitations. "Voluntary" has connotations that obscure the sector's economic character and, with its links to the notion of volunteering, seems to slight professional management and paid labor. "Philanthropic" is inappropriate for religious, educational, and health care organizations that loom large in this sector. "Independent," "nonprofit," and "third sector" all inappropriately derive an identity from relationships to government or business. "Independent," the positive and inclusive term adopted by Independent Sector, an American umbrella organization founded in 1980, misses the sector's interdependence with other sectors[5] and the partnerships that exist between nonprofit organizations and government[6] or business.[7] "Nonprofit" contrasts the sector with for-profit enterprise in terms of tax exemptions. This label suggests that legal status is the key to organizational identity. It also tends to overlook mutual benefit organizations such as collectives and cooperatives that, although nonproprietary, enjoy a different legal status.[8] Finally, the term "third sector" connotes lesser status and later origins than business and government, whereas historically this sector could be considered a matrix from which both the market economy and welfare state emerge.[9]

Dissatisfied with the common labels, I use the term "civic sector" where others speak of the nonprofit or independent sector. "Civic

[4] See, for example, Jon Van Til, *Mapping the Third Sector: Voluntarism in a Changing Social Economy* (Washington, D.C.: Foundation Center, 1988), pp. 5–6, and Virginia Ann Hodgkinson, "Key Challenges Facing the Nonprofit Sector," in *The Future of the Nonprofit Sector: Challenges, Changes, and Policy Considerations*, ed. Virginia Ann Hodgkinson et al. (San Francisco: Jossey-Bass, 1989), pp. 4–8.

[5] Peter Dobkin Hall, "A Historical Overview of the Private Nonprofit Sector," in *The Nonprofit Sector: A Research Handbook*, ed. Walter W. Powell (New Haven: Yale University Press, 1987), pp. 3–26.

[6] Lester M. Salamon, *Partners in Public Service: Government-Nonprofit Relations in the Modern Welfare State* (Baltimore: Johns Hopkins University Press, 1995).

[7] Van Til, *Mapping the Third Sector*, pp. 151–63.

[8] See the useful survey of mutual benefit organizations in chapter 10 of Michael O'Neill, *The Third America: The Emergence of the Nonprofit Sector in the United States* (San Francisco: Jossey-Bass, 1989), pp. 156–68.

[9] Hodgkinson, "Key Challenges," p. 4.

sector" indicates an economic zone of nonprofit, mutual benefit, and nongovernmental organizations. It is the primary way in which economic differentiation and integration occur among civil society, the proprietary economy, and the administrative state. Conversely, civil society has an economic dimension whose primary articulation occurs in the civic sector. Although many organizations in the civic sector are incorporated as nonprofits, and although the sector as a whole is, in some sense, independent from government and proprietary businesses, I do not take either nonprofit status or sectoral independence to be definitive, for reasons indicated in due course. "Civic sector" also has the potential to be more precise than either "civil society sector" (Lester Salamon) or "civil sector" (Jeremy Rifkin). Whereas terms using "civil" tend to expand to include *all* of civil society, my term tries to pick out the economic dimension of civil society, which has other dimensions as well.[10] I do occasionally use the synonym "third sector," but only for convenience and variety, and not out of any conviction about the sector's derivative status and origins. The relative merits of my proposed term should become apparent by the end of this chapter. Because the most precise and influential economic theories of the sector concentrate on nonprofit organizations, the next section adopts a similar focus.

5.1 FAILURE THEORIES

Mainstream economists regard the civic sector as a response to systemic failures in other sectors of the economy. To be more precise, the most prominent economic theories in North America postulate either a response to unavoidable failure in the proprietary market to provide certain goods and services or a response to government's failure to respond adequately to market failure. Before discussing a few theories, let me clarify their scope.

The dominant economic theories restrict themselves to explaining nonprofit organizations, and they do so with a view to questions of public policy involving taxation, grants, and government regulations.

[10] For uses of the term "civil society sector," see Lester M. Salamon and Helmut K. Anheier, *Defining the Nonprofit Sector: A Cross-National Analysis* (Manchester: Manchester University Press, 1997). The term "civil sector" occurs in Jeremy Rifkin, *The End of Work: The Decline of the Global Labor Force and the Dawn of the Post-Market Era* (New York: G. P. Putnam's Sons, 1995).

As Henry Hansmann indicates in his influential survey article,[11] such theories concern either the role of nonprofits or their behavior. I limit my attention to theories that seek to explain the role of non-profits: why such organizations exist in societies that have a capitalist economy, what economic functions they perform, and why they occur in differing proportions within various industries. Although there are debates as to what distinguishes a genuine nonprofit, and although I disagree with Hansmann's conclusions, I use his characterization of all such organizations by the "nondistribution constraint": "[T] hey are subject, by the laws of the state in which they were formed, to a constraint... that prohibits the distribution of residual earnings to individuals who exercise control over the firm, such as officers, directors, or members." While not prohibited from earning profits, nonprofit organizations must "devote any surplus to financing future services or distribute it to noncontrolling persons."[12]

Government Failure

The first general economic theory of the role of nonprofits is the gov-ernment failure theory proposed by Burton Weisbrod in the 1970s and consolidated in the 1980s.[13] Postulating a three-sector economy (pri-vate, public, and voluntary), Weisbrod describes voluntary nonprofit organizations as institutional hybrids combining features of both for-profit and governmental institutions. The private sector delivers private goods in order to generate private profit; the public or govern-mental sector provides collective goods "for which the private sector is an unsatisfactory production vehicle"; and nonprofit organizations

[11] Henry Hansmann, "Economic Theories of Nonprofit Organization," in Powell, *The Nonprofit Sector*, pp. 27–42.
[12] Ibid., p. 28.
[13] Burton A. Weisbrod, *The Nonprofit Economy* (Cambridge, Mass.: Harvard University Press, 1988). Weisbrod's initial statement of his "institutional choice theory" is "Toward a Theory of the Voluntary Non-Profit Sector in a Three-Sector Economy," in *Altruism, Morality, and Economic Theory*, ed. Edmund S. Phelps (New York: Russell Sage Foundation, 1975), pp. 171–95. A revised version appears as chapter 3 in Weisbrod's *The Voluntary Nonprofit Sector: An Economic Analysis* (Lexington, Mass.: Lexington Books, 1977), pp. 51–76, and is reprinted in *The Economics of Nonprofit Institutions: Studies in Structure and Policy*, ed. Susan Rose-Ackerman (New York: Oxford University Press, 1986), pp. 21–44; citations of the essay are from the Rose-Ackerman anthology.

provide "public-type" or "collective" consumption goods that the first two sectors will not make available, despite consumer demands. Weisbrod defines collective goods as "goods that enter, positively, the utility functions of more than one person simultaneously."[14] Because this definition implies the "non-rivalry" and "non-excludability" conditions that characterize what other economists label "public goods" (see Chapter 2), my summary often substitutes "public goods" for Weisbrod's "collective goods."

Weisbrod's leading question is why certain collective or public goods are provided by hybrid institutions that, like private firms, are independent and unable to levy taxes, but, like government, are subject to the nondistribution constraint, and, moreover, often receive tax subsidies (tax-deductible donations, tax exemptions, special postal rates, and the like). His answer postulates a form of government failure for which the private sector cannot compensate.

Weisbrod's answer has three steps leading to a conclusion about the economic role of nonprofit organizations. First, democratically elected governments tend to satisfy demands for public goods only to the extent that this is compatible with "the demands of the median voter."[15] Hence, there will be quantities and qualities of public goods for which demand exists among voters and taxpayers, but the demand is insufficient for the government to satisfy it. Second, the likelihood of undersatisfied demand increases with the diversity in a population, because class, religious, ethnic, educational, and other diversity leads to greater heterogeneity in the public goods demanded. Much of it will remain unfulfilled by government, particularly in countries whose populations are as diverse as those of the United States and Canada. This leaves two possible suppliers: the for-profit market, whose failure to provide public goods gives rise to government provision in the first place, and the nonprofit market. Third, although the proprietary market can offer "private-good substitutes" (such as air filters and purifiers) for collective consumption goods (such as the provision of clean air), these substitutes are never perfect and often are expensive or "socially inefficient."[16] The private market cannot meet all of the undersatisfied demand for public goods.

[14] Weisbrod, "Toward a Theory," pp. 21–2.
[15] Ibid., p. 23.
[16] Ibid., pp. 28–9.

Weisbrod concludes that the primary role of nonprofit organizations is to provide those public goods which government cannot deliver, because of political constraints, and for which the private sector can provide only inadequate substitutes, despite consumer demand. Nonprofit organizations are *"extragovernmental providers of collective-consumption goods.* These organizations will 'supplement' the *public* provision ... and provide an alternative to the *private*-sector provision of the private-good substitutes for collective goods."[17]

Other economists have criticized Weisbrod's government failure theory for failing to explain the role played by those nonprofits, such as day care centers and nursing homes, whose services are not public goods; what permits nonprofits "to serve as private suppliers of public goods when proprietary firms cannot or will not";[18] and why donations are made to nonprofit organizations, a question particularly troublesome for mainstream economics because of the "free-rider" problem.[19]

Contract Failure

The perceived limitations of government failure theories are addressed by contract failure theories, the most influential of which has come from Henry Hansmann. In "The Role of Nonprofit Enterprise," a seminal essay published in 1980,[20] Hansmann argues

[17] Ibid., p. 30. Weisbrod gives the following succinct statement of his theory in the entry on "Non-profit Organizations," *The New Palgrave: A Dictionary of Economics*, vol. 3, ed. John Eatwell et al. (New York: Stockton Press, 1987), pp. 677–8: "For the 'undersatisfied' demanders of collective goods, the failure of government to correct the private market failures gives rise to the search for other institutions to meet their demands. Thus, diversity of demand for public-type activities appears to constitute the driving force behind the demand for non-profit sector activity."

[18] Hansmann, "Economic Theories," p. 29.

[19] Rose-Ackerman, introduction to *The Economics of Nonprofit Institutions*, p. 5. This question is taken up by Jeffrey H. Weiss, "Donations: Can They Reduce a Donor's Welfare?" in the same collection, pp. 45–54. Briefly, according to rational choice theory, the free-rider problem is this. In the absence of unusually strong incentives or coercive force, many people will not pay for collective goods from which they derive no exclusive benefit – they will rather take a free ride and let others pay. Why, then, do some people make donations to nonprofit organizations?

[20] Henry Hansmann, "The Role of Nonprofit Enterprise," *Yale Law Journal* 89 (1980): 835–901. I cite the revised version in Rose-Ackerman, *The Economics of Nonprofit Institutions*, pp. 57–84. This article is incorporated into Hansmann's "Economic Theories of Nonprofit Organization" (1987) as well. Among his many other articles on related topics, the following has particular relevance to the

that the expectation of contract failure is the most important factor
making certain tasks more suitable to nonprofit than to for-profit
organizations. When people find it difficult to measure the quantity
or quality of the contracted goods or services and to enforce future
contracts, they turn to nonprofit organizations, expecting that,
because of the nondistribution constraint, nonprofit organizations
will not sacrifice quality for private profit. For-profit firms, by con-
trast, have both incentive and opportunity to exploit their customers'
ignorance and weakness by providing less than was promised and
purchased. Theoretically, then, if not historically, nonprofits arise in
response to contract failures in the proprietary sector, provided the
value of the customers' expected protection outweighs the economic
disadvantages of the nonprofit form.[21]

Hansmann says that his theory helps explain why charitable ser-
vices are typically provided by nonprofit organizations. We do not
normally turn to for-profit firms to send relief aid overseas, for exam-
ple, because the purchasers of services (donors) and the recipients
(people in need) have little direct connection. The nonprofit form
of organization provides assurance that providers perform their
services adequately even though the purchaser of services cannot
directly monitor performance.[22] So too the theory of contract fail-
ure helps explain why public goods are more commonly produced by
nonprofit than by for-profit organizations. The reason is not simply,
as many economists think, because "the private market is an ineffi-
cient means of providing public goods," but rather because contract
failure "is likely to be a problem if consumers seek to purchase public
goods from profit-seeking producers."[23] Hansmann gives the exam-
ple of listener-supported radio stations that provide independent and

arts: "Nonprofit Enterprise in the Performing Arts," *Bell Journal of Economics* 12
(1981): 341–61; reprinted in *Nonprofit Enterprise in the Arts: Studies in Mission and
Constraint*, ed. Paul J. DiMaggio (New York: Oxford University Press, 1986), pp.
17–40.
[21] Hansmann discusses three such disadvantages: limited access to capital, fewer
incentives for efficient management, and less responsiveness to changes in demand
for products and services ("The Role of Nonprofit Enterprise," pp. 78–80). I have
omitted "cross-subsidization" from this list because Hansmann does not clearly
establish it as a liability. Other authors have argued that cross-subsidization is in
fact a strength of nonprofit organizations.
[22] Ibid., pp. 63–4.
[23] Ibid., p. 65.

commercial-free programming. If a for-profit station tried to solicit listeners' donations, what assurance would they have that their voluntary contributions subsidize the services they receive and do not simply line the pockets of the station's owners?[24] The nonprofit form of organization partially ensures a connection between the amount contributed and the quality of the station's broadcasts.[25]

Although this approach fills some of the explanatory gaps in government failure theories, it has its own limitations. Estelle James identifies two.[26] First, contract failure theories such as Hansmann's overestimate the trustworthiness of nonprofit organizations and overlook the incentives they have to downgrade the quality of services and to divert donations from intended purposes. Not only can managers of such organizations funnel income into "high wages, expense accounts, and plush working conditions" but they also can use cross-subsidization to earn a profit. As James explains in a separate essay, nonprofit organizations typically undertake a variety of activities, some of which their managers (members, staff, and board) more strongly prefer. Often when the more strongly preferred activities do not cover their own costs, managers use other profit-making activities to cover the deficit.

[24] It would be instructive to test Hansmann's theory of contract failure in the case of a radio station such as Toronto's JAZZ.FM91, whose Web site (http://www.jazz.fm/content/blogcategory/57/131/) describes it as "Canada's only not-for-profit radio station dedicated to jazz and all its communities of interest." Originally known as CJRT (the radio station of Ryerson Institute of Technology, now Ryerson University), it began broadcasting four minutes of advertising per hour after neoconservative government cutbacks in 1996 "reduced its annual operating stipend from $1,300,000 to zero." Yet it still solicits individual donations for about half of its annual revenues as well as "donations from corporations, businesses and foundations." This story is not unique. Although other "listener-supported" radio stations affected by reductions in government funding in Canada and the United States may not resort to commercial advertising, the line between corporate program sponsorship and outright advertising has become increasingly blurred, sometimes to the point of disappearing altogether.

[25] Hansmann's subsequent remarks on price discrimination in the high-culture performing arts and on implicit loans in private education shed additional light on the suitability of nonprofit institutions for providing public goods. See "The Role of Nonprofit Enterprise," pp. 69–70. His "Economic Theories of Nonprofit Organization," p. 30, describes Weisbrod's government failure theory, with its focus on public goods, as "a special case of the contract failure theory." It also points out that government donations (grants or subsidies) to nonprofits often respond to the same issues of contract failure that confront individual donations.

[26] Sharon Oster and Estelle James, "Comments," in Rose-Ackerman, *The Economics of Nonprofit Institutions*, pp. 152–8; James's comments occur on pp. 154–8.

Thus, for example, art museums run gift shops and mount special
exhibitions to subsidize the establishing and curating of their collec-
tions. Because of such cross-subsidization, says James, nonprofit orga-
nizations have as much incentive as for-profit organizations have to
downgrade the quality of less-preferred activities and to divert dona-
tions toward another set of preferred goods. Such organizations seek
a form of profit, although it is not private profit.[27]

A second limitation of contract failure theories pertains to what
motivates nonprofits. Empirical research in various industrialized
and developing countries shows that religious groups and other
"ideological" groups establish many nonprofit organizations for the
purpose of promoting faith or gaining adherents. In many cases it
is not the expectation of contract failure but rather a stance of com-
mitment that explains the choice of the nonprofit rather than the
for-profit form of organization.[28]

James's two objections point up a need to supplement economic the-
ories with political and sociological perspectives. Not only do theories
of government failure and contract failure take for-profit enterprise as
their standard, thereby occluding the unique economic characteris-
tics of the civic sector, but they also tend to ignore factors that cannot
be captured in narrow rational-choice models of utility and consumer
preference, thereby misinterpreting the political and cultural fabric
of nonprofit organizations. As a result, such theories underestimate
the societal significance of the civic sector and overlook the interde-
pendence between government and nonprofit organizations.

Voluntary Failure

Political scientist Lester M. Salamon, who propounds a voluntary fail-
ure theory, has championed the scope and merit of interdependence.[29]

[27] See Estelle James, "How Nonprofits Grow: A Model," in Rose-Ackerman, *The
Economics of Nonprofit Institutions*, pp. 185–95. A longer version first appeared under
the same title in *Journal of Policy Analysis and Management* 3 (1983): 350–65.
[28] See in particular Estelle James, "The Nonprofit Sector in Comparative Perspective,"
in Powell, *The Nonprofit Sector*, pp. 397–415.
[29] Before becoming director of the Nonprofit Sector Project at the Urban Institute,
Salamon served as deputy associate director of the U.S. Office of Management and
Budget during the Carter administration. Many of his writings from the 1980s and
early 1990s are collected or incorporated into his book *Partners in Public Service*.

Salamon sees a direct correlation between the nonprofit sector's dramatic growth and the welfare state's rapid expansion in the United States between 1950 and the 1980s. Yet for a long time policy makers and scholars ignored this correlation. Salamon points to both political and theoretical reasons why. Politically, the Left did not want to weaken the case for expanded governmental services, while the Right did not want to undermine claims that expanded state activity threatens private initiative and voluntary service. Both sides shared a paradigm emphasizing "the inherent conflict" between government and nonprofits. Theoretically, prevailing conceptions of both the American welfare state and the nonprofit sector have emphasized "the ever expanding role of a hierarchic state administration," thereby becoming "increasingly out of touch" with how the federal government in the United States actually operates. These conceptions remain locked into a conventional European model of the welfare state that leaves little role for nonprofit organizations.[30]

By contrast, Salamon argues that the American federal government has not swallowed up social functions at the expense of other institutions. Rather, it has fostered a growing network of alliances among government, for-profit, and nonprofit bodies. Federal agencies increasingly depend on nonprofit organizations to carry out government policies and programs. So long as political theorists overlook this new system of "third-party government," they cannot do justice to the sizable role of nonprofit organizations in the implementation of government programs.[31] Similarly, economic theories of government failure and contract failure cannot acknowledge the exponential growth of the government-nonprofit partnership because they regard the third sector as substituting for the state in the provision of public goods. These theories suggest that the existing partnership "could not, and should not, exist."[32] The facts of the matter are quite different, however. On the one hand, in several fields of human service nonprofits "deliver a larger share of the services government finances than do government agencies themselves." On the other

Salamon currently serves as director of the Center for Civil Society Studies at the Johns Hopkins University.

[30] Ibid., pp. 1–2, 37–8.
[31] Ibid., pp. 2–6, 17–32.
[32] Ibid., p. 36.

hand, government now outdistances private donations and service fees as "the single most important source of nonprofit human service agency income." Indeed, government-nonprofit cooperation has become "the central financial fact of life of the country's... nonprofit sector."[33]

Neoconservative attempts to strengthen the proprietary and the nonprofit sectors by cutting domestic government programs seem particularly misguided in this regard. Salamon explains that the central problem with welfare-state theory in the American context is that it fails "to differentiate between government's role as a provider of funds and direction, and government's role as a deliverer of services." While the federal government has grown as a provider of funds and direction, increasingly it has turned elsewhere for the actual delivery of services, with the result that the federal government "shares a substantial degree of its discretion over the spending of public funds and the exercise of public authority with third-party implementers." Although this system of third-party government complicates public management and poses problems of accountability and control, it lessens the need for a huge state bureaucracy. It also accords well with the country's pluralistic political structure and promotes flexibility and efficiency in the provision of government-financed services.[34]

Salamon proposes an alternative theory to account for such facts and to portray partnership as "a reasonable model to be promoted and improved."[35] The theory hinges on the notion of "voluntary failure." Its core intuition is this: *government* is not the typical response

[33] Ibid., p. 34. This is also so on an international scale. In a comprehensive anthology published in 1989, Estelle James reports that private donations are small in many countries other than the United States, and most nonprofit income derives from government subsidies and fee financing. See Estelle James, ed., *The Nonprofit Sector in International Perspective: Studies in Comparative Culture and Policy* (New York: Oxford University Press, 1989). A more recent study, *The Emerging Sector Revisited* by Salamon and Anheier, indicated in 1998 that nonprofits and other nongovernmental organizations worldwide get 47 percent of their budgets from government contracts and agencies, 42 percent from fees, and 11 percent from philanthropy. According to the report *Global Civil Society* by Salamon et al. from 2003, in thirty-two countries on which revenue data were available in the late 1990s, civic-sector organizations received on average more than half of their income (53 percent) from fees, dues, and investments, with 35 percent coming from government contracts, grants, and reimbursement payments, and 12 percent from philanthropy.

[34] Salamon, *Partners in Public Service*, pp. 41–3.

[35] Ibid., p. 6.

to the proprietary market's failure to provide public goods, and non-profits are not derivative institutions filling in for either government failure or contract failure. Instead, *nonprofit organizations* are the primary response mechanism for market failure, and government is a derivative institution responding to the inherent limitations of the voluntary or nonprofit sector. Government programs arise in response to voluntary failure.

According to Salamon, voluntary failure can take four forms. "Philanthropic insufficiency" arises from the voluntary sector's inability to generate resources of sufficient scope and reliability to cope with the challenges of an advanced industrial society, whether because of the free-rider problem or because charitable dollars are unavailable when or where needed. "Philanthropic particularism" occurs because donors and nonprofits tend to focus on their own preferred subgroups, and some parts of the population find it hard to gain representation in existing nonprofits or to establish their own organizations. This can leave "serious gaps in coverage" and can create "wasteful duplication of services." "Philanthropic paternalism" stems from the fact that voluntarism allows those who command the most money, time, or education to have the most say in defining community needs, creating an undemocratic structure that generates dependency on one side and paternalism on the other. "Philanthropic amateurism" takes place when the addressing of social and cultural problems is left to well-meaning amateurs who substitute good intentions for knowledgeable solutions.[36]

Such voluntary failures not only necessitate government action but also justify government support of nonprofit organizations. Yet government should not step in too quickly, according to Salamon. Because the "transaction costs" are usually much higher when government responds,[37] the nonprofit sector "will typically provide the

[36] Ibid., pp. 45–8.
[37] Transaction costs are ones assigned to factors that are required to bring about an economic exchange but are not themselves the product or service being exchanged. Such costs can occur in production itself, between producers and consumers, or among consumers. Michael Krashinsky, "Transaction Costs and a Theory of the Nonprofit Organization," in Rose-Ackerman, *The Economics of Nonprofit Institutions*, pp. 114–32, argues that conventional discussions of market failure assume transaction costs among factors of production to be usual but consider other transaction costs to be unusual. This leads such theories to regard for-profit firms as normal, because such firms arise to reduce production costs,

first line of response to perceived 'market failures,' and ... government will be called on only as the voluntary response proves insufficient."[38] On this model, government supplements rather than replaces non-profit action. In fact, the respective strengths and weaknesses of the voluntary sector and government are so highly complementary that collaboration between the two makes perfect sense.[39]

Although the voluntary failure theory accords greater societal significance to the civic sector than do the economic theories of Weisbrod and Hansmann, Salamon shares their fundamental assumption that the role of nonprofit organizations is to compensate for market failure. He simply switches the positions of government and nonprofit organizations. Whereas Weisbrod and Hansmann give government the primary role of compensating for the failure of for-profit firms to provide public goods of adequate quantity and quality, Salamon gives this primary role to nonprofits. Diagrammatically, he changes the order, from proprietary failure → government response and failure → nonprofit response, to proprietary failure → nonprofit response and failure → government response.

Despite this shift, all three mainstream failure theories assume the factual and normative primacy of the proprietary market. To my mind this is a fatal flaw. It leads them to treat nonprofit organizations as derivative institutions whose economic role is to compensate for failures by government or for-profit firms. It is possible, perhaps, to subscribe to a form of market failure theory without giving normative priority to the proprietary market. Instead of thinking that the proprietary market *should* provide "public goods" and "sociocultural goods" but sometimes fails to do so, one could think that in principle

but to regard nonprofit institutions as unusual and in need of special treatment, because they arise to overcome other kinds of transaction costs. Krashinsky rejects the conventional approach and thereby challenges theories of government failure and contract failure.

[38] Salamon, *Partners in Public Service*, p. 44.
[39] Ibid., pp. 48–9. It should be noted that in speaking of the voluntary sector Salamon has in mind "public-benefit organizations that exist primarily to serve others, to provide goods or services ... to those in need or otherwise to contribute to the general welfare" – educational and cultural organizations, social welfare agencies, health care providers, and the like (p. 54). Excluded or less emphasized are funding agencies, member-serving organizations, advocacy groups, and religious institutions.

the proprietary market should *not* provide such goods and when it tries, it will fail, having overstepped its proper role.[40] So far as I can tell, however, none of the failure theories I have discussed places such normative constraints on the proprietary market. All of them end up giving compensatory roles to nonprofit organizations and, by extension, to all civic-sector organizations. Not only does this approach misinterpret the principles underlying the civic sector, but it also ignores the normative priority of public justice for establishing the economic role of the state.

What is needed instead is an account of civic-sector organizations that explains their economy in terms of their normative concerns, rather than one that explains their normative concerns in terms of their (misunderstood) economy. While I do not attempt a complete account, which would require expertise in economics that I do not have, I wish to lay foundations for such an account by examining normative self-understandings among civic-sector organizations and the implications of these self-understandings both for the economy of the civic sector in general and for arts organizations in particular.

5.2 CIVIC-SECTOR ORGANIZATIONS

Under the external pressures of hypercommercialization and performance fetishism, which I describe in the next chapter, and in response to internal tendencies toward organizational independence and staff professionalism, many civic-sector organizations explicitly seek to remain "mission driven" in a not-for-profit manner. The fact that this explicit aspiration has become commonplace in the civic sector indicates both the increasing reflexivity of the entire sector and a heightened awareness that many factors threaten to divert such organizations from the purposes for which they are established. In general, there are two primary ways in which contemporary civic-sector organizations can fail to remain mission driven: either through adopting pervasive "bottom-line" strategies imported from the efficiency-driven proprietary sector or through embracing a bureaucratic administrative logic that resembles power-driven processes in

[40] I am indebted to Michael DeMoor for suggesting the possibility of such a normative recasting of market failure theories.

the governmental sector. By contrast, a truly mission-driven organization in the civic sector will keep strategies, procedures, policies, and implementations of policy attuned to the substantive purposes and communicative processes that characterize organizations in this sector and their economic role in society.

By "mission," civic-sector organizations mean something different from that of for-profit firms, which also adopt "mission statements" and try to be mission driven. Philosophically, to be mission driven in the civic sector has at least three implications.

1. Providing services or advancing a social cause is central to the life of the organization, and "profit making" remains subordinate to service-provision or social advocacy (I label this a pursuit of social goods in which sociality has normative priority).
2. The organization's resources, including labor, are shared rather than hoarded and are held in trust for others, including future generations.
3. The organization's communicative capacities do not become mere means for its self-promotion and self-preservation but foster the pursuit of social goods and the sharing of resources.

Although nothing prevents proprietary businesses and democratically elected governments from upholding and highlighting sociality, resource sharing, and open communication, the overriding considerations of turning a monetary profit or pursuing enforceable public justice typically make such considerations subservient to the distinctive logics of the proprietary and governmental sectors of the economy. The three implications of being mission driven in the civic sector all point toward solidarity as the primary societal principle for civic-sector economics. Let me elaborate each implication in turn.

Sociality

Henry Hansmann argues that people turn to nonprofit organizations when it is hard to measure the quantity or quality of the products or services for which people contract. They turn to nonprofit organizations because the nondistribution constraint guarantees that such organizations will not sacrifice quality for private profit. Hansmann's argument is only partially correct. As Estelle James objects, the

nondistribution constraint by itself does not prevent attempts to downgrade the quality of services or to undertake cross-subsidizing activities that yield a form of profit. There is no legal or economic guarantee that civic-sector organizations will make the provision of suitable products and services central to their existence.

Yet there *is* a strong cultural expectation, rooted in the history of the civic sector, that the raison d'être of such organizations is to provide socially significant products and services of collective benefit. This is so across the board, regardless of whether the products and services provided are medical, educational, artistic, scholarly, environmental, legal, political, or religious, and even when proprietary or governmental alternatives exist. When such alternatives exist, it quickly becomes apparent that for-profit firms provide health care, entertainment, and the like primarily as a means to reap a monetary reward, despite, and even by way of, glowing language about being mission-driven service-providers. Similarly, government-provided services quickly become means to secure and allocate administrative power in areas and for causes singled out for public attention through the political process.

This is not to deny that the products and services provided by proprietary firms and government agencies often reach levels of quality and quantity or attain important purposes for which civic-sector organizations are inadequate. The point is simply that when civic-sector organizations properly fulfill their missions, they make the pursuit of social goods primary, and not the pursuit of monetary rewards or administrative power. While not a guarantee that this will occur, the nondistribution constraint is a legal codification of the civic sector's self-understanding. It provides some recourse in situations where nonprofit organizations flagrantly abuse the public trust that they will not place money or power above sociality in the pursuit of social goods. Such abuse occurs when the directors or staff members of a civic-sector organization use its activities simply to fatten their own wallets or to increase their own clout.

It is so, of course, that cooperatives, nonprofits, and community-based organizations are businesses. But they are not only businesses, and they are not primarily businesses. There is an obvious sense in which a food cooperative resembles a grocery store, a "private" school resembles a commercial training center, and a "public"

museum resembles Disneyworld. In each case, similar products and services are provided, and the organization must generate sufficient revenues, exercise fiscal oversight, and attract the right kind and the right number of "customers." But members of a food cooperative, students at a school, and those who visit a museum are not simply customers. These organizations would undermine their own credibility if they were to reduce themselves simply to being "in the business" of satisfying consumers' demands. To the extent that such organizations are businesses, they are unusual businesses, and this has an effect on internal economic functions such as budgeting and revenue generation.

Budgeting provides a crucial indicator of the extent to which civic-sector organizations give primacy to sociality over money and power. There are three ways in which inappropriate budgeting can lessen an organization's ability to be mission driven. First, if the process of making and implementing decisions about the budget is not sufficiently transparent to the organization's members and supporters, organizational priorities can take root that do not accord with a shared understanding of the organization's mission. Second, if the process does not take account of efforts and achievements that are not easily quantified, the budget can easily be skewed in favor of those programs and positions that stand out as sources of short-term revenue, even if such sources are not priorities for accomplishing an organization's mission in the long run. Third, if an organization treats its budget as merely a neutral tool for accounting purposes, the budget's fixed assumptions can begin to replace the organization's mission as a touchstone for daily operations. Rigidly controlled, narrowly focused, and decontextualized budgets might well be predictive of weakness in the mission-driven character of civic-sector organizations, even when these deficiencies do not show up in a standard financial audit. Although such organizations might seem to thrive when judged by market criteria of efficiency and productivity, they have in fact begun to lose sight of their primary purposes.

The normative primacy of sociality means that the organization's mission should never become a means to some other end and that its strategies and policies ought to further that mission. To give a public account of why it exists, or to defend or promote some program or activity, a civic-sector organization must be able to point to

its mission. If the organization's supporters no longer deem the mission to be worthwhile, or if the organization is no longer thought to be pursuing that mission, then the organization has little reason to exist, even though it might survive many years beyond the demise of its mission or its legitimacy. Similarly, internal decisions and actions must be capable of justification with reference to the organization's mission. Attempts to avoid such justification, or to pursue approaches that most staff and board members can see to be at odds with the mission, weaken the organization and undermine the credibility of the persons responsible. This is so despite any short-term success the course of action may enjoy in an instrumental or strategic sense.

Resource Sharing

Lester M. Salamon views nonprofit organizations as the first line of response to failure by the proprietary market to provide public goods. Government steps in, he says, where, for lack of resources, accessibility, or expertise, the civic sector itself fails to provide such goods in sufficient amount and quality. Although this perspective accords greater societal significance to the civic sector than do government-failure and contract-failure theories, it misinterprets a fundamental principle of the civic sector. If, taking a cue from Habermas, we consider solidarity to be the primary societal principle governing civil society and the public sphere, then we can regard the civic sector as the way solidarity gets institutionalized in civil society's economic dimension. Whereas the dominant economic system allows the integrating resource of money to flow constantly toward the private profit of those who control the market, the civic sector brings a different principle to bear on the resource of money. This principle, which helps constitute the civic sector's social economy, is the imperative to share resources without assurance of private gain.

In that sense we should not regard nonprofits and other civic-sector organizations as responses to market failures, as if such organizations would not be necessary were the proprietary economy less flawed. Rather, they are responses to a different set of needs from those which a for-profit economy satisfies in the first instance: not the needs of self-preservation or personal gratification or private wealth, but the need to care for others, to participate in a common project, to

advocate for social change, and to give away what has been received. So too, we should not consider government programs supporting the arts, health care, social welfare, and the like to be responses to failures on the part of civic-sector organizations, as if the two sectors were simply pragmatic responses to the same problems. Considered normatively, government programs should not be substitutes for inadequate generosity any more than they should be ways to guarantee private profit for the captains of capitalism. Rather, they should secure public justice and general well-being, particularly for the marginalized or oppressed. Partnerships between government agencies and nonprofit organizations do not spread the same work across two sectors. Rather, they allow two different kinds of efforts to address concerns perceived to have social significance.

Obviously, the sharing of resources *can* be interpreted as a mere means to self-interested ends: companies sponsor nonprofit events to burnish their own image and reputation; wealthy individuals give away their money in order to secure their own fame and the good name of their heirs and partners; donations function as a way to get rid of excess wealth and unwanted goods in return for sizable tax breaks; and people become dues-paying members of nonprofit organizations to receive certain perks and privileges. None of these observations is completely inaccurate. Yet whatever explanatory power they seem to have stems from a dubious assumption that all economic interactions, no matter where they occur, aim primarily or exclusively at the maximization of utility. To the extent that economists, politicians, and civic-sector leaders buy into that assumption, it becomes a self-fulfilling prophecy.

What such observations fail to explain, however, is why people bother with civic-sector organizations when there are simpler ways to acquire the "utilities" in question. They do so because many people genuinely subscribe to the principle of sharing resources, out of a commitment, vague though it might be, to solidarity with people beyond one's own narrow circle of acquaintances. It is because of this widespread principle and commitment that the sharing of resources can also have a "public relations value," enhance personal reputations, or strengthen social standing. If these secondary effects not only became the donor's primary objective but also became recognized as such by the recipient, they would swiftly lose their force. The

situation would resemble what happens to the speech act of promising when the promisor utters the words not in order to promise something but in order to get something else, and the promisee knows this. No promise is actually made, despite the words "I promise" being uttered. Because no promise occurs, the likelihood of achieving the desired perlocutionary effect also diminishes.

Support for civic-sector organizations arises from convictions about the importance of their substantive purposes and confidence about their ability to achieve these purposes. People who support such organizations, whether as donors or as members or as volunteers, believe both that these organizations are doing worthwhile work and that the resource sharing they enact is socially significant. Similarly, board members and staff members, who have primary responsibility for governance and daily operations, typically view their efforts as ways to achieve socially significant goals. When board membership becomes no more than a resume enhancer, and when staff efforts become no more than a job or a career, people lose sight of the organization's mission, and their dedication to "the cause" falters. One danger accompanying greater independence and professionalism in the civic sector is that, because of how the proprietary sector defines success, boards and staffs will adopt purely instrumental stances toward their own participation in civic-sector organizations.

Open Communication

To be mission driven in the civic sector also means that the communicative capacities of a civic-sector organization do not become mere survival mechanisms. This implication is missed by Burton Weisbrod's government failure theory, which regards nonprofit organizations as "extragovernmental providers of collective consumption goods." According to such a theory, how communication happens does not seem to matter, so long as the organization maintains its ability to deliver the goods. Contrary to this instrumentalist view, however, it is crucial to the existence of civic-sector organizations, and to the self-understanding of their participants, to remember that such organizations arise when certain people commit themselves to promoting a set of social goods by providing specific products and services on the basis of shared resources. Such organizations are voluntary in a way

that governments and families and proprietary businesses are not. But this does not mean that civic-sector organizations are contractual, as if they were formed and sustained by unattached individuals seeking only their own private benefit. Rather, they arise from inter-subjective efforts structured around shared commitments, and they require dedicated cooperation from members, staff, and supporters to achieve their missions. Such cooperation cannot be sustained in the absence of open communication.[41]

Internally, open communication requires that everyone within the organization whose participation could be affected by a decision or policy or strategy has adequate opportunity to know about its formation, to discuss its implications, and to challenge its rationale. In addition, those who implement a decision should have some say about the decision itself. Although consensus need not be achieved on every decision, policy, or strategy, governance and administration must continually orient themselves to the actual understandings and commitments of the organization's members toward its mission. Top-down modes of governance and administration are less likely to achieve such orientation than are more horizontal or circular modes.

Externally, open communication requires that the organization deliver its social goods and share its resources in ways that encourage evaluation and public accountability. Damage control or image building or organizational self-promotion should not be the dominant mode of communication. Clients, supporters, and the public should have ready access to information about the organization's internal operations; they should be able to expect that legitimate concerns and grievances will be heard and receive a proper response; and the organization should encourage them to assure themselves that the organization is indeed pursuing its stated mission.

This aspect of organizational life needs emphasis, given the explosion of marketing and public relations within the third sector and the concomitant tendency to import first-sector rules along with

[41] Jon Van Til's *Mapping the Third Sector* hints at the need for open communication when it describes voluntarism as the underlying principle of the social economy that civic-sector organizations ought to promote. Because of his communitarian emphasis on building habits of the heart, however, Van Til does not pursue the normative implications of voluntarism for the type of communication that should characterize the life of such organizations and their relations to supporters and the public.

sales techniques and strategies. Civic-sector organizations are under intense pressure to bend their communicative capacities to strategies of advertising, marketing, and public relations whose primary objective is to promote and preserve the organization itself. While such strategies are necessary if people are to hear about the worthy work the organization accomplishes and to learn why the organization deserves their support, openness suffers when communication subserves these strategies rather than these strategies themselves submitting to tests for open communication. Internally, promotional strategies should be subject to the same participatory scrutiny as all other strategies receive. Externally, promotional pitches should not drown out other modes of communication or be wrapped in an aura of inherently untestable claims.

Contrary to mainstream economic theories, then, the mission-driven character of civic-sector organizations suggests the following:

1. They are considered dependable sources of social goods not simply because of the "nondistribution constraint" but because of a cultural expectation that sociality in the pursuit of social goods has normative priority.
2. They can be worthy partners for government programs not simply because the government has power to step in where civic-sector organizations fall short but because these organizations embody commitments to solidarity that complement the government's task of securing public justice and general well-being.
3. They can be effective providers of socially significant advocacy and service not simply because they have fewer worries about what is politically feasible or economically efficient but because they operate on principles of open communication.

5.3 SOCIAL ECONOMY

These normative perspectives suggest that civic-sector organizations are not designed to do "business as usual." Given the bias in capitalist societies and among many economists that maximizing private profit is the most legitimate or viable way to do business, such normative perspectives can seem hopelessly "idealistic" or "old-fashioned." Every attempt to counter this bias by demonstrating the "success" of worker

or consumer cooperatives, community-based organizations, and various nonprofits simply confirms the bias, so long as the criteria for success come from the proprietary sector. A more fruitful approach is to explore normative implications for civic-sector economics. Here the concept of a social economy becomes crucial. Let me explore this concept with two concerns in mind: the intersections of the civic sector with the proprietary economy and with the political economy of the governmental sector, and the societal role of the civic sector's social economy.

Initially the concept of a "social economy" is as puzzling as it is provocative. It is puzzling because it weds two perspectives that mainstream economists prefer to keep separate: the supposedly factual notion of an "economy," understood by many economists as a system for the efficient maximization of utilities by discrete individuals; and the normative notion of "solidarity," with its connotations of sociability and inclusion. The wedding of two perspectives also makes the concept of a social economy provocative. It not only challenges the standard distinction between "fact" and "value" or "norm" but also suggests that not all of economic life either is or needs to be organized to maximize private profit.

Among writers on the civic sector, two have given prominence to the concept of a social economy: urban sociologist Jon Van Til and policy analyst Jeremy Rifkin. Both Van Til and Rifkin trace the concept back to publications in the 1980s by the French economist Thierry Jeantet.[42] Jeantet sees the social economy as having four institutional components: associations, mutual aid societies, cooperatives, and informal groups. And across these components, it has six characteristics: voluntary membership, democratic administration, not-for-profit organization, solidaristic impetus, and emphases on quality and individual empowerment. The social economy fuses "the Economy with the Social," Jeantet explains: "It isn't properly measured the way one measures capitalism, in terms of salaries, revenues, etc., but its outputs integrate social results with indirect economic gains,

[42] Van Til also mentions a book published by Severyn Bruyn in 1977. See Severyn Ten Haut Bruyn, *The Social Economy: People Transforming Modern Business* (New York: Wiley, 1977); also, Bruyn's more recent *A Civil Economy: Transforming the Marketplace in the Twenty-first Century* (Ann Arbor: University of Michigan Press, 2000).

for example the number of handicapped persons cared for well at home and not in hospitals, the degree of solidarity between persons of different age groups in a neighborhood....The Social Economy is best understood in terms of results that add considerably to what traditional economics does not know how to or want to measure."[43]

Van Til and Rifkin take this shared concept in two different directions. Van Til views the social economy as a set of values. These values are to be pursued via "social entrepreneurship" in a "third space" where, through voluntary action, individuals come together "to address issues of significant personal, community, and social concern" and "improve the world as a result of that dialogue."[44] Rifkin, by contrast, sees the social economy as a source of "social capital." This social capital gets generated in a "third sector," and it can offset losses in employment and social services due to both the impact of new information technologies in the "market sector" and a withdrawal from welfare-provision in the "government sector."[45] A summary of their perspectives on the social economy will provide a context for my own account.

Social Entrepreneurs

In *Growing Civil Society* Jon Van Til argues for a shift in emphasis from a "third sector" to a "third space." The notion of a third sector calls attention to the differences among society's major institutions. Initially Van Til groups these institutions into four *sectors*: government; economy; nonprofit and voluntary organizations; and the "'informal' sector of family, kin, neighborhood, and community."[46] Later he reorganizes this categorization into three *spaces*: a first space as "the private sphere of family, kin, and neighborhood"; a second space "occupied by the large-scale structures of governmental, corporate, and many large nonprofit organizations"; and a third space where smaller nonprofit organizations and voluntary associations are at home.[47]

[43] Thierry Jeantet, translated and quoted in Van Til, *Mapping the Third Sector*, p. 101; quoted from Van Til by Jeremy Rifkin, *The End of Work*, p. 242; requoted in part by Jon Van Til, *Growing Civil Society: From Nonprofit Sector to Third Space* (Bloomington: Indiana University Press, 2000), pp. 12–13.

[44] Van Til, *Growing Civil Society*, p. 209.

[45] Rifkin, *The End of Work*, especially pp. 294–5.

[46] Van Til, *Growing Civil Society*, p. xi.

[47] Ibid., pp. 207–9.

Third Space

Van Til has two reasons for moving from an analysis of "sectors" to a conception of "spaces." The first is that an emphasis on sectors usually fails to recognize significant interdependence among the sectors and considerable fluidity in action across them. The second and more decisive reason is that many of the nonprofit organizations that are predominant in the American third sector are no longer "substantially voluntary and citizen driven" but are essentially "tax-exempt businesses."[48] This is so especially of large nonprofit organizations in health care, higher education, and social services.

Because many analysts and advocates of the "third sector" tend to equate it with nonprofit organizations, and because, according to Van Til, many of these organizations do not bear the hallmarks of a genuinely social economy, he wishes to speak of a "third space" instead. The organizations most at home in the third space would not be large nonprofit hospitals, universities, and social service agencies that gain most of their revenues from commercial operations and from government contracts, even though their budgets and staffs make up approximately two-thirds of the nonprofit sector. Rather, they would be smaller organizations in education, religion, local social services, advocacy, the arts, culture, and recreation that receive approximately two-thirds of all charitable donations.[49]

Having distinguished nonprofit organizations that are "essentially commercial" from ones that continue to serve "a voluntary or charitable purpose," Van Til then proposes that commercial nonprofits should lose their tax-exempt status. Thus ushered out of the third sector, they would leave behind "a true third sector," one that consists "only of organizations true to principles of voluntary citizen-driven service and advocacy." This true third sector "would merit both the public privileges and the reputation it must continue to earn."[50] In fact, what defines the "third space" in contemporary society is not

[48] Ibid., pp. 191–203.

[49] Three charts (ibid., pp. 197–200) show that, according to data from 1998, large "commercial" nonprofits in the United States account for 77.5 percent of the operating expenses and 67.5 percent of the employment (both paid and voluntary) in the nonprofit sector. Nearly half of all charitable donations in the United States go to churches and other faith-based organizations.

[50] Ibid., pp. 202–3.

so much the nonprofit status of organizations at home in it, Van Till claims, as the quality and purpose of actions and interactions within society's third space. Such quality and purpose are not the prerogative of certain organizations: "What distinguishes the third space is not the formal characteristics of its organization, but the quality of its process and the scope of its ambition. It is in the third space that whole persons come together to reflect and act upon what they need as members of a broader community and world. That space can exist within organizations of any time, as well as in the interstices between them."[51]

Structural Problems

Van Til's concept of a third space and his proposal concerning tax exemptions raise important questions about the distinctiveness and proper roles of nonprofit organizations. But he privileges the notion of participatory and dialogical voluntary action at the expense of specifically economic considerations. In this way a more or less communitarian notion of "sociality" comes to trump any alternative understanding of how economic life could be organized. That might help explain his focus on "voluntary and citizen-driven nonprofits," organizations whose character is closer to the "informal" space of what Peters calls "affectional communities"[52] than to the "formal" space of the administrative state and the dominant economic system. Van Til gives very little attention to the economics of cooperative and community-based organizations. He also downplays the economic limitations of small nonprofits, which, more than large "commercial" nonprofits, tend toward what Salamon labels as philanthropic insufficiency, particularism, and amateurism. In Van Til's account, the specifically economic character of the social economy tends to dissipate into a realm of free-floating values that, in principle, any organization, whether proprietary, governmental, or nonprofit, could realize, but in fact, according to Van Til, only certain smaller nonprofits actually pursue.

One wonders, however, whether and how "noncommercial" nonprofits can maintain the supposed purity of their advocacy and service.

[51] Ibid., pp. 208–9.
[52] Rebecca Todd Peters, *In Search of the Good Life: The Ethics of Globalization* (New York: Continuum, 2004).

Van Til proposes a number of tests to identify organizations that do not deserve tax exemptions.[53] He also offers five criteria for "the productive development of human activity in society's third space" as well as ten steps for "building, preserving, and extending society's third space."[54] Yet, other than urging us to resist "the commercialization of nearly everything in American life" and the "privatization, isolation, and trivialization of so much of contemporary politics, media, and family life,"[55] Van Til does not really say whether and how properly tax-exempt nonprofit organizations can resist and challenge the systemic logics of the proprietary economy and an administrative state. Indeed, his shifting from the language of "sectors" to that of "spaces" suggests that he has not recognized the full force of such concerns.

These are the sorts of concerns that one would expect from the political Left. In a chapter on major commission reports concerning the third sector, Van Til astutely observes the absence of a voice from the American Left.[56] He also says what such a voice would articulate: "A progressive vision of the third sector would recognize the impact that structural control of the economy exercises on political, social, and community life. It would define a democratic polity in which the equality of citizenship was backed by an awareness that inequalities in income, wealth, and control can overwhelm the impact of a 'one person, one vote' political system. It would view the third sector with a similar awareness of the ways in which giving and volunteering can be used to oppress as well as to liberate disadvantaged individuals."[57]

Yet Van Til does not himself provide a left-leaning alternative to more centrist positions that use a language he calls "secular Marxism": "Secular Marxism is like classical Marxism in that it describes serious problems associated with the economic system in terms of their consequences, but it differs from the classical view in its avoidance of any implication that these problems might be caused by anything that is structured into the economic system."[58]

[53] Van Til, *Growing Civil Society*, pp. 200–2.
[54] Ibid., pp. 207, 210–14.
[55] Ibid., pp. 210–11.
[56] Ibid., pp. 167–79.
[57] Ibid., p. 176.
[58] Ibid., p. 177.

If one added the thought that serious problems could also be structured into the system of the administrative state, one would quickly arrive at the more robust critique suggested by thinkers and activists on the European Left such as Jürgen Habermas. For such a critique, talk of "social entrepreneurship," which, as Van Til rightly notes, Americans tend to prefer over discourses about a "social economy," would sound like can-do jargon that covers up structural problems.

Social Capital

Unlike Van Til, Jeremy Rifkin pays attention to the need for structural transformation. Although Van Til often cites Rifkin with approval,[59] the proposal to remove tax-exempt status would play havoc with Rifkin's transformative vision for the third sector or "civil sector," in Rifkin's terminology. *The End of Work* regards the third sector's "social capital" as a crucial economic resource for creating employment and addressing basic needs. It could hardly accomplish this if the nonprofits whose budgets make up two-thirds of the civic sector lost tax-exempt status.

Structural Transformation

To be sure, Rifkin's concept of a social economy is not simply economic. It has an ethical core, namely, the notion of "community service." Rifkin describes community service as "a revolutionary alternative to traditional forms of labor. Unlike slavery, serfdom, and wage labor, it is neither coerced nor reduced to a fiduciary relationship.... [I]t is more akin to the ancient economics of gift giving. Community service stems from a deep understanding of the interconnectedness of all things and is motivated by a personal sense of indebtedness." Whereas market exchange "is always material and financial" and "the social consequences are less important than the economic gains and losses," community service is primarily "a social exchange, although often with economic consequences to both the beneficiary and the benefactor."[60] Yet this ethical core comes combined with Rifkin's emphasis on the

[59] See ibid., pp. 12–13, 138, 151–3, 180–2, 219–23n.
[60] Rifkin, *The End of Work*, p. 242.

third sector's actual economic contributions. For Rifkin, social capital is indeed capital.[61]

To accommodate both the economic and the ethical angles in his vision of a dawning postcapitalist society, Rifkin distinguishes two levels of transformation, structural and ideological. At the structural level, the third sector can provide jobs and basic services that are no longer available from the first and second sectors. At the ideological level, he suggests, the third sector can offer ingredients for a compelling vision of life to replace the productivism and consumerism long fostered by a capitalist economy. The values of growing productivity and endless consumption have become hollow for people who are underemployed, unemployed, or trapped in meaningless jobs. For such people, and for society as a whole, the social economy can offer "an alternative vision steeped in the ethos of personal transformation, community restoration, and environmental consciousness." If this vision were to "gain widespread currency," it would lay "the intellectual foundation ... for the post-market era."[62]

Yet here, perhaps, Rifkin slides too easily between the languages of economics and ethics. The very term "social economy" can suggest an economy both governed by economic considerations and pervaded by a certain ethos, an ethos of care and participation and generosity. This is clearly Rifkin's understanding. He believes that third-sector organizations around the world share a "biospheric perspective" that transcends conventional economic thinking and limited political agendas. This perspective embraces "democratic participation at the local level, the re-establishment of community, service to ... fellow human beings, and stewardship of ... the earth's common biosphere." For Rifkin, the social economy these organizations foster is "the last best hope for re-establishing an alternative institutional framework for a civilization in transition." Unlike the market economy, whose focus on productivity has let the machine triumph over human labor, "the social economy is centered on human relationships, on feelings of intimacy, on companionship, fraternal

[61] David Throsby, *Economics and Culture* (Cambridge: Cambridge University Press, 2001), pp. 44–60, briefly summarizes disputes among economists about whether social capital is in fact capital – in the context of introducing Throsby's own concept of "cultural capital."

[62] Rifkin, *The End of Work*, pp. 246–7.

bonds, and stewardship – qualities not easily reducible to or replaceable by machines." It is to this social economy that "the displaced workers of the Third Industrial Revolution" will have to turn, he says, "to find renewed meaning and purpose in life after the commodity value of their labor in the formal marketplace has become marginal or worthless."[63]

Blind Spots

Unfortunately, this bracing vision of a social economy has both economic and political blind spots.[64] Economically, Rifkin's argument assumes that the third sector can replace the jobs destroyed under technological imperatives in the proprietary economy. There are two problems with this assumption. The first is that the same technological imperatives at work in the proprietary economy could very well reduce opportunities for paid employment in the third sector as well. Technological changes do not stop at sectoral boundaries: they have an impact on productivity and labor no matter where these occur, as was noted by Baumol and Bowen's diagnosis of a "cost disease" in the performing arts.[65] A second problem is that Rifkin's assumption overlooks the specifically economic motivations for new technologies, namely, the push for new levels and sources of private profit. Short of either a massive transformation within the economic system or government redirection of the market on a much greater scale than anything attempted by the welfare state, there is no reason in principle why the first sector would not exploit the third sector in search of additional profit.

Politically, Rifkin does not sufficiently thematize the potential impact of government initiatives on the civic sector. Government

[63] Ibid., pp. 285–92.
[64] I leave aside criticisms raised by Rifkin's fellow economists, such as the empirical objection that his predictions of massive unemployment are invalid and the ideological objection that illegitimate government interventions in the economy rather than technological changes have created unemployment and other problems for the economically disadvantaged.
[65] This disease may not be as fatal as Baumol and Bowen originally predicted, however. Throsby, *Economics and Culture*, pp. 118–19, points to six ways in which the performing arts "have withstood the pressures imposed by stagnant productivity" and says that, in the thirty-five years since Baumol and Bowen presented their diagnosis, empirical studies found "little evidence of differential rates of inflation in the performing arts compared with other sectors of the economy."

programs necessarily require civic-sector organizations to meet standardized tests of competence and output. Such tests pressure organizations to give priority to strategic calculations rather than to communicative considerations. As Van Til recognizes, if government funding and tax incentives became the major source of third-sector revenue, this could well unintentionally undermine the very qualities that make the sector's social economy an attractive alternative to efficiency-driven proprietary and power-driven governmental economies. Consider, for example, Rifkin's suggestion that we could establish national purpose and direction by giving larger deductions for volunteer efforts and charitable contributions "that the public and their elected officials...deem more urgent and pressing."[66] It does not take too cynical an imagination to wonder what would happen to the third sector's vaunted community spirit if organizations were to vie to have their causes declared national priorities. Nor does it take years of experience in grant writing to see how political pressures could begin to shape the internal agenda of civic-sector organizations. Although there is no denying the importance of increased and progressive government support of third-sector ventures, the potential impact of such support on the sector's social economy needs additional scrutiny.

In other words, for Rifkin's scheme to make sense, a distinctive economic "logic" really does need to govern the civic sector. Moreover, the organizations that make up this sector must remain capable of subordinating monetary and administrative considerations to the primary reasons for which they have been established. Otherwise, over the long term, the third sector will not be an equal player alongside the first and second sectors but one of the other players in disguise. Nonprofit organizations and other civic-sector associations will become the derivative institutions that mainstream economic theory makes them out to be.

This worry helps motivate Van Til's notion of a "third space" that excludes "commercial" nonprofit organizations. Whereas Van Til criticizes commercial nonprofits but fails to address structural problems at the interfaces among three economic sectors, Rifkin envisions a structural transformation but overlooks problems inherent

[66] Rifkin, *The End of Work*, p. 258.

to the civic sector. Likewise, whereas Van Til emphasizes solidarity at the expense of economy, Rifkin emphasizes the civic sector's potential economic impact but wraps his emphasis in a mantle of hortatory ethicality. Neither author has managed to think past the polarity of value and fact that marks most contemporary discussions of civil society and the civic sector, a polarity encapsulated in the term "social economy." We need both a normative critique of economic life in general and a critical theory of its social-economic inflection within the civic sector.

Economic Solidarity

Triaxial Model

My alternative account of the social economy assumes a triaxial model of contemporary Western societies and distinguishes three vectors along each axis. The three axes of society, which intersect, include the levels at which interaction in society is configured, the macrostructures within which social life occurs, and the societal principles that obtain for social life in its configuration and structuration. The three levels of interaction are institutions, practices, and interpersonal relations. The macrostructures of contemporary social life consist of economy, polity, and civil society, along with the interfaces among them. And the most relevant societal principles that obtain for social life at these levels and within these macrostructures are ones of resourcefulness, justice, and solidarity. By "solidarity" I mean the expectation, indigenous to modern democratic societies, that no individual, group, or community should be excluded from the recognition we owe each other as fellow human beings. As Hauke Brunkhorst has shown, this expectation is a fundamental principle of democracy, and it needs to be secured by egalitarian efforts and universal human rights.[67]

What I have discussed as the civic sector and the public sphere lie at the interfaces of civil society with economy and polity, respectively. More precisely, the civic sector is the way in which civil society links up with the economic system, and the public sphere is the way

[67] Hauke Brunkhorst, *Solidarity: From Civic Friendship to a Global Legal Community*, trans. Jeffrey Flynn (Cambridge, Mass.: MIT Press, 2005).

in which civil society links up with the administrative state. Because the economic system and administrative state are complementary systems both heavily dependent upon each other and in constant tension, whatever flows from civil society toward the economic system via the civic sector has direct implications for the public sphere. Similarly, whatever flows from civil society toward the administrative state via the public sphere has direct implications for the civic sector. The same holds for movements in the opposite direction, from the economic system through the civic sector and from the administrative state through the public sphere. In order for civil society to remain intact, and not simply to become a pawn of economic and political systems, the interfaces among these macrostructures must maintain their identity and integrity. Specifically, the civic sector and public sphere must remain responsive to the imperatives of civil society and not become fully colonized by the economic system and administrative state. This is a structural reason why the prospects for a social economy are so important.

Unfortunately, the champions of a social economy tend to hive it off from the economy as a whole, installing it within either a sacrosanct third sector (Rifkin) or a diffuse third space (Van Til). They are right to think that a social economy can best thrive among organizations in the civic sector. But they are mistaken, in my judgment, to restrict the social economy's location to the civic sector. For the social economy is also a hidden current in both the proprietary economy of the economic system and the political economy of the administrative state. As a hidden current in both of these powerful systems, the social economy holds the potential to disrupt their operations and to give such operations normative redirection. Such redirection cannot occur merely from the outside, via the structural pressures and normative concerns that civic-sector organizations bring to bear upon capitalism and the state. Redirection also needs to occur from within these systems.

Normative Redirection

One reason why normative redirection must occur *within* economic and political systems is that civil society and its civic sector also need redirection. Recognizing both the pervasive influence and the potential destructiveness of capitalism and the administrative state, Van Til and Rifkin place their hopes for a better society in civil society and

its civic sector. They thereby overlook normative distortions in civil society itself. These distortions are not simply the tendency for large nonprofits to behave as proprietary businesses do (Van Til). Nor are such distortions merely due to governments' giving the civic sector inadequate support and recognition (Rifkin). Rather, a normative failure occurs within civil society, and this failure complements differently inflected failures in the economic system and the administrative state. All three macrostructures, each in its own way, fail to carry out what Dutch economist and social philosopher Bob Goudzwaard calls "the simultaneous realization of norms."[68] Let me explain.

I have argued elsewhere that, as an economic system, contemporary capitalism displays normative failure in two regards. First, it gives priority to certain sorts of economic expansion and technological innovation, and it does so at the expense of justice and solidarity, turning such considerations into mere means to achieve so-called progress. Second, the capitalist economic system also distorts the societal principle of resourcefulness. Instead of fostering a society where human and nonhuman potentials are carefully stewarded so that all the earth's inhabitants can flourish, contemporary capitalism twists the principle of resourcefulness "in the direction of efficiency, productivity, and maximal consumption for their own sakes." The second failure reinforces the first, for it turns considerations of justice and solidarity into "economic afterthoughts," into "belated attempts to alleviate the damage necessarily done by a system that does not prize resourcefulness in the first place."[69] When unrestrained, contemporary capitalism shows itself to be an exploitative and unsustainable system.

Often the critics of capitalism turn to either the administrative state or civil society to make up for normative deficiencies in the economic system. Unfortunately this not only helps secure the economic system as it is but also presupposes that the state or civil society is itself normatively intact. I see little reason to endorse this presupposition. Both the contemporary state and today's civil society suffer

[68] Bob Goudzwaard, *Capitalism and Progress: A Diagnosis of Western Society*, trans. and ed. Josina Van Nuis Zylstra (Grand Rapids, Mich.: Eerdmans, 1979), pp. 65–8, 204–23. I discuss Goudzwaard's work in Lambert Zuidervaart, *Social Philosophy after Adorno* (Cambridge: Cambridge University Press, 2007), pp. 129–30.

[69] Zuidervaart, *Social Philosophy after Adorno*, p. 129.

from normative deficiencies that complement those of the economic system. Just as capitalism prioritizes "growth" at the expense of justice and solidarity, distorting the meaning of resourcefulness, so the administrative state gives priority to certain types of bureaucratic control at the expense of resourcefulness and solidarity. In tandem with this failure, the contemporary administrative state also distorts the societal principle of justice. Instead of providing legal frameworks and democratic governance that would ensure just distributions of resources and meaningful participation in the affairs of state, it redirects the justice it should uphold toward positions of power and privilege. So too, contemporary civil society gives priority to diversity and charity at the expense of resourcefulness and justice. It thereby distorts the societal principle of solidarity. Rather than provide a robust array of avenues for cross-cultural dialogue and social inclusion, contemporary civil society tends to equate solidarity with tolerance and kindness.

In other words, the three macrostructures suffer from two types of mutually complementary normative deficiencies. They distort the meaning of resourcefulness, justice, and solidarity, and they make it less likely for these societal principles to obtain across society as a whole. Instead, the principles are relegated to separate zones, as if, for example, justice is of little concern to proprietary businesses or solidarity does not count in governmental matters or resourcefulness need not be an important consideration in civil society. In fact, the two types of deficiency reinforce each other, for resourcefulness, justice, and solidarity are mutually complementary: the intrinsic meaning of each societal principle depends on the others also being in effect at the same time. Instead of mutual normative complementarity, we have a society whose macrostructures both distort the meaning of specific societal principles and render other societal principles inoperative. The economic system distorts resourcefulness while downplaying justice and solidarity. The political system disfigures public justice while thinning out the meaning of resourcefulness and solidarity. Civil society reduces the scope of solidarity while underemphasizing considerations of resourcefulness and justice.

Having said this, I also wish to recognize that the three societal principles at issue here cannot have equally decisive roles in all three macrostructures. Just as resourcefulness and justice set the primary

tasks of the institutions within economic and political systems, respectively, so solidarity is the primary normative consideration within civil society. An economic system that gave greater weight to considerations of solidarity or justice than to careful mobilization of the earth's resources would be no less problematic than one that blindly pursues efficiency, productivity, and maximal consumption, no matter what the social and political costs. Similarly, a political system that gave greater weight to considerations of resourcefulness or solidarity than to achieving and maintaining public justice would be no less flawed than one that pursues administrative power for its own sake. So too, a civil society that made resourcefulness or justice its highest consideration would quickly turn into an economic system or administrative state. That would be no less destructive of civil society than is diluting solidarity into the mere promotion of tolerance and kindness.

Economic Intersections

All of this has implications for a normative understanding of the civic sector's social economy. Although it is an economy, and neither a polity nor a set of values, the social economy of the civic sector is one in which solidarity needs to inflect considerations of resourcefulness and justice – just as resourcefulness needs to inflect considerations of justice and solidarity in the proprietary economy, and justice needs to inflect considerations of resourcefulness and solidarity in the political economy of the administrative state. From a normative perspective, then, one can distinguish between a social economy of solidarity-inflected resourcefulness and a political economy of justice-inflected resourcefulness. In the proprietary economy, by contrast, resourcefulness should play the leading role, inflecting considerations of solidarity and justice.

This normative understanding supports a more-than-pragmatic conception of how the three economies would properly intersect. Intersections with the civic sector's social economy would not be thought to arise as mere responses to "government failure" (Weisbrod), "contract failure" (Hansmann), or "voluntary failure" (Salamon). The civic sector would not be viewed as simply offering "social capital" as a structural and ideological alternative to the proprietary economy and administrative state (Rifkin). Nor would

the contributions of civic-sector organizations be channeled into boundary-blurring "social entrepreneurship" (Van Til). Rather, we would regard the civic sector's social economy as the sort of economy that is especially appropriate for the civic sector, one that enables civic-sector organizations to foster solidarity in society, always with a view to considerations of resourcefulness and justice, but not as a substitute for what the proprietary economy and administrative state should properly accomplish. Because the latter systems are normatively deficient, pressures have built for civic-sector organizations to take on what these systems fail to provide, such as sustainable sources of energy or universal health care. It would be better for agencies of civil society to call these systems to account than to act as the de facto dumping ground for systemically generated problems.

Part of calling economic and political systems to account is to point out the social economy submerged within them. I realize it is controversial to claim that these systems have a hidden social economy; initially the claim will strike other social theorists as implausible. Nevertheless, I think a hidden social economy is what gives some credence to Van Til's concept of a third space that has no sectoral boundaries. Van Til cites the example of the University College of Cape Breton. In the 1990s it developed an array of collaborative partnerships with businesses, nonprofits, and government agencies and thereby helped revitalize the economy of a traditionally impoverished region in Nova Scotia.[70] A hidden social economy also confers some plausibility to Rifkin's proposal that governments forge a new partnership with the third sector via "shadow wages for voluntary work" (i.e., tax deductions for the time workers volunteer to tax-exempt organizations) and "a social wage for community service," which would provide the unemployed with "meaningful work...in the third sector to help rebuild their own neighborhoods and local infrastructures."[71] But Van Til does not comment on the macrostructural conditions that allowed the Cape Breton experiment to succeed. Nor does Rifkin uncover sufficient impetus within the administrative state for forging his new partnership.

[70] Van Til, *Growing Civil Society*, pp. 153–8.
[71] Rifkin, *The End of Work*, pp. 256–67.

In my judgment, Van Til's social entrepreneurial experiment would not succeed if proprietary businesses had only their "bottom lines" in view. Nor could Rifkin's two-sector partnership thrive if government agencies sought only to extend the economic reach of their administrative power. There must be something like a social economy submerged in proprietary and political economies – submerged both because the imperatives of such systems do not allow them to make solidarity their primary focus and because the reduction of resourcefulness and justice within them hides from view the need for solidarity to be in effect there at the same time.

Yet one can find evidence of a submerged social economy in both systems.[72] Thanks in part to examples and advocacy stemming from the civic sector, proprietary businesses often use the language of "social responsibility." They develop procedures of social accounting and undertake social audits. They also adopt voluntary codes of conduct within specific branches of industry and commerce that go beyond business ethics toward something like a social ethic. In other words, there is a growing recognition, at least among socially enlightened firms, that the proprietary economy has a social-economic moment, that showing solidarity toward the workers, customers, and communities that sustain these enterprises and are affected by them cannot be an economic afterthought. So too government agencies regularly use the language of "community involvement." They develop procedures of consultation with stakeholders and undertake impact studies before launching new projects. They also put in place self-regulatory guidelines that go beyond minimal legal requirements toward something like a social ethic. In these ways politicians

[72] Here I disagree with Hauke Brunkhorst, who claims that differentiated social systems "use human substance without replacing it" and that "functional systems like the market economy or sovereign state power, taken in themselves, represent new forms of social integration without solidarity" (*Solidarity*, pp. 82–3). Like Habermas, to whom he is strongly indebted on this point and whose diagnosis of economic and administrative systems I also partially employ, Brunkhorst fails to recognize the elements of solidarity submerged in the proprietary economy and administrative state and tends to treat these systems as normative vacuums. This, of course, is part of a larger concern about the "seducements" of systems theory for Habermasian critical theory – see Thomas McCarthy, "Complexity and Democracy: The Seducements of Systems Theory," in *Ideals and Illusions: On Reconstruction and Deconstruction in Contemporary Critical Theory* (Cambridge, Mass.: MIT Press, 1991), pp. 152–80.

and civil servants, at least in some levels and departments of government, demonstrate awareness that the political economy has a social-economic moment, that showing solidarity with citizens and with the beneficiaries of government programs cannot remain on the margin of government operations.

To point out this hidden social economy in economic and political systems is not to deny that they need redirection. Nor is it to suggest that systemic economies should become full-fledged social economies. The point instead is to indicate a social-economic basis within economic and political systems for giving appropriate weight to considerations of solidarity, considerations that their own focus on efficiency-reduced resourcefulness and administratively diminished justice would seem to preclude. There is a social-economic basis within the proprietary and political economies for what I have termed a "differential transformation" of all three macrostructures and their interfaces.[73] Civic-sector organizations need to highlight this social-economic basis. They need to call for significant restructuration of both systems. And they need to envision and pursue a redirection of the civic sector.

This is the larger framework within which we need to address the economic dialectic between civic-sector arts organizations and a proprietary economy. I claimed in Chapter 2 that civic-sector arts organizations, which promote societally important aesthetic worth, offer a real economic alternative that for-profit firms need. At the same time, however, as Chapter 6 shows in greater detail, the financial imperatives of global capitalism threaten the existence of such organizations. Now we can see that, to carry out this dialectic, and not simply succumb to it, arts organizations in the civic sector will need to rededicate themselves to participating in a social economy. They cannot allow themselves to become overly dependent on either the proprietary or the political economy. They must maintain a focus on promoting artistic practices and relations that are sociocultural goods. They need to acquire and tend their resources as a public trust to be shared with others. They should develop and maintain patterns of communication that invite participation by both their members and a wider public. They should not attempt to beat

[73] See Zuidervaart, *Social Philosophy after Adorno*, pp. 126–31, 168–70.

commercial businesses at their own game. Nor should they become subservient wards of the state. Rather, one could say, they should be "arts organizations in public." At the same time, they must recognize the flaws currently inherent to civil society, the proprietary economy, and the administrative state. They should not accept the reduction of solidarity to a celebration of cultural diversity, or the reduction of resourcefulness to efficiency and growth, or the reduction of justice to bureaucratic control. Instead, in their very structure and operations, civic-sector arts organizations need to provide creative alternatives to such normative reductions.

Plainly, arts organizations cannot provide these alternatives all on their own. They need compatible efforts by other organizations in the civic sector. They also need appropriate support from organizations in the proprietary economy and the administrative state. Government funding for the arts can be one channel of such support, provided the rationale and delivery of such funding do not simply reinscribe "business as usual." Similarly enlightened corporate and foundation funding would also help. Civic-sector arts organizations, in turn, seeking to remain true to the principle of solidarity, can expose elements of a social economy lying latent in economic and political systems. Perhaps more than anything else, such fidelity and exposure are the contribution that contemporary society needs from art in public.

6

Countervailing Forces

Without a vision, the people perish.

Proverbs 29.18

Previous chapters have proposed that participation in the public sphere and the civic sector is what justifies government protection and support for art in public. Art in public is a culturally mediated and societally constituted sociocultural good whose imaginative disclosure draws nuanced attention to issues and interests of public concern. It can do so because of its role in civil society, especially at the interfaces of civil society with political and economic systems. These interfaces are, respectively, the public sphere and civic sector. Organizations fostering art in public need government protection and support not only because political and economic systems threaten civil society but also because these systems require a robust civil society in order to function properly.

Here, however, difficult questions rise. How viable is civil society under current conditions? How viable are the public sphere and the civic sector? What are the prospects for arts organizations that do not simply follow the dictates of bureaucratized administrative states and an increasingly globalized capitalist economy? What if appropriate arts organizations do not exist or will soon disappear? What if the public sphere is the "phantom" Bruce Robbins and others claim it to be?[1] What if the civic sector

[1] Bruce Robbins, ed., *The Phantom Public Sphere* (Minneapolis: University of Minnesota Press, 1993).

does not embody the social economy that Van Til and Rifkin attribute to it? In these cases my attempt to reconceptualize the arts and civil society would lose its point, and the project of promoting art in public would seem futile. We need to explore the viability of the proposed conception and of its implicit agenda under current conditions.

The exploration in this chapter takes three steps. First I discuss an illuminating study on the arts and globalization by Joost Smiers. Next, building on his account, I identify systemic pressures that threaten the existence and flourishing of arts organizations in the civic sector and indicate the partial or reversible character of these pressures. Then I use the story of one contemporary arts center to illustrate how arts organizations can resist systemic pressures and thereby enhance the potential for democratic communication and economic solidarity that a thriving civil society would offer.

6.1 ART AND GLOBALIZATION

In *Arts under Pressure*, Dutch political scientist Joost Smiers claims that economic globalization threatens cultural diversity in countries around the world. This threat is especially strong in the arts, "where emotional incompatibilities, social conflicts and questions of status collide in a more concentrated way than happens in daily communication."[2] According to Smiers, democracy requires cultural and artistic diversity. That is why the threat posed by globalization must be countered and artistic diversity needs to be promoted at the local level: "A characteristic of democracy is that many different voices can be heard and many different opinions expressed. The public domain in any democratic society is the...space in which the exchange of ideas and an open debate...can take place without interference from state agents, who may have their own agenda, or from commercial forces whose only purpose is to sell as much as they can. The arts are crucial to democratic debate and to the process of responding...to the multitude of questions that life raises. For this to happen, a wide diversity of forms of expression and channels of communication is needed."[3]

[2] Joost Smiers, *Arts under Pressure: Promoting Cultural Diversity in the Age of Globalization* (The Hague: Hivos; London: Zed Books, 2003), p. 1.
[3] Ibid., p. vii.

Delocalization

Among many pressures on artistic diversity that Smiers identifies, three stand out. One is the adoption of neoliberal trade policies under the aegis of the World Trade Organization (WTO). These policies give priority to global over local markets. They promote new technologies, unrestrained competition, the removal of protective trade barriers and government regulations, and the privatization of "everything in the public domain."[4]

A second pressure arises from the formation of "a handful of huge transnational cultural conglomerates," most of them headquartered in the United States and Europe: "AOL/Time Warner, Vivendi-Universal, Sony, BMG, EMI, Disney, News Corporation, Viacom."[5] Increasingly these conglomerates have worldwide control over the means of "cultural production, distribution and promotion."[6] Neoliberal trade policies work to the advantage of such corporations and to the detriment of smaller and more local ventures in the arts.

The third pressure arises from the ownership and enforcement of copyright, "one of the most valuable commercial products of the twenty-first century," according to Smiers.[7] Supported by the WTO's treaty on intellectual property known as TRIPS,[8] transnational cultural conglomerates are acquiring copyrighted control of more and more artistic material. In fact, controlling creative content is a primary motivation for recent mergers in the culture industry. As a result, copyright, which had been a "sympathetic concept" for artists and writers, becomes a way for a few gigantic corporations to dominate "the intellectual and creative commons."[9]

The combined effect of these three trends is not so much the homogenization of artistic culture, says Smiers, as its delocalization. By "delocalization" he means the tendency for artistic activities and relationships to become uprooted from local or regional origins

[4] Ibid., p. 16.
[5] Ibid., pp. 36, 22. Smiers, pp. 36–8, also discusses several "second-tier" cultural corporations in Brazil (Globo), Mexico (Televisa), India (which is "by far the world's biggest producer of films"), and Japan.
[6] Ibid., p. 28.
[7] Ibid., p. 59.
[8] "TRIPS" stands for "trade-related aspects of intellectual property rights."
[9] Smiers, *Arts under Pressure*, p. 60.

and settings and displaced "into networks whose reach is distant or worldwide."[10] His objections to delocalization do not stem from a romantic image of peaceful, secluded neighborhoods and villages – many of these places "are not safe at all."[11] Nor do his objections come from an attachment to national cultures – usually these forma-tions by "dominant groups within a national territory" occur at the expense of other groups and their cultural traditions, he says.[12] His objections arise from an agonistic vision of participatory democracy. On this vision, both cultural orientation and social identity require direct involvement in artistic activities and relations: "In any society people should have the right to communicate in their own way about what moves them, what they find exciting, what is pleasurable or what keeps them busy. This provides them with an identity, individually as well as collectively. Theatre, film, music, the visual arts, design, literature, works of mixed media, all these forms of art are essen-tial vehicles of communication. From the democratic perspective it is desirable that major parts of the local artistic landscape of any society are related to what is going on in this particular society."[13]

Cultural conglomerates do not eliminate every local artistic land-scape. Rather, by taking over local and regional infrastructures for artistic production, distribution, and reception, they annex some landscapes and bury others, especially in poor countries with weak states. Lost in the process are "the self-construction of cul-tural identity," "curiosity about what artists are doing," the ability to ask "what is really valuable," and a readiness to address cultural differences – in short, both "active...involvement in cultural mat-ters" and "intercultural competence" to communicate across cul-tural differences.[14]

In a chapter titled "Freedom and Protection," Smiers presents a plethora of proposals to undo the "oligopolization and delocaliza-tion" of artistic endeavors.[15] He offers some proposals as suggestions

[10] Ibid., p. 85, quoting John Gray, *False Dawn: The Delusions of Global Capitalism* (London: Granta Books, 1998), p. 57.
[11] Smiers, *Arts under Pressure*, p. 82.
[12] Ibid., p. 86.
[13] Ibid., p. 83.
[14] Ibid., pp. 122, 129.
[15] Ibid., pp. 168–237.

and others as recommendations. Given the three pressures already noted, the following recommendations have particular relevance. The first is to secure the right to localized artistic expression in a legally binding international convention and, in keeping with this, to revise international trade agreements so that states have the right "to protect the development of cultural diversity in their own societies." He calls the proposed convention an "International Convention on Cultural Diversity."[16] A second recommendation is to set quotas for the market share of "cultural products coming from one foreign country"[17] and to develop cultural policies within each country that support diversity and that free the cultural commons from corporate control. His third recommendation, perhaps the most controversial one, is to abolish the system of copyright, replacing it with "a system that provides better payment to artists in Western and Third World countries alike, gives due respect to their work and brings the public domain back to a central place in our lives."[18]

Unresolved Tensions

Although I see merit in the first two recommendations, and I find the third one intriguing albeit problematic, I think both the diagnosis Smiers undertakes and the remedies he proposes lack systematic and normative perspective. This lack becomes apparent in unresolved tensions within his approach. On the one hand, Smiers decries the widespread commercialization of culture at the hands of cultural conglomerates. On the other hand, he seems to accept the economic imperative under which such conglomerates operate. He simply wishes to restrict the scope of their control. Such restriction would require a high degree of government intervention, for which

[16] Ibid., pp. 187, 241.
[17] Ibid., p. 192.
[18] Ibid., p. 209. Smiers also recommends "getting rid of moral rights as they have been defined in our legal contexts" (p. 209) – a recommendation that addresses the European legal context, where the notion of moral rights plays a stronger role than it does in North America. Smiers thinks that both copyright and moral rights stem from an outdated romantic notion of originality and hinder what he calls "dialogic practice." He does not seem to consider whether the notion of "cultural diversity" might itself have a romantic origin and might also pose problems for dialogic practice.

properly functioning states would be needed. Yet Smiers does not propose a normative task for the state, seeing it mostly as a necessary evil to protect local cultures from the even greater evil of delocalization: "The challenge is thus both to reinforce the state again as an entity that protects the variety of interests of people – interests that are not corporate driven – and to ensure that this entity creates as much space as possible for people to make locally the decisions that touch their daily life."[19]

This in turn gives rise to a tension between freedom and protection, which he recognizes but does not resolve: the freedom of artists and their local publics to participate in meaningful cultural expression, and protection for cultural diversity offered by states and international agencies that need to adjudicate conflicting interests and claims at a nonlocal level. Smiers urges us "to keep our balance as we walk the tightrope between freedom and protection."[20] But how can we achieve such balance when state and international protection, unless internally limited by normative considerations, could easily outweigh artistic freedom, or when artistic freedom, if understood in an agonistic and particularist way, could easily undo effective protection? This dilemma has notable prominence in the area of copyright. Dismantling the current system of copyright might seem to promote artistic freedom, but it could very well jettison one of the few legal protections of artistic freedom that artists enjoy.

One would hope that a more robust conception of civil society – a concept Smiers does not employ – can help address such tensions. Yet, if the pressures Smiers identifies are indeed in effect, then civil society is no less threatened than are the local artistic ventures that he considers crucial for a democratic culture. So let me propose an alternative, civil-society-based account of the "arts under pressure," with a view to developing a transformational response.[21]

[19] Ibid., p. 181.
[20] Ibid., p. xi.
[21] In making this proposal I rely on the case made by Jean Cohen and Andrew Arato, *Civil Society and Political Theory* (Cambridge, Mass.: MIT Press, 1992), for "the viability of a reformulated concept of civil society in relation to contemporary conditions" (p. 420). See especially their chapters 9 ("Social Theory and Civil Society," pp. 421–91) and 10 ("Social Movements and Civil Society," pp. 492–563).

6.2 SYSTEMIC PRESSURES

My approach builds on Habermas's account of interchange relations
between the "lifeworld" and the political-economic system. Rather than
use his concept of a lifeworld, however, I focus on civil society and its
relationship to the economic system and the administrative state. This
focus adopts Cohen and Arato's revision of Habermas's system-lifeworld
model. They claim that Habermas's concept of the lifeworld has two
distinct levels: "the background assumptions... embedded in language
and culture and drawn upon by individuals in everyday life"; and the
institutions that specialize "in the reproduction of traditions, solidari-
ties, and identities."[22] Cohen and Arato equate civil society with the sec-
ond, institutional level of the lifeworld. Civil society is constituted by
the institutions of communicative interaction that reproduce cultural
traditions (religious, artistic, and scientific organizations), social soli-
darities (groups, collectives, and associations), and personal identities
(family and education). As a complex of such institutions, civil society
is relatively independent from the state and economy, and it draws on
traditions, convictions, and other resources embedded in language and
culture. At the same time, modern civil society is made possible in part
by the way in which the political and economic media of power and
money "relieve communication of many of its time constraints."[23]

 I understand civic-sector arts organizations to be agents of civil
society. As such, they undergo the same pressures that affect civil
society as a whole but in ways that are specific to the arts. Three sorts
of systemic pressure threaten the existence and flourishing of these
organizations in countries, such as Canada and the United States,
whose economic system is capitalist and whose governments are
administrative states. These pressures have to do with commercial
and administrative encroachments in civil society, the isolation of
cultural expertise from everyday practice, and the effects of techno-
logical innovation on participation in cultural practices. Whereas the
first of these involves primarily external pressures upon civil society,
and the second is primarily internal to organizations within civil soci-
ety, the third is both internal and external to such organizations. I

[22] Ibid., pp. 428–9.
[23] Ibid., p. 440.

call all three of them systemic pressures because they mutually reinforce one another and cannot be explained without reference to economic and political systems.

Jürgen Habermas identifies some of these pressures when he reinterprets Max Weber's theses about the losses of freedom and meaning that accompany societal rationalization in the West. On the one hand, the uncoupling of the proprietary economy and the administrative state from civil society (Habermas uses the term "lifeworld") not only releases tremendous potentials for economic growth and administrative efficiency but also frees culture and persons from the constraints of traditional worldviews and hierarchical institutions. On the other hand, the economic system and administrative state have developed "*irresistible inner dynamics* that *bring about* both the colonization of the lifeworld and its segmentation from science, morality, and art."[24]

What Habermas calls "colonization" and "segmentation" indicate the first two systemic pressures already mentioned. When one applies his diagnosis to cultural organizations in general and to arts organizations in particular, "colonization" of the "lifeworld" can be seen to occur as hypercommercialization and performance fetishism. So too, the "segmentation" of the "lifeworld" takes the more specific forms of cultural exclusion and balkanization. Such pressures receive reinforcement from technological effects that occur across the board, in the economic system, in the administrative state, and in civil society. Let me discuss each of the three pressures in turn.

Hypercommercialization and Performance Fetishism

Habermas's *Theory of Communicative Action* identifies four social roles that crystallize around interchange relations between civil society and the political-economic system: employee, consumer, welfare-state client, and citizen. To these roles I propose to add those of cultural audience and cultural producer. "Cultural audience" expands the notion of a reading, viewing, or listening public into the notion of participants in organizationally mediated cultural practices. "Cultural producer" generalizes the notions of scientist, artist, writer,

[24] Jürgen Habermas, *The Theory of Communicative Action*, trans. Thomas McCarthy, 2 vols. (Boston: Beacon Press, 1984, 1987), 2:331.

and the like into the notion of producers of organizationally medi-
ated cultural practices. Because these are social roles, one person or
group can act as both audience and producer with regard to any one
set of cultural practices.

My thesis is that today's capitalist economy threatens to reduce the
social role of cultural audience to that of the consumer, and that the
administrative state threatens to reduce the role of cultural producer
to that of the welfare state client. Moreover, even in their distinction
from the roles of consumer and client, the roles of cultural audience
and cultural producer serve to channel the pressures of monetariza-
tion and bureaucratization into cultural organizations in civil soci-
ety. Both role reduction and the channeling effect contribute to what
I call hypercommercialization and performance fetishism.

The latter notions are not new. They stem from Karl Marx's account
of commodity fetishism, Georg Lukács's theory of reification, and
Theodor W. Adorno's critique of the culture industry.[25] Unlike these
earlier accounts, my approach assumes, following Habermas, that the
differentiation of cultural "value spheres" (science, morality, and art)
and of societal macrostructures (economy, state, and civil society),
which accompanies the growth of reification, is a positive achieve-
ment. At the same time, I hold that recent developments point toward
a potentially destructive de-differentiation under systemic impera-
tives at odds with the missions of cultural organizations in the civic
sector and public sphere. Such de-differentiation could turn cultural
institutions, including art, into serfdoms controlled and contested by
the economic system and the administrative state.

The term "*hyper*commercialization" indicates that cultural orga-
nizations such as schools and museums and mass media have long
had a commercial side, even when audiences and producers ignored,
denied, or resisted this commercial side. A common tendency in North
America during the past three decades, however, has been to make
commercial potential a primary reason for building and maintaining
cultural organizations. This tendency can be seen in moves to "privat-
ize" state-funded schooling, to market the economic benefits of arts
activities, and to maximize sales spinoffs and product placements in

[25] For a summary of these accounts, see Lambert Zuidervaart, *Adorno's Aesthetic
Theory: The Redemption of Illusion* (Cambridge, Mass.: MIT Press, 1991), pp. 72–82.

the movie industry. What Adorno analyzed as the culture industry's replacement of use value by exchange value[26] has invaded many cultural organizations. Further, the replacement of use value has turned into a full-scale celebration of exchange value, such that questions about cultural needs and cultural norms become increasingly difficult to raise and to address. This celebration is an obvious dynamic in the emergence of a celebrity culture, where one's "personal" salability becomes the only qualification apparently needed to get public attention. Once cultural audiences and cultural producers accept exchange value as the only "bottom line," the communicative capacities of cultural organizations become twisted to noncommunicative and strictly commercial ends.

A parallel development, one that complements and sometimes challenges hypercommercialization, is the rise of performance fetishism. Performance fetishism goes beyond the culture industry's system of hits and stars that Adorno lambasted in the 1930s and 1940s. During the intervening years, increasing demands have come from the administrative state for bureaucratically manageable certifications of competence and output. Although legislation, regulations, and judicial rulings can help keep cultural organizations responsive to their publics, such state interventions also put pressure on cultural organizations to replace communicative considerations with strategic calculations, or at least to subordinate the communicative to the strategic. Once strategic calculations win the upper hand, it becomes increasingly difficult for an organization's members to recall or to return to the cultural purposes for which the organization was established. When such purposes become occluded, full-blown performance fetishism can set in, along with an internal bureaucratization aimed at generating and implementing strategic calculations. Evidence of a trend toward performance fetishism can be found in legislative and administrative efforts to "retool" school curricula and pedagogies for the sake of competitiveness in the global economy. Such efforts put pressure on instructors to "teach to the test" rather than on behalf of subject matters and genuine learning. Additional

[26] I summarize and criticize Adorno's analysis of the culture industry in Lambert Zuidervaart, *Social Philosophy after Adorno* (Cambridge: Cambridge University Press, 2007), pp. 132–54.

signs occur in attempts to "rationalize" government arts funding in accord with cost-benefit criteria.

Although these examples suggest that performance fetishism complements hypercommercialization, other examples indicate that the two tendencies can also conflict. Some telling cases occur in government approaches to telecommunications and new information technologies. While regulatory agencies such as the U.S. Federal Communications Commission adopt policies that favor large corporations and their mergers into ever larger transnational conglomerates, legislative hearings and judicial rulings put pressure on these same companies to adopt internal and industry-wide standards of performance that, if taken seriously, would curtail controversial and commercially profitable programs and products. One saw this in 1997, for example, when American television networks adopted industry-wide TV Parental Guidelines, in response to congressional hearings on sex, violence, and crude language in the media. Often the conflict between commerce and standards of performance puts independent producers and distributors at a further disadvantage and makes them ripe for takeovers and mergers – a result that is at odds with other government standards having to do with cultural diversity and equal access. To the extent that government standards diverge from strictly commercial criteria, conflicts can occur between hypercommercialization and performance fetishism.[27] At times such conflicts can provide opportunities for resisting or reversing either hypercommercialization or performance fetishism.[28]

As Smiers rightly points out, neoliberal trade policies, which weaken or remove government regulations, have strengthened hypercommercialization at the expense of cultural and artistic diversity. Yet the remedies he recommends could easily tip the balance away from hypercommercialization toward what I have labeled performance fetishism. If states receive both the room and the mandate to protect

[27] One can find other examples of the conflict between commerce and performance in the areas of health care and environmental protection.
[28] To the extent that hypercommercialization reinforces performance fetishism, they together manifest the systemic organization of what Marcuse calls "surplus repression" and the "performance principle," which arise in a society geared to over-production and forced consumption. See Herbert Marcuse, *Eros and Civilization: A Philosophical Enquiry into Freud* (1955), 2nd ed. (Boston: Beacon Press, 1966), pp. 35ff.

such diversity, they will most likely establish and enforce standards that apply to all artists and arts organizations within their own jurisdictions. With such standards will come demands for certifiable competence and output. Historically such demands have worked to the disadvantage of smaller organizations and marginalized groups that do not have the capacity to meet bureaucratic requirements. Rarely does a small community-based arts organization, for example, have full-time grant writers and grant administrators who can provide all the documentation and reporting needed to qualify for government funding, at least not as this funding is organized in the United States and Canada. So it is not obvious that government protection would foster cultural diversity. It would more likely increase the pressure toward performance fetishism.

This implies that administrative states themselves are part of the problem and not simply part of the solution. The reason is that governments and their citizens have let considerations of administrative control outweigh the primary normative task of the state. In my view, the state's task is not simply to balance competing economic interests, an exercise that almost inevitably rewards whoever has the most resources and greatest influence, whoever can, for instance, lobby effectively or mount persuasive media campaigns. Rather, the state's primary task is to achieve and maintain public justice for all the institutions, communities, and individuals within its jurisdiction. Similarly, the primary normative task for agencies of international governance is to achieve and maintain something like global justice for all countries within the framework of such governance.

Viewed from this normative perspective, the cultural problem with neoliberal trade policies is not simply that they undermine diversity, although they do have that effect and, like Smiers, I think cultural diversity is worth preserving and fostering. Instead, the primary cultural problem is that neoliberal trade policies make it more difficult for governments and citizens to pursue public justice at home and to support the pursuit of global justice abroad. What we need is not so much an "International Convention on Cultural Diversity" as an International Convention on Cultural Justice, along with revisions to international trade agreements aimed at incorporating a robust framework of cultural rights. Orientation points for such revisions could be the 1948 Universal Declaration of Human

Rights and UNESCO's 1996 report on *Our Creative Diversity*.[29] Yet new
international frameworks would not suffice if various states do not
give greater priority to public justice for the arts and culture within
their own countries.

Democratic states cannot pursue public justice if they lack means
to ensure compliance with regulations and to carry out democrati-
cally decided policies within their own jurisdictions. As a normative
task of the state, public justice must be enforceable justice. Conversely,
the power of the state within its own jurisdiction must be justifiable
force – justifiable, that is, with respect to democratically interpreted
considerations of public justice. This construal of the state's task sets
normative limits to its considerable power. It suggests that the state
cannot simply operate according to a logic of administrative power.
Whatever power it has not only stems from the consent of the gov-
erned but also appeals, for its own legitimacy, to a societal principle
of justice.

We need to understand the pressure toward hypercommercializa-
tion in this light. To a surprising extent, cultural policies and regu-
lations in democratic constitutional states such as Canada and the
United States have served the interests of cultural conglomerates at
the expense of other organizations and groups. Although tempered
somewhat by Canadian attempts to protect cultural production and
distribution from the dominance of U.S.-based corporations and
to foster national unity (e.g., by way of the Canadian Broadcasting
Corporation), proprietary interests have had pride of place for the
Canadian government as well. Canadian and American support for
the neoliberal trade policies of the WTO and the North American
Free Trade Agreement (NAFTA) is an extension of domestic cultural
policies. If that is correct, then not only international trade policies
but also domestic frameworks need revision in order to pursue pub-
lic justice in cultural matters. At the same time, arts organizations
within each country must find ways to resist the economic pressure
toward hypercommercialization while challenging government-
imposed performance fetishism.

[29] *Our Creative Diversity: Report of the World Commission on Culture and Development*, 2nd
rev. ed. (Paris: UNESCO, 1996).

Exclusion and Balkanization

Additional pressures on arts organizations in civil society come not from external encroachments but from the isolation of expertise from everyday practice within cultural institutions. Following Habermas, Cohen and Arato write in this connection of a "selective institutionalization" of "the potentials of cultural modernity" that results from the "preponderant weight" given to economic and administrative imperatives: "The resulting gap between expert cultures involved in the differentiation of the value spheres of scientific knowledge, art, and morality and that of the general public leads to the cultural impoverishment of a lifeworld whose traditional substance has been eroded."[30] Extending and revising the diagnosis of selective institutionalization, I submit that the "gap" takes two forms. One is a tendency toward cultural exclusion. The other is a complementary and sometimes conflicting tendency toward cultural balkanization.

To the extent that contemporary cultural organizations purport to be democratic, they harbor a built-in promise to involve and serve inclusive publics without discriminating according to social status, gender, race, sexual orientation, disability, age, and other such factors. Yet many museums, universities, orchestras, and similar organizations primarily involve and serve a cultural elite defined as much by occupation and education as by socioeconomic class. Until fairly recently, such organizations have been somewhat closed to women, peoples of color, and other subaltern groups, despite the well-intentioned efforts of staff members and governing boards. Another range of organizations, usually ones that operate for profit, are so intent on capturing a mass market that they resist or ignore the cultural needs of (potential) publics that lack sufficient purchasing power. Examples include commercial radio, network television, and the major movie studios. While these mass-marketing organizations cannot be charged with cultural elitism, they can be faulted for another kind of exclusivity, the exclusivity of pseudopopulism.

At the same time, however, the politics of multiculturalism has encouraged high-brow organizations to reach out to formerly excluded producers and audiences, just as the economics of niche

[30] Cohen and Arato, *Civil Society*, p. 448. Cf. Habermas, *The Theory of Communicative Action*, 2:323–31.

marketing has encouraged the culture industry to reach out to new
segments of national and international populations. At first glance,
such developments would seem to counter the tendency toward cul-
tural exclusion. On closer examination, however, this need not be the
case. So long as the control of these organizations has not become
more inclusive, their diversified programs can create the impression
of wider recognition while avoiding its substance. The problem of
segmentation shifts from the gap between expert cultures and the
general public to multiple gaps among diverse publics, most of whom
still have too little voice in core decisions about which cultural prac-
tices to promote and how to pursue them. The problem shifts from
cultural exclusion to cultural balkanization, but either way a deficit
in recognition can occur.

The move from elitism and mass marketing to multiculturalism and
niche marketing creates new tensions within cultural organizations,
however, and these tensions can provide occasions for an increase in
cross-cultural recognition. For example, an art museum that vigorously
pursues new artists and audiences may find itself caught between the
desires of traditional supporters and the interests of diverse publics.
The most creative solution might be a drastic change in the structure
and patterns of the museum's governance and administration, such
that nontraditional participants have a greater say in the museum's
core decisions. Even if this change were driven by strategic calcula-
tions in response to guidelines for foundation grants and government
funding, it could lead to an increase in cross-cultural recognition.

The dialectic of exclusion and balkanization suggests that what
Smiers calls "oligopolization and delocalization"[31] do not simply result
from the globalizing reach of transnational cultural conglomerates.
It is undeniable, of course, that such conglomerates have become
ever larger and more powerful in the past few decades. It is also so
that their control of cultural production and distribution sucks the
air from attempts to build arts organizations attuned to the needs
and potentials of civil society. The segmentation of high art from the
general public, which characterized the modern art movement, was
in part a defensive formation against culture-industrial absorption
of artistic practices into commercial networks. Simply rejecting that

[31] Smiers, *Arts under Pressure*, p. 168.

defense and embracing such absorption, as sometimes occurs under the guise of "postmodernism," would be even more problematic than artistic "elitism." Nevertheless, and in distinction from the account provided by Smiers, segmentation is a problem intrinsic to high art. It is not simply a justifiable attempt to ward off hypercommercialization. Both exclusion and balkanization arise within art in public because the modern differentiation of cultural spheres has become decoupled from their integration.

The integration needed would be both structural and normative. Structurally, the control of arts organizations and other agents of civil society must be opened to primary participants in the practices that artistic, educational, and other such organizations foster. Both exclusion and balkanization arise in part when the governance and administration of cultural organizations in civil society do not reflect the needs and concerns of cultural producers and audiences – artists and their publics, in the case of arts organizations, or teachers and students, in the case of schools and other educational organizations. Normatively, a more expansive vision of solidarity needs to guide cultural organizations than either "rational self-interest" or "identity politics" would allow. Organizations that define their missions in either self-serving or group-protecting ways have little motivation to address needs and concerns that exceed the confines of their own constituencies.

Both structurally and normatively, it would not be enough merely to promote cultural and artistic diversity. The relevant question here is not simply whether people can exercise "the right to communicate in their own way about what moves them" and thereby to form their own "identity."[32] The relevant question is whether existing or future arts organizations can enable people to communicate in the right way and thereby to achieve cross-cultural recognition.

That is why setting market quotas and developing national policies to support cultural diversity, as Smiers recommends, would not suffice as responses to exclusion and balkanization. In and of itself, a market quota on foreign cultural products would not loosen the grip of cultural elites and of corporate and governmental forces within a particular country. Nor would national policies to support cultural

[32] Ibid., p. 83.

diversity necessarily address weaknesses in solidarity within cultural
organizations with respect either to local and national populations
or to global civil society. Indeed, there are genuinely democratic
concerns about how national governments *should* promote solidarity
within civil society. Historically, the effects and perhaps the causes
of such governmental efforts, when combined with a truncated
vision of solidarity, have been nationalism at home and imperialism
abroad.

Smiers is right to identify corporate control as a threat to cultural
diversity. But he does not emphasize that corporate control under-
mines structural and normative integration within civil society. More
specifically, corporate control decreases or eliminates the ability of
cultural practitioners to govern their own organizations and to turn
these in the direction of social solidarity. The governmental policies
we need are not simply ones that support cultural diversity but ones
that also create room for cultural organizations to foster intracul-
tural and intercultural recognition.

Pastiche and Neomania

A third pressure on art in public and on civil society stems from the
logic of technological innovation. The rise of postmodernism has
not ended a modernist emphasis on experiment but rather shifted
it from techniques and materials to technologies and images. This
can be seen, for example, in the movie industry's huge investment in
special effects exploiting the latest developments in computer tech-
nology. Here, too, a tension prevails, between the demand to include
as much reassuring imagery as possible and the need to stay ahead of
the technological curve. Whereas responses to the first demand often
result in nostalgic pastiche, responses to the second often generate
blind neomania.

In speaking of "nostalgic pastiche," I draw on Fredric Jameson's
description in his path-breaking essay on "The Cultural Logic
of Late Capitalism."[33] Jameson portrays postmodern pastiche as

[33] In Frederic Jameson, *Postmodernism, or, The Cultural Logic of Late Capitalism*
(Durham: Duke University Press, 1991), pp. 1–54; see especially pp. 16–25. The
essay was first published as "Postmodernism, or, The Logic of Late Capitalism,"
New Left Review, no. 146 (July–August 1984): 53–92.

"blank parody,"[34] as the imitation of an idiosyncratic style without satiric intent. Increasingly, he says, postmodern architects and artists have turned to imitating dead styles while bracketing the historical import of such styles. These practices are nostalgic insofar as they use stereotypical images of the past in order to endow the present "with the spell and distance of a glossy mirage."[35] Although Jameson is careful neither to condemn nor to celebrate such practices, it seems clear to me that they often distance both producers and audiences from their traditions and identities without providing occasions for reflective participation in those traditions and identities.

"Blind neomania," by contrast, refers to the breathless creation and consumption of new technologies simply because they are new. If one flaw of modernism in the arts was the assumption that what is new is thereby better, then perhaps a compensatory flaw of postmodernist culture is the assumption that what is new does not need to be better, just so long as it is new. It is not hard to see how such an assumption can foster technological tunnel vision and can work against people's taking responsibility for the outcome of their cultural endeavors.

Nostalgic pastiche and blind neomania are secular counterparts, if you will, to a deep cultural clash between insufficiently reflective rejection and insufficiently reflective promotion of economically driven innovation – between Jihad and McWorld, in Benjamin Barber's memorable phrase.[36] Contemporary arts organizations find themselves caught in the middle, pushed from one side by people who are deeply suspicious of anything new and from the other side by those who think art is all about creating the latest "sensation." Nor is this dynamic peculiar to arts organizations in the civic sector. In the commercial film industry, too, a tension prevails between providing familiar stories in well-worn genres and creating unpredictable "shock effects." What often gets lost is any sense that neither the old nor the new is good just by virtue of being old or new, that both

34 Jameson, *Postmodernism*, p. 17.
35 Ibid., p. 21. Among Jameson's examples are nostalgia films such as George Lucas's *American Graffiti* and Lawrence Kasdan's *Body Heat*, the Eaton Centre in Toronto, and E. L. Doctorow's novel *Ragtime*.
36 Benjamin R. Barber, *Jihad vs. McWorld* (New York: Ballantine Books, 2001).

preservation and innovation need to serve cultural considerations that are not simply technological.

As I suggested earlier and have argued elsewhere, such considerations include the artistic task of imaginative disclosure.[37] The arts have the task of proffering and provoking exploration, presentation, and creative interpretation of what matters in people's lives. This needs to occur with respect to both the personal and the social worlds that people inhabit. Participation in the arts can open these worlds to what lies beyond them. It can also help orient or reorient participants within the worlds they inhabit. There is a significant difference between such opening and (re)orientation, on the one hand, and either frantically chasing the latest thing or cynically recycling conciliatory clichés, on the other. Whereas opening and (re)orientation would allow and encourage people to come to terms with the past and to take it up into their own future,[38] pastiche and neomania isolate people from both past and future, frenetically freezing them into an all-consuming contemporary moment either nostalgically tinged or sensationally splashed. Because of such isolation in the present, what matters in their lives no longer seems to matter, as cultural questions about innovation and preservation disappear under a technological veil.[39]

This places issues surrounding copyright in a new light. The societal role of the copyright regime is not simply to secure ownership and control of cultural content, although it does play that role and needs to do so in relation to the economic system and administrative

[37] Lambert Zuidervaart, *Artistic Truth: Aesthetics, Discourse, and Imaginative Disclosure* (Cambridge: Cambridge University Press, 2004), pp. 55–73, 118–39.

[38] On the political implications of coming to terms with the past, in the context of postwar Germany, see Theodor W. Adorno, "The Meaning of Working through the Past," in *Critical Models: Interventions and Catchwords*, trans. Henry W. Pickford (New York: Columbia University Press, 1998), pp. 89–103.

[39] This trend is only one stream within the larger tendency Marcuse characterizes as "the technological veil" that "conceals the reproduction of inequality and enslavement," in Herbert Marcuse, *One-Dimensional Man* (Boston: Beacon Press, 1964), p. 32. See also Habermas's diagnosis of the increasing interdependence between science and technology and the technocratic ideology that accompanies this trend, in Jürgen Habermas, "Technology and Science as 'Ideology,'" in *Toward a Rational Society: Student Protest, Science, and Politics*, trans. Jeremy J. Shapiro (Boston: Beacon Press, 1970), pp. 81–122.

states. Copyright also helps define the civil societal space where pro-
ducers and audiences can address the dynamics of cultural innova-
tion and preservation. On the one hand, the awarding of copyright
can give public endorsement of what is genuinely new in a cultural
sense – and not merely in a technological sense. On the other hand,
the maintenance and enforcement of copyright can protect the status
of what is genuinely worth preserving in a cultural sense. Although
the European notion of "moral right" may be more explicit on these
matters, the Anglo-American regime of copyright would lose its cul-
tural point if it became no more than a means to secure ownership
and control.

Seen in this light, the threat to cultural participation does not
simply stem from the copyrighting campaigns of cultural conglom-
erates, as Smiers seems to suggest. The threat also arises from insuf-
ficiently reflective responses to technological innovations when
producers and audiences alike fail to ask, for example, whether the
artistic practices and products made either possible or available via
new technologies actually warrant our engagement with them. It is
so, as Smiers insists, that we need a legal framework that "provides
better payment to artists" and "gives due respect to their work."[40]
Yet even the best legal framework cannot ensure that their work
deserves payment and respect, just as it cannot prevent cultural con-
glomerates from exploiting and trivializing their work. At most we
can make a legal framework more responsive to considerations of
cultural participation, perhaps through transformation of the copy-
right regime. It is up to artists and their publics, and more generally
to cultural producers and their audiences, to sort out which prac-
tices and products genuinely deserve our participation. For this to
occur, the participants in cultural innovation and preservation will
need to shed the blinders of technological tunnel vision. Crucial in
this regard are arts organizations both sustained by a social econ-
omy and active in the public sphere. Cultural policies aimed at pro-
tecting and supporting such organizations would be an important
step in the right direction.

I have presented three sorts of systemic pressure upon arts orga-
nizations and civil society. Each one involves a dialectical tension,

[40] Smiers, *Arts under Pressure*, p. 209.

whether between economically driven hypercommercialization and politically driven performance fetishism, or between cultural exclusion and cultural balkanization, or between pastiche and neomania, both of them technologically induced. Sometimes such tensions create possibilities for significant change. Significant change cannot occur, however, without concerted efforts on the part of organizations within the economy, state, and civil society. For these efforts to be worthwhile, they need normative orientations that challenge the sources of systemic pressure. To resist hypercommercialization and performance fetishism, arts organizations and other cultural organizations need to maintain their communicative freedom, protected and supported by states that pursue public justice. To counteract exclusion and balkanization, such organizations need to give primacy to cross-cultural recognition, opening their governance and administration to the primary participants in cultural practices and embracing a civil-societal vision of solidarity. To recover from nostalgic pastiche and blind neomania, arts organizations need to recall the task of imaginative disclosure, asking anew what genuinely worthwhile participation in culture requires, and attending to a social economy and public sphere that create more than legal space for such participation.

6.3 THE UICA STORY

The systemic pressures upon arts organization in civil society are as daunting as they are unavoidable. Yet they do not dictate what arts organizations do, nor are the sources of such pressures immune to change. Arts organizations can help redirect economic, administrative, and technological imperatives. They can diminish cultural segmentation. And they can foster communicative freedom, cross-cultural recognition, and substantial participation. To illustrate such potentials, let me tell the story of an arts organization in which I have been directly involved.

New Vision for Old Spaces

The Urban Institute for Contemporary Arts (UICA) in Grand Rapids has become the largest multidisciplinary contemporary arts center

in the state of Michigan.[41] But its beginning was modest. UICA was founded as a small nonprofit artists' organization in 1977, during a decade that saw the establishment of many artists' organizations in Canada and the United States. Artists' organizations proliferated as an alternative to mainstream arts organizations and commercial galleries. Typically they were run by and for artists, and they championed work in new media and genres by women and by artists of non-European descent.[42]

UICA began when several visual artists decided to secure studio spaces together at an old furniture warehouse in downtown Grand Rapids. The warehouse was demolished two years later to make way for a parking lot at the new Gerald R. Ford Museum. So UICA moved to a rented industrial building on Race Street, where it remained for thirteen years. There UICA grew into a multidisciplinary arts center, as actors, dancers, musicians, and writers became involved and an organic structure of volunteer programming committees and board governance evolved. Eventually UICA hired its first full-time staff member, an executive director. Yet volunteers continued to do much of the organization's work, from program planning and presenting to advertising and fundraising and building renovations and maintenance.

In its early years, UICA was a community-based organization. Most members of its community, both its cultural producers and its cultural audience, were practicing artists. This profile began to change in the late 1980s when more people discovered UICA's innovative programming in dance, film, literature, music, interdisciplinary media, and the visual arts at the funky Race Street Gallery. Gradually more nonartists joined the programming committees and the governing board. Nevertheless, the artists who rented studios at UICA's Race Street facility or served on UICA's programming committees remained at the center of governance and administration.

[41] Grand Rapids is the second-largest city in Michigan, with a current population of about 200,000 in the city proper and about 750,000 in the larger metropolitan area. It is the site of Alexander Calder's abstract sculpture *La Grande Vitesse*, installed in 1969 as the first work of public art funded by the newly founded NEA.

[42] UICA was a founding member of the National Association of Artists' Organizations (NAAO). Established in 1982, NAAO aimed to provide a unified national voice for artists and artists' organizations in every discipline.

UICA began to outgrow its building around the same time
that the NEA came under right-wing attacks and John Engler, the
Republican governor of Michigan, drastically cut state funding for
the arts. UICA had received grants from both sources. But it had
never become heavily dependent on government funding, making
up for limited financial resources with remarkable levels of volun-
teer labor and donations. Perhaps that helps explain why, amid a
national recession that hit rustbelt states such as Michigan especially
hard, UICA's board dared to talk about finding and buying a differ-
ent facility. The catalyst for this discussion was an announcement by
Consumers Power Company (later: Consumers Energy), the owner of
UICA's rented facility, that it planned to tear down the Race Street
Gallery to construct an electrical substation.

That is when I became more directly involved, having already been
an appreciative audience member and the supportive spouse of a
UICA studio artist. I recall vividly the first UICA board meeting that,
as a newly elected board member, I attended. It was a cold, blustery
evening in January 1993. The board of directors met that evening to
plan UICA's move to yet another rental space, a temporary location
until UICA could buy its own building. Longtime members of the
board found it hard to say farewell to Race Street Gallery. After thir-
teen years and countless hours of volunteer effort, the building on
Race Street had been transformed from a nondescript industrial site
into a lively arts center. Now, within a month, it would be abandoned.
A mixture of sadness and anticipation hung in the air.

This recollection says something crucial about the Urban Institute
for Contemporary Arts and organizations like it. Many of them have a
remarkable ability both to care deeply about their programs, people,
and spaces and to move on imaginatively when circumstances call for
change. In my own experience, UICA has embodied caring creativity
and visionary democracy. Because of this ethos, an untimely eviction
turned into a strategic opportunity for the organization to make its
own contribution to an urban renaissance in Grand Rapids.

When the UICA began to talk about buying its own facility, it had
a tiny annual operating budget of only $75,000, a one-person staff,
hardly any assets, and no prior experience with major fundraising. I
became president of the board in the summer of 1994 and co-chair
of UICA's capital campaign one year later. The organization faced

two significant challenges: overcoming the limitations of rented and adapted facilities, and expanding and stabilizing its programs and services. To meet these challenges, UICA needed a permanent home.

The organization's needs came into focus in September 1994, when UICA purchased an abandoned automotive garage and showroom at 41 Sheldon Boulevard in the Heartside District of downtown Grand Rapids. Immediately we began to envision ways to transform our run-down building into an attractive destination for a broad West Michigan public. We hoped it would provide a supportive environment in which professional artists work and share their lives. It would also be a community center where fellow citizens, both young and old, learn about contemporary arts and can try their own hand at cultural creation. We pictured an intimate performance space where engaging music, film, poetry, and dance are enjoyed and discussed by a variety of audiences. We imagined inviting gallery spaces for lively displays of visual art by local, national, and international figures. We dreamed about a friendly gathering place for educators, students, and other community members. That is what the Sheldon facility would be like: a hub of creation, communication, and collaboration for artists in all disciplines and for participants from many walks of life.

UICA's newly purchased building had been built in 1911 as the city's first Ford automobile dealership. It had two levels, a parking garage below and a showroom and work area above, plus a two-level addition at the back. The building had stood vacant for several years. All the large plate glass windows had been replaced with ugly industrial brick. The roof leaked badly, the basement stank, and pigeons and mice had the run of the place. But the price was right: only $110,000 for 25,000 square feet of usable space.

The area surrounding the building was just as run down. Many residents of the Heartside District were homeless or poor or disabled. They depended heavily on social agencies in the area. Many vacant and neglected buildings stood nearby. The street itself had seen better days. It was an area where few people ventured unless they worked or lived there. At the time, perhaps only a cash-poor but vision-rich organization would have dared to buy a neglected building at this location.

Yet we saw an opportunity where others, quite frankly, saw a mess. The building itself reflected the daring architectural ideas that Albert

Kahn developed for the Ford Motor Company in Detroit. Steel trusses created an unusual 22-foot clear span. Ten sawtooth skylights brought in even, northern light. The original plate glass windows, which we hoped to restore, had followed a modernist credo of bringing the outside in to create better conditions for workers. So the building had great potential. It seemed appropriate for a contemporary arts center to reuse a building that had once broken new ground in architecture. Sturdy, inexpensive, easily reconfigured materials could demonstrate new approaches to renovation, design, and urban renewal.

Civic Engagement

Not long after purchasing 41 Sheldon Boulevard, UICA developed a compelling story about the organization's potential role in downtown Grand Rapids. We needed to tell this story to ourselves as well as to our neighbors and potential funders. It responded to an innovative and controversial report titled *Voices & Visions*, which the Grand Rapids Downtown Development Authority (DDA) released in 1993. *Voices & Visions* said that people want downtown Grand Rapids to be an urban center that is inclusive and open, respectful of the past and the natural environment, user- and pedestrian-friendly, culturally diverse, and economically strong.

Three of the report's recommendations gave shape to UICA's story: that combined efforts should expand and promote arts and entertainment activities downtown; that the governmental, proprietary, and civic sectors should cooperate to develop the downtown economy; and that the Heartside District should become a better neighborhood in which to live and work. We began to tell others and ourselves that UICA's building project would serve each of these goals. In fact, one could label the three chapters of our story "cultural renewal," "economic redevelopment," and "neighborhood partnership." Let me briefly summarize each chapter to the story that sustained UICA's efforts to turn 41 Sheldon Boulevard into a contemporary arts center.

Cultural Renewal

As the *Voices & Visions* report recognizes, cultural renewal is important in its own right, and it should not simply be equated with economic redevelopment. Cultural renewal means making more options

available, letting more people and a greater variety of people partici-
pate, and providing events and services that truly address the cultural
needs of a diverse population. For this to happen downtown, when
so many people have moved to the suburbs, some arts organizations
must step outside the box of more established museums, theaters,
and concert halls. UICA is exactly that sort of unconventional orga-
nization. UICA has a history of putting on events and serving people
that fall outside the box. By creating its own facility downtown, it
would greatly increase the prospects for cultural renewal. In fact,
UICA took a leading role in the formation of a six-block downtown
"cultural corridor" first identified by *Voices & Visions*. UICA's new
facility would provide a southern hub for that corridor, and it would
encourage people to venture south from Fulton Street rather than
staying on the familiar and "safe" north side. Quite simply, the build-
ing project would be a catalyst for cultural renewal downtown.

Economic Redevelopment
There is also an economic angle to UICA's story. During our capital
campaign we asked John Logie, the mayor of Grand Rapids, to write
in support of our project. Here is an excerpt from Mayor Logie's let-
ter, addressed to UICA's executive director Marjorie Kuipers:

As Mayor of Grand Rapids, I am always interested in furthering eco-
nomic development in the struggling neighborhoods in our city. It there-
fore pleases me to support UICA's efforts to help revitalize Grand Rapids'
Heartside neighborhood. By renovating the historically important building
at 41 Sheldon Blvd. into a contemporary arts center, UICA will not only help
create jobs, but…will also become an important factor in the economic and
cultural rejuvenation of the entire downtown area.
 In neighborhoods such as the Heartside community, development and
support of the arts…often…trigger economic growth in the area. UICA's
commitment to the Heartside community and economic investment in the
area will foster the kind of environment in which economic growth is likely.

As the mayor's letter attests, the potential economic spillover far
exceeded the stream of money invested in our building.

Neighborhood Partnerships
We did not want our contributions to cultural renewal and economic
redevelopment to occur at the expense of Heartside residents. That

introduces the third chapter of UICA's story. Our capital campaign received an enthusiastic letter from George Heartwell, a city commissioner at the time and the pastor of Heartside Ministry, which serves disadvantaged people in the area. (Later Heartwell became the next mayor of Grand Rapids.) Heartwell wrote: "I am particularly delight[ed] with the partnership between UICA and Heartside Ministry to provide cultural opportunities for the men and women trapped by poverty in this neighborhood. Already our programmatic joint ventures have improved the quality of life for Heartside residents even as they afford income generating opportunities in the arts for these residents."

Such partnerships do not just happen. Even before completing our building purchase, we initiated discussions with residents and leaders in the Heartside District. We included them in our planning at every stage. That planning was thorough, beginning with a collaborative facility redevelopment strategy in 1994, continuing with capital campaign planning, scenario planning, and a conceptual master plan for the facility in 1995, followed by a new organizational strategic plan in 1996 and a new business plan in 1997. At each step we asked how UICA could serve Heartside residents, and we sought their advice. These discussions directly affected the facility's renovation. Its entrance, for example, is modest and not imposing. The reinstated large windows let any passerby see what is happening inside. And local residents together with UICA artists installed the mosaics in the sidewalk outside, using recycled materials. Although UICA could not control what would happen to surrounding properties, we aimed to do our best to include disadvantaged neighbors in the scope of UICA's mission.

Revitalization

The three-chapter story just summarized sustained both the building project and the capital campaign, with outstanding results. Originally we designed the campaign as a two-stage effort having a $2.25 million goal and lasting from March 1996 to December 1999. Midway through the campaign we accelerated its pace and increased the goal by a half million dollars. To everyone's surprise, we concluded the campaign six months *ahead* of the original schedule and more

than $100,000 *above* the final $2.75 million goal. Of that amount, more than 40 percent came from three major foundations in West Michigan[43] and the national Kresge Foundation; nearly a third from corporations and major individual donations; more than 11 percent from UICA's Board and Capital Campaign Cabinet; and nearly 8 percent from the state of Michigan. The remaining amounts came from small businesses and hundreds of small individual donations.

Economically, one can see that organizations in all three sectors – proprietary, governmental, and civic – stepped up to the challenge, and that the campaign relied heavily on the support of foundations that serve as intermediaries among the three sectors. One can also note that government support was important not so much because of its monetary clout but because it helped establish the credibility of UICA's project and its importance in a political and civil-societal context. In addition, it is clear that the entire campaign depended on visionary leadership and highly dedicated volunteers. Otherwise a small, understaffed organization could not have pulled this off, not even with the exceptional ability of Executive Director Marjorie Kuipers to inspire and guide ongoing programming and services while overseeing both a capital campaign and a complex building project.

Architecture

Key to UICA's success at fundraising were the renovations completed while the capital campaign unfolded. The renovated building was such a unique and exciting place, and it so powerfully captured UICA's story. Credit for this goes to the architects, general contractor, and volunteer design and construction teams, all of whom translated UICA's hopes and desires into wonderful spaces, systems, finishes, and ambience. Only after much planning with many stakeholders did we send out a call for architectural proposals in September 1996. About twenty architectural firms responded, from which four were interviewed. When the Ann Arbor firm Architects 4, with its strong record in renovations, proposed to partner with the Birmingham firm McIntosh and Poris, with its cultural facilities background,

[43] The three West Michigan foundations, all of them headquartered in Grand Rapids, included a community foundation (the Grand Rapids Community Foundation), a corporate foundation (the Steelcase Foundation), and a family foundation (the Frey Foundation).

we recognized an ideal match. Just as important was the architects' enthusiasm about an interactive and collaborative process of design. All the different volunteers who served on UICA's programming committees, board, and planning groups had a stake in the building. Our interviews with architects Lorri Sipes, Michael Poris, and Doug McIntosh demonstrated that they could work productively in a democratic design process and enjoy it too. That is why UICA's new arts center, when it was completed, reflected the organization's collective vision while addressing the specific needs of various stakeholders.

The architectural results exceeded our most optimistic dreams. Well-known design critic Beverly Russell described our contemporary arts center like this:

> The design team allowed the sweeping, light-filled, 9,000-square-foot ground floor space to remain unobstructed by conventional partitions. Where separation is required for smaller galleries, a library, kitchen, boardroom and administrative offices, architectural components are inserted to give the appearance of a small village within the overall envelope.
>
> The lower level comprises spaces for visiting artists, as well as rooms for art instruction including facilities to study photography, ceramics and performance. A glass block floor surrounding the stairway connecting the two levels allows daylight to filter down into these lower gathering spaces. In an addition at the back of the building, the floor was removed allowing the double height space to be converted into an auditorium suitable for film, performance and lecture use.
>
> The UICA is receiving significant attention for this spirited move...which many supporters believe is another jewel in Grand Rapids' artistic crown.[44]

Perhaps the most striking facet to this artistic "jewel," one that raised our campaign goal by a half million dollars, was the multipurpose film theater. One of my joys when showing the building was to take first-time visitors through all the open spaces on the first floor and then calmly say, "Now I'd like to show you our film theater." Some visitors did not realize it was there, tucked quietly behind the main building. When I opened the doors, and they saw the illuminated stage and the raked stadium seating and the cool tech booth and the dark blue walls, it would take their breath away. It would be a genuine surprise, and they would immediately think of creative uses to which this simple and flexible space could be put.

[44] Beverly Russell, "Artful Remodeling," *Interiors & Sources* 7, no. 78 (June 1999): 28–9.

Opened in June 1998, the fully renovated building reenergized the entire organization, kicking it into a lively phase of expansion and redefinition. The building became a beehive of arts and educational activities. Soon it was also in high demand as a rental facility for banquets, receptions, fundraisers, weddings, and office parties. The arts center made West Michigan even more attractive to professionals who move there to work at local corporations, hospitals, and universities, even as it drew a remarkable diversity of people and organizations through its open doors.

Impact

At the same time, UICA's new contemporary arts center had an immediate impact on the downtown core. When preparing a talk about UICA for a 1999 symposium in Detroit on the arts and urban renewal, I asked several civic leaders in Grand Rapids to comment on how UICA's building project had affected downtown revitalization. David Cassard, president of the Waters Corporation and a member of the DDA, said that it had given an "economic boost to emerging arts and cultural organizations," which together encourage more visits downtown, more restaurants, and more jobs. Hank Meijer, co-chair of the Meijer Corporation, observed that UICA's new facility had pushed the bounds of cultural renewal "further than ever" and would encourage private development farther south. He expected it to have an economic "ripple effect." Tami Ramaker, executive director of the Arts Council of Greater Grand Rapids, pointed out that the new facility provided the only alternative film theater downtown, filling a crucial gap. Susan Shannon, business advocate for the city of Grand Rapids, said that UICA had made an "incredible difference" in helping to revitalize a "blighted area." George Heartwell, while appreciating UICA's inclusiveness, cautioned that enormous pressure was building to "upscale" the Heartside District and throw poor people out. He urged UICA to continue to acknowledge the local poor as having equal value with the rich.

Mayor John Logie sent me a letter that puts all of this in a helpful perspective:

Jane Jacobs, the [author] of *The Death and Life of Great American Cities*, well understood the importance of arts and cultural organizations in a successful downtown. She understood that in addition to...uplifting...the psyche

of a community, they also [are] one of the material and connecting links to other forms of entertainment, to restaurants, to libraries, and other public facilities which attract people from throughout the region. There is...a symbiotic synergy among the different components of a successful urban area.

Back in the bad old days of urban renewal after World War II, these concepts were not well understood. As a consequence, throughout America, and in Grand Rapids, downtowns suffered, deteriorated, and died. Pockets of that malaise crept into our downtown area. One of them was along Sheldon Blvd. where an old medical office building ceased to function..., where car dealerships were abandoned in favor of suburban locations, and where "mean streets" became the rule of the day. The decision by UICA to take over the old Becker Automotive Dealership property and rehabilitate it...was and is a major catalyst in the resurgence of that area. Across the street, the old medical office building has found new life as low- and moderate-income apartments. They are fully leased. Two blocks away, we opened a new Van Andel Arena....The entire area between UICA's new building and the Arena is undergoing a renaissance in which empty, former commercial buildings are being brought back to life, new housing is being developed, and new retail is entering the marketplace. I have great confidence that this trend will continue for many years to come.

Mayor Logie was not the only one to recognize the quality and impact of UICA's project. Within a year of the building's grand opening, UICA received four awards in this connection: an Economic Development Award from the city of Grand Rapids; a Historic Preservation Award from the Grand Rapids Historic Preservation Society; a Nonprofit Excellence Award from the Direction Center in West Michigan; and a statewide Cultural Organization Award, one of the Michigan Governors' Awards for Arts and Culture for 1999.

Reflections
How does one explain such achievements? Certainly one could point to many sociological factors that, while individually not unique to Grand Rapids, in combination made for an especially hospitable environment. Historically, for example, this area has one of the highest levels of charitable giving in the United States. It is also home to a number of family-based corporations that take a special interest in their civic region, including Steelcase, a leading international manufacturer of office furniture, and Meijer, a "hypermarket" chain that

ranks among the largest private companies in the United States.[45] In addition, excellent programs at area colleges and universities nurture local artistic talent and develop leadership for civic-sector organizations in the arts and culture. Even the conservative character of West Michigan culture may have contributed, because it helped the creative class see a need to combine its efforts in a progressive and not unduly transgressive way.

But there were also other factors, elements of sociocultural vision that are harder to measure. Let me mention three. First, UICA recognized early on that, although planning is crucial to urban revitalization, even more crucial is the right kind of planning. Too often plans get made without sufficient participation by the people most directly affected: the current residents of a neighborhood; the many potential users of a building; the ordinary citizens of a city, state, province, or nation. Participatory democracy is messy and time consuming. In the short run, it appears inefficient. If it is organized well, however, and guided by gifted leaders, it can be generative and exhilarating. In short, UICA recognized that genuinely democratic decision making is intrinsically better and can also lead to better results.

Second, UICA understood the relationship between local initiatives and global forces. Jacques Ellul once urged agents of social change to think globally but act locally. That may be only partly correct, because what needs to change locally so often depends on regional, national, and international conditions. Hence acting locally must be a way of thinking and acting globally. Otherwise, to the extent that local projects have a wider reach, they will not have the right kind of ripple effects, whether economically, politically, or in civil society. I think UICA understood this and shaped its project accordingly.

The third factor pertains specifically to the role of artists in civil society. Too often artists are seen, and see themselves, as unwanted eccentrics on society's margins. UICA did not believe that cities and countries can afford to leave them there. They cannot afford this because artists often have the imagination to see and hear things

[45] Not accidentally, Kate Pew Wolters, from one of Steelcase's founding families, and Hank Meijer, grandson of Meijer's founder, were honorary co-chairs of UICA's capital campaign. Steelcase became a publicly held company during the campaign (in 1997), but members of the three founding families still held a large portion of its stock.

differently, the keenness to challenge fixed assumptions about what is worthwhile, and a passion to push for significant change. UICA saw the need to welcome artists into the center of our civic adventures, and it made this need palpable and attractive to a wider public.

A Hebrew proverb said long ago that without a vision the people perish. The three factors just mentioned are all about vision – about discovering it, about developing it, about imagining it anew. Of course, vision alone will not repair decades of decay and neglect and exploitation. But all the economic resources and political power in the world will not suffice either, in the absence of a compelling and creative vision. That, UICA claimed, is what gifted artists can help people find. With such a vision, cities and civil society can flourish.

Moving Forward

In the decade since moving to 41 Sheldon Boulevard, UICA has experienced exponential growth. Membership has quintupled from about 300 to more than 1,500; paid staff and programming have quadrupled; and the annual operating budget has increased from $300,000 to more than $800,000. In 2006 UICA merged with Artworks, absorbing this organization's development programs for youth aged fourteen to twenty-one and aiming to serve 10,000 young people per year by 2010. In 2009 UICA became the founding institutional sponsor of the ArtPrize competition, which garnered national and international attention and attracted hundreds of thousands of viewers and voters to venues across the city. To accommodate such expansion, UICA has undertaken an exciting new building project supported by a $13.5 million capital campaign. After outgrowing its renovated home in just ten years, UICA decided to build a new state-of-the-art facility, with an opening date of spring 2011. The new UICA is just a few blocks away from 41 Sheldon Boulevard, at one of the most visible intersections in downtown Grand Rapids. Current executive director Jeff Meeuwsen has led this transition.

Obviously risks accompany such dramatic growth. One is that the need to generate new revenue and to attract new sources of funding can subtly shift the organization's priorities in programming and services. A second risk is that distance can increase between the board and staff, on the one hand, and volunteers and practicing artists on the other. Artist members of UICA, for example, no longer have a

prominent place on the board of directors. Another risk is that the organization could become so upscale that the disadvantaged groups it traditionally served, including undercompensated artists, no longer feel at home at UICA or no longer have their needs addressed. If such patterns were to develop, then the story of cultural renewal, economic development, and neighborhood partnerships would have to change.

More important, UICA could well end up following rather than redirecting economic, administrative, and technological imperatives. It could also reinscribe the cultural segmentation it has worked so hard to diminish. The organization could become less adept at nurturing communicative freedom, cross-cultural recognition, and substantial participation. Given UICA's history, however, and the diverse and committed members it continues to attract, I expect it to recognize these risks and find ways to address them. UICA will continue to show how, despite systemic pressures, and in response to them, a nonprofit organization dedicated to fostering art in public can be a transformative agent of civil society.

PART III

MODERNISM REMIXED

7

Relational Autonomy

A kind of transcendence is preserved...in the negativity of modern art. The trivial and everyday must be open to the shock of what is absolutely strange, cryptic, or uncanny.

Jürgen Habermas[1]

The discussion of art's role in civil society has shown why public debates about government arts funding often shed more heat than light. The debates presuppose an opposition between market and state that overlooks both the distinctiveness of civil society as a non-systemic macrostructure and its interfaces with economic and political systems. The debates' binary frame also fails to articulate either the systemic pressures that threaten civil society and the arts or the normative deficiencies that pervade society's macrostructures. As a result, debates about government arts funding often divert our attention from how art in public could help challenge the forces of hypercommercialization and performance fetishism and normatively redirect contemporary society.

Yet these debates concern more than the contest over market and state, and there are additional reasons why they so frequently short-circuit. As was indicated in Chapter 1, the typical debate embodies a tension between promoting the freedom of artistic expression and

[1] Jürgen Habermas, *Between Facts and Norms: Contributions to a Discourse Theory of Law and Democracy*, trans. William Rehg (Cambridge, Mass.: MIT Press, 1996), p. 490.

maintaining the authority of traditional values. It also carries out a conflict between art as liberating transgression and art as a decadent menace. Built into such polarities are individualistic assumptions about artists and their publics and vanguardist assumptions about the role of the arts in society.

Among the concepts inherited from the eighteenth-century Enlightenment and refined by aesthetic discourse in the intervening years, one in particular connects the polarities and assumptions just mentioned, namely, the "autonomy" of art. This is a central concept in modernist aesthetics, which not only emphasizes the autonomy of art but also ties this to the creation and experience of authentic artworks. My attempt to reconceptualize the government funding debate using the concept of "art in public" points to an alternative account of art's purported autonomy. The alternative I have in mind retains the differentiated character of art in modern society but acknowledges art's societal imbrication. My alternative also recasts the notion of artistic freedom, undoing its individualistic armor and exposing it to notions of intersubjective dialogue and shared responsibility. By reconfiguring art's autonomy as "relational autonomy," I aim to challenge vanguardist assumptions without denying the role that art can play in achieving a more democratic society.

To accomplish this, Chapter 7 proposes a tripartite conception of the autonomy of art as consisting of societal autonomy, internal autonomy, and interpersonal autonomy. Chapter 8 elaborates the notion of interpersonal autonomy by highlighting a creative tension between artistic authenticity and social responsibility. Chapter 9 explores the implications of art's relational autonomy for achieving a more fully democratic culture. What all of this means for cultural policy emerges in Chapter 10. As will become apparent, my tripartite conception provides a normative background to the concerns about systemic pressures presented in the previous chapter. Hypercommercialization and performance fetishism directly threaten art's societal autonomy and thereby tend to undermine internal and interpersonal autonomy. Similarly, exclusion and balkanization directly endanger art's internal autonomy; neomania and pastiche present challenges to interpersonal autonomy; and together these pressures reinforce the threats to art's societal autonomy posed by hypercommercialization and performance fetishism.

The distinctions among societal, internal, and interpersonal autonomy derive from the aesthetics and social philosophy of Theodor W. Adorno. Following Adorno, although disagreeing with his specific formulations, I regard these three forms of autonomy as closely interlinked. The societal autonomy of art has to do with how the arts relate to political and economic systems. The internal autonomy of art, on which modernist aesthetics focuses, pertains to characteristics or qualities that help distinguish art from other realms of cultural endeavor and make it both intrinsically worthwhile and societally important. Interpersonal autonomy has to do with normative expectations concerning mature agency among participants in the arts. I use the term "interpersonal" rather than "personal" to indicate that, on my view, relations to others sustain the agency of persons: their autonomy is intersubjective. Interpersonal autonomy is personal, to be sure, but on my view persons are constituted by their relations with others. If it were not cumbersome, I would use the term "(inter)personal" to indicate this combination of the personal and the relational.[2]

Because a previous discussion of autonomy in *Social Philosophy after Adorno* concentrates on distinctions and relations between art's societal and internal autonomy but says little about interpersonal autonomy, let me first consider this third form of autonomy and then link it, respectively, with internal and societal autonomy. My initial point of reference is the nuanced account of autonomy in Habermas's philosophy of law and democracy.

7.1 INTERPERSONAL PARTICIPATION

Jürgen Habermas's gesture toward modern art is odd. The passage from *Between Facts and Norms* quoted in this chapter's epigraph is practically the only reference to modern art in the entire volume. Suddenly, in the last paragraph of an appendix to Habermas's extensive treatment of law and democracy, modern art appears as a site of transcendence, alongside "the unfulfilled promise disclosed by

[2] The most important sources for my conception of interpersonal autonomy and more generally of relational autonomy lie in feminist theory. See, for example, Catriona Mackenzie and Natalie Stoljar, ed., *Relational Autonomy: Feminist Perspectives on Autonomy, Agency, and the Social Self* (Oxford: Oxford University Press, 2000).

the critical appropriation of identity-forming religious traditions."
"A culture without thorns," Habermas writes, "would be absorbed
by mere needs for compensation." That is why contemporary society
needs "the negativity of modern art."[3] At a time when modern art
had lost its capacity to shock and disturb, having ceded the field to
postmodern trends, Habermas resolutely appeals to the negativity of
modern art, implicitly recalling Adorno's famous description of mod-
ern art as "the social antithesis of society."[4] The passage reads as if a
moment of unreconstructed Adorno had slipped past the master of
reconstruction.

Yet Habermas's gesture toward modern art is not as strange as it
first seems. Much of his discourse theory floats upon an undercur-
rent of aesthetic modernism that, rarely thematized, bursts to the
surface when he seeks a utopian horizon from which the structural
transformation of society need not seem impossible. At those times,
his debt to Adorno becomes obvious.

One clue to this reading lies in the idea of art's autonomy, an
idea as complex as it is crucial in the critical theories of Adorno and
Habermas. As a social-theoretical concept, it indicates the differen-
tiation (Habermas) or division of labor (Adorno) whereby distinct
regions of culture and society acquire their own legitimacies and log-
ics. Both Adorno and Habermas think that autonomy is crucial for
art's contributions to modern society. For Adorno, autonomy is cru-
cial because it is a precondition for artistic truth. For Habermas, art's
autonomy is crucial because it guarantees an area where the rules
of science, technology, morality, and politics do not bind expression
and interpretation.

To understand why both Adorno and Habermas emphasize art's
autonomy, one must turn to further inflections of "autonomy" that
stem from Immanuel Kant's account of enlightenment and morality.
The link to Kant becomes particularly visible in passages where the
authors identify the nonnegotiable convictions of their philosophies.
Consider, for example, the following excerpt from the introduction to

³ Habermas, *Between Facts and Norms*, p. 490. "Popular Sovereignty as Procedure," the
 appendix in which this passage occurs, was originally presented as a lecture in 1988
 and published in 1989.
⁴ Theodor W. Adorno, *Aesthetic Theory*, trans. Robert Hullot-Kentor (Minneapolis:
 University of Minnesota Press, 1997), p. 8.

Horkheimer and Adorno's *Dialectic of Enlightenment*: "We have no doubt – and herein lies our *petitio principii* – that freedom in society is insepa- rable from enlightenment thinking. We believe we have perceived with equal clarity, however, that the very concept of that thinking, no less than...the institutions of society with which it is intertwined, already contains the germ of the regression which is taking place everywhere today. If enlightenment does not assimilate reflection on this regres- sive moment, it seals its own fate."[5] When Adorno and Horkheimer appeal to the necessary link between societal freedom and enlighten- ing thought, they recall a definition that they later challenge, namely, Kant's characterization of enlightenment as humanity's leaving self- imposed adolescence, under the guidance of reason.[6]

A closely related passage concludes the final chapter in Habermas's *Between Facts and Norms*: "Certainly this understanding [of law], like the rule of law itself, retains a dogmatic core: the idea of autonomy according to which human beings act as free subjects only insofar as they obey just those laws they give themselves in accordance with insights they have acquired intersubjectively. This is 'dogmatic' only in a harmless sense. It expresses a tension between facticity and valid- ity...that *for us*, who have developed our identity in such a form of life,...cannot be circumvented."[7] When Habermas describes the idea of autonomy as the harmlessly dogmatic core to his discourse theory, he recalls the Kantian account of morality whose scope he had earlier qualified, with its emphasis on the concept of rational self-determi- nation.[8] For both Adorno and Habermas, although in differing ways, the autonomy of art is important because it supports the pursuit of self-determination. It is to Habermas's elaboration of autonomy as rational self-determination that we now turn.

[5] Max Horkheimer and Theodor W. Adorno, *Dialectic of Enlightenment: Philosophical Fragments* (1947), ed. Gunzelin Schmid Noerr, trans. Edmund Jephcott (Stanford, Calif.: Stanford University Press, 2002), p. xvi.

[6] According to Kant, "*Enlightenment is the human being's emergence from his self-incurred minority. Minority [Unmündigkeit] is inability to make use of one's own under- standing without direction from another.*" "An Answer to the Question: What Is Enlightenment?" (1784), in Immanuel Kant, *Practical Philosophy*, trans. and ed. Mary J. McGregor (Cambridge: Cambridge University Press, 1996), p. 17. Horkheimer and Adorno quote this definition in *Dialectic of Enlightenment*, p. 63.

[7] Habermas, *Between Facts and Norms*, pp. 445–6.

[8] For a discussion of Kant's moral theory in relation to legal theory, see especially ibid., pp. 82–131.

Private, Public, and Moral Autonomy

What does it mean for a human being to be autonomous? More spe-
cifically, what does it mean for human beings to exercise autonomy
when they participate in the arts, whether as producers of art or as
audiences for art? With regard to human autonomy in general, *Between
Facts and Norms* distinguishes between "private" and "public" auton-
omy in order to argue that "private and public autonomy reciprocally
presuppose one another in such a way that neither one may claim
primacy over the other."[9] Habermas specifies the distinction with ref-
erence to law and the democratic process. *Private* autonomy refers to
the legally protected freedom of individuals to choose and pursue
their own personal success and happiness. This freedom is guaran-
teed within the "system of rights" by basic negative liberties, member-
ship rights, and due-process rights. *Public* autonomy refers to an idea
of self-legislation by citizens. It "requires that those subject to law as its
addressees can at the same time understand themselves as authors of
law."[10] This freedom of political self-governance is guaranteed within
the "system of rights" by the rights of political participation. Whereas
political liberals tend to emphasize private autonomy, modeled along
the lines of morally grounded human rights, civic republicans tend
to emphasize public autonomy, modeled along the lines of ethically
grounded popular sovereignty. Habermas argues that neither moral
nor ethical grounding will do, however, and that neither private nor
public autonomy may claim primacy over the other. Instead, "the *dem-
ocratic process* bears the entire burden of legitimation. It must simulta-
neously secure the private and public autonomy of legal subjects."[11]

The bridge between these specifications of "autonomy" and the
Kantian concept of moral autonomy runs through Habermas's "dis-
course principle" (D): "Just those action norms are valid to which
all possibly affected persons could agree as participants in rational
discourses."[12] The fundamental intuition here is that, to be valid,
a norm must be capable of impartial justification. Only when one
adds the stipulation of *universalizability* does this discourse principle

[9] Ibid., p. 455.
[10] Ibid., p. 120.
[11] Ibid., p. 450.
[12] Ibid., p. 107.

become specifically suited for the justification of *moral* norms.[13] Accordingly, one should neither equate moral autonomy with either private or public autonomy nor make it the basis for either one. Rather, moral autonomy is the capacity and obligation to act according to intersubjectively acquired and tested insight into what can be judged to be equally good for all (i.e., just). Hence, "morality is an authority that crosses the boundaries between private and public spheres."[14]

To summarize: Habermas defines autonomy as the freedom of humans to act according to laws they give themselves in conformity with intersubjectively acquired insights. As private autonomy, it is the legally protected freedom of individual choice and action. As public autonomy, it is the constitutionally secured freedom of political self-governance. And as moral autonomy, it is the freedom to act according to insight into what is just. Both private and public autonomy receive legitimation through the democratic process, and they reciprocally presuppose one another. Common to both, and to moral autonomy as well, is the requirement that, to be valid, norms for autonomous action must be capable of impartial justification in the manner articulated by D.

Autonomy and Authenticity

Although Habermas's account of autonomy is more clearly intersubjective and dialogical than Adorno's, and therefore less prone to depict "correct consciousness" as the origin and destination of autonomous art, nevertheless he breaks even less than Adorno does with an emphasis on rational insight as the linchpin of private, public, and moral autonomy. Moreover, because Habermas does not think that art is a vehicle of rational insight (at least not with respect to rightness

[13] For Habermas, the discourse principle captures postconventional requirements of justification at a sufficiently abstract level that D is not specifically moral or legal or political. Yet it can be specified for different complexes of norms (or "generalized behavioral expectations") that have their own reference system. Habermas notes in *Between Facts and Norms* that his previous writings on discourse ethics had not "sufficiently distinguished between the discourse principle and the moral principle" (p. 108), but he also uses his newfound clarity to resist once again Albrecht Wellmer's attempt to restrict the discourse principle to an explanation of the principle of democracy – see pp. 459–60.

[14] Ibid., p. 109.

and truth), the increased intersubjectivity in his account tends to disconnect moral autonomy from the autonomy of art.

I refer here to his insisting on a distinction between ethical and moral discourses, each of which he links with a certain idea of self-governance: "The modern ideas of *self-realization* and *self-determination* signaled not only different issues but two different kinds of discourse tailored to the logics of *ethical* and *moral* questions."[15] According to Habermas, *self-realization* is at the core of modern *ethical* discourse in its two versions: ethical-existential discourse, with its emphasis on individual self-fulfillment and a tendency toward individualism, and ethical-political discourse, with its emphasis on the cultural expression of collective identities and a tendency toward cultural pluralism. *Self-determination*, by contrast, remains central to *moral* discourse, with its emphasis on universal justice. And "these ideas of self-determination and self-realization cannot be put together without tension."[16] The same applies to the concepts of authenticity and autonomy, which Habermas sometimes uses as equivalents to the ideas of self-realization and self-determination, respectively.

Given Habermas's distinctions, much of contemporary aesthetic discourse seems to have greater affinities with the ethical-existential discourse of "authenticity" than with moral discourse, despite Kant's famous description of beauty as the symbol of morality, and despite recent attempts to make good on that description. Moreover, much vital and provocative contemporary art arises within the struggles of oppressed and marginalized groups among which, on Habermas's interpretation, ethical-political discourse prevails. Habermas's way of parsing the ethical and the moral would imply that authenticity and self-realization, not autonomy and self-determination, provide orientations for such aesthetic discourse and politically engaged art.

Cultural Politics
This implication emerges indirectly in his response to Charles Taylor's understanding of the "politics of recognition." Habermas's response relies heavily on his distinction between moral and ethical discourses. According to Habermas, Taylor's argument for constitutionally secured

<hr>

[15] Ibid., p. 95.
[16] Ibid., p. 99.

collective rights does not simply reinterpret the liberal principles of the democratic constitutional state. Rather, Taylor "attacks the principles themselves and calls into question the individualistic core of the modern conception of freedom."[17] Whereas Taylor derives the politics of recognition from authenticity as a "moral ideal," Habermas thinks that authenticity is not a *moral* category pertaining to universalizable norms: at best it is an *ethical* ideal pertaining to individual or communal visions of the good.

Habermas does acknowledge an important political role for discourses aiming at collective authenticity and self-realization, however.[18] His acknowledgment occurs in a discussion of feminism. Habermas describes feminism as a liberation movement in which women seek to "defend themselves against oppression, marginalization, and disrespect and thereby struggle for the recognition" of their collective identity. He takes it that the political goals of feminism "are defined primarily in cultural terms."[19] According to Habermas, the history of feminism demonstrates that "the system of rights is blind neither to unequal social conditions nor to cultural differences."[20] But it also shows that neither an appeal to formal equality under the law nor an attempt to remedy actual inequities through social-welfare interventions suffices to realize the system of rights: the first does not promote "actual equality in life circumstances or positions of power," and the second restricts "the capacities of the presumed beneficiaries to shape their lives autonomously."[21] Consequently, as

[17] Habermas, "Struggles for Recognition in the Democratic Constitutional State," in Charles Taylor et al., *Multiculturalism: Examining the Politics of Recognition*, ed. Amy Gutmann (Princeton, N.J.: Princeton University Press, 1994), p. 109. It is not clear that when Taylor discusses Quebec and Canada he is actually arguing for constitutionally secured collective rights. In fact, as Habermas points out, it is not clear which claim Taylor is actually arguing.

[18] Maeve Cooke suggests contra Habermas (and, implicitly, also contra Taylor) that, insofar as ethical-political discourse functions as "the hermeneutic explication of shared value-orientations," it "is guided as a rule not by the norm of authenticity but by a concern with truth and by the norm of autonomy." For Habermas, however, discourses guided primarily by a concern with truth and by the norm of autonomy would not be ethical-political discourses, by definition. See Maeve Cooke, "Authenticity and Autonomy: Taylor, Habermas, and the Politics of Recognition," *Political Theory* 25 (1997): 286n41.

[19] Habermas, "Struggles for Recognition," p. 117.

[20] Ibid., p. 113.

[21] Ibid., p. 114.

radical feminists have insisted, the relevance of gender differences for opportunities to exercise individual liberties must become a topic for public debate and political contention.

According to Habermas, this moves the understanding of rights past an opposition of individual freedoms versus guaranteed benefits toward "a proceduralist conception of rights according to which the democratic process has to safeguard both private and public autonomy at the same time. The individual rights that are supposed to guarantee women the autonomy to shape their private lives cannot even be appropriately formulated unless those affected articulate and justify in public discussion what is relevant to equal or unequal treatment in typical cases. Safeguarding the private autonomy of citizens with equal rights must go hand in hand with activating their autonomy as citizens of the nation."[22] Accordingly, ethical-political discourses are required on the part of women, as on the part of ethnic and cultural minorities and other oppressed or marginalized groups, if the system of rights is to be elaborated in a democratic fashion via politics and the law. Contra Taylor, however, such discourses cannot legitimately have as their aim the procurement of collective rights at the constitutional level, for that would undermine both the private and the public autonomy on which any legitimate actualization of the system of rights depends.[23] Where discourses aim at self-realization, whether as individual self-fulfillment or as collective cultural expression, they follow the idea of authenticity, not the idea of autonomy. Such ethical discourses do not lend themselves to the same sorts of tests for impartiality as do moral, political, and legal discourses of self-determination.

Impure Discourses

In some ways the debate with Charles Taylor involves a semantic dispute over the terms "moral" and "ethical." Yet there is a

[22] Ibid., p. 116.

[23] For the more extended argument in support of this claim, see ibid., pp. 122–35. In "Authenticity and Autonomy," Maeve Cooke argues that Habermas's conception "accords priority to autonomy over the realization of substantive conceptions of the good life." Although this does not entail the suppression of difference, nevertheless "its self-professed neutrality with regard to citizens' substantive ethical commitments and convictions disguises...a lack of neutrality: its privileging of those conceptions of the good life that affirm the priority of autonomy over the realization of individual or collective substantive goals" (pp. 274–5).

substantive issue here of relevance to the autonomy of art. If discourses of culture-political struggle are not aimed at securing self-determination, then they are not discourses of liberation. For disadvantages, privations, and the like to be perceived as forms of oppression in the modern world, a discourse of liberation must appeal to a concept or intuition of universal justice. Habermas accommodates this fact by acknowledging that actual political discourses are usually mixtures of the ethical and the moral. Yet his system of classification makes the "moral" dimension, in Habermas's vocabulary, seem like an afterthought or a merely strategic addition, rather than intrinsic to cultural-political discourses such as one finds in the feminist movement.

At the same time, Habermas's conception of autonomy cannot accommodate the freedom of agents *as participants in cultural communities*, whether those communities are based on religion, ethnicity, gender, race, or sexual orientation. His theory suggests that we can be authentic in articulating ourselves as individuals and members of communities, and we can be autonomous in making individual, political, and moral decisions, but cannot be autonomous when engaging in individual or communal self-articulation, and we cannot be authentic in the way we articulate ourselves through our individual, political, and moral decisions and actions. This suggestion is worrisome. Granted, it would be a mistake to reduce political and moral decisions to individual or communal self-articulations, or to reduce self-articulations to political or moral decisions. Nevertheless, the two types of discourse are less pure than Habermas's theory suggests.

Indeed, in much of contemporary art the political is the personal just as much as the personal is the political. Such art is made and experienced as both criticizing the status quo and articulating personal or communal identities, as aiming at both autonomy and authenticity among the participants, and as carrying out social criticism via cultural articulation and vice versa. For such art, the question is not simply whether a norm is capable of impartial justification but also whether a norm can be articulated in such a way that it solicits recognition from those who wonder about its justification. This suggests that the notion of autonomy needs to include some of the elements that Habermas reserves for the notion of authenticity.

Interpersonal Autonomy

The expanded version would go like this: human beings act as free
subjects insofar as they follow laws they not only have given them-
selves in accordance with intersubjectively acquired insights but also
have embraced in ways that genuinely articulate their own identity
and dialogically solicit recognition from others. The laws in question
can be politically framed as regulations formulated and enacted by
the state. But they can also be personal codes of conduct or orga-
nizational policies or artistic expectations. At bottom, all such laws
articulate interpretations of what societal principles such as justice
and solidarity require, and the interpretations embody intersubjec-
tively acquired insights. Yet the acquisition of insights is not restricted
to the discursive practices that Habermas seems to privilege. People
also acquire insights in nondiscursive and prediscursive ways, most
notably, in the current context, via the practices of making and inter-
preting the arts, as I have argued elsewhere.[24]

It is not enough, however, simply to follow self-given laws in accor-
dance with such insights. As implied by the notion of intersubjectively
acquired insight, freedom to decide or to act or to participate requires
openness, both openness to the sources of one's own motivations
and commitments and openness with respect to what others expect.
Openness to one's own sources in an intersubjective context is not sim-
ply a matter of being self-aware. It also requires one to articulate these
sources in a manner that not only does justice to them but also makes
them accessible for others. Similarly, being open with respect to what
others expect is not simply a matter of acknowledging their concerns.
It also involves engagement with these concerns, to the extent that one
is able. Nor can such openness to one's own sources and to others be an
afterthought in our following self-given laws. It must be intrinsic to the
process of establishing such laws and acquiring the insight that guides
our following them. Otherwise the giving of the law and the acquisi-
tion of insight will lack the freedom that comes with intersubjective
communication. To be free, human agents must not only follow self-
given laws but also genuinely embrace them in a dialogical fashion.

[24] See especially chapters 3 and 6 in Lambert Zuidervaart, *Artistic Truth: Aesthetics,
Discourse, and Imaginative Disclosure* (Cambridge: Cambridge University Press,
2004), pp. 55–73, 118–39.

This account of interpersonal autonomy seeks to avoid two pitfalls in common understandings of human autonomy. On an individualistic construal such as sustains political liberalism, autonomy comes down to a type of negative liberty. As we saw when we discussed welfare economics and minimal instrumentalism in Chapters 2 and 3, individualism reduces human autonomy to either consumer sovereignty or the exercise of individual rights. The problem with individualistic construals of autonomy is that they ignore the extent to which consumer preferences and individual rights presuppose the collective cultural formation of persons, the societal constitution of individuality, and the importance of intersubjective relations for either pursuing consumer preferences or exercising individual rights. The expanded notion of public justice suggested in Chapter 3 – expanded to encompass institutional and cultural pluralism – seeks to address these ignored presuppositions.

On a collectivistic construal such as sustains identity politics and some communitarian approaches, autonomy comes down to authentic membership in a privileged community. The problem with this construal, as Habermas points out and as Seyla Benhabib has shown in greater detail, is that it overlooks the multiplicity of sources to both personal and collective identities, immunizes these identities from criticism and self-criticism, and ignores the extent to which dialogue with others is "internal rather than extrinsic" to both personal and collective identities.[25] At the level of personal identity, to equate autonomy with authenticity is to fall "into some form of romanticized essentialism, which ascribes to each individual a unique selfhood, over and against which her actions and conduct can be judged to be authentic or inauthentic" – a judgment for which the criteria will be either opaque to the individual or inaccessible to others.[26] A similar problem besets attempts to equate autonomy with collective

[25] Seyla Benhabib, *The Claims of Culture: Equality and Diversity in the Global Era* (Princeton, N.J.: Princeton University Press, 2002), p. ix. Although I agree with Benhabib on this point, I do not endorse her view, argued in chapter 1 of *The Claims of Culture*, that all cultures are radically hybrid and polyvocal.

[26] Ibid., p. 196n1. For a detailed examination of the travails of personal authenticity in twentieth-century philosophy, see Lauren Bialystok, "Being Your Self: Identity, Metaphysics, and the Search for Authenticity" (Ph.D. dissertation, University of Toronto, 2009).

authenticity, with the added difficulty that they undermine the legitimacy of laws pertaining to multiple communities, as Habermas demonstrates in his critique of Taylor's politics of recognition.

The proposed alternative account of interpersonal autonomy does not ignore the importance of individual rights. But it resituates them in a framework where to be a person is to be culturally formed, to belong to diverse social institutions, and to participate in intersubjective relations. As Habermas indicates in a legal context, "private autonomy" and "public autonomy" presuppose one another and depend on the democratic process for legitimation. The proposed alternative also does not overlook the need for persons to belong to cultural communities and for cultural communities to maintain their identities. But it understands such belonging to be open-ended, to involve, in Benhabib's terms, "egalitarian reciprocity, voluntary self-ascription, and freedom of exit and association."[27] My alternative also regards the maintenance of communal identity as intrinsically reflexive and dialogical, such that the identity of a cultural community is never permanently fixed but always under construction and reconstruction. Like Benhabib, I resist the politics of cultural enclavism and endorse "the reflexive reconstruction of collective identities."[28]

Critical and Creative Dialogue

In order for art to support interpersonal autonomy, it must foster people's freedom both to pursue intersubjectively justifiable and self-determined norms and to articulate themselves dialogically in this pursuit. This, in turn, suggests that a larger purpose for promoting art's societal autonomy and internal autonomy, as described later, is to foster interpersonal autonomy that includes an element of self-realization. But what does it mean to exercise autonomy when people participate in the arts? The normative notion of interpersonal autonomy suggests three interlinked meanings. First, the participants, whether as producers or as audiences, must be free to follow self-given standards for artistic practices. These standards can be technical standards of competence and fit or social standards of relevance and suitability.

[27] Benhabib, *The Claims of Culture*, p. 19.
[28] Ibid., p. 70.

The most decisive standards have to do with the quality of exploration, presentation, and interpretation, all within a horizon of aesthetic validity that I have described as the societal principle of imaginative cogency.[29] To recognize such standards as their own, and to be free in following them, participants in the arts need to be critical and self-critical with respect to their own artistic practices. This is not to say that their critical and self-critical stances must always have attained discursive formulation. Yet such stances do require that the insights employed in following standards for artistic practices have been inter-subjectively acquired and are subject to intersubjective revision.

Second, autonomous participation in the arts means that the participants embrace the relevant standards, whether technical, social, or aesthetic, as ones that genuinely articulate their own identities. Note that I use the verb "articulate" rather than the more common "express." The problem with a romantic notion of expression, and of the ideal of authenticity to which it usually attaches, is that it assumes an essential core whose sources are opaque and whose manifestation is inexplicable. If the arts are thoroughly hermeneutical, as I have suggested elsewhere,[30] and if personal and communal identities are never pure, then autonomous participation in the arts cannot be a matter of simply expressing a preexisting identity. Such participation requires instead a genuine articulation of identity, one that helps construct or reconstruct the self or community even as it invites others to interpret what is being explored and presented. Nor is the articulation of identity somehow at odds with following artistic standards, as if the freedom of the self or the community consisted in the absence or mere rejection of artistic standards. Rather, these standards and their acknowledgment are part of what constitutes the identity of participants in the arts, even when the participants challenge existing standards or uncover new ones. In other words, genuine articulation of identity in the arts is creative rather than merely destructive or deconstructive.

In the third place, autonomous participation in the arts means that both the following and the embracing of artistic standards occur in openness to the expectations of other participants. The openness required concerns both relations between producers and audiences

[29] See Zuidervaart, *Artistic Truth*, pp. 62–5, 130–2.
[30] Ibid., especially p. 7.

and relations among members of an audience. One problem with individualistic construals of artistic participation is that they isolate artists from those who experience their work and turn art publics into random collections of disconnected consumers. On a postindividualist, nonprivatist, and communicative construal, by contrast, neither artists nor members of their publics are self-contained atoms. The relations they sustain with one another inflect their very participation in the arts. In a word, to be autonomous, their participation must be dialogical.

The critical, creative, and dialogical character of autonomous participation in the arts provides a counterweight to systemic pressures generated by the logic of technological innovation. At the same time, tendencies toward nostalgic pastiche and blind neomania, described in Chapter 6, pose severe challenges to autonomous participation in the arts. By freezing people into a contemporary moment, pastiche and neomania make it difficult for artists and their publics to acknowledge artistic standards in a critical fashion, to articulate complex identities in a creative way, and to be dialogically open to the expectations of other participants. One challenge facing arts organizations today is to break open the contemporary moment in order to support critical, creative, and dialogical participation.

Arts organizations that meet this challenge will also open pathways beyond the freedom-authority divide that has derailed debates about government arts funding in North America. Both those who defend the freedom of artistic expression and those who defend the authority of traditional values have problematic understandings of what it means to participate in the arts. Both sides either miss or misconstrue the freedom of artists and art publics to follow self-given standards for artistic practices and the need to be critical and self-critical in this pursuit. The two sides also fail to recognize that autonomous participants can and should embrace these standards in ways that genuinely articulate their own identities rather than treat artistic standards as either optional or externally imposed. So too, the freedom-authority divide discourages the openness to others' expectations that characterizes autonomous participation. Neither blindly defending the "freedom of expression" nor forcibly imposing "community standards" or "family values" encourages artists and their publics to engage in critical, creative, and dialogical art practices.

Instead, the debate between these two sides reinforces neomania and pastiche, with advocates of free expression tending to promote whatever is new just because it is new, as in the controversial Sensation exhibition at the Brooklyn Museum of Art in 1999, and with advocates of traditional values tending to embrace stereotypical images of an irretrievable and likely nonexistent past, as in the saccharine fabrications of Thomas Kinkade.

7.2 INTERNAL ARTISTIC AUTONOMY

The proposed notion of interpersonal autonomy has implications for the internal autonomy of art. By internal artistic autonomy, I mean the following: the constituents that make up the artistic realm have their own legitimacy and worth, and, in a modern differentiated society, they cannot be reduced to nonartistic matters without significant cultural and societal loss. It is not the artwork as such, or the artist's talent and experience, or some other single constituent that secures such legitimacy and worth, but rather the entire dynamic complex of constituents, as mediated by appropriate organizations. Described in this preliminary fashion, the notion of internal artistic autonomy does not commit one to art's uniqueness (as if only art could contribute that which makes it legitimate), or to art's superiority (as if to be worthwhile art must be better than religion or morality or politics), or to the purity of art's media (as if only certain highly refined examples can count as truly legitimate and worthwhile). Nor does this notion require that art be one-dimensional (as if, for example, its legitimacy and worth reside fully and exclusively in art's aesthetic dimension).

The key to this account lies in how one characterizes art's dynamic complex of constituents. The path of Western aesthetics lies strewn with the remains of partially successful attempts. After Kant and Hegel, most philosophers of art have focused on the internal autonomy of art and have had little to say about either art's societal autonomy or the connection between art's internal autonomy and interpersonal autonomy. They usually have tried either to argue for the uniqueness of art as a source of irreducible aesthetic value or to demonstrate that what art offers cannot be explained in terms of nonaesthetic factors. Adorno's work provides a notable exception, and it inspires my own tripartite conception of the autonomy of art. Yet Adorno's conception

of autonomy, like the claims it supports concerning modern art and the culture industry, is inherently problematic. I have addressed the problems with his conception elsewhere and need not repeat my arguments here.[31] Instead, let me summarize the alternative conception of art's internal autonomy proposed in *Social Philosophy after Adorno* and elaborate its connection with interpersonal autonomy.

Art and the Aesthetic

My conception of art's internal autonomy relies on two fundamental claims: first, that art and the aesthetic dimension of life and culture are distinct yet closely linked; second, that art itself is multidimensional, even though its aesthetic dimension is definitive in ways that technical, political, economic, and other dimensions are not. These two claims put my conception at odds with much of modernist aesthetics, which tends to equate the aesthetic and the artistic and to overlook the nonaesthetic dimensions of art. My claims have sources in Adorno's paradoxically modernist aesthetics. Like most aesthetic modernists, however, Adorno locates the key to art's autonomy in authentic works of art and in the aesthetic experience of individual artworks. My earlier discussion of "art in public" already indicates that such a focus on individual artworks is unduly restrictive. Yet I also question the anti-aesthetic and anti-artwork postures of much postmodern thought. In attacking a problematic marginalization of nonaesthetic concerns within the modern art world, postmodernism overlooks what makes art both intrinsically worthwhile and societally important.

The correct intuition in modernist aesthetics and in much of aesthetic discourse since Kant, it seems to me, is that the aesthetic dimension of art is central to art's internal autonomy. But this dimension is not restricted to art, nor is it the only important dimension of art. Accordingly, one must characterize the aesthetic dimension as both encompassing nonartistic phenomena and linking up with nonaesthetic dimensions of art. I have attempted such a characterization by

[31] See Lambert Zuidervaart, *Adorno's Aesthetic Theory: The Redemption of Illusion* (Cambridge, Mass.: MIT Press, 1991), pp. 217–47, and Lambert Zuidervaart, *Social Philosophy after Adorno* (Cambridge: Cambridge University Press, 2007), pp. 16–47, 132–54.

describing "the aesthetic" in modern Western societies as a complex of three intersubjective processes: exploration, presentation, and creative interpretation. My general term for this aesthetic dimension is "imagination." The intersubjective processes that make up imagination are tied to a wide array of institutions and practices ranging from informal recreation and adventure to more formalized cultural production and artistic activity. A great variety of entities, such as landscapes, ceremonies, and art products, can enter the processes of imagination. They do so as "aesthetic signs" that sustain intersubjective exploration, presentation, and creative interpretation. We evaluate such signs and processes in terms of aesthetic standards indicated, for example, by the notions of complexity, depth, and intensity that aesthetic theorists have formulated. We can approximate the normative horizon of these standards – the principle of aesthetic validity to which our discourses about aesthetic merit appeal – with the notion of imaginative cogency.

This characterization of the aesthetic dimension of life and culture, as institutionalized in modern Western societies, calls attention to both the pervasiveness of imagination and the inescapability of the normative horizon within which the intersubjective processes of imagination occur. The aesthetic dimension shows up in many institutions and practices, not simply in art, and so do concerns about aesthetic merit. Yet the aesthetic dimension is no more ubiquitous in society than are other dimensions of various institutions and practices, and imaginative cogency does not supersede other societal principles such as justice and solidarity.

Intersubjective imagination and the expectation of imaginative cogency are decisive for internal artistic autonomy. If the practices of making and interpreting art were simply ethical or political or economic, or if they were primarily ethical or political or economic, then they would no longer be artistic practices. So too, if art making were simply a matter of technical competence or if the interpretation of art were merely the satisfying of psychological needs, then they would lose their character as artistic practices and fail to provide what art as an institution promises. The ethical, political, economic, technical, and psychological dimensions of art, which are indeed intrinsic to art, must be aesthetically inflected. These nonaesthetic dimensions must be guided by practices in which exploration, presentation, creative interpretation, and the principle of imaginative cogency prevail.

Imaginative Disclosure

I have characterized this decisive art-internal role of imagination using a trilateral conception of artistic truth as "imaginative disclosure."[32] Describing artistic truth as involving authenticity, integrity, and significance, this conception gives as much weight to mediated intersubjective relations among artists and their publics as to the relational import internal to a work of art. Relational import may well be peculiar to *works* of art, however, as distinct from other art products and events, and it gives rise to the expectation of integrity. "Integrity" refers to the expectation that artworks will meet their own internal demands, which usually include the requirement to live up to more than their internal demands. We expect artworks to present a nuanced import in the very process of presenting themselves for exploration and interpretation.

A second relation of artistic truth pertains to our interpretation of art products and events and the expectation of significance. In modern Western societies, art products and events, whether they occur as folk art, popular art, mass-mediated art, or so-called high art, are expected to be true with respect to a public's need for cultural presentations that are worth its engaging. We commonly find some products and events of art to be more worthwhile than others in this regard, on the basis of how well they lend themselves to creative interpretation.

The third relation pertains specifically to the practices of art making, again in all forms of art, both "high" and low." Art making raises the expectation of "authenticity," by which I mean the expectation that art products and events should be true with respect to the experience or vision from which competent art making allows them to arise. In this expectation, the importance of exploration comes to the fore. I have more to say about artistic authenticity in the next chapter.

Authenticity, integrity, and significance are the three relations that make up artistic truth as imaginative disclosure. Relying on suitable media and methods – the media and methods of imagination – and giving prominence to intersubjective processes that also occur, albeit

[32] See Zuidervaart, *Artistic Truth*, especially pp. 127–34.

less prominently, in other institutions and practices, "art discloses matters of vital importance that are hard to pin down." We expect art "to be imaginatively disclosive of the experience from which it arises, of the artwork's own internal demands, and of a public's need for worthwhile cultural presentations."[33]

The prominence art gives to imaginative disclosure and the articulation art gives to the principle of imaginative cogency secure art's internal autonomy. More than anything else, imaginative disclosure aimed at imaginative cogency distinguishes art, whether "high" or "low," from other fields of cultural endeavor within modern Western societies. The arts make relatively unique contributions to human life and culture, and these contributions are worthwhile and indispensable. Because the arts are societal sites for imaginative disclosure, reducing them to economic, political, psychological, or other factors cannot explain their existence and functions. Yet imaginative disclosure does not isolate the arts. Instead, it supports individual and communal attempts to find cultural orientation and reorientation, opening windows to personal and social worlds and either affirming or disturbing the worlds we already inhabit. Products and events of art call attention to the worlds toward which they point, which often exceed the worlds already familiar to current participants in the arts.

A capacity for cultural (re)orientation is what sustains the ability of some art to open the "trivial and everyday... to the shock of what is absolutely strange, cryptic, or uncanny," in Habermas's words.[34] Yet this ability to disturb is not the sole prerogative of modern art or, more generally, of so-called high art, nor is it the only way in which the arts support cultural (re)orientation. Nor are the internal autonomy of art and its societal importance restricted to a professional art world overseen by experts and cognoscenti. Anyone who engages in the practices of art can participate in artistic truth, so long as one becomes conversant with the media and methods of imagination. For everyone is familiar already with the processes of exploration, presentation, and creative interpretation that, while especially prominent in art, also occur in a wide range of nonartistic institutions and practices.

[33] Zuidervaart, *Social Philosophy after Adorno*, p. 43.
[34] Habermas, *Between Facts and Norms*, p. 490.

Unlike many accounts of internal artistic autonomy that make the art product or aesthetic object central, my characterization calls attention to human interactions and connections. I regard art as primarily a force field of practices, organizations, and relationships rather than a collection of artifacts and experiences. Art is a social institution. This is not to deny the importance of artifacts and experiences in art, but rather to recontextualize them as ways in which human beings connect with one another. In mediating disclosive presentations and in functioning as interpretable articulations, art products and events provide reference points around which and through which human interactions can occur, both discursive and nondiscursive.

Autonomy and Participation

The internal autonomy of art calls for certain types of participation and, by fostering such participation, strengthens a certain type of agency. Specifically, the internal autonomy of art solicits and fosters a critical and self-critical pursuit of artistic standards, both aesthetic and nonaesthetic; an embrace of these standards that creatively articulates the participants' individual and communal identities; and a dialogical disclosure of the expectations that various participants bring to artistic practices, whether as artists or as art publics. Art's internal autonomy solicits and fosters (self-)critical participation because the horizon of imaginative cogency provides an inescapable principle of aesthetic validity but leaves the content of this principle open-ended. Creative articulation of identities is encouraged and required because both artists and art publics undertake practices of imaginative disclosure – artists in articulating their experience or vision, and art publics in uncovering their need for worthwhile cultural presentations. Art's internal autonomy also sustains and invites dialogical unconcealment of the participants' expectations because imaginative disclosure aimed at imaginative cogency both affirms and disturbs our personal and social worlds, freeing us to experience and consider expectations that are not our own and opening others to our own expectations.

I do not claim, however, that the arts are the *only*, or the *best*, or the *most pure* ways in which such dialogue can occur. Nor do I assert that "critical and creative dialogue" captures adequately all of the ways in

which people interact within an artistic context. Rather, I simply suggest that, in contemporary differentiated societies, what especially makes the arts worthwhile is their capacity via imaginative disclosure to generate, sustain, and renew dialogue that is both critical and creative in character. Moreover, just as in the cases of private, public, and moral autonomy the requisite freedom relies on social protections in the form of legal, constitutional, and structural guarantees, so freedom in the cases of interpersonal and art-internal autonomy depends upon macrostructural conditions provided by polity, economy, and civil society and upon cultural supports in the form of appropriate education, intellectual justifications, and the like. To the extent that artistic autonomy intersects private and public autonomy, as it surely does, legal and constitutional safeguards are also necessary for maintaining artistic autonomy.

From my normative account of internal autonomy and its links with autonomous interpersonal participation in the arts, one can see why systemically reinforced cultural exclusion and cultural balkanization put pressure on arts organizations in civil society. One can also understand, however, why maintaining art's internal autonomy, as I have described it, far from strengthening such pressures, can serve to decrease the isolation of artistic expertise from everyday practice. On the one hand, cultural exclusion and balkanization make it difficult for arts organizations to provide settings where artists and art publics alike can pursue imaginative disclosure in autonomous ways. Exclusion makes art less attentive to what needs to be disclosed, and balkanization blunts the critical, creative, and dialogical edge of participation in the arts. Together, these tendencies serve to isolate art from other institutions and practices and the participants from one another. On the other hand, arts organizations that dedicate themselves to the task of imaginative disclosure can break down barriers of communication between artistic and nonartistic endeavors, between artists and their publics, and among various art publics, while maintaining a focus on what gives the arts their intrinsic worth and societal importance.

Such arts organizations will break out of the impasse created by transgressive and reactionary vanguardism in the arts. Public debates about government arts funding in North America have pitted those who regard contemporary art as a transgressive challenge to the status quo against those who think contemporary art is leading society down

the road to destruction. Each side seizes on an element in art's internal autonomy and turns it into a distorting lens through which to view art's intrinsic worth and societal importance. The transgressivists, if I may coin a label, pick up on the need for art to be true with respect to the vision or experience that artists bring to their art making, to disclose this vision or experience in an imaginative way. But by emphasizing transgression above all else, they play fast and loose with the expectations of artistic integrity and significance. Cultural fundamentalists, by contrast, seize on the need for art to be true with respect to a public's need for worthwhile cultural presentations and consider most contemporary art to be dangerously deficient in that regard. By emphasizing art's supposed decadence, they give short shrift to the expectations of artistic authenticity and integrity.

Not surprisingly, neither side gives sufficient weight to the integrity of artistic import, arguably a primary concern of modern art and modernist aesthetics. In that sense, both transgressivism and fundamentalism belong to a "postmodern" moment in art. Isolating one relation of artistic truth to the exclusion of the other two relations, and ignoring the need for artworks to be true with respect to their own demands, transgressivism and fundamentalism undermine an internal autonomy that requires all three relations. They also cloud the horizon of imaginative cogency toward which all three relations point, thereby neglecting the role of art in disclosing personal and social worlds. Art that is not disclosive in these ways, or that is not expected to support cultural orientation and reorientation, quickly becomes merely a pawn in larger culture-political struggles. It also becomes even more vulnerable to cultural exclusion and balkanization, with transgressivists content to isolate artistic expertise from everyday practice, and with fundamentalists intent on letting a certain type of everyday practice dictate what artists should do. Despite the hostility between them, the two sides inadvertently collaborate in destroying art's capacity for cross-cultural recognition.

7.3 ART AND SOCIETY

My accounts of internal autonomy and interpersonal autonomy return us to the question whether the proposed conception of art in public is viable under current societal conditions. Does art have, or

can it have, the sort of societal autonomy that meshes with internal artistic autonomy and autonomous participation in the arts? Does art have, or can it have, the requisite mixture of independence and inter-dependence with respect to political and economic systems?

Multidimensional Art

The key to addressing this question lies in the claim, mentioned earlier, that art is multidimensional, even though the aesthetic dimension – imaginative disclosure – is decisive for art's existence and functions in modern Western societies. In particular, art has pre-cisely those dimensions where the greatest systemic threats to art's autonomy occur: technical, political, and economic. At a superficial level, the presence of these dimensions in art seems incontrovertible, despite the lack of attention given them by many philosophers of art. Art employs and revises the latest technologies; art figures in polit-ical controversies and public policies; art products operate as eco-nomic commodities under laws governing ownership and use. Yet each dimension is more complex than it initially appears, and such complexity frames the possibilities for art's societal autonomy.

In the technical dimension, for example, one needs to distinguish between social technologies and artistic techniques. "Technology" refers to instruments and procedures of production and distribution, such as televisual and computer technologies, that art shares with other fields of human endeavor. "Technique" designates media and methods that are somewhat unique to art itself, for example, frag-mentary repetition of tonal sequences in minimalist music and site-specific installations in the visual arts. As I suggest elsewhere, social technologies and artistic techniques, which interact and intersect, together constitute the technical dimension of the arts.[35]

Moreover, the aesthetic dimension of art is directly dependent on art's technical dimension. Any imaginative disclosure in art presup-poses the employment of appropriate technologies and techniques in the making and interpreting of art products and events. That is why, as I indicated earlier, autonomous participation in the arts requires that artists be competent in making art and art publics be conversant

[35] Zuidervaart, *Social Philosophy after Adorno*, p. 35.

with artistic techniques. Otherwise there is no sufficient basis for undertaking the sorts of exploration, presentation, and creative interpretation that art makes possible. At the same time, technologies and techniques that are not attuned to the task of imaginative disclosure quickly lose their status as artistic ones: imaginative disclosure is decisive for the constitution of art as art, also for art's technical dimension. This is an important reason why arts organizations need to resist pastiche and neomania and lift the technological veil.

The political dimension of art exhibits a similar complexity. The "politics of art" is not simply a matter of how art functions in political struggles and political institutions external to "art proper." It also pertains to political import and impact that occur in the very making and interpreting of art. Participants in the arts do not leave their political convictions and positioning behind, as if art were a neutral sanctuary of apolitical purity. What they desire as citizens and how they struggle for equity and recognition inform what art making articulates, what art publics find worthy of interpretation, and how both the articulation and the interpretation occur. So too, the import of art is not politically irrelevant. It calls attention to personal and social worlds in which political convictions and positioning matter. That is why, as Chapters 3 and 4 argued, art in public can disclose issues and interests of public concern and can emphasize nuanced consideration of public matters.

The economic dimension of art also exceeds the operations of art products and events in a proprietary economy. Economically, such products and events are not simply commodities. The potential "exchange value" of artworks does not explain why many artists devote so much time and talent to making works of art. For artists, and for art publics too, the economic worth of their activities does not equal the price of the transaction. The reason for this is not simply that, on Marx's analysis, price and exchange value are not the same or that the production of commodities under capitalist conditions typically involves the creation of surplus value.[36] The reason is

[36] Karl Marx, *Capital: A Critique of Political Economy* (1867), vol. 1, trans. Samuel Moore and Edward Aveling, ed. Frederick Engels (New York: International Publishers, 1967), pp. 35–230. Although it might be possible to account for "aesthetic value" in terms of "use value," I do not think that Marx's notion of use value adequately captures the economic worth of imaginative disclosure.

also that, when engaging in artistic production and use, participants in the arts orient their concerns about economic worth to the quality of the imaginative disclosure that takes place, and this "aesthetic value" unsettles standard measurements of "economic value." The economic worth of art products and events cannot be equated with either their exchange value or their price.

Nevertheless, as was shown in Chapter 6, contemporary economic and political systems put enormous pressures on arts organization to align art with the logics of money and power, to accede to hyper-commercialization and performance fetishism. Hence, the question of art's societal autonomy is an urgent matter. What sorts of societal structures and social institutions are required in order for the arts to maintain appropriate relationships with political and economic systems? And how are such relationships connected with internal and interpersonal autonomy?

Interlinkage

Given both art's multidimensional character and the differentiated complexity of modern Western societies, the key to societal autonomy cannot lie in either isolating art from other social institutions or erecting protective barriers around it. Rather, the key lies in how art and other social institutions interlink and whether society's macrostructures support interlinkages that permit and encourage art's societal autonomy. Just as interpersonal autonomy should not be reduced to negative liberty, and just as art's internal autonomy should not be equated with one-dimensional aesthetic purity, so art's societal autonomy should not be regarded as a freedom to be separate from the rest of society. Even when challenging existing patterns and tendencies in society, art remains, in Adorno's words, a *social* antithesis of society. Like internal and interpersonal autonomy, art's societal autonomy involves relationships that are not simply negative. The normative notion of freedom at stake here is a matter not only of relative independence but also of proper interdependence. The autonomy of art is a matter of relational autonomy.

The crucial relationships for art's societal autonomy in contemporary Western societies lie between art and the dominant economic and political systems. How should art relate to the proprietary

economy and administrative state? More specifically, how should
arts organizations position themselves with regard to commercial
businesses and formally democratic governments? The preceding
discussion makes clear that arts organizations should focus on imagi-
native disclosure and should foster critical, creative, and dialogical
participation in the arts. But they should not pretend that art lacks
economic and political dimensions or that these organizations stand
outside the economic and political fray. Rather, as I have argued in
Social Philosophy after Adorno, arts organizations need to develop coun-
tereconomic and counterpolitical spaces where proper participation
in imaginative disclosure can thrive. These spaces cannot be overly
dependent on the corporate economy and on state agencies but must
emerge from the activities of arts organizations and from the agency
of their participants. Such spaces are definitely economic and politi-
cal, but they are aligned with the expectations of a social economy
and democratic communication and are not simply sites for market
competition and governmental power.[37]

Previous chapters have pointed in this direction, emphasizing the
role that arts organizations can play at the intersections between civil
society and the proprietary economy and between civil society and
the administrative state. Noncommercial and nongovernmental arts
organizations are both elements and agents of the civic sector and
the public sphere. In principle they operate in a social economy and
within networks of public communication. They thereby help provide
counterweights to the proprietary economy and the administrative
state and help secure the societal autonomy of art.

Given the pressures of hypercommercialization and performance
fetishism on all civic-sector organizations and on the public sphere,
however, arts organizations cannot maintain art's societal auton-
omy all on their own. They need to form partnerships with other
organizations that have similar social-economic and communicative
profiles, not only in the arts but also in education, research, health
care, social advocacy, and other areas. Such partnerships do not pre-
clude strategic alliances with commercial businesses or selective par-
ticipation in the delivery of government programs. Nevertheless, arts
organization need to be clear about the limits to such alliances and

[37] See Zuidervaart, *Social Philosophy after Adorno*, pp. 145–8.

participation, in order to avoid a dependency that opens even wider the floodgates of hypercommercialization and performance fetishism. Partnerships in the civic sector and public sphere are a priority if arts organizations are to make art-appropriate contributions and receive art-appropriate support of an economic or political sort.

Macrostructural Shift

Differential Transformation

Partnering with other organizations in the civic sector and public sphere will help arts organizations contribute to a shift in the macrostructural conditions that make art's societal autonomy possible. I refer here to a structural change that I have labeled "differential transformation."[38] Differential transformation is a significant change in contemporary society as a whole. It occurs at differing levels (social institutions, cultural practices, and interpersonal relations), across various structural interfaces (among economy, polity, and civil society), and with respect to distinct societal principles (especially resourcefulness, justice, and solidarity).

The change envisioned would be a society-wide transformation and not simply a modification at one level or one structural interface. Yet this transformation would be differential, involving mutually reinforcing developments across the various levels and interfaces and strengthening the legitimate differentiation of macrostructures and societal principles that is a historical achievement in Western society. Differential transformation would redirect the proprietary economy away from the maximization of private profit toward the societal principle of resourcefulness. It would redirect the administrative state away from merely bureaucratic power toward a genuinely democratic pursuit of public justice. It would also allow societal principles such as resourcefulness, justice, and solidarity, which are distinct and pervasive, to be in effect across the board and not be relegated to separate zones within society. The envisioned redirection of economic and political macrostructures, along with complementary changes in civil society, would generate freedom to pursue a life-giving disclosure of society.

[38] Ibid., pp. 126–31, 162–75.

Chapter 5 highlighted the need for differential transformation when it pointed to complementary normative distortions in economy, polity, and civil society and identified hidden elements of a social economy in the proprietary economy and administrative state. A similar case could be made for hidden elements of a social polity – a tendency toward genuine democracy – in both of these macrostructural systems. In the long run, art will not maintain the sort of societal autonomy that internal autonomy and interpersonal autonomy both foster and require unless the systems of society pursue resourcefulness and justice in ways that complement rather than undermine solidarity in civil society. That is another reason why arts organizations cannot maintain art's societal autonomy all on their own, as well as a reason why arts organizations need to contribute to a macrostructural shift.

Habermas Revisited

One can find clues to this linking of art's societal autonomy and a macrostructural shift in Habermas's emphasis on the role of "autonomous public spheres" in democratic processes of law and politics. *Between Facts and Norms* describes the public sphere "as a communication structure rooted in the lifeworld through the associational network of civil society." It serves "as a sounding board for problems that must be processed by the political system," and it encompasses many distinct publics.[39] Habermas explains that this structure is not an institution, an organization, a framework of norms, or a system. Rather, it is "a network for communicating information and points of view" that allows "streams of communication" to "coalesce into bundles of topically specific *public* opinions. Like the lifeworld as a whole, so, too, the public sphere is reproduced through communicative action."[40]

Habermas accords special significance to autonomous public spheres because he regards solidarity as an endangered "resource" for social integration that is weaker than the resources of money and administrative power. Were the money and power concentrated in

[39] Habermas frequently uses the term "public spheres" (plural) without indicating how it relates to the notion of "the public sphere" (singular). Occasionally, as in the sentence to which this note is appended, I substitute the term "publics" for "public spheres."

[40] Habermas, *Between Facts and Norms*, pp. 359–60.

economic and political systems to win out altogether, democratic processes would become societally untenable. Hence, autonomous public spheres are required as solidaristic counterweights to money and power and as channels through which democratic discourses can flow: "From a normative standpoint, this understanding of democracy requires a realignment in the relative importance of the three resources from which modern societies satisfy their needs for integration and steering: money, administration, and solidarity. The normative implications are obvious: the socially integrating force of solidarity... must develop through widely diversified and more or less autonomous public spheres, as well as through procedures of democratic opinion- and will-formation institutionalized within a constitutional framework. In addition, it should be able to hold its own against the two other mechanisms of social integration, money and administrative power."[41] From this position one needs only a few more steps to arrive at the prospect of a macrostructural shift.[42]

Despite his emphasis on autonomous public spheres, however, Habermas does not consider in detail how the arts might be configured within them, what the arts might contribute to the development of solidarity, and how they might carry "currents of communication and public opinion that...are converted into communicative power through democratic procedures" and that constitute "the social substratum for the realization of the system of rights."[43] Such relative silence on the arts, at the very point where Habermas reaches "the core" of his proceduralist paradigm of law,[44] is all the more curious given his gesture toward modern art as a site of negative transcendence. One would have thought that, as an agent of openness to "what is absolutely strange, cryptic, or uncanny," the arts would

[41] Ibid., p. 299.
[42] These are not small steps, however. For example, as should be apparent from my discussion of economic solidarity in Chapter 5, I regard solidarity as a societal principle that holds not only for civil society but also for the proprietary economy and the administrative state. For that reason, I do not fully endorse Habermas's treating it as a "resource" or "mechanism" lined up against two other "resources" or "mechanisms," namely, money and power.
[43] Habermas, *Between Facts and Norms*, p. 442.
[44] See ibid., p. 442, where "reciprocal mediation of legally institutionalized and noninstitutionalized popular sovereignty" (a quote from Ingeborg Maus) is described as "the key to democratic genesis of law."

figure prominently among the channels through which to resist the dominance of money and power and among the democratic processes through which to pursue "public" and "private" autonomy.

There are some obvious reasons why *Between Facts and Norms* does not thematize art when it discusses the public sphere. First, the book discusses publicity (*Öffentlichkeit*) primarily with reference to political institutions – as a political public sphere – and not as a cultural public sphere. Second, whereas Habermas conceives of the public sphere as an *informal* nexus of communication, he regards art as a *system* that takes up a validity aspect of everyday communicative action, namely, veracity (*Wahrhaftigkeit*). Third, he tends to limit the content of communication in the public sphere to "information and points of view,"[45] thereby excluding images and other nondiscursive or prediscursive modes of experience. At the same time he tends to segregate art, where nondiscursive modes of experience flourish, from content "systems" such as science and morality in which universalizable claims are raised and adjudicated. As a result, Habermas's conception diminishes art's potential for being politically relevant either through the formation of public opinion or through interaction with scientific and moral discourses that thematize universalizable claims about truth and justice.

When Habermas does mention the arts in connection with the public sphere, he highlights their capacity to give expression to "personal life experiences" as affected by the performances and failures of "functional systems." Here, while not relegating art and literature to what he calls "private spheres," Habermas restricts their political relevance to expressing private and personal experiences in ways that allow "socially generated problems" to be "*assessed in terms of one's own life history.*"[46] In other words, Habermas thinks the arts can play a role in ethical-*existential* discourse. He does not seem to recognize the contribution of the arts to ethical-*political* discourse in the public sphere, despite their obvious centrality in the cultural politics of emancipatory social movements such as feminism. Moreover, it would seem that the more specialized art is as a "system" for sorting out veracity claims, the less it can contribute to ethical discourse of either

45 Ibid., p. 360.
46 Ibid., pp. 365–6.

sort. And the art that can contribute must do so by expressing personal experiences, not by providing a forum in which matters of public concern can be imaginatively disclosed.

Autonomy and Transformation
In its emphasis on the artistic system and personal experience, Habermas's view of the arts remains deeply indebted to Adorno's paradoxical modernism. Along with this debt, he shares a tendency to understand art's autonomy in such a way that the arts become more or less irrelevant for cultural politics. Whereas Adorno's emphasis on artistic truth content isolates art from cultural politics, while continuing to insist on the political significance of the import of authentic works of art,[47] Habermas's emphasis on autonomous public spheres suggests the relevance of art for cultural politics, while isolating artistic import from the spaces where it could have political relevance. The challenge for their successors is to give an account of art's societal autonomy that does not isolate art, and to give an account of art's internal autonomy that does not reduce its internal constituents to expressions of personal experiences. My tripartite account of art's autonomy has tried to meet this challenge.

In addition, however, I have tied the prospects for art's societal autonomy to the differential transformation of society as a whole. Unlike Habermas, I do not regard art as a specialized system for taking up matters of veracity. His view of art as a specialized system marginalizes it with respect to the centers of money and power – the economic and administrative systems – and leaves those centers immune to the alternatives and challenges articulated and enacted in art.

This marginalization suggests yet another reason why *Between Facts and Norms* does not say much about art. Perhaps, unlike Adorno, Habermas does not theorize the implications of art for structural transformation because the project of society-wide transformation has faded from view. Although Habermas holds out the hope that different areas of society can undergo internal transformation, he seems to have given up the Marxian notion of a society-wide transformation linked to fundamental change in the economic system,

[47] For an argument to this effect, see Zuidervaart, *Adorno's Aesthetic Theory*, pp. 141–9, 217–47.

writing that "democratic movements emerging from civil society must give up holistic aspirations to a self-organizing society, aspirations that also undergirded Marxist ideas of social revolution. Civil society can directly transform only itself, and it can have at most an indirect effect on the self-transformation of the political system."[48] Perhaps Habermas's abandoning the project of economic and society-wide transformation is what turns modern art into a site of negative transcendence.

By linking the prospects for art's societal autonomy with a differential transformation of society as a whole, I take issue with a vision of law and democracy that seems too modest. While not embracing indiscriminate holism, according to which either economic or political revolution would change society as a whole, I retain the Marxian critique of the capitalist system as inherently totalizing and exploitative. I consider economic transformation to be unavoidable if "colonization of the lifeworld" is to end. The macrostructures of contemporary society are interlinked, both in their normative deficiencies and in their structural potentials. A transformation of civil society that did not accompany a complementary transformation of economic and political systems would not generate freedom for life-giving disclosure.

That is why, as interfaces between civil society and economic and political systems, the civic sector and public sphere are crucial and why the role of art at these interfaces needs emphasis. By making a social economy and public communication central to their missions, arts organizations can foster critical, creative, and dialogical participation in the task of imaginative disclosure. In fostering such participation, they can point toward the differential transformation of society on which their own futures, and the future of art's autonomy, depend.

[48] Habermas, *Between Facts and Norms*, p. 372.

8

Authenticity and Responsibility

No artwork...can be socially true that is not also true in-itself.
Theodor W. Adorno[1]

The proposed link between differential transformation and art's
societal autonomy raises questions about autonomous participation
in the arts. Would promoting this link so "politicize" art making and
art interpretation that participation in the arts cannot be creative
and dialogical? Would it in fact replace the opposed vanguardisms of
transgressivists and fundamentalists with problematic progressivism
of a different sort, burdening art with the task of changing society as
a whole? Have I simply turned Adorno's paradoxical modernism into
an equally paradoxical post-postmodernism?

To begin to address these questions, and to elaborate my concep-
tion of interpersonal autonomy in the arts, this chapter explores a
tension between authenticity and social responsibility in contempo-
rary artistic practices. Although one can note earlier forms of this
tension in modernist aesthetics, and although Adorno gave it par-
ticularly telling formulations, the shape of the tension has shifted
in recent years. Adorno thought that modern art was one of the few
places left where capitalist society can be challenged and genuine
alternatives can be envisioned. Since his death in 1969, Adorno's

[1] Theodor W. Adorno, *Aesthetic Theory*, trans. Robert Hullot-Kentor (Minneapolis:
University of Minnesota Press, 1997), p. 248.

241

combination of aesthetic modernism and radical social critique has become increasingly difficult to sustain. This is due in part to contemporary tension around the ideal of artistic authenticity.

One can see precursors to this tension in modern art and modernist aesthetics. On the one hand, modernists expect artists to devote themselves to their aesthetic tasks, and not to be distracted by questions of morality, politics, or religion. On the other hand, the terms in which modernists recommend this singular devotion have unmistakably moral, political, and religious overtones. They believe that what is artistically good is also good for society, that artistic progress promotes social progress. As Adorno puts it in this chapter's epigraph, an artwork's authenticity (its being "true in-itself") is a necessary precondition for its having socially critical potential (its being "socially true"). And, he adds, such authenticity cannot arise from social false consciousness, which is "incapable of becoming aesthetically authentic."[2] This, despite notoriously difficult cases such as the composer Richard Wagner[3] and the filmmaker Leni Riefenstahl.

In recent years, modernist notions of authenticity have come under attack from social conservatives who wish to uphold the authority of traditional values. Moreover, those who respond to the social conservatives by defending the freedom of artistic expression often are unclear about how art making should be authentic. These, roughly, are the two camps that have squared off in North American debates about government funding for the arts. The terms and the fervor of their debates suggest that certain modernist assumptions might no longer hold sway. This possibility also affects the reception of Adorno's aesthetics. Yet what distinguishes Adorno's approach from that of other aesthetic modernists, and what helps make his modernism paradoxical, is that he puts authenticity and social critique into a dialectical relationship. His dialectical approach suggests a pathway through and beyond the contemporary freedom-authority impasse.

Two concepts in particular need to be reexamined in light of such debates. One is the notion of authenticity, so central to much of

[2] Ibid.
[3] See Theodor Adorno, *In Search of Wagner*, trans. Rodney Livingstone (London: Verso, 1981).

modern art and modernist aesthetics. The other is an idea of social responsibility, to which both critics and advocates of artistic freedom appeal, albeit with conflicting understandings and implications. Artistic authenticity and social responsibility often seem to be contradictory expectations in contemporary culture. Taking a hint from Adorno's dialectic, however, I argue that they in fact depend upon each other and form a creative tension. Moreover, certain forms of contemporary art in public demonstrate this creative tension. There one finds new practices of art making and art interpretation in which authenticity and responsibility can go hand in hand. Critical, creative, and dialogical participation in the arts can flourish when authenticity and responsibility meet.

8.1 IMMIGRANT CHILDREN

Let me discuss an example before I develop these concepts at greater length. I begin with a poem by Linda Nemec Foster titled "Immigrant Children at Union School":

> We come from Bratislava and Wroclaw,
> Budapest and Prague, Minsk and Tulcea:
> a veritable United Nations in my kinder-
> garten class. Our halting English
> frustrates the teacher but never our-
> selves – we know what we're trying to say.
> We color and paint and draw and listen
> to a story read aloud about a missing
> princess and the poor peasant boy
> who must find her. All the girls
> want to be the princess, all the boys
> want to be the peasant. I just want
> to be here in America, in Ohio,
> in Cleveland, living on Salem Avenue
> four houses from my grandparents,
> and walking to Union School every
> morning holding my grandfather's
> right hand. In other words, I hardly want
> anything else. But maybe three things:
> to be smart enough to read English
> and brave enough to scold that princess
> for getting lost and kind enough not

> to make fun of the girl from Hungary
> with the bright red ribbon in her hair
> who always draws her cats with eight legs.[4]

American poet Linda Nemec Foster grew up in a Polish Catholic neighborhood of Cleveland, Ohio. Her poems carry the aroma of everyday life – "halting English," "a story read aloud," the walk to school "holding my grandfather's right hand." I know her through my work at the Urban Institute for Contemporary Arts (UICA), the community-based arts center where she chaired a volunteer committee that organizes public literary events. For more than three decades she has traveled the state of Michigan teaching young people to write and interpret poetry. Both her poetry and her teaching display commitments to artistic authenticity and social responsibility that arise in part from her religious and ethnic background.

In the 1990s UICA sponsored Linda's grant proposal to the Arts Foundation of Michigan for a poetry project on the themes of cultural heritage and ethnic identity. While creating a collection of new poems about her Polish background, including "Immigrant Children at Union School," Linda spent three days at a local public school serving primarily Hispanic and African American students. She wanted to help the students write poetry about their identity and heritage. Her experience at the school offers instructive clues to the creative tension I wish to explore.

Picture the scene at Hall Elementary School in the spring of 1996. The fourth- and fifth-grade students are shy, maybe a little scared. They have never tried to write autobiographical poetry. As Linda's hearty laugh and infectious smile fill the room, memories and experiences find words on the students' papers. Words of hope and fear, of joy and sorrow, of loneliness and community, of violence and peace. Words both true with respect to the students' lives and socially significant.

When Linda arrives on her third day, the local news media are out in full force. The day before a teenager had shot at a bus outside the school, sending glass flying and striking terror into young

[4] Linda Nemec Foster, "Immigrant Children at Union School," in *Amber Necklace from Gdansk: Poems* (Baton Rouge: Louisiana State University Press, 2001), p. 10.

hearts. Eleven-year-old Kenya Sturdivant writes an "I Am" poem that concludes as follows:

> I understand why the world is like this
> I say the world could be better
> I dream there was no violence
> I try to make my friends stop violence
> I hope my kids won't have to live like this
> I am from America and Kenya[5]

I first heard Kenya's poem when she read it during a public event at UICA. Families and friends sat with the students. Many had never visited an arts center before. They listened proudly as the students came forward to read their poems and local media recorded the event. I did not know about the shooting incident when I heard Kenya's poem. But one did not need this information to be moved by an eleven-year-old girl saying in public "I hope my kids won't have to live like this / I am from America and Kenya." Although she was not a professional artist, and although her poem began as a school exercise, one caught glimmers of both social engagement and aesthetic honesty in the way she read her poem. The poem would never have been written, however, nor would it have been read aloud, were it not for instruction and encouragement provided by a published writer who cares deeply about poetry, education, and the future of her society.

Might not this story provide a suitable image for art in public today? Several civic-sector organizations and government agencies play a role: a community-based arts center, a private arts foundation, a state cultural agency, a tax-supported school, and public broadcasters. Commercial media and publishers also contribute by covering the event, by writing about Linda's work with schoolchildren, and by publishing her poetry. Equally important is the fact that the public in this case is not a homogeneous slice of the middle class, but a rich mixture of classes, ethnicities, religions, and educational backgrounds – "a veritable United Nations." The key, however, lies in the

[5] From *A Poetry Sampler on Two Themes*, prepared by the fourth and fifth graders of Hall Elementary School, ed. Linda Nemec Foster (Grand Rapids, Mich., May 1996), with support by a grant from the Arts Foundation of Michigan, in conjunction with the Michigan Council for the Arts and Cultural Affairs. Kenya Sturdivant's poem also appears in "Poetry in Motion," a story by Terri Finch Hamilton in the *Grand Rapids Press*, April 3, 1996, pp. C1–C2.

commitment of a professional writer to interact with amateurs in her field and with a wider public. From Linda Nemec Foster's ethnic heritage and public schooling and religious faith arises a strong commitment to interactive border crossing in the creation of culture.

Such a commitment finds only tentative support within the insular spaces of the academy and the professional art world, which nevertheless frame Foster's work. Nor does it come easily to religious and ethnic groups more concerned to maintain their status and traditions than to learn from others or to share their own resources, even though religious and ethnic traditions have nurtured Foster's commitment. Organizations dedicated to art in public will look quite different from the middle-class enclaves that many cultural organizations have become. To help develop arts organizations that embrace critical and creative dialogue, scholars and public intellectuals need to develop a new understanding of autonomous participation in the arts.

Specifically, I want to consider the ideas of authenticity and social responsibility that figure prominently in the work of contemporary artists such as Linda Nemec Foster. Let me first introduce the concept of artistic authenticity before I mention additional artistic examples and explore the concept of social responsibility. I begin with an account of the closely related concept of ethical authenticity.

8.2 CONTESTED CONCEPTS

Artistic Authenticity

Charles Taylor argues in *The Ethics of Authenticity* that the modern notion of personal authenticity is a valid ethical ideal.[6] He tries to

[6] Charles Taylor, *The Ethics of Authenticity* (Cambridge, Mass.: Harvard University Press, 1992). For a more sustained systematic and historical argument, see Charles Taylor, *Sources of the Self: The Making of the Modern Identity* (Cambridge, Mass.: Harvard University Press, 1989). Although Taylor considers authenticity to be a *moral* ideal, I use the term "ethical" instead, in keeping with Habermas's characterization of authenticity as an *ethical* ideal, as was discussed in Chapter 7. One issue in dispute between Taylor and Habermas is whether authenticity is itself a moral ideal, or simply a necessary condition for the pursuit of morality in contemporary Western societies. See in this connection Maeve Cooke, "Authenticity and Autonomy: Taylor, Habermas, and the Politics of Recognition," *Political Theory* 25 (1997): 258–88, and Alessandro Ferrara, *Reflective Authenticity: Rethinking the Project of Modernity* (New York: Routledge, 1998).

rescue this ideal both from reactionary critics of contemporary culture who disparage authenticity and from progressive advocates who fail to articulate its moral sources. He also suggests that modern artistic creation is an especially crucial site for envisioning and contesting this ideal.[7] Taylor describes the ethical ideal of authenticity as a commitment to personal originality. It is the imperative to be "true to oneself." By calling this a "moral ideal," Taylor means that it is "a picture of what a better or higher mode of life would be," such that it offers "a standard of what we ought to desire."[8] As he elaborates, "Being true to myself means being true to my own originality, and that is something only I can articulate and discover. In articulating it, I am also defining myself. I am realizing a potentiality that is properly my own.... This is the background that gives moral force to the culture of authenticity, including its most degraded, absurd, or trivialized forms."[9] Although some contemporary forms of culture might make the pursuit of authenticity seem either amoral or immoral, Taylor argues that the dialogical character of human life and the inherent demands of authenticity itself can prevent the ideal from collapsing into mere narcissism and egoism.

As Taylor indicates, this ethical ideal is closely related to notions of authenticity that figure prominently in modern art and modernist aesthetics. I say "notions," in the plural, because at least three different concepts are linked to "authenticity" in the vocabulary of modernist aesthetics.[10] The first concept has to do with authenticity of performance, in the sense of being faithful to the original artwork. This is the concept musicians employ when they talk about "authentic instruments" for the "authentic performance" of, say, baroque music. The second concept has to do with the authenticity of the artwork itself, in the sense that the work is original, unique, and genuine – not derivative, not replaceable, and not a forgery. This is the concept Adorno employs, with modifications, to argue that no artwork can be

[7] In fact, Taylor takes his cue for identifying authenticity as a powerful ethical ideal from Lionel Trilling's interpretation of modern literature in *Sincerity and Authenticity* (Cambridge, Mass.: Harvard University Press, 1972). See Taylor, *Ethics*, pp. 15–16.
[8] Taylor, *Ethics*, pp. 15–16.
[9] Ibid., p. 29.
[10] See the entries on "authenticity" in *A Companion to Aesthetics*, ed. David E. Cooper (Cambridge, Mass.: Blackwell, 1992), pp. 27–33.

"socially true" if it is not authentic. The third concept has to do with authenticity in art making, in composing, writing, painting, and the like. This is the expectation that the artist should make something original that is true with respect to the experience or vision from which competent art making allows an art product or art event to arise. One writer expresses the expectation as follows: "Authentic artists are supposed to have their own style and viewpoint; we look to them to 'make it new,' to use their unique perspective and experience to confront us with the ambiguous and unexpected. When they succeed, their work offers a model of the alert and critical mentality required for a life lived according to the ethical ideal of authenticity."[11]

Of these three concepts – authenticity in performance, authenticity of the artwork, and authenticity in art making – I believe that the third has been the most influential in shaping artists' self-understanding. Moreover, the concept of authenticity in the making of art most closely parallels the ethical ideal of authenticity, as the passage just quoted indicates. In what follows I emphasize the concept of authenticity in the artist's making of art products and events, and for that I use the term "artistic authenticity." Artistic authenticity is the expectation that artists should undertake artistic practices with a view to creating original products or events that are true with respect to the experience or vision that sustains their art making. An expectation along these lines, combined with an emphasis on authentic artworks (i.e., original, unique, and genuine), has been central to modern art and to modernist aesthetics. Later I shall suggest that an expectation of authenticity also holds for how audiences participate in art.

On one side, then, we have the ethical ideal of being true to oneself and one's own originality, as articulated and discovered for oneself. On the other side, we have the modernist artistic expectation of the artist's making art that is true with respect to the artist's own experience or vision, and doing so in ways that are compelling and possibly unexpected. Perhaps the connection from one side to the other is stronger than a mere parallel. Perhaps, as Charles Taylor sometimes suggests, the one is an indispensable metaphor for the other, such that we cannot interpret the ethical ideal apart from practices and agents that enact the artistic expectation – and also the other

[11] Paul Taylor, "Authenticity and the Artist," in Cooper, *A Companion to Aesthetics*, p. 29.

way around. On that hypothesis, a shift involving artistic authenticity would be significant for an interpretation of ethical authenticity.

At this point, however, Taylor's account comes up short, for his references to the arts do not go beyond the modernist period. He has little to say about artistic practices and self-understandings of the past few decades. Nor does he seem to recognize the tension in recent decades between a modernist emphasis on personal authenticity and contemporary emphases on community, collaboration, and political commitment. That tension needs to be explored, not only in ethics but also in aesthetics. Moreover, if, as Taylor argues, the ethical ideal of authenticity must be rescued from both reactionary critics and progressive advocates, then perhaps artistic authenticity needs a similar retrieval. Such retrieval might help us reinterpret recent emphases on community, collaboration, and commitment.

New Genre Public Art

In fact, developments in what Suzanne Lacy calls "new genre public art" raise questions about the meaning and validity of authenticity as an artistic expectation. These developments hold great theoretical interest and societal significance. Artistic practices have arisen that aim to empower a community or to promote a social cause rather than uniquely articulating an artist's experience or vision. Let me call attention to a few projects, in the hope that readers know about these projects or others like them. My examples do not represent the full range of contemporary art, but they call attention to a field within contemporary art that raises questions about the expectation of artistic authenticity.

The first project is called *Womanhouse*. It grew out of the Feminist Art Program begun by Miriam Schapiro and Judy Chicago at the California Institute of the Arts in Valencia. Over several months in 1972, the two artists and their twenty-one students, joined by three women artists from Los Angeles, converted a dilapidated Hollywood mansion into what Charlotte Streifer Rubenstein describes as "a repository of the fantasies, frustrations, and nightmares of women."[12]

[12] Charlotte Streifer Rubenstein, *American Women Artists* (Boston: G. K. Hall; New York: Avon Books, 1982), p. 406.

Rubenstein portrays the results as follows: "When the public walked through the various rooms they found themselves in another world... A bathtub was filled with sand into which a female figure seemed to be sinking.... The kitchen ceiling was covered with fried eggs made out of plastic that also resembled breasts. In a bedroom a woman... sat endlessly painting her face with makeup, hour after hour. A manikin was stuck fast in a linen closet, trapped in the sheets and pillow cases. According to news reports, some women walked through the rooms and burst into tears, overwhelmed by a sudden sense of the futility of their own lives."[13] By all accounts, the project caught the public's imagination, and it constituted a profound consciousness-raising experience for the artists and their students.

Another project is *The Great Wall of Los Angeles*, begun in 1976. Under the direction of Judith Baca, hundreds of teenagers were hired and taught over many summers to create a huge mural in a flood control channel of the Los Angeles River. The mural provides an alternative history of California, portraying the struggles and contributions of those whom official histories have left out: indigenous peoples, immigrant minorities, and women. One commentary notes that the monumental logistics for this project includes "cooperation from the Army Corp of Engineers, the city, local politicians, teachers, anthropologists, teenage gang members and the criminal justice system, among others. Its strategy aims at political activism and education through art."[14]

The third project I want to mention is *The Dinner Party*. This grand five-year effort involving hundreds of women and several men aimed at building a provocative and loving memorial to the contributions women have made to culture and history.[15] Collaborative projects of more recent years include the AIDS Memorial Quilt, which I discussed in Chapter 4, and Jim Hubbard's photography project for

[13] Ibid., p. 411. For additional commentary on the aims and political context of this "*Gesamtkunstwerk* of women's images," see Irving Sandler, *Art of the Post-Modern Era: From the Late 1960s to the Early 1990s* (New York: Icon Editions, 1996), pp. 118–20.
[14] Suzanne Lacy, ed., *Mapping the Terrain: New Genre Public Art* (Seattle: Bay Press, 1995), p. 202.
[15] See the catalog by Judy Chicago, *The Dinner Party: A Symbol of Our Heritage* (Garden City, N.Y.: Anchor Books, 1979).

homeless children called *Shooting Back*, to which I make reference in Chapter 9.[16] The commitment in such projects to empowering a community or challenging oppressive conditions differs from a modernist attachment to personal self-articulation through unique artworks. Indeed, it seems to clash with the modernist expectation of artistic authenticity, of the artist's making something original that is true with respect to the artist's own experience or vision.

Like Linda Nemec Foster's interactive poetry project, the projects just mentioned are examples of new genre public art. Suzanne Lacy says that new genre public art "uses both traditional and nontraditional media to communicate and interact with a broad and diversified audience about issues directly relevant to their lives." Unlike older forms of public art, new genre public art "is based on engagement" and involves a high degree of collaboration. Because it aims at social intervention, it has a highly developed "sensibility about audience, social strategy, and effectiveness."[17] Whereas detractors take the emphasis on social intervention as evidence that new genre public art is not art at all, I take it as a sign that artists themselves are questioning modernist notions of authenticity in favor of a new emphasis on social responsibility.[18]

Social Responsibility

The new emphasis on social responsibility is not immediately transparent, however, for the idea of social responsibility is as complex as it is diffuse. Often people equate it with moral or ethical responsibility. But I think that "social responsibility" indicates a more specific idea. To say of artists that they have a social responsibility is not simply to say that as individuals those people who happen to be artists ought to be moral and ethical in their persons and their conduct. This

[16] Collected in *Shooting Back: A Photographic View of Life by Homeless Children*, selected by Jim Hubbard, introduction by Dr. Robert Coles (San Francisco: Chronicle Books, 1991).

[17] Lacy, *Mapping the Terrain*, pp. 19–20.

[18] The emphasis on social responsibility is "new" relative to much of modern art and modernist aesthetics. It is not so new relative to politically engaged art making that never entirely fit the modernist model or relative to art in cultures that have not undergone the process of modernization that gave rise to "fine art" or "high art" during the past few centuries in Europe and North America. I thank Hilde Hein for remarks on a draft of this chapter that reminded me of this point.

would not pick out what is specific to the idea of social responsibility, because as individuals such people would have the same moral and ethical responsibilities as anyone who is not an artist – for example, being honest or treating others with respect. The social responsibility of artists pertains to the tasks, expectations, and decisions that confront artists *in their capacity as artists.* Three concepts enter this idea of social responsibility, namely, trustworthiness, accountability, and responsiveness.

In the first place, the artist is called to be trustworthy with respect to imaginative tasks such as social visioning, advocacy, and critique. People become artists by virtue of certain gifts, training, and positioning in a society. With such gifts, training, and positioning comes a calling to employ these on behalf of society by undertaking the tasks with which artists are thereby entrusted.

Second, the idea of social responsibility contains a significant component of accountability. Merely undertaking the imaginative tasks of visioning, advocacy, and critique is not enough. By entering upon such tasks, artists raise the expectation that they will actually make contributions to society, contributions that are significant and worthwhile and that nonartists would be less likely to accomplish. In that sense, artists are socially accountable, not only to themselves but also to their neighbors, to society as a whole, and to that which they give their ultimate allegiances.

Third, socially responsible artists are responsive as they try to make contributions to society. The thought here is that, by themselves, undertaking the tasks of social visioning, advocacy, and critique and actually contributing to society are incomplete. An artist could do all of this but nevertheless miss certain opportunities, ignore certain issues, and avoid certain situations, all of which deserve the artist's attention. The artist cannot avoid choosing various methods and approaches and partners, and she or he is answerable for the quality of the decisions made. Hence, the social responsibility of artists encompasses not only their trustworthiness with respect to the work they do and their accountability for the outcome of their efforts but also their responsiveness within the situation where all of this occurs.

Admittedly, it is controversial to apply the concepts of trustworthiness, accountability, and responsiveness to the work of artists. One could object, for example, that such an account of social responsibility

would make better sense for doctors, lawyers, and teachers. These occupations are widely recognized as professions in contemporary society, and they have established codes of professional conduct. But how can we consider artists to be socially responsible in and for their work? Surely the occupational category of "artist" is far too diffuse to permit societal recognition as a profession, and one would be hard pressed to find a code of conduct for artists like the codes that obtain for doctors, lawyers, and teachers. Moreover, our objector might add, that is a good thing. If being an artist were fully professionalized and codified, this would spell the death of art.

There is something to this line of objection. For artists do have a different "line of work" from those of doctors, lawyers, teachers, and other professionals, and artists have neither the societal standing nor the occupational organization to be fully "professionalized." These peculiarities in how artists carry out their social responsibility have to do with their being "experts" in the work of imagination, in the pursuit of exploration, presentation, and creative interpretation. Precisely because their primary work is imaginative rather than, say, medical, legal, or educational, it is more open-ended, less readily and less properly codified. The peculiarities also have to do with prevailing commitments to economic, political, and technological "solutions" to social problems, commitments sustained by a truncated vision of what makes for a good society. Historically, despite art's societal imbrication, many artists have seen themselves, and have been seen by others, as standing either outside or in opposition to such commitments and vision.

Yet it would be premature to infer from a lower degree of professionalization that artists do not make up a profession, just as it would be shortsighted to take the lack of codification to mean an absence of social responsibility. Conversely, it would be a reductio ad absurdum to insist that to assign social responsibility to an occupational group is to claim that it is a fully recognized profession with an established code of conduct. No one, for example, would deny that parents have social responsibility in nurturing their children, yet we do not regard parenting as a profession with an established code of conduct. Although I think that being an artist is more like being a doctor, lawyer, or teacher than like being a parent, the somewhat informal character of the artist's vocation makes it similar in that respect to being a familial caregiver.

Closely related to the issue of profession is the question why the expectation of social responsibility arises in the arts. The answer seems relatively straightforward in the case of well-recognized professions, where the work performed seems clearly to serve society as a whole, and the persons who seek medical, legal, or educational services know more or less what they need to receive. These matters are less obvious in the case of art, not only because of the type of work performed but also because of cultural and democratic deficits, noted in previous chapters, that accrue to our understanding and appreciation of artistry.

If we were to recognize how the work of artists both contributes to society as a whole and addresses our own cultural needs, it would become more obvious why the expectation of social responsibility arises in the arts. For it would become apparent that society as a whole benefits from having trained and gifted practitioners who explore, interpret, and present nuances of meaning in culture and society. It would also become apparent that individuals and groups need what results from such work of imagination in order to gain orientation or reorientation. Artists have a calling to be socially responsible in the exercise of their imaginative gifts, training, and social position. Their calling arises from the fact that society and its inhabitants receive benefit from artists' work when it is done well and can be harmed aesthetically and otherwise when the work is done poorly.

Not even the artist who denies social responsibility can escape this calling. Consider, for example, the following comments by the painter Georg Baselitz: "The artist is not responsible to anyone. His social role is asocial; his only responsibility consists in an attitude to the work he does. There is no communication with any public whatsoever. The artist can ask no question, and he makes no statement; he offers no information, and his work cannot be used. It is the end product which counts, in my case, the picture."[19] Referring to these and later comments by Baselitz, Suzi Gablik observes that they harbor "the personal and cultural myth that has formed the artist's identity in the modern world: the myth of the solitary genius whose perfection lies in absolute independence from the world."[20] Yet Baselitz does not completely deny

[19] Quoted by Suzi Gablik from the catalog of Baselitz's exhibition at the Whitechapel Art Gallery in London in 1983, in Gablik's essay "Connective Aesthetics: Art after Individualism," in Lacy, *Mapping the Terrain*, p. 77.
[20] Ibid.

the fact of responsibility. Rather, he restricts this responsibility to "an attitude to the work" such that "it is the end product which counts." On the view expressed by Baselitz, to be trustworthy an artist must be devoted to the end product; to be accountable is to make sure that the end product counts; and to be responsive is to pay complete attention to what the artwork requires. Such devotion, dedication, and attentiveness, highly demanding as they are, are meaningless, however, when they become untethered from the idea of social responsibility, as happens in what Patricia Catto has called "bad modernism."[21]

I propose that we take a few steps beyond bad modernism. In taking these steps, however we must keep in mind the imaginative character of the artist's work. The artist is not a doctor, a lawyer, or a teacher. Artists work at a societally constituted site where exploration, presentation, and creative interpretation make all the difference. Because they work there, and because they have the gifts, training, and positioning to work there, artists have a social responsibility. That is why the notion of artistic authenticity, so central to the modernist credo, needs to be rescued from the absurdities to which some advocates have pushed it. To that end, let me construct a dialectic between artistic authenticity and social responsibility.

8.3 CREATIVE BORDER CROSSING

When properly understood, and when pursued as valid expectations, not as poor rationalizations for either threadbare elitism or self-serving populism, authenticity and responsibility are not incompatible. Rather, they constitute a creative tension in which neither expectation can be fruitfully pursued in the absence of the other. Let us look at this tension in each direction, first from responsibility to authenticity, and then from authenticity to responsibility, focusing for now on the work of artists.

Art Making

The new emphasis on social responsibility brings out hidden aspects of artistic authenticity and helps prevent it from collapsing into aesthetic solipsism. In his retrieval of the ethical ideal of authenticity,

[21] Quoted in ibid., p. 78.

Charles Taylor argues that subjectivation is irreversible. By "subjecti-
vation" he means the historical movement whereby more and more
decisions, understandings, and practices center on the human agent
and not on some external reality. Yet it makes a big difference, Taylor
says, whether the *manner* of action or the *matter* of action becomes
centered on the self. Properly understood, ethical authenticity has to
do with the *manner* of action, not its *matter* or content. In fact, when
people begin to think that the matter of action – action's goals and
significance – can be derived only from the individual self, and not
from nature or society or the divine, then authenticity becomes both
incoherent and unattainable as an ethical ideal.[22]

It seems to me that an all-too-common view of artistic authenticity
makes precisely this sort of mistake. People who expect artistic prac-
tices to be authentic frequently slide between two claims. They slide
from the legitimate claim that artists should be true with respect to
the vision or experience that sustains their art making to the inco-
herent claim that each artist must be the only source of this vision
or experience. The latter claim is incoherent both because artistic
practices are inescapably dialogical[23] and because one cannot have
a personal vision apart from the larger contexts (societal, cultural,
environmental) that help make it personal.

Artistic practices are inescapably dialogical in a double sense. First,
art making involves the production of something that others can
interpret, even when initially the only interpreter is the artist as she
or he fashions the emerging product or event. Second, when mem-
bers of an art public interpret an art product or event, they necessar-
ily experience it as having been presented for their interpretation by
someone else, whether that be the artist as such or other producers
and performers. Expanding the reference for a term Mikel Dufrenne
applies to artworks, we can say that all art products and events are
"quasi subjects."[24] More precisely, they are ways in which people inter-
act, in however mediated a fashion.

[22] Taylor, *Ethics*, pp. 81–91.
[23] Among well-known philosophers of art, Leo Tolstoy and R. G. Collingwood get at
the dialogical character of artistic practices, although I find their emphasis on the
"expression" of "emotion" unduly restrictive.
[24] Mikel Dufrenne, *The Phenomenology of Aesthetic Experience*, trans. Edward S. Casey et
al. (Evanston, Ill.: Northwestern University Press, 1973), especially pp. 190, 196.

Furthermore, if every person, including someone who is an artist, has been culturally formed, belongs to diverse social institutions, and participates in intersubjective relations, then no one, not even an artist, can have experience or acquire a personal vision of life and society in isolation from such contexts. That is why the expectations of uniqueness and originality, when applied to the artist's experience and vision, are thereby misplaced and would be better directed to the manner in which the artist works or the outcome of the artist's efforts. The fact that a vision or experience is personal does not make it unique, and the fact that a particular artist articulates a personal vision or experience in making an art product or event does not make what is articulated original. In addition, what gets articulated need not be a personal vision or experience. It can equally be intersubjective or communal, or it can be both personal and more than personal.

Properly understood, artistic authenticity concerns the *manner* in which art making uncovers, presents, questions, and reappropriates a sustaining vision, not the *matter* that art making articulates. The art product or event does not need to be *about* the artist's vision or experience, nor does this vision or experience need to be original and unique. Rather, to be authentic, the manner in which the artist works from a sustaining vision or experience needs to be true with respect to that vision or experience. This understanding implies that the artist is responsible for doing these things in ways that are genuinely significant. And, as Charles Taylor indicates in the ethical context, judgments about significance can be made only in the context of something larger than the individual self. The strict aesthetic solipsist cannot achieve authenticity in art. Both authenticity and artistry imply what Taylor describes as "openness to horizons of significance" and "self-definition in dialogue."[25] So artistic authenticity should not be pitted against social responsibility. Authenticity is necessarily embedded in larger contexts the artist is called to address. The expectations of originality and uniqueness that give texture to artistic authenticity gain their force from the assumption that such qualities are necessary for art making to be significant in a society such as ours.

[25] Taylor, *Ethics*, p. 66.

Similarly, the proposed notion of artistic authenticity helps dis-
close hidden dimensions to the idea of social responsibility. It helps
prevent the contemporary emphasis on social responsibility from
expanding into uncritical collectivism. A tendency toward uncritical
collectivism may be the dark side of an otherwise salutary emphasis.
This can be seen from Suzanne Lacy's description of "integrity." She
observes that new genre public art gives artists new roles as educa-
tors, mythmakers, and social healers. With these new roles comes a
new sense of integrity. "Integrity," she writes, "is based not on artists'
allegiances to their own visions but on an integration of their ideas
with those of the community."[26] I find Lacy's description of integrity
problematic, and many artists would find it worrisome. Quite apart
from the difficulty of identifying "the community" and the hazards
of assuming that a community can have a fixed and univocal iden-
tity, should artists simply voice what some group desires? Do artists
no longer need to examine, challenge, and rearticulate the group's
needs and aspirations? If they do not, then any notion of the artist's
personal integrity would disappear. Although Lacy does not endorse
such a position, her pitting communal integration against personal
authenticity raises the specter of uncritical collectivism.

By contrast, but in line with much of what Lacy writes, I hold that
the contemporary emphasis on social responsibility necessarily feeds
upon the ideal of artistic authenticity, even when authenticity seems
to impede social responsibility. To take on the tasks of educator, com-
munity builder, and social healer, the artist must have a vision of what
needs to be learned, where a community is fragile, and how suffering
and oppression must be countered. Moreover, to address these mat-
ters as an artist, and not simply as a teacher, social worker, or political
leader, the artist must discover and articulate that vision in genuinely
artistic ways. Were these expectations simply forgotten, and were the
manner of artistic practice simply derived from a group's interpreta-
tion of the social matters to be addressed, then the legitimate call to
social responsibility would slide into a repressive demand for commu-
nal conformity, as if only a community or society at large can establish
the manner in which artists should do their work. But such a demand
would be incoherent, both because artistic practices are inescapably

[26] Lacy, *Mapping the Terrain*, p. 39.

imaginative and because one cannot pursue social responsibility as an artist apart from the social institution of art that frames the artist's position and self-understanding.

Properly understood, the social responsibility of the artist concerns the position, setting, and effect of the artist's work. The artist is personally responsible for interacting with others in artistic ways that contribute to society. Judgments about societal contributions cannot be delegated to a community or to society at large, however. Artists themselves must make them, sometimes in conflict with a community or society. The strict social conformist cannot achieve social responsibility in the arts. Both sociality and responsibility imply the ability and readiness to take a personal stand, at the risk of offending those with whom one seeks to collaborate. Social responsibility in the arts should not be pitted against artistic authenticity. Social responsibility is inescapably linked to the imaginative disclosure the artist is called to nurture and exercise. The emphases on community, collaboration, and commitment that inform current discussions of social responsibility gain their force from the assumption that those features are necessary for art making to be authentic in a society such as ours.

Audience Interpretation

To this point I have concentrated on the artist. I have portrayed the expectations of artistic authenticity and social responsibility as a creative tension in which each is required in order for the other to flourish. I do not wish to downplay the reality of the tension, although I do want to stress its creative potential in the making of contemporary art. The development of new genre public art implies, however, that social responsibility in the arts does not accrue to artists alone. If art is indeed dialogical and interactive, as the practitioners and theorists of new genre public art claim, then a degree of social responsibility rests with the artists' collaborators, critics, and publics. The imaginative work of social visioning, advocacy, and critique cannot occur in a vacuum. If this is so, then perhaps the expectation of authenticity also applies to audiences, especially to audiences that are no longer regarded as passive consumers of a finished product. So let me explore why the expectations of social responsibility and artistic authenticity should hold for audiences and not simply for artists.

The importance of ascribing social responsibility to audience members, and not only to artists, emerges from some implications of contemporary emphases on community, collaboration, and commitment. On the one hand, the emphasis on community gives artists responsibility for speaking from, for, and to a relatively cohesive social group, while helping to construct and reconstruct that group. The emphasis on collaboration gives artists responsibility for listening to, inspiring, and working alongside others on a shared project. The emphasis on political commitment gives artists responsibility for understanding, addressing, and helping to change oppressive situations and structures. On the other hand, artists cannot be community spokespersons and builders, project facilitators, or agents of political change unless other community members, project participants, and political activists assume their own responsibility for the process and its outcome. Audiences share social responsibility in new genre public art.

Moreover, to the extent that more traditional forms of art require autonomous participation, audiences for such art also have a responsibility to be critical, creative, and dialogical when they participate. This social responsibility is implied by the way in which I have described "significance" as an element of artistic truth. If, in expecting art products and events to be significant, we expect them to be true with respect to a public's need for worthwhile cultural presentations, then members of an audience are obliged to interpret art products and events with reference to that need. They have this obligation by virtue of the social position they occupy as audience members, their expectation that art will be significant, and the necessity of discovering which artistically mediated cultural presentations are more or less worthwhile. Although the concepts of trustworthiness, accountability, and responsiveness may not be as fully applicable to audience members as they are to artists, these concepts nevertheless do have some purchase for traditional audiences.

It is a little more difficult to ascribe the expectation of authenticity to audience members. The difficulty arises from a double tendency to link authenticity with the making of art products and to remove the audience from the process of art production. Two different questions arise: first, whether it makes sense to expect authenticity on the part of traditional audiences, and, second, whether authenticity can

plausibly be demanded of nontraditional audiences in their roles as collaborators, volunteers, and public participants.

Concerning the first question, I argue that, despite appearances to the contrary, we do expect authenticity on the part of traditional audiences. Mindless consumption and expert resistance are both incompatible with the normative role of the traditional audience. What Adorno describes as "good listeners," for example, are expected to give themselves to the music, to be open to that which they do not immediately understand or appreciate, and to make up their own minds about the music's quality.[27] Good listening requires precisely those marks of an "alert and critical mentality" that artistic authenticity is supposed to model for the ethical ideal of authenticity.[28] Although good listeners or viewers or readers are not engaged in the productive practices of composing, painting, or writing, and hence cannot be expected to *make something* that is true with respect to their own vision, yet they do *make something of* the art product or event. In that capacity they can be expected to be true not only to the work but also with respect to their own vision and experience. Because of the latter expectation, even traditional art is dialogical. Neither the artist nor the audience has the final word concerning the meaning and quality of an art product. Whereas bad modernism violates such dialogue by discounting the audience's contribution, postmodern consumerism, particularly as fostered by the culture industry, violates the dialogue by trivializing the artist's contribution. On both sides, such disruptions of dialogue often happen in the name of a supposed "individuality" – "I'm just expressing myself" or "I know what I like" – that, ironically enough, cannot be authentic.

But what about nontraditional audiences? Is authenticity a plausible expectation for people whose involvement occurs primarily as collaborators, volunteers, and public participants? To begin with, we must recognize how complex the role of the audience becomes in new genre public art. In the essay "Debated Territory: Toward a Critical Language for Public Art," Suzanne Lacy portrays the audience as "a series of concentric circles with permeable membranes that allow continual movement back and forth." In this nonhierarchical image,

[27] Theodor W. Adorno, *Introduction to the Sociology of Music*, trans. E. B. Ashton (New York: Seabury Press, 1976), pp. 5–6.
[28] Paul Taylor, in Cooper, *A Companion to Aesthetics*, p. 29.

the primary originators of the creative work – usually the artists – occupy the center. The next circles out from the center represent first the primary collaborators or co-developers, then the volunteers and performers, and then the immediate audience, many of whom, like the veterans and their families visiting Maya Lin's Vietnam Veterans Memorial, bring "a deep level of experiential engagement." The outer two circles indicate first the media audience of newspaper readers, television viewers, and attendees of documentary exhibitions and then the "audience of myth and memory" for whom the artwork becomes part of the ongoing life of a community.[29] Lacy's point is that, depending on the circle they occupy at a certain time, audience members have different degrees of responsibility for the outcome. Moreover, they can easily move from one circle to another or occupy several at once.

Accordingly, the question about authenticity requires a more precise formulation. If different audience members have different degrees of responsibility for a dialogical art process, and if the level of their participation is fluid and dynamic, then at what levels can we plausibly expect their participation to be authentic? To answer this, we need to acknowledge that the newer audience roles frequently shade into producer roles, so that the relevant concept of authenticity often has more to do with art making than with audience interpretation. At the same time, the role of the artist has become more highly interactive, so that artistic authenticity has as much to do with the quality of the artist's empathy, reporting, situational analysis, and consensus building as with the originality and uniqueness of the artist's modus operandi.[30]

Still, the core intuitions of authenticity in art remain relevant for all of the newer audience roles, often in the context of a shared vision or experience. The sharing occurs both between creative leaders (artists) and creative participants (audience members) and among the members of a group or community or public on behalf of which people embark upon a creative process. To be authentic in one's participation means that, relative to one's level of participation, one makes

[29] Lacy, *Mapping the Terrain*, pp. 178–80.
[30] Lacy describes the new "interactivity" as involving a continuum of artist positions from experiencer and reporter through analyst and activist. See ibid., pp. 173–7.

the emerging production one's own. "Making it one's own" means not only that one embraces it in one's own manner but also that the creative process receives the benefit of one's own dedication, openness, and critical judgment toward that which is being given birth. The reverse side to this, as Lacy's language suggests, is that the audience, too, is responsible for the creative process and its outcome.[31]

Authentic Co-Responsibility

Bringing together the notions of authenticity and social responsibility, both with regard to artists and with regard to audiences, we can say that new genre public art at its best provides us with experiences and metaphors of authentic co-responsibility in the creative process. On the one hand, such art refuses to divorce the creativity with which artists discover, articulate, and test their personal visions from the social obligations they have by virtue of their gifts, training, and positioning in society. On the other hand, new genre public art at its best also refuses to exempt audiences from the double expectation of authenticity and social responsibility as they participate in the creative process. Hence, contrary to Adorno, it is not simply the authenticity of the artwork itself that complements social responsibility. Instead, relationships of complementarity hold between the mutual authenticity and social responsibility of both artists and their audiences. And, as I have tried to show, these relationships, while highlighted by new genre public art at its best, also occur, albeit less obviously, in more traditional art. In general, the complementarity between mutual authenticity and social responsibility provides normative contours for what I have labeled art in public.

Such relationships challenge philosophers to rearticulate the way in which intellectuals and citizens understand the arts. New genre public art encourages us to regard artists as members of cultural communities and social institutions who make important contributions to a civil society that is itself essential to the well-being of all

[31] The fact that such responsibility is difficult to achieve when "public art" is simply imposed on an unsuspecting public may indicate a need to find better ways to involve the public in the commissioning, planning, and installation of such art. A crucial but sometimes neglected concept in the background of many debates about public art is that of cultural democracy, which I examine in the next chapter.

communities and institutions in contemporary society. Because all of us live within the environment of civil society, however, and because artists have specific gifts and tasks in the care of this environment, the relationship between artists and their publics must be one of directed co-responsibility: co-responsibility, because all of us have a stake in the environs we inhabit; directed, because some of us – the artists – have special contributions to make to the care of that environment. It is in conflicts over the quality and future of civil society that the tension between authenticity and responsibility acquires its greatest creative potential.

Seen in this light, the conflict between transgressivists and fundamentalists over government arts funding appears to concern not simply the arts but the quality and future of civil society. Indeed, the conflict is a struggle over the direction in which art should lead society as a whole. Although I do not share a vanguardist assumption that the arts are at the leading edge of societal development, whether for good or ill, I do acknowledge the weight of the concern the two camps bring to their debates about government arts funding. For the arts are an important element and agency of civil society, and contemporary society as a whole, including civil society, needs to undergo pervasive transformation. Because the transformation needed is differential, however, and because the arts are only one agency of civil society, art cannot and should not carry the burden of changing society as a whole. What the arts can contribute to this process is to foster nuanced consideration of the changes needed, to engender imaginative public communication about issues of general concern, and to offer winsome models of a social economy in operation.

Because of the creative tension between authenticity and social responsibility, the arts can also nurture the sort of interpersonal autonomy that agency in civil society requires. The preceding chapter describes interpersonal autonomy as the freedom of an agent to follow self-given laws and to embrace these laws in ways that genuinely articulate the agent's identity and dialogically solicit recognition from others. Insofar as it is autonomous, participation in the arts both exemplifies and enriches such agency. Autonomous participation in the arts, whether as artists or as audience members, teaches people to take critical and self-critical stances toward standards for art making and audience interpretation. It helps them learn to

articulate their identities, both constructively and reconstructively, in embracing such standards. And it opens them to the expectations of other participants, both artists and nonartists. In short, autonomous participation in the arts, when it occurs, inculcates critical, creative, and dialogical agency of a sort that reinforces the interpersonal autonomy required for agency within civil society in general.

That is why participants in the arts need to acknowledge not only the tension but also the complementarity between authenticity and social responsibility. Rather than isolating authentic self-articulation from social responsibility and playing these off against each other, acknowledgment of mutual complementarity challenges the misconstruals of interpersonal autonomy that underlie transgressivist and fundamentalist positions. By divorcing artistic authenticity from the artist's social responsibility, transgressivists subvert the dialogical character of autonomous participation in the arts. So too, by separating expectations of social responsibility from questions of authenticity pertaining to both art making and audience interpretation, cultural fundamentalists undermine the critical and self-critical quality of autonomous participation. Together, although no doubt unintentionally, the two camps, in their struggle over art's role in societal development, suppress openness to oneself and to others – openness that not only marks creative participation in the arts but also forms a basis for agency in civil society, where the principle of solidarity is decisive.

In challenging us to rearticulate our understanding of the arts, the creative tension between authenticity and social responsibility also calls into question the insular self-understandings of some traditional religious and ethnic communities, self-understandings that feed cultural fundamentalism and erupt in attacks on contemporary art. The child in Linda Nemec Foster's poem wants to read English, to scold the princess for getting lost, and to be kind to a stranger. Traditional religious and ethnic communities could learn from this child, who herself appears to have embraced such aspirations in a religious and ethnic context. Three fundamental requirements of civil society under conditions of institutional and cultural pluralism are open communication, responsiveness toward each community's claim for recognition, and the pursuit of social responsibility beyond one's own religion or clan. It will not be enough for religious and

ethnic communities to speak their old familiar languages. It will not
do for them to help people hide in the forests of fixed roles of gender,
class, and social status. Nor will it suffice for them to restrict their
interaction with others to random acts of kindness. To help sustain a
vital civil society, and to be part of it, traditional religious and ethnic
communities will need to learn from art in public how to encourage
creative border crossing.

Fortunately, innovative leaders and groups within Judaism,
Christianity, Islam, and other religions have already begun this pro-
cess, just as some contemporary artists partially derive their commit-
ment to intercultural conversation from generous impulses within
traditional religions. In contributing to a vital civil society, traditional
communities will slowly and painfully shed shackles of both authori-
tarian and liberal sorts, giving up attempts to secure their authority
by force as well as attempts to privatize the content of their own tra-
ditions. It will not be enough for religious and ethnic communities
to turn up their noses at the sourness of a culture of authenticity
gone bad: the pursuit of authenticity turns into narcissism and ego-
ism partly because traditional communities offer inadequate vision
for addressing contemporary concerns. Neither will it be enough for
them to strike the pose of society's social conscience: one reason why
writers and other artists seek new ways to pursue social responsibility
is because the social agendas of many religious and ethnic communi-
ties have proved inflexible and hypocritical.

There is no easy road to a civil society in which both authentic-
ity and social responsibility flourish. Many different institutions and
communities will need to contribute. Writers and other artists who
have genuine concerns about religious and ethnic communities will
need to "scold that princess for getting lost." Members of traditional
communities who care deeply about literature and the arts will need
to be "kind enough not to make fun of the girl...who always draws
her cats with eight legs." In the process, although from different
places and in different ways, these creators of culture, so often at
odds in the past, may come to speak a common tongue, the polyglot
language of a vital civil society.

9

Democratic Culture

This precious mess. Democracy. How much can be done in its name
before, like an egg consumed by a snake, it becomes merely a shell?
Ann-Marie MacDonald[1]

On August 1, 1995, the *New York Times* carried a front-page story
boldly captioned "Walt Disney Acquiring ABC in Deal Worth $19
Billion; Entertainment Giant Born." In slightly smaller type, next to
the photograph of a laughing Michael D. Eisner, chairman of Walt
Disney, and an apparently self-satisfied Thomas S. Murphy, chair-
man of Capital Cities/ABC, the subtitle read "Wall St. Stunned."
The merger combined one of the world's largest entertainment com-
panies, whose sales in 1994 exceeded $10 billion, with one of the
world's largest media companies, with total sales that year of over $6
billion. At the time it was the second-largest takeover in the history of
American corporate capitalism.

Meanwhile, back at the Republican ranch in Washington, D.C.,
Congress was stampeding toward approval of legislation to dereg-
ulate American telecommunications industries, in the name of fos-
tering competition. On July 31, however, the *New York Times*, hardly
a disinterested party, had run an editorial condemning the bill as
"A Threat to Media Diversity," a theme also sounded in President

[1] Ann-Marie MacDonald, *The Way the Crow Flies* (Toronto: Vintage Canada, 2003),
p. 724.

Clinton's promise that evening to veto the telecommunications bill – just hours after the Walt Disney Company announced its plans to take over Capital Cities/ABC. Within days Westinghouse Electric Corporation (1994 sales of just under $9 billion) had agreed to pay $5.4 billion to acquire the broadcast network CBS Inc. (1994 sales of $3.7 billion); the House of Representatives had signed its blank check for the nation's telecommunications industries to merge and gouge at will; and the *New York Times* had run several critical commentaries to complement its own detailed coverage of media merger mania.

When one looks back at this tumultuous week in 1995, a remark made several years earlier, when Warner Communications acquired Time Inc., seems increasingly prescient. In an article titled "No Bigness Like Show Bigness," industry analyst Richard Gold said the 1989 merger of Time and Warner "could prefigure a 21st century in which all of show business is controlled by two or three conglomerates."[2] Many mergers later, the communications/entertainment/information/media industries have entered just such a century.

It was in this context that I first tried to collect my thoughts on the arts and democracy. My first impulse was to change the topic. For the magnitude and speed of global changes in the culture industry can make a discussion of the arts seem quaint, and the potential such changes hold for the concentration of wealth and power can make talk of a democratic culture seem quixotic. Nevertheless, the topic merits attention, especially because antidemocratic movements have strengthened in North America and elsewhere. I think in particular of a minority culture that has aimed to be in the majority, a so-called "Moral Majority," seeking ever greater political and economic power and spawning its own culture industry in music, television, publications, and electronic communications. There is no ignoring how influential this culture of the religious Right has become. Clearly the Right has little use for what this book calls "art in public" – witness its campaign in the 1980s and 1990s to shut down the National Endowment for the Arts. Nor does the agenda of the religious Right

[2] Richard Gold, "No Bigness Like Show Bigness," *Variety*, June 14–20, 1989, p. 1. For further comment on the Time-Warner merger, see Chapter 5 in *Dancing in the Dark: Youth, Popular Culture and the Electronic Media*, ed. Roy Anker (Grand Rapids, Mich.: Eerdmans, 1991), especially pp. 131–8.

seem any more conducive to a democratic culture than does merger mania in the North American culture industry.

This chapter considers the democratic potential of contemporary art in public. I hope to find democratic tendencies that are worth nurturing, despite the power of cultural colonizers, whether religious or secular. I also wish to find a pathway past vanguardism, both fundamentalist and transgressivist, concerning contemporary art's contributions to society. After describing a shift from modern art to postmodern arts that conditions the democratic potential of contemporary art, I explore the idea of democracy and some features of a democratic culture and then consider how contemporary art in public can foster the growth of a democratic culture.

9.1 CULTURAL DIALECTIC

Contemporary art in public presupposes a protracted shift from modern art to postmodern arts. To describe this shift, let me first comment on two portraits of the artist within twentieth-century literature before exploring three cultural polarities that help drive the artistic transition from modern to postmodern and that inform contemporary art in public.

Lily and Elaine

The transition shows up in passages from two novels whose main characters are women painters. The first passages come from *To the Lighthouse*, a novel by the British writer Virginia Woolf, published in 1927. In this novel Lily Briscoe returns day after day to a painting she cannot complete. She has a vision of what she must paint, but Mr. Tansley and Mr. Ramsey, the dominant males of the household, continually drive her to distraction. I quote first from a scene around the dinner table where Lily muses about how Mr. Tansley affects her:

He was really, Lily Briscoe thought,...the most uncharming human being she had ever met. Then why did she mind what he said? Women can't write, women can't paint – what did that matter coming from him, since clearly it was not true to him but for some reason helpful to him, and that was why he said it? Why did her whole being bow, like corn under a wind, and erect itself again from this abasement only with a great and rather painful effort?

She must make it once more. There's the sprig on the table-cloth; there's my painting; I must move the tree to the middle; that matters – nothing else. Could she not hold fast to that, she asked herself, and not lose her temper, and not argue; and if she wanted revenge take it by laughing at him.[3]

Only ten years later, at the very end of the novel, does Lily Briscoe complete her painting. Here is the paragraph that concludes the story:

Quickly, as if she were recalled by something over there, she turned to her canvas. There it was – her picture. Yes, with all its greens and blues, its lines running up and across, its attempt at something. It would be hung in the attic, she thought; it would be destroyed. But what did that matter? she asked herself, taking up her brush again. She looked at the steps; they were empty; she looked at her canvas; it was blurred. With a sudden intensity, as if she saw it clear for a second, she drew a line there, in the centre. It was done; it was finished. Yes, she thought, laying down her brush in extreme fatigue, I have had my vision.[4]

In Virginia Woolf's novel, as in her own life, the struggle of a woman to find her voice coincides with the lonely struggle of an artist to be true to her painterly vision. There are few references in the novel to the political, academic, and artistic institutions that frame these struggles.

Now we fast-forward more than sixty years to *Cat's Eye*, a novel by the Canadian writer Margaret Atwood, published in 1989. The novel's main character is Elaine, a middle-aged painter who is having a retrospective at an alternative gallery in downtown Toronto. Early in the novel Elaine introduces herself to the reader:

Alongside my real life I have a career, which may not qualify as exactly real. I am a painter. I even put that on my passport, in a moment of bravado, since the other choice would have been *housewife*. It's an unlikely thing for me to have become; on some days it still makes me cringe. Respectable people do not become painters: only overblown, pretentious, theatrical people....

My career is why I'm here.... I'm having a retrospective, my first. The name of the gallery is Sub-Versions, one of those puns that used to delight me before they became so fashionable. I ought to be pleased by this retrospective, but my feelings are mixed; I don't like admitting I'm old enough and established enough to have such a thing, even at an alternative gallery

[3] Virginia Woolf, *To the Lighthouse* (New York: Harcourt, Brace, 1927, 1955), p. 130.
[4] Ibid., pp. 309–10.

run by a bunch of women. I find it improbable, and ominous: first the retrospective, then the morgue. But also I'm cheesed off because the Art Gallery of Ontario wouldn't do it. Their bias is toward dead, foreign men.[5]

One can hardly miss the critique of political, academic, and artistic institutions running throughout Atwood's novel. Whereas women artists of Virginia Woolf's generation struggled in an overwhelmingly male-dominated house to find a "room of their own," later feminists have set about reconstructing or deconstructing the house itself.

But there is more. Atwood's Elaine gives quite a different portrait of the artist from Woolf's Lily Briscoe. Whereas Woolf portrays a solitary, misunderstood individual dedicated to pure form and pursuing an ecstatic vision, Atwood portrays a sardonic, self-deprecating, and worldly wise professional concerned about the context in which she works and problematizing the social and cultural conditions that make her life difficult. The contrast between these two portraits contains many of the differences between being an artist during the heyday of modernism and being an artist at the height of postmodernism: on the one side, the modern artist as solitary, form-creating visionary; on the other side, the postmodern artist as socially constructed, context-oriented ironist.

From these contrasting portraits emerge three cultural polarities that propel the shift from modern art to postmodern arts – polarities between the freedom of art and the constructed character of the arts, between the priority of form and the importance of context, and between a vision oriented to the future and a sense of historical contingency. To simplify, we can say that modern art tends to emphasize the first side in each polarity: freedom, form, and futurity. Postmodern arts tend to emphasize the second side: construction, context, and contingency. Cultural polarities are not exclusions, however; one side links tightly with the other. Significant traces of an emphasis on construction, context, and contingency surface within modern art, just as one can find concerns for freedom, form, and futurity within postmodern arts. Moreover, contemporary art in public presupposes these polarities but does not come down neatly on either side. Let me say a little more about each pole.

[5] Margaret Atwood, *Cat's Eye* (New York: Doubleday, 1989), pp. 15–16.

Freedom, Form, Futurity

One of the great themes in aesthetic modernism is the freedom or
autonomy of art. The new art movements in the first half of the twenti-
eth own century – expressionism, cubism, constructivism, and so forth –
grapple with a twofold assumption: first, that art has a unique nature
quite unlike science, religion, and popular culture; and, second, that
art should be free to develop without interference from commerce, pol-
itics, morality, or any other social institution. Central to modern art is
the struggle to liberate painting to be painting, and music to be music,
and poetry to be poetry, and not to let them subserve other purposes
and institutions. And as art must be free, so must the artist. Consider,
for example, the following words by the early modernist art critic Clive
Bell, writing in 1914: "The one good thing Society can do for the artist
is to leave him alone. Give him liberty. The more completely the artist
is freed from the pressure of public taste and opinion, from the hope
of rewards and the menace of morals, from the fear of absolute starva-
tion or punishment, and from the prospect of wealth or popular con-
sideration, the better for him and the better for art, and therefore the
better for everyone. Liberate the artist: here is something that those
powerful and important people who are always assuring us that they
would do anything for art can do."[6]

A second theme of modern art, closely related to an emphasis on
freedom, is the primacy of form over both content and context. For
the aesthetic modernist, the unique nature of art is tied to formal
pursuits: art is that great arena in which we can discover the deep
structure of our world, imagine new patterns for life, and unlock
the secret codes of the unconscious. This occurs primarily through
devoted attention to formal qualities in various art forms. Clive Bell,
while not alone in his enthusiasm for formal qualities, is among the
most eloquent in proclaiming their abiding significance:

Imperfect lovers bring to art and take away the ideas and emotions of their
own age and civilisation.... But the perfect lover, [one] who can feel the pro-
found significance of form, is raised above the accidents of time and place....
The ideas of [human beings] go buzz and die like gnats; [people] change
their institutions and their customs as they change their coats; the intellectual

[6] Clive Bell, *Art* (1914) (London: Arrow Books, 1961), p. 222.

triumphs of one age are the follies of another; only great art remains stable and unobscure. Great art remains stable and unobscure because the feelings that it awakens are independent of time and place, because its kingdom is not of this world.... The forms of art are inexhaustible; but all lead by the same road of aesthetic emotion to the same world of aesthetic ecstasy.[7]

Accordingly, Bell argues that content and context are irrelevant for the appreciation of good art, an argument repeated by literary New Critics, musical formalists, and countless other advocates of modern art.

A third theme of modern art is what I call futurity. By this I mean a strong and sometimes utopian orientation toward the future. The leading practitioners and defenders of modern art saw it as the harbinger of a better future, in an age when hopes for humanity were sorely tested. Shortly before the outbreak of World War I, the Russian painter Kasimir Malevich wrote: "It does not dawn on the public that it fails to recognize the real, true value of things.... A true, absolute order of human society could only be achieved if [hu]mankind were willing to base this order on lasting values. Obviously, then, the artistic factor would have to be accepted in every respect as the decisive one."[8] In 1937, a few years before World War II, the Dutch painter Piet Mondrian articulated this theme by claiming that "evolution, ultimately, is never the expression of the mass. The mass remains behind yet urges the pioneers to creation. The pioneers...discover...the fundamental laws hidden in reality, and aim at realizing them. In this way they further human development."[9] Like Malevich and Mondrian, many modern artists saw themselves as pioneers for a better future.

One by one, these powerful themes of freedom, form, and futurity came to be challenged during the course of the twentieth century. Yet they remain hidden within the discourse, attitudes, and self-images of artists and audiences alike. They are like artistic auroras, surging, shifting, flaring up, and dying down. By recognizing their presence, we begin to understand more fully the cultural environment in which we live.

[7] Ibid., pp. 44–6.
[8] Kasimir Malevich, "Suprematism," in *Art and Its Significance: An Anthology of Aesthetic Theory*, ed. Stephen David Ross, 3rd ed. (Albany: State University of New York Press, 1994), p. 671.
[9] Piet Mondrian, "Plastic Art and Pure Plastic Art," in Ross, *Art and Its Significance*, pp. 679–80.

Construction, Context, Contingency

The postmodern condition in art arises with the development of artistic practices and organizations in which construction, context, and contingency outweigh freedom, form, and futurity. With respect to construction, for example, one thinks of photographs by Cindy Sherman. What look like depictions of various women in different settings turn out to be studies of the artist herself in different guises. One comes away with a sense that, like the human subject, the artist and photography itself are social constructs, endlessly malleable and indefinitely permeable.

Or consider the pastiche of architectural styles and historical references in the *Piazza d'Italia*, created by the architect Charles Moore for the Italian American population in New Orleans. One catalog says that the Piazza "brings the dignified vocabulary of classical architecture up to date with Pop Art techniques, a post-modernist palette, and theatricality. It conceives of history as a continuum of portable accessories, reflecting the way the Italians themselves have been 'transplanted' to the New World. It presents a nostalgic picture of Italy's renaissance and baroque palaces and its piazzas, but at the same time there is a sense of dislocation. After all, this is not realism, but a facade, a stage set, a fragment inserted into a new and modern context."[10] Again one gets a strong sense of social constructedness, in this case the constructedness of immigrants, traditions, and urban architecture. Regular remodeling of Madonna in popular music, fluid morphing of characters and settings in film, and abrupt time-traveling between fictional worlds in literature exemplify similar trends in other art forms.

Such examples point to a displacement of emphasis from art's uniqueness to its being transversed by disparate waves of societal energy. Whereas modern artists struggled to free art from the dictates of commerce, politics, and organized religion, postmodern artists tend to question or abandon the assumption that art can or should be autonomous. For some postmodern artists this means embracing those vernacular or outdated idioms that modern artists kept at a distance, as well as giving up qualms about the supposedly corrupting influences of advertising, fashion, and consumer capitalism.

[10] *Post-Modern Visions* catalog, as quoted by David Harvey, *The Condition of Postmodernity: An Enquiry into the Origins of Cultural Change* (Cambridge, Mass.: Blackwell, c. 1989), p. 95.

Parallel to this shift from freedom to construction, the modernist priority of form gives way to a new emphasis on context. The context – what happens in people's lives – becomes at least as important as the formal qualities of the finished product. The efforts of feminist artists have been crucial in this regard, as was apparent from examples of new genre public art in the previous chapter. Such examples break with a modernist fixation on the form and aesthetic quality of an individual artwork. Some of them also challenge closely related concerns about the prestige of the work in question. The formal purity or professional status of the finished product does not have primacy; rather, it is the degree to which the ongoing project supports and empowers the lives of its participants or challenges structures and conditions that marginalize and oppress. This new approach represents a striking shift in the way people regard and practice the arts, accompanied by gradual changes in how schools, museums, and arts organizations describe their tasks and try to accomplish them. From establishments that privilege discrete artworks, they turn into centers that emphasize the process of creation and interpretation, often with an aim to engender or involve a community.

The new attention to context brings with it a revaluation of the notion of progress. In the early decades of the twentieth century, many European and North American intellectuals believed that society could be improved, and that the arts and sciences had a leading role to play in achieving progress. In the meantime, however, many intellectuals have come to doubt the ability of the arts and sciences to usher in a more humane future. This doubt lies at the heart of postmodern arts and postmodernist aesthetics. It questions not simply the ability of the arts and sciences, but rather the entire notion that there is a more humane future toward which intellectual culture can and must contribute. Perhaps the more humane future, on behalf of which aesthetic modernists emphasized artistic freedom and artistic form, has been an illusion all along.

Instead of the future, many artists now emphasize the contingent. In a book titled *Art and Enlightenment*, David Roberts argues that the shift from modern to postmodern, by reducing the European tradition to mere grist for the artist's mill, replaces the idea of progress with an awareness of contingency. In fact, he says, an awareness of art's own contingency has come to dominate art as a self-contained

system. And this heightened awareness of contingency marks a step forward in the emancipation of art itself.[11]

Despite reservations about Roberts's argument,[12] I think his notion of contingency is illuminating. Postmodern artists do not regard their efforts as somehow contributing to the necessary development of their fields and of society. With the burden of progress lifted, artists can blend and bend their genres seemingly at will. Now, according to Roberts at least, artists can choose among virtually endless options unbounded by tradition. As we have seen in the case of Charles Moore's *Piazza d'Italia*, one option is to create collages of quotations from many different traditions, which, of course, no longer have the authority of traditions.

More needs to be said about the shift from modern art to postmodern arts. I have not provided a historical account. I have not indicated sufficiently that the cultural trends prevalent in postmodern arts can also be found, albeit less prominently, in modern art, and vice versa. Nor have I explicated the differences and connections among "modernity" or the "modern age" as a societal formation spanning several centuries and "postmodernity" or a "postmodern time" as a period within modernity that dates roughly from the 1940s to the present; "modern art" and "postmodern art," both of which occur within modernity; and "modernism" and "postmodernism" as intellectual positions that involve various theories and practical orientations with respect to not only modern and postmodern art but also modernity and postmodernity. Perhaps the contrasts I have laid out between modern and postmodern art suffice, however, to ask about democratic potential in contemporary art making and art interpretation.[13] Next I consider relationships between culture and democracy.

9.2 DEMOCRATIC MATRIX

The idea of a democratic culture unites two intricate and contested concepts. Raymond Williams describes "culture" as "one of the two or three most complicated words in the English language," and he says

[11] David Roberts, *Art and Enlightenment: Aesthetic Theory after Adorno* (Lincoln: University of Nebraska Press, 1991).

[12] See my review in the *Journal of Aesthetics and Art Criticism* 50 (Summer 1992): 262–3.

[13] None of this is intended to suggest that *modern* art lacks democratic tendencies. To explore the connections between modern art and democracy would require a separate treatment, however. For useful pointers in that direction, see Theo de

of "democracy" that "its meanings have always been complex."[14] In the case of "culture," the complications arise primarily from the distinct uses to which the word has been put in various disciplines and systems of thought. Williams distinguishes four types of usage. The first and earliest refers to "the tending of something, basically crops or animals." The other three, which provide metaphorical extensions of the first, stem from the past few centuries: culture as "a general process of intellectual, spiritual and aesthetic development"; culture as "a particular way of life, whether of a people, a period, [or] a group"; and culture as "the works and practices of intellectual and especially artistic activity."[15] Moreover, cultural anthropology has used the word primarily to refer to material production, while cultural studies has tended to use it to refer to systems of signification. Hence, when one speaks of "Japanese culture," for example, one could be speaking as an anthropologist about artifacts, tools, and the like, or one could be speaking in the vocabulary of cultural studies about the linguistic, social, and religious practices and institutions that pervade and frame a Japanese way of life.

Amid such complications one has little choice but to specify one's concepts and strive for relatively consistent usage of terms. As was mentioned in Chapter 2, I use "culture" in two senses. Culture in the generic sense refers to the entire network of practices, relationships, and products or events through which traditions are shaped and transmitted, social connections solidify and are contested, and personal identities develop and are embraced. Language, education, organized religion, the arts, and leisure provide several nodes of this network in a complex society. Culture in the specific sense of a culture or a subculture refers to a relatively cohesive and dynamic array of such practices, relationships, and products or events where certain habits, sensibilities, and self-understandings are characteristic.[16] To

Boer's essay "Why Interpretation?" in *The Arts, Community and Cultural Democracy*, ed. Lambert Zuidervaart and Henry Luttikhuizen (London: Macmillan; New York: St. Martin's Press, 2000), pp. 165–79.

[14] Raymond Williams, *Keywords: A Vocabulary of Culture and Society*, rev. and exp. ed. (London: Fontana, Flamingo, 1983), pp. 87, 93.

[15] Ibid., pp. 87, 90.

[16] By speaking of a "relatively cohesive and dynamic array," I do not mean to deny the "hybridity" of many specific cultures. Unlike Jan Nederveen Pieterse, however, I do not consider hybridity to be either definitive or normative for all specific cultures. See Jan Nederveen Pieterse, *Globalization and Culture: Global Mélange* (Lanham, Md.: Rowman & Littlefield, 2004).

speak, then, of "a democratic culture" is to refer to a relatively cohesive and dynamic array of practices and the like that evinces characteristically democratic dispositions.

This brings us to the second intricate concept: "democracy." Williams notes that "democracy" was "a strongly unfavorable term" before the nineteenth century. Only since the turn of the twentieth century have most political parties "united in declaring their belief in it."[17] The term literally means "people rule." Many variations in the term's usage stem from divergent understandings, first, of how this rule occurs and, second, who constitutes the people. With regard to "how," we can distinguish between direct democracy, in which governance is carried out directly by the people themselves, and representative democracy, in which governance is carried out by elected representatives of the people. With regard to "who," we can distinguish between popular or radical democracy, in which all qualified members of a population make up the people, and liberal democracy, in which the people include only those with the right to vote – historically, a continually expanding segment.

Both of these distinctions pertain primarily to democracy in the political sense, as a way in which civil society intersects the state. It is possible, however, to extend the reach of this concept to include matters economic and cultural. Indeed, at the heart of Marxist and feminist critiques of liberal representative democracies is the fact that such democracies not only exclude many people from the channels of governance but also restrict the scope of democracy to the political arena, leaving economic and cultural orders as exploitative and hegemonic as ever. Liberal proponents of democracy tend to soft-pedal the ideas of economic and cultural democracy. Accordingly, the standard liberal conception of a democratic culture is one that promotes and sustains the qualities and attitudes that make for good citizenship, as can be seen in work on citizenship theory that emerged from the liberal-communitarian debate.[18] By contrast, the ideas of

[17] The content of this paragraph derives from the entry on "Democracy" in Williams, _Keywords_, pp. 93–8.
[18] See the excellent survey of the literature by Will Kymlicka and Wayne Norman, "Return of the Citizen: A Survey of Recent Work on Citizenship Theory," _Ethics_ 104 (January 1994): 352–81. The authors observe that "the concept of citizenship seems to integrate the demands of justice and community membership" and hence

economic democracy and a democratic culture point beyond ques-
tions of political representation and electoral franchise to broader
questions of power, justice, and solidarity.

Political, Economic, and Cultural Democracy

In this connection, I have two hypotheses to propose. The first is that
the viability of a democratic culture is conditioned to a significant
degree by the prospects for a democratized economy. The second
hypothesis is that the meaning and vigor of a political democracy
depend on the degree to which this is sustained by a democratic cul-
ture. This chapter focuses on the first hypothesis, and the next chap-
ter makes a few comments about the second.

Taken together, my hypotheses refine and extend an argument
by John Dewey. In *The Public and Its Problems*, a series of lectures first
published in 1927, Dewey distinguishes between democracy as "a
social idea" and political democracy as "a system of government." He
writes: "The idea of democracy is a wider and fuller idea than can be
exemplified in the state even at its best. To be realized it must affect
all modes of human association, the family, the school, industry,
religion."[19] For Dewey, the primary problem facing Western democ-
racies in the 1920s was not simply the absence of a well-informed,
engaged, articulate, and effective political public, such as Walter
Lippmann documented and analyzed in *The Phantom Public* (1925).[20]
Rather, the problem was that what Dewey, following Graham Wallas,
calls the Great Society[21] – a society of large, impersonal organizations
in a technological age – had not yet become the Great Community – a

"may help clarify what is really at stake in the debate between liberals and com-
munitarians" (p. 352).

[19] John Dewey, *The Public and Its Problems*, in *The Later Works, 1925–1953*, vol. 2: *1925–
1927*, ed. Jo Ann Boydston (Carbondale: Southern Illinois University Press, 1984),
pp. 235–372; the quote is from p. 325.

[20] For Dewey's review of Lippmann's book, see *The Later Works, 1925–1953*, vol.
2: *1925–1927*, pp. 213–20. James Gouinlock's introduction to this volume notes
that "*The Phantom Public* inspired Dewey to write *The Public and Its Problems*"
(p. xxiii). Dewey acknowledges his indebtedness to Lippmann in a footnote on
p. 308.

[21] Graham Wallas, *The Great Society: A Psychological Analysis* (London: Macmillan,
1914), a book dedicated to Walter Lippmann that Dewey mentions in *The Public
and Its Problems*, p. 295.

society in which all human associations approximate the social idea of democracy.

Dewey summarizes the social idea of democracy as follows: "From the standpoint of the individual, it consists in having a responsible share according to capacity in forming and directing the activities of the groups to which one belongs and in participating according to need in the values which the groups sustain. From the standpoint of the groups, it demands liberation of the potentialities of members of a group in harmony with the interests and goods which are common. Since every individual is a member of many groups, this specification cannot be fulfilled except when different groups interact flexibly and fully in connection with other groups." Described in this fashion, "democracy is not an alternative to other principles of associated life. It is the idea of community life itself."[22] In keeping with this idea, Dewey advocates the development of habits and institutions of open communication informed by systematic and experimental inquiry as well as by challenging and significant art. Under such conditions, "democracy will come into its own, for democracy is a name for a life of free and enriching communion.... It will have its consummation when free social inquiry is indissolubly wedded to the art of full and moving communication."[23]

In my own terms, what Dewey recommends is the development of a democratic culture. He sees the arts and sciences as the most crucial nodes for this development, particularly in connection with schooling.[24] What Dewey could not foresee, however, was the extent to which the arts and sciences would become enmeshed with the operations of a hegemonic economy. Nor could he consider the prospects for "a life of free and enriching communion" in a 1990s world where Capital Cities/ABC, the company of news anchor Peter Jennings, came under the control of Walt Disney, the owner of cartoon character Mickey Mouse. NBC, the first of the large commercial broadcasting networks in the United States, was not founded until the year Dewey gave these lectures (1926), and ABC was not created until nearly twenty years later. In the brave new world that emerged in the 1990s and that continues today,

[22] Dewey, *The Public and Its Problems*, pp. 327–8.
[23] Ibid., p. 350.
[24] The importance of schooling becomes particularly apparent from Dewey's reflections in the 1930s and 1940s on "Democracy and Education," part I in John Dewey, *Problems of Men* (New York: Philosophical Library, 1946), pp. 21–140.

however, questions about the viability of a democratic culture cannot be addressed without considering the prospects for economic democracy.

Participation, Recognition, Freedom

Following Dewey, I wish to suggest that three concepts are crucial to the overarching idea of democracy, before its specification as cultural or economic or political democracy: the concepts of participation, recognition, and freedom.

In the first place, for a people or community to exercise authority over their own affairs, members of the community must have opportunity to participate in this process and to take responsibility for the outcome, to the extent that they are able. This constitutes the core intuition within the emphasis on equality in most theories of political democracy. Dewey brings that intuition to the fore when he says equality "denotes the unhampered share which each individual member of the community has in the consequences of associated action. It is equitable because it is measured only by need and capacity to utilize, not by extraneous factors which deprive one in order that another may take and have."[25]

Second, for a community's self-rule to achieve legitimacy, both among its own members and in the estimation of other communities, the unique worth of each member and the collective worth of each community must be in a position to command and receive public recognition. This is the intuition driving what Charles Taylor calls the politics of recognition. The older, noninclusive term for this in theories of political democracy was "fraternity," which Dewey describes as a "name for the consciously appreciated goods which accrue from an association in which all share, and which gives direction to the conduct of each."[26]

In the third place, what propels the search for legitimate self-rule is a desire for freedom – the freedom of each member of a community, the freedom of various communities within a society, and the freedom of society as a whole. Theories of political democracy often articulate this desire in the notion of liberty, as secured by various civil, political, and social rights. Dewey's description, however, is more

[25] Dewey, *The Public and Its Problems*, p. 329.
[26] Ibid.

expansive. He describes liberty as "the power to be an individualized self making a distinctive contribution and enjoying in its own way the fruits of association."[27] One could add to his description the ability of various communities and institutions to flourish in their own way and to contribute to a society in which human beings and other creatures come to flourish.

Participation, recognition, and freedom – these three concepts together constitute what Dewey calls the social idea of democracy. When students claim a more substantial role in their own education, or when ethnic and racial minorities demand to be heard and to have their voices respected, or when women seek to liberate themselves from the oppressive patterns of patriarchy, those same three concepts are almost always at work, even when the more specific questions of *political* democracy are not on the table. Indeed, the struggles of the new social movements of multiculturalism, feminism, gay liberation, and the like always go beyond questions of political democracy to concerns for economic justice and a democratic culture.[28]

A democratic culture arises when the practices, relationships, and products most crucial to the formation of traditions, social connections, and personal identities tend to be democratic – when they are ones in which the norms of participation, recognition, and freedom usually prevail. A setting in which the crucial formative institutions are patriarchal families, authoritarian schools, and rigidly dogmatic churches, mosques, or synagogues, for example, would hardly be conducive to a democratic culture, no matter how much praise its leaders might sing to free enterprise and a democratic government. Such a setting would not foster the characteristically democratic habits, sensibilities, and self-understandings that characterize a democratic culture. Democratic dispositions have more chances to thrive

[27] Ibid. In an important essay on freedom written around the same time, Dewey rejects the assumption of classic liberalism that people are equally free to act "if only the same legal arrangements apply equally to all," irrespective of differences in education, class, and economic power. Rather, "the attainment of freedom conceived as power to act in accord with choice depends upon positive and constructive changes in social arrangements." "Philosophies of Freedom," *The Later Works, 1925–1953*, vol. 3: *1927–1928*, ed. Jo Ann Boydston (Carbondale: Southern Illinois University Press, 1984), pp. 92–114; the quotes are from pp. 100, 101.

[28] See David Trend, *Cultural Democracy: Politics, Media, New Technology* (Albany: State University of New York Press, 1997).

in an environment where participation, recognition, and freedom set the tone for people's lives. Such dispositions do not simply flow from membership in a political democracy and from participation in the political process. They require a *cultural* environment in which independence, mutual respect, critique, creativity, and public dialogue prevail. Such an environment presupposes appropriate schools, cultural centers, neighborhood associations, religious communities, arts organizations, and media of communication.[29] It is the combination of practices, products, and relationships that permits and fosters democratic dispositions.

Democratized Economy

If the dominant *economic* sites in people's lives – the shopping mall, the workplace, and the home entertainment center – do not support such a cultural environment, however; if in fact these sites block the pursuit of participation, recognition, and freedom, then it is highly unlikely that democratic dispositions will characterize a culture. Democratic dispositions are unlikely to thrive when the conditions under which people work and shop and meet their economic needs not only resist their control but also funnel their resources toward those who already wield enormous wealth and power. What is "learned" in school, for example, will be lost at work or play. That is why the viability of a democratic culture depends on the prospects for a democratized economy.

By "a democratized economy" I mean one in which the norms of participation, recognition, and freedom play a significant role in a society's organization of production, distribution, and consumption. Although the discussion of economic solidarity in Chapter 5 already points in this direction, I leave the phrase "significant role" undefined, in order not to enter this theoretical minefield beyond what my

[29] Although I would not go so far as Michael Walzer, who claims that "the civility that makes democratic politics possible can only be learned in the associational networks" of civil society, I agree that such civility can hardly be learned in the absence of a properly functioning civil society, and that associational networks may need to be reconstructed "under new conditions of freedom and equality." See Walzer, "The Civil Society Argument," in *Dimensions of Radical Democracy: Pluralism, Citizenship and Community*, ed. Chantal Mouffe (London: Verso, 1992), pp. 89–107.

own reconnaissance warrants. Perhaps I can suggest the issues at stake by referring to a couple of passages in *Beyond Poverty and Affluence*, a passionate appeal for economic transformation written by the Dutch economists Bob Goudzwaard and Harry de Lange. Although their main argument is for a "precare economy" and not for economic democracy as such, democratizing the proprietary economy is clearly part of what they have in mind.

Goudzwaard and de Lange advocate a transition to an economy oriented to the real needs of the poor, the unemployed, the environment, and future generations. To move toward such a "precare economy," they argue, "we must alter the ways in which ends and means become connected."[30] In a *micro*economic context, this implies, for example, that various industries and unions must reallocate their buying power toward "more care for employment, people, and the environment, in *combination* with a willingness to limit the income they would otherwise receive." For this to occur, employees may need to become "full partners" in the process of deciding how such reallocation is to occur.[31] In other words, the structure of control in industries and unions may need to be democratized, as has happened already in many cooperative businesses.

Goudzwaard and de Lange know, of course, that companies and workers who make such decisions in isolation will get clobbered in the current marketplace. Hence, renewal is also imperative at the *macro*economic level, and for this appropriate government regulation is required. Also required is a significant change to "current disparities in the exercise of economic power." Let me quote at length:

[W]e cannot solve macroeconomic problems by merely appealing for changes in the microeconomic sphere, because such an appeal does not fully address the current wielding of economic control. We therefore need to locate new ways of democratizing important decisions about investments and their financing.... [T]hose who wield economic power must become more accountable for the decisions they make. The right of people to own and

[30] Bob Goudzwaard and Harry de Lange, *Beyond Poverty and Affluence: Toward an Economy of Care*, trans. and ed. Mark R. Vander Vennen (Grand Rapids, Mich.: Eerdmans; Geneva: WCC Publications, 1995), p. 90. The implications of this stance for cultural activity are explored in the essay "The Global and the Local" by Bob Goudzwaard and André Droogers, in Zuidervaart and Luttikhuizen, *The Arts, Community and Cultural Democracy*, pp. 40–66.

[31] Goudzwaard and de Lange, *Beyond Poverty and Affluence*, pp. 91–2.

participate in the significant decisions affecting their lives deserves much broader attention in economics. We must seek mutual responsibility. And we must explore avenues for enhancing mutual responsibility, such as pursuing local community economic development and giving mutual responsibility more emphasis in child and adult education.[32]

To this I would add that to democratize economic institutions and the economic order would have more than strategic value. The pursuit of economic democracy would do more than facilitate the shift from a postcare to a precare economy. It would itself help meet real needs for justice and solidarity that are crucial to human flourishing, needs that must be addressed in all three sectors of the economy.[33] By contrast, economic institutions and an economic order that regularly rob workers and the poor of economic power continually violate the principles of justice and solidarity that make for human flourishing. A key to honoring these principles within economic transactions lies in the pursuit of economic democracy at the local, national, and international levels. Goudzwaard and de Lange hint in this direction when, acknowledging how the harmful effects of our economic actions conflict with a "participatory society," they call for "inclusive thinking" to replace the dominant mode of thinking, which is antagonistic.[34]

To the extent that the meaning and vigor of a political democracy depend on the presence of a democratic culture (a hypothesis to be addressed in the next chapter), and to the extent that the viability of a democratic culture cannot be divorced from the prospects for economic democracy, to those same extents a political democracy cannot sustain itself in the long run in the absence of a sufficiently democratized economy.[35] Hence the future path of the culture industry,

[32] Ibid., p. 128.

[33] Goudzwaard and de Lange distinguish three types of economic needs: material luxury needs that are harmful or frivolous; real and significant needs that are not essential to the preservation of life; and basic subsistence needs. They argue for an economy in which, at the very least, basic subsistence needs take priority over luxury needs (ibid., p. 85). My describing justice and solidarity as "real needs that are crucial to human flourishing" does not equate them with subsistence needs for food, shelter, and the like but does suggest that the need for justice and solidarity should have similar priority over luxury needs.

[34] Ibid., p. 131.

[35] The long-term dependence of political democracy upon a democratized economy is what I take to be the correct insight in Nancy Fraser's claims about the relation between political parity and social equality with which I took issue in Chapter 4.

including entertainment, information, and communication, is cru-
cial to the prospects for political, economic, and cultural democracy.
So is the ongoing development of art in public.

9.3 CONTEMPORARY PROSPECTS

Earlier I characterized a cultural shift in the arts from the priority
of freedom, form, and futurity to emphases on construction, con-
text, and contingency. At that point, I said little about the economic
upheavals that have accompanied this shift. Let me discuss those
upheavals now, focusing on developments in recent decades.

Economic Upheavals

In *The Condition of Postmodernity*, David Harvey argues that there is
a "necessary relation between the rise of postmodernist cultural
forms, the emergence of more flexible modes of capital accumula-
tion, and a new round of 'time-space compression' in the organiza-
tion of capitalism."[36] What I describe as emphases on construction,
context, and contingency Harvey views as cultural representations of
a crisis in late capitalism. The long postwar boom in Western econo-
mies ended in the early 1970s, he says. To continue squeezing prof-
its from the economy, corporations and their allies in government
sought more flexible approaches to the control of labor, production
of goods, creation of markets, and financing of investments. Harvey
gives numerous examples of these new and more flexible approaches,
of which I mention just a few: first, a move away from regular employ-
ment to part-time, temporary, or subcontract work arrangements that
undermine the power of labor unions and decrease wage levels and
job security; second, a transition from large-scale production of stan-
dardized goods for a stable mass market to small-batch production of
a variety of goods for volatile niche markets; and, third, a dramatic
speed-up in turnover time through computerized automation, just-
in-time delivery, and exploitation of quick-changing fashions, many
of them induced by advertising and cultural commodities. Along
with such changes has come the increased importance of up-to-date

[36] Harvey, *The Condition of Postmodernity*, p. vii.

information and style as well as the creation of a global but deregulated system of finance and investment. In these ways, and in many others, new profits could be squeezed out of an economy that would otherwise have too much idle capital and idle labor lying around.[37]

Of course, with all this squeezing, someone has to get squeezed, and we now know the wealthiest nations and the wealthiest classes within these nations have not been the ones to suffer. Yet the resulting compression of space and time, of the places in which people live and of the pace of their lives, has taken a toll on everyone. According to Harvey, postmodern forms of culture, including the arts, provide ways in which people try to come to terms with the new time-space compression.[38]

Two decades after Harvey's book appeared, we can ask whether contemporary cultural practices and institutions simply help people to "go with the flow," to adapt to their ever-changing circumstances and even to celebrate the process of rapid-fire change without critique or creativity, or whether contemporary culture also provides avenues of resistance and renewal. On this question I would say the jury is not in. Or, rather, the intellectual world has already experienced a number of hung juries, and we need, perhaps, to raise more fundamental questions that exceed the boundaries of various professionalized fields.

The specific question to be addressed now is whether contemporary arts can be conducive to the birth of a more democratic culture. I want to answer yes, provided they accompany steps toward a greater democratization of the states and economies to which the arts are linked. Previous chapters have uncovered structural and normative clues to what greater democratization would involve.[39] Structurally, political and economic systems would become more open to the legitimate concerns of civil society. But they would also foster within themselves elements of democratic communication and a social economy that are mostly latent at present. Normatively, the state would place priority on the task of promoting and securing public justice for all individuals, communities, and institutions within its jurisdiction. In doing so, the state would give appropriate attention to concerns for

[37] Ibid., pp. 141–72.
[38] Ibid., pp. 284–307.
[39] See especially Chapters 5 and 6.

economic resourcefulness and social solidarity as well. So too the economic system would give priority to pursuing resourcefulness and not to exploiting people and habitats for private gain. Hidden elements of a social economy would become stronger, and considerations of economic justice would find their proper place. In tandem with these structural and normative redirections of the state and economic system, the institutions of civil society would need to become robust sites for social solidarity and not be mere release valves for pressures generated by normative deficiencies in the administrative state and proprietary economy. In its networks of public communication and its social economy, civil society would provide solidaristic inflections to justice and resourcefulness that political and economic systems need but cannot themselves provide. A differential transformation along these lines would result in a more genuinely democratic society across the board, in all three macrostructures.

Artistic Midwifery

This is the context in which a more fully democratic culture could flourish, supported by a democratized economy and lending support to the institutions and practices of political democracy. Insofar as steps toward greater political and economic democracy occur, contemporary art in public can encourage the birth of a democratic culture. It can do so in three ways.

First, the emphasis on contingency that achieved prominence in postmodern arts can promote a degree and quality of participation that exceeds anything previously witnessed in recent Western history. If the arts are not chained to a logic of historical progress, and if artists do not have to defend the purity of their own art forms, then the process of creating and interpreting the arts becomes open to many voices with many pasts and many possible futures. In order for this new openness to support democratic dispositions, however, every participant must be able and ready to take responsibility for the outcome. For this to make sense, arts organizations, schools, museums, and funding arrangements will need to be restructured along the lines of directed co-responsibility.

The flip side to this opportunity, however, is that postmodern contingency has left people vulnerable to blind neomania and nostalgic pastiche, as these were discussed in Chapter 6. The flywheel of

technological innovation, propelled by the demand for highly flexible modes of capital accumulation, makes it increasingly difficult for anything from the past to retain nontechnological significance. This pertains as much to art-historical traditions and styles as it does to ethnic heritages and philosophical ideas. Whether artists and their publics will have anything to orient their participation other than the latest celebrities and fads remains an open question. Opportunities for greater and better participation opened by postmodern contingency will not foster democratic dispositions in the absence of cultural counterbalances to neomania and pastiche. Although such counterbalances do not mandate a revival of modernist futurity, they do require an orientation toward societal transformation, and for that elements of a hopeful social vision are required.

In the second place, postmodern attention to context can promote ways for the worth of various communities and their members to achieve public recognition. If the point of participating in art is no longer simply the formal qualities of individual artworks and the experiences they afford, and if artists no long define their own worth in terms of success at producing self-sufficient artworks, then doors can swing open for multifaceted collaborations in which the worth of many individuals and of entire communities can be explored, contested, and celebrated.

Let me give one local example. In the summer of 1995, inspired by a project in Washington, D.C. called *Shooting Back*,[40] the Urban Institute for Contemporary Arts sponsored a collaborative project titled *Expanded Visions*. Working with a nonprofit housing agency, UICA invited teens and preteens in the inner city of Grand Rapids to use cameras to document their lives and neighborhoods. Each young person teamed up with an adult professional photographer. The photographers taught their young partners how to use a camera, gave them tips about interesting angles and lighting, and helped them develop their photographs. Professional authors helped the young people write titles, captions, or storylines for their photos. Local businesses donated cameras and film. With advice from UICA staff and volunteers, the young people also helped organize and hang their

[40] See *Shooting Back: A Photographic View of Life by Homeless Children*, selected by Jim Hubbard, introduction by Dr. Robert Coles (San Francisco: Chronicle Books, 1991).

show. This was one of the most inspiring art openings I have attended; for some of the families and young people, it was probably the *first* art opening they had attended. The point of the project was not solely to display the formal qualities of the finished products, which were excellent. The point was just as much the discovery and presentation of the worth of these young lives and of the families and communities to which they belong. Such experiences are crucial to the development of democratic dispositions across the barriers of class and race and gender and religion and expertise that so often divide us.[41]

Of course, contextualism presents potential problems, as further reflection on my example will indicate. Too often the worth of an individual or community gets reduced to whatever "plays well" in the media or with funding agencies. Moreover, programming that encourages recognition for marginalized people and groups can also function as mere compensation that does little to secure structural change in the direction of social justice. This is not surprising, in light of tendencies toward cultural exclusion and balkanization noted in Chapter 6. Given the barriers among groups in contemporary society, however, which also stand in the way of justice, the emphasis on context holds important potential. To achieve this potential, art in public will need a contemporary rearticulation of the modernist emphasis on form. For this I would propose the ideas of imaginative disclosure and imaginative cogency presented in previous chapters.

Third, and finally, postmodern constructedness can promote new practices of freedom in which people can achieve fulfillment by acting and interacting within a horizon of shared expectations and with the benefit of public support. If the arts do not need to guard their borders against incursions from other areas of culture and society, and if artists do not need to insist on the specialness of their own professional identity, then opportunities can surface to align artistic efforts with a more positive vision of freedom. That vision would not preclude tensions between artists and their publics, nor would it mean that the arts simply fade into the cultural woodwork. But it would require that artists and other intellectuals articulate anew the contributions they

[41] Projects like this indicate that what Cornel West calls "The New Cultural Politics of Difference" can also be what Charles Taylor would call the politics of recognition. See the essay by this title in Cornel West, *Keeping Faith: Philosophy and Race in America* (New York: Routledge, 1993), pp. 3–32.

wish to make to a culture in which everyone has a stake. What they articulate would no longer be the negative freedom that characterized modern art and modernist aesthetics. Yet neither would it be an uncritical embrace of postmodern constructedness. It would expand the modernist understanding of autonomy into a more highly textured notion of art's relational autonomy as an element and agency of civil society. In pursuing relational autonomy, arts organizations would find avenues either to resist or to redirect hypercommercialization and performance fetishism.

The culture in which everyone has a stake would be a democratic culture. Although artists could no longer presume to have a privileged place just by virtue of being artists, they also would no longer have to pretend that their contributions are inevitably marginal or misunderstood. Moreover, the practices and qualities people learn through proper engagement with the arts would promote the critique, creativity, and dialogue that nurture democratic dispositions. Emphasis must be placed on "proper," however, to counteract the mistaken notion, all too common among educators and arts advocates, that exposure to the arts will in and of itself make people better citizens and community members. Hypercommercialization and performance fetishism do not stop at the museum portal or the schoolhouse door. Their effects make it difficult for cultural audiences and producers to pursue the creative tension of artistic authenticity and social responsibility in which practices and qualities of freedom can flourish.

Birth Pangs

Hence, the polarities informing both modern and postmodern art need to be transformed in order to fulfill the cultural potential of contemporary art in public. The fundamental choice facing contemporary artists and their publics does not lie between either freedom, form, and futurity, on the one hand, or construction, context, and contingency, on the other. Rather, the choice is whether to subsume legitimate elements within these contrasting emphases into artistic practices and arts organizations that foster and presuppose critical, creative, and dialogical participation. At bottom we need to decide whether and how our art making and art interpretation will contribute to a democratic culture.

None of the changes needed can occur without struggle, and the outcome is far from certain. Separated from a legitimate concern for relational autonomy, a postmodern emphasis on construction can engender opportunism rather than freedom. Removed from qualitative judgments about the worth of artistic practices, the priority of context can foster parochialism rather than recognition. So too, absent a transformative social vision, a culture of contingency can become one of cynical despair rather than hopeful participation. And, in the end, political and economic trends far more powerful than contemporary artistic practices may turn the entire globe into a gigantic Disneyworld.

Alternatively, if the forces of religious and ethnic fundamentalism carry the day, the world could become an uninhabitable battleground for implacable cultural warriors. We could even arrive at the worst of both possible worlds, enveloped by a culture where hypercommercial infotainment keeps most of us preoccupied while cultural warriors destroy any remnants of justice and solidarity – a world where quite literally, in Neil Postman's phrase, we amuse ourselves to death.[42] In such a world, the hope for a democratic culture to which art in public contributes would indeed be both quixotic and quaint. So far as I can tell, however, this political, economic, and cultural nightmare has not arrived. In fact, many agencies in civil society, including arts organizations like UICA, actively resist it. Opportunities remain in North America and beyond for the continuing birth of a democratic culture.

[42] Neil Postman, *Amusing Ourselves to Death: Public Discourse in the Age of Show Business* (New York: Viking, 1985).

10

Transforming Cultural Policy

*In the wood there are paths, mostly overgrown, that come to an abrupt
stop where the wood is untrodden. They are called Holzwege.*

Martin Heidegger[1]

From culture wars to a democratic culture – that is the trajectory of
this book. Might it also be the direction in which cultural policy needs
to be transformed? Before I take up this question, let me first review
the paths we have taken. While some have been fairly straightfor-
ward, others have meandered or stopped short of their destination.
They may seem like what Martin Heidegger calls *Holzwege* – paths
that head toward "a clearing in the forest where timber is cut" but
have become "overgrown" and perhaps lead "nowhere."[2] So I should
retrace our steps to see where this book's pathways have led us. Then
I can present my sociocultural case for government arts funding and
explore some implications for cultural policy.

10.1 PATHWAYS

We began at a place familiar to many in North America: an ongoing
debate over government arts funding that became especially heated in
the late 1980s and early 1990s. Chapter 1 describes three conceptual

[1] Martin Heidegger, *Off the Beaten Track*, ed. and trans. Julian Young and Kenneth
Haynes (Cambridge: Cambridge University Press, 2002), p. ix.
[2] "Translators' Preface," in Heidegger, *Off the Beaten Track*, p. ix.

polarities in this debate: government versus market, freedom versus authority, and provocation versus decadence. It also identifies three underlying assumptions, common to both sides of the debate, which reflect outdated and questionable views of the state, the arts, and a democratic society. The first assumption is the general acceptance of a politico-economic system in which government funding primes the pump for an art world dominated by corporate business interests. The second is an individualistic view of artists and their work. The third assumption is a vanguardist understanding of contemporary art's role in society.

Aiming to move beyond the impasse created by this debate, subsequent chapters challenge the problematic assumptions sustaining it. They thereby create a new conceptual framework for cultural policy. To unsettle acceptance of the systemic status quo, I introduce the concept of civil society as a third macrostructure distinct from economic and political systems but linked to them. To challenge individualism, I develop the concept of relational autonomy and demonstrate a creative tension between artistic authenticity and social responsibility. To break with vanguardism, in both its transgressivist and fundamentalist versions, I ask what contemporary art can contribute to cultural democracy.

Each of these moves follows the central intuition of this book, namely, that much of contemporary art both is and aspires to be art in public. We cannot think that the state becomes involved with the arts only when it directly subsidizes them. Nor can we continue to regard art making and art interpretation as marginal practices undertaken by scattered individuals at either the cutting edge or the yawning abyss of North American society. What we *can* assume, perhaps, is that tendencies to endorse the systemic status quo and to adopt individualist and vanguardist stances toward art reflect deficient understandings of culture and democracy as well as deep apprehensions about a democratic culture.

Chapters 2 and 3 look into this apparent "double deficit." They do so by considering theoretical attempts to justify direct state subsidies for the arts. Reviewing the efficiency, equity, and merit good arguments offered by mainstream economists, Chapter 2 claims that all of them suffer from a cultural deficit. Efficiency arguments fail to say why the arts are important in their own right and not simply as

sources of external benefits. Equity arguments, although they suggest that everyone has a cultural right to participate in the arts, do not say why governments should give this cultural right priority. Merit good arguments call attention to the cultural deficit in efficiency and equity arguments but fail to overcome it, for the arts are still portrayed as objects of consumer satisfaction.

This cultural deficit points to a misalignment of culture and economy, a misalignment addressed by Russell Keat, who calls for state subsidies to address inappropriate market boundaries. Building on Keat's analysis, although criticizing his notion of "cultural meta-goods," I claim that we need to understand the arts as a sociocultural good. As Charles Taylor suggests, the measure of their goodness does not lie in the domain of preferences, whether individual or collective, but in a domain of cultural meaning that is irreducibly social.

I distinguish in this connection between (generic) culture as a dynamic network of human practices, relationships, and products or events and a (specific) culture as a relatively cohesive and complex configuration of practices and the like where certain dispositions prevail. My main point, however, is that the arts are societally important constituents of culture in both senses. One of their primary roles in contemporary society is to help individuals and communities find cultural orientation – to discover purpose and meaning or their absence – within the imaginative disclosure of meaning that the arts make possible. Because of this role, and because the dominant economic system threatens it, arts organizations confront an economic dialectic: they foster a sociocultural good that a proprietary economy both needs and impedes. The key to addressing this economic dialectic is to develop robust arts organizations in the nonproprietary social economy of the civic sector. For this, government arts funding may be required.

The cultural deficit in economic justifications amplifies a democratic deficit in mainstream political justifications of government arts funding. Chapter 3 considers both minimal and robust instrumentalist arguments as well as a perfectionist argument – arguments that run parallel to efficiency, equity, and merit good arguments, respectively. None of these political arguments offers a sufficiently nuanced notion of public justice, one that would include not simply the rights of individuals to participate in culture but also the rights of social

institutions and cultural communities. Mainstream political argu-
ments fail to address the rights of people to participate in culture in
ways that foster mutual recognition and substantial freedom within
appropriate communities and institutions.

David Schwartz tries to deal with this democratic deficit. He
argues for government arts funding as a way to further democratic
education that citizens endorse and that a democratic state legiti-
mately promotes. Although his attempt falls short, I think it points
in a fruitful direction. To indicate this direction, I propose to regard
much of contemporary art as "art in public." By this I mean that its
production or use depends on government support (ranging from
direct and indirect subsidies to administrative, legal, and regulatory
involvements) and that its meaning is available to a public that goes
beyond the art's original audience. On the proposed conception, the
state is present in the societal constitution of contemporary art, much
of which is public in orientation. Accordingly, we need a postindivid-
ualist, nonprivatist, and communicative framework for understand-
ing and justifying government arts funding.

This framework considers civil society to be the primary location
of art in public. I describe civil society as one of three societal mac-
rostructures, alongside the proprietary economy and the administra-
tive state. Containing a diffuse array of organizations, institutions,
and social movements, civil society is a space of social interaction
and interpersonal communication. Intersections among the three
macrostructures have particular relevance for justifying government
arts funding, I claim, especially the civic sector as civil society's inter-
section with the proprietary economy and the public sphere as civil
society's intersection with the state. Just as the case for direct state
subsidies must address an economic dialectic via the civic sector, so it
must take up a political dialectic by way of the public sphere. For cul-
tural rights get articulated and claims for their satisfaction get com-
municated in the public sphere.

The political dialectic goes like this. By virtue of its imaginative
character and its participation in the public sphere, art in public has a
central role to play in bringing nuanced attention to issues and inter-
ests that require government response if public justice is to be done.
But the state, organized as a power-driven administrative system, puts
enormous pressures on the public sphere, to the detriment of such

imaginatively disclosive public communication. In other words, art in public promotes the sort of public communication that the administrative state both needs and undermines. The state especially needs public communication that resists the state's power-driven operations and reminds the state of its normative task. The challenge, then, is to develop modes of government funding that support rather than weaken imaginatively disclosive communication in the public sphere.

The next three chapters (Chapters 4–6) elaborate on the roles of art in public within civil society and the dialectical tensions already mentioned. Chapter 4 argues that the public sphere is an essential structure and principle in modern democratic societies. The shifting discourses and media of the public sphere support struggles for recognition and liberation and permit the general circulation of cultural practices and products. This, in turn, allows multiple publics to engage in democratic communication and to mount challenges toward the economic system and administrative state.

Various political and cultural institutions secure the public sphere's existence as a societal structure, and the premises on which they operate point to the normative principle of democratic communication. Although I acknowledge with Nancy Fraser that the existing public sphere is exclusionary in both origins and current operations, I think this must be a point of immanent critique, holding the public sphere to its own principle of democratic communication. Likewise, although I agree with Seyla Benhabib that universal respect and egalitarian reciprocity are central to interactions in the public sphere, I claim these normative considerations can be met only within the impure texture of existing political and cultural institutions.

Art is one of those institutions. Taking a clue from Hilde Hein, albeit questioning her actual account, I argue that art in public has a significant role to play in an existing public sphere. The public sphere, in turn, helps constitute the public character of art in public. Art's role is one of imaginatively disclosing matters of general concern, bringing them to the attention of both formal and informal political publics. This role allows artists and their publics to challenge the systemic logics of money and power and to strengthen the fabric of civil society. In doing so, they also raise democratic expectations of respect and reciprocity within their own patterns of artistic communication, as I illustrate with reference to the AIDS Memorial Quilt.

Chapter 5 argues that, to fulfill a democratic role in the public
sphere, the arts need a form of economic organization that keeps
them relatively independent from both the economic system and the
administrative state. To have room to disclose matters of general con-
cern, the arts must participate in the social economy of a civic sector.
First I show why economic attempts to explain civic-sector organiza-
tions as responses to market failure themselves fail to explain the
normative concerns of such organizations. I characterize these con-
cerns in terms of sociality, resource sharing, and open communica-
tion, all of which point to solidarity as the primary societal principle
for civic-sector economics. And I define solidarity as the expectation
that no individual, group, or community should be excluded from
the recognition we owe each other as fellow human beings.

This implies that civic-sector organizations participate in a "social
economy" distinct from both the proprietary economy of the so-
called first sector and the political economy of the administrative
state. Unlike Jon Van Til and Jeremy Rifkin, both of whom make
prominent use of this concept, I do not think that the social economy
makes civic-sector organizations either superior to proprietary and
governmental organizations or immune to systemic pressures. But
it is a key to their societal importance, and it gives them the poten-
tial to resist such pressures and to challenge economic and political
systems.

Such resistance and challenge occur within in a larger context,
however. I argue that none of society's macrostructures – proprie-
tary economy, administrative state, and civil society – avoids norma-
tive distortions and that each needs normative redirection. All three
macrostructures distort the meaning of resourcefulness, justice, and
solidarity, and they make it less likely for these societal principles to
obtain across society as a whole.

More specifically, solidarity in civil society needs to become sub-
stantially dialogical and inclusive. It also needs to inflect consider-
ations of resourcefulness and justice there that themselves have
primary normative weight for the proprietary economy and admin-
istrative state, respectively. Insofar as economic and political systems
distort these societal principles and restrict their scope, the agencies
of civil society need to call these systems to account. Part of doing
this is to point out a social economy hidden within the proprietary

economy and administrative state and to urge agencies within them to accord this social economy greater emphasis, in order to give appropriate weight to considerations of solidarity that these systems otherwise suppress or avoid.

All of this implies that arts organizations in the civic sector must rededicate themselves to participating in a social economy and not become overly dependent on either the proprietary or the political economy. They must focus on promoting artistic practices and relations as sociocultural goods, tending their resources as a public trust, and maintaining patterns of communication that invite public participation. At the same time, they should recognize the normative flaws of civil society, the proprietary economy, and the administrative state – the reduction of solidarity to a celebration of cultural diversity, for example, or the reduction of resourcefulness to efficiency and growth, or the reduction of justice to bureaucratic control. Civic-sector arts organizations need to provide creative alternatives to such normative reductions. In this way they can address the economic dialectic already mentioned and foster democratic artistic communication in the public sphere.

It might not be obvious, however, that my conception of art in public within civil society is viable under current conditions. Perhaps the public sphere is a phantom, the civic sector does not embody a social economy, and the requisite arts organizations do not exist or will soon disappear. Chapter 6 addresses the question of viability. Responding to a study of art and globalization by Joost Smiers, I argue that the "oligopolization" and "delocalization" of artistic endeavors threaten more than cultural and artistic diversity. They threaten civil society as such. Yet the forces that threaten both civil society and art in public are not monolithic, and they are not impervious to normative redirection.

I identify these forces as three pairs of systemic pressures on cultural organizations: hypercommercialization and performance fetishism, which arise from commercial and administrative encroachments in civil society; exclusion and balkanization, which reflect democratic deficits within cultural organizations; and neomania and pastiche, which stem from the effects of technological innovation in all three macrostructures. Chapter 6 points out a dialectical tension in each pair, and it claims that such tension creates openings for resistance

and redirection. Without such resistance and redirection, the forces at play here lessen the scope for communicative freedom, cross-cultural recognition, and meaningful participation in civil society.

Yet cultural organizations, including those dedicated to art in public, cannot resist and redirect either on their own or in the absence of normative orientations that confront the sources of systemic pressure. To resist hypercommercialization and performance fetishism and to maintain their communicative freedom, such organizations need protection and support from states that pursue public justice. To counteract exclusion and balkanization and to give primacy to cross-cultural recognition, they need to embrace a civil-societal vision of solidarity. To recover from blind neomania and nostalgic pastiche and to foster meaningful participation in culture, they need to attend to a social economy and public sphere that create more than legal space for such participation.

Do such organizations exist, and are they up to these challenges? I do not give an extended empirical argument in the affirmative. Instead, I tell the story of one organization that seems to fit my descriptions, the "UICA story." I try to show how a small nonprofit organization dedicated to nurturing art in public could rise to the economic, political, and cultural challenges it faced and not succumb to systemic pressures. I also suggest that an expansive and democratic vision of the arts in society has been a key to UICA's accomplishments. There is no guarantee that UICA and organizations like it will not succumb to systemic pressures. Yet they have the potential to find appropriate responses and to be transformative agents of civil society.

Filling in the normative background to my understanding of art in public, Chapters 7, 8, and 9 transform two modernist concepts that have helped short-circuit debates about government arts funding, namely, the concepts of autonomy and authenticity. Chapter 7 proposes a tripartite conception of relational autonomy. I argue that the autonomy of art consists of interpersonal, art-internal, and societal autonomy, that all three forms of autonomy are relational, and that they are closely interlinked. This tripartite conception adds normative texture to the concerns voiced in Chapter 6 about systemic pressures. Hypercommercialization and performance fetishism threaten art's societal autonomy; cultural exclusion and balkanization endanger

art's internal autonomy; neomania and pastiche present challenges to interpersonal autonomy; and together the pressures on art-internal and interpersonal autonomy reinforce the threats that hypercommercialization and performance fetishism pose to art's societal autonomy.

Conversely, to the extent that these forms of autonomy flourish in the arts, they serve to resist and redirect such systemic pressures. The critical, creative, and dialogical character of autonomous interpersonal participation in the arts, for example, provides a counterweight to systemic pressures generated by the logic of technological innovation. Arts organizations that foster such participation will challenge blind neomania and nostalgic pastiche. They will also open pathways beyond the freedom-authority divide that has derailed government funding debates. I claim that neither a dogmatic defense of "free expression" nor a forcible imposition of "community standards" encourages artists and their publics to engage in critical and creative dialogue. Instead, the freedom-authority divide reinforces tendencies toward neomania and pastiche that undermine autonomous participation in the arts.

So too, the internal autonomy of art, insofar as it is relational, can challenge tendencies toward cultural exclusion and balkanization. Central to the legitimacy and worth of art in a modern differentiated society, I argue, is the art-internal role of intersubjective imagination. Imaginative disclosure within art supports attempts to find cultural orientation and reorientation, and it gives the arts the capacity to generate, sustain, and renew critical and creative dialogue. Arts organizations that dedicate themselves to the task of imaginative disclosure can counter both the isolation of artistic expertise from everyday practice and the formation of subcultural silos. They can also break out of the impasse created by the contest between transgressive and reactionary vanguardism, a contest that reinforces cultural exclusion and balkanization and undermines the capacity of art to foster cross-cultural recognition.

The societal autonomy of art, in turn, serves to maintain communicative freedom in the face of hypercommercialization and performance fetishism. It can do so because the societal autonomy of art involves a proper mixture of independence and interdependence with respect to political and economic systems. To secure societal

autonomy, and to counteract hypercommercialization and perfor-
mance fetishism, arts organizations need to develop countereconomic
and counterpolitical spaces where participation in imaginative disclo-
sure can thrive, spaces that emerge from their activities and from the
agency of their participants. But arts organizations cannot maintain
art's societal autonomy in isolation. They need to form partnerships
with similar organizations in the civic sector and public sphere.

Arts organizations also need to contribute to a shift in the mac-
rostructural conditions that make art's societal autonomy possible.
This macrostructural shift, which I call "differential transformation,"
would enable the economic and political systems of society to pursue
resourcefulness and public justice in ways that complement solidar-
ity in civil society. The future of art's autonomy depends on this shift.
That is why the role of art at the interfaces between civil society and the
economic and political systems needs emphasis. It is also why the oppo-
sition between market and state in typical debates about government
arts funding obscures the most important issues at stake and reinforces
systemic pressures that jeopardize the relational autonomy of art.

Chapter 8 elaborates my conception of interpersonal autonomy by
examining a tension in contemporary art between a modernist expec-
tation of artistic authenticity and a more recent emphasis on social
responsibility. I define artistic authenticity as the expectation that
artists should create original products or events, and these creations
should be true with respect to the experience or vision that sustains
their art making. Social responsibility is the expectation that artists,
by virtue of the gifts, training, and societal positioning that enable
them to be artists, should be trustworthy with respect to imaginative
tasks, accountable for the outcome of their efforts, and responsive
within the situations where their imaginative tasks arise.

Properly construed, I argue, these two expectations are in creative
tension with each other, such that we cannot fruitfully pursue one
without pursuing the other. If they are not kept in creative tension,
then authenticity deflates into aesthetic solipsism, and social respon-
sibility inflates into uncritical collectivism. Further, this creative
tension pertains not only to art making but also to audience inter-
pretation. We can learn this from new genre public art, which at its
best offers experiences and metaphors of authentic co-responsibility
in the creative process.

Such art also challenges individualistic views of the artist that surface on both sides of the government funding debate. It shows artists to be members of cultural communities and social institutions who make important contributions to civil society. The tension between artistic authenticity and social responsibility acquires its greatest creative potential in conflicts over the quality and future of civil society. This tension also allows art in public to nurture critical, creative, and dialogical practices that reinforce the interpersonal autonomy all people need in order to be agents in civil society.

Another set of tensions opens a pathway beyond fundamentalist and transgressivist vanguardism, according to Chapter 9 – namely, the cultural polarities between freedom, form, and futurity, on the one hand, and construction, context, and contingency, on the other. I uncover these polarities in the shift from modern to postmodern arts, and I suggest that they condition the democratic potential of contemporary art in public.

This potential is important because democratic tendencies in polity, economy, and culture intermesh. Appropriating ideas from John Dewey, I describe a democratic culture as one where the norms of participation, recognition, and freedom usually prevail in the practices, relationships, and products most crucial to the formation of traditions, social connections, and personal identities. I also suggest that the prospects for a democratized economy significantly condition the viability of a democratic culture, and that a democratic culture is needed to sustain the meaning and vigor of a political democracy. The "time-space compression" in post-Fordist capitalism (David Harvey) and the culture industry's continuing consolidation into mega-conglomerates give added urgency to concerns about a democratic culture.

Chapter 9 argues that contemporary arts in public can be conducive to the birth of a more democratic culture, provided they accompany steps toward greater democratization of the states and economies to which they are linked. But such artistic midwifery will not be automatic. Postmodern contingency can promote new degrees and qualities of participation, but it can also leave people vulnerable to blind neomania and nostalgic pastiche. To counterbalance these pressures, art in public needs elements of a hopeful social vision reminiscent of modernist futurity. So too, postmodern

contextualism can promote public recognition for the worth of various communities and their members, but it can also degenerate into superficial compensation that reinscribes cultural exclusion and balkanization. To prevent such degeneration, art in public needs a contemporary rearticulation of the modernist emphasis on form, for which I have proposed the ideas of artistic truth and imaginative cogency. Moreover, postmodern constructedness can promote new practices of freedom in which people achieve fulfillment, but it can also engender mere opportunism that feeds into hypercommercialization and performance fetishism. To avoid opportunism and to promote communicative freedom, art in public needs to rework the modernist emphasis on freedom into new practices and understandings of relational autonomy. To contribute to a democratic culture, then, contemporary art in public must transform the polarities informing both modern and postmodern art.

10.2 SOCIOCULTURAL JUSTIFICATION

Such are the pathways this book has taken from culture wars to a democratic culture. To move past the remaining underbrush and reach a clearing requires that I state the alternative case for government arts funding to which these pathways lead. In fact, the need to transform cultural polarities within contemporary art in public returns us to the conceptual polarities with which this book began: the oppositions within the government funding debate between state and market, between artistic freedom and traditional authority, and between art as provocation and art as decadence. I have called this oppositional framework counterproductive, and I have tried to undo all three polarities, replacing their philosophical assumptions with a structurally complex and normatively textured understanding of the state, the arts, and civil society. I have also indicated elements of an alternative case for government arts funding, without presenting the entire case. Now we are in a position to consider a more complete sociocultural justification for direct state subsidies to the arts.

My case for government arts funding makes a large number of claims, most of them stated and elaborated in previous chapters, although not always identified there as premises in a justificatory

argument. One can boil these down to the following five, plus a conclusion.

1. The state has a public justice obligation toward art as a social institution. Let's call this the "public justice premise."
2. Society (including the state) needs arts organizations that foster imaginative disclosure. We can call this the "societal need premise."
3. The state's public justice obligation extends to the public sphere and civic sector to which such arts organizations contribute. This is the "civil society premise."
4. The state's public justice obligation extends to such arts organizations as well. Call this the "arts organizations premise."
5. Direct state subsidies to civic-sector arts organizations are appropriate and effective ways to discharge the state's public justice obligations to the institution of art, to civil society, and to such arts organizations. We can describe this as the "state subsidies premise."
6. Therefore, direct state subsidies for the arts are warranted on the basis of both public justice and societal need.

Without repeating all the details found in earlier chapters and reviewed in the previous section, let me indicate how I would support each of these premises and then mention some necessary refinements to the conclusion.

Public Justice Premise

The main assertion here is that *the state has a public justice obligation toward art as a social institution.* Here are the most important claims supporting this premise.

1. The normative task of the state is to secure and maintain public justice for all of the institutions, communities, and individuals within its jurisdiction.
2. Social institutions have distinctive and legitimate tasks in society; they have a claim to state protection from encroachments on their tasks by other social institutions; and they need state support for the performance of their tasks.

3. Art is one of these social institutions, and interpersonal participation in the arts is one of the important ways in which communities and individuals meet their cultural needs.
4. Therefore, given the state's normative task and art's status as an important social institution, the state has a public justice obligation toward art as a social institution, an obligation to protect it from encroachments by other social institutions (such as the proprietary economy and the state itself) and to support art in performing its task.

Societal Need Premise

Not only does the state have a public justice obligation toward art but also, because art helps people meet their cultural needs, society requires that to which the state owes this obligation. In other words, the case for direct state subsidies does not necessitate special pleading. But my societal need premise is more specific than this. I claim that *society (including the state) needs arts organizations that foster imaginative disclosure.* Support for this claim includes the following.

1. In contemporary differentiated and pluralistic societies such as Canada and the United States, one of the most important tasks for art as a social institution is to help individuals and communities find cultural orientation within the imaginative disclosure of meaning that the arts make possible.
2. The greatest external threats to art's performing this task come from the proprietary economy and the administrative state, which tend to subsume the arts under the imperatives of monetary profit (hypercommercialization) and bureaucratic control (performance fetishism).
3. Under current conditions, the best way for the arts to resist such systemic pressures and to pursue culturally orienting imaginative disclosure is by way of noncommercial and nongovernmental arts organizations in civil society.
4. Therefore, insofar as society needs culturally orienting imaginative disclosure and such arts organizations best provide it, society (including the state) needs arts organizations that foster imaginative disclosure.

Civil Society Premise

The external threats to art's imaginative disclosure also threaten civil society. That puts the state's public justice obligation to art as an institution into a larger context, where a tension internal to the state between an administrative logic of power and the democratic task of justice spills over into a conflict in the state's stance toward other macrostructures, in this case toward civil society. That is the context where the civil society premise arises, namely, that *the state's public justice obligation extends to the public sphere and civic sector to which such arts organizations contribute.* Consider the following claims in support of this premise.

1. Arts organizations dedicated to furthering imaginative disclosure contribute to the civic sector's social economy and promote democratic communication in the public sphere.
2. The civic sector's social economy fosters solidarity across diverse institutions, communities, and individuals, and it does so in ways that the proprietary economy, despite elements of a social economy hidden within it, neither can nor should attempt.
3. Democratic communication in the public sphere highlights issues and interests of general concern that the state, as the primary institution of public justice, must address.
4. In general, then, the state must protect and support the civic sector in order to do justice to the various institutions, communities, and individuals whose social solidarity gets organized through the civic sector's social economy.
5. Again, in general, the state must protect and support the public sphere in order to do justice to the various institutions, communities, and individuals whose rights and violations of rights get articulated in the public sphere's processes of democratic communication.
6. In other words, state's public justice obligation extends to the public sphere and civic sector to which such arts organizations contribute.

Arts Organizations Premise

It might be possible to route the entire case for direct state subsidies through the state's public justice obligation to civil society. I suspect,

308 Modernism Remixed

however, that this route would leave the arts high and dry when questions about priorities arise, as might happen, for example, if one channeled the case through "democratic education" à la David Schwartz and then discovered that schooling, sport, and scouting are equally effective vehicles of democratic education or even more effective than the arts. Hence, in addition to asserting that the state has a public justice obligation to art in general and to civil society, I claim that *the state's public justice obligation extends to civic-sector arts organizations that promote culturally orienting imaginative disclosure.* Although I find this premise more complicated to support than some of the others, here are my reasons.

1. We have established that society needs such organizations as the best way to promote culturally orienting and arts-based imaginative disclosure.

2. We have also established that the state has a public justice obligation toward art as a social institution and toward the public sphere and civic sector to which such arts organizations contribute.

3. Now we can add that civic-sector arts organizations are the primary way in which art remains viable as a social institution in North America. They are the primary way in which room is created for communities and individuals to participate in arts-based imaginative disclosure, as well as the primary way in which art as a social institution retains the ability to pursue its task relatively free from unjust encroachments by other social institutions, including the state itself.

4. We can also make explicit that such arts organizations are nevertheless continually threatened by external encroachments, especially economic and political ones.

5. Therefore, given a societal need for such organizations, their vulnerability to external pressures, and the state's public justice obligations toward art and civil society, the state's public justice obligation extends to civic-sector arts organizations that promote culturally orienting imaginative disclosure – the state needs to protect and support such organizations.

State Subsidies Premise

So far the argument, if successful, has established that the state has a public justice obligation to protect and support art, civil society, and civic-sector arts organizations. As we have seen, however, there are other ways to meet this obligation than through direct state subsidies – indirect subsidies, for example, and legislation and regulation. It is another step, then, to claim that *direct state subsidies to civic-sector arts organizations are appropriate and effective ways to discharge the state's public justice obligations to the institution of art, to civil society, and to such arts organizations.* Here are some considerations in support of this claim.

1. The appropriateness of direct state subsidies depends on a number of factors, including questions of equity raised by mainstream political arguments. But these are not decisive. The overriding criterion of appropriateness in the current context must be whether direct state subsidies would be publicly justifiable as upholding cultural rights.

2. The effectiveness of direct state subsidies also depends on a number of factors, including questions of efficiency raised by mainstream economic arguments. But the most decisive consideration in the current context must be whether direct state funding would promote the relative autonomy of art.

3. Questions of appropriateness and effectiveness raise empirical concerns that theory cannot settle on its own. Yet one can ask in theory whether the absence of direct state subsidies would be more effective and more appropriate from the perspective of public justice. My diagnosis of systemic pressures strongly suggests a negative answer.

4. Insofar as direct state subsidies to civic-sector arts organizations are publicly justifiable as upholding cultural rights, would promote the relative autonomy of art, and would be better from the perspective of public justice than would the absence of direct state subsidies, such subsidies are appropriate and effective ways to discharge the state's public justice obligations to the institution of art, to civil society, and to such arts organizations.

Conclusion

The state subsidies premise raises some issues of implementation to which we shall return shortly. But now we have in place a full-scale sociocultural justification for government arts funding, and we can conclude that *direct state subsidies for the arts are warranted on the basis of both public justice and societal need.* By having a basis in both societal need and public justice, the warrant I have given for direct state subsidies addresses both of the questions raised by mainstream theoretical justifications: What good is art? And what right do people have to participate in the arts?

More specifically, I have argued that direct state subsidies for *civic-sector arts* organizations are warranted for reasons of both public justice and societal need. This leaves open the possibility that such subsidies are not warranted for *individual artists* or for *specific audiences.* I am open to persuasion either way, although I think the main lines of a suitable argument would have to include considerations of public justice, civil society, and imaginative disclosure. Simply making claims about market inefficiencies and distributional inequities would not suffice. Nor would arguments based on notions of intrinsic aesthetic value (Feinberg), intergenerational equity (Rawls), and maintaining a rich cultural structure (Dworkin). What we need, and what I have tried to provide, is an argument that does justice both to the cultural character of the arts and to the democratic potentials and vulnerabilities of civil society.

Nevertheless, I recognize a worry about direct state subsidies that arises precisely because of such democratic potentials and vulnerabilities. My own diagnosis of systemic pressures and of the economic and political dialectics affecting art in public raises a caution flag: the wrong kind of direct state subsidies could increase the pressures of hypercommercialization and performance fetishism, thereby bringing about exactly the opposite of what government funding should promote, namely, art-institutional justice and a democratic culture.

Moreover, this worry goes to the issues of appropriateness and effectiveness broached by the considerations I mentioned in support of the state subsidies premise. For if the general effect of direct state subsidies were that they strengthen the pressures of hypercommercialization and performance fetishism, then it would be difficult indeed to justify them as upholding cultural rights and promoting

the relative autonomy of art. And it is possible that the regimes of government arts funding in North America, especially at the federal level, have had this cumulative effect.

I do not take this possibility as an argument against direct state subsidies as such, however. Rather, it is a reminder that, in addition to why governments should fund the arts – the focus of my sociocultural justification – a complete case for direct state subsidies would also need to consider how such funding should be procured and what the optimal means of providing it would be. To address these questions would take us well beyond the scope of this book. Yet I hope to have set a direction for considering questions of procurement and provision: we should not try to answer them without asking about the effects of direct state subsidies on the satisfaction of cultural rights for individuals and communities as well as on the relative autonomy of art as a social institution. In addition, when asking about these effects, we should not restrict our horizons to the proprietary economy and administrative state, as frequently occurs in public debates about government arts funding, but give full weight to civil society as the societal space in which we can best maintain cultural rights and democratic participation in the arts.

10.3 CULTURE AND DEMOCRACY

The pathways of this book may have reached a clearing, but the same probably cannot be said about cultural policy debates in North America. These remain as brambly as ever. Yet we can see now that democracy, articulated in the concepts of participation, recognition, and freedom, is the contested terrain traversed by the typical debate about government arts funding. The opposition of government versus market is also a conflict over which people, under which constraints, can participate in the co-creation of culture. To criticize the oppositional framing of this debate is to call for a greater range and number of participants. So too, the polarity of artistic freedom versus traditional authority points to a struggle for recognition in which neither marginalized individuals nor unfashionable communities want to be left out. My objection to the standard binary opposition posits that recognition must be reciprocal, and for this neither the atomic individual nor the dogmatic community suffices. Likewise, the opposition of provocation versus decadence

is at bottom a contest over the meaning of freedom in contemporary society. My criticism of this polarity asks both sides to adopt a more supple and generous understanding of what it means to be a free member of a free society, and of what the arts can contribute to such freedom. The battle about government arts funding is simultaneously a struggle over the shape of a democratic culture.

Constitutional democratic states have a stake in this struggle. They cannot retain their legitimacy if citizens do not participate in the political process, if a high proportion of individuals and communities cannot achieve public recognition, and if freedom becomes an empty word. Yet these are the likely outcomes if the cultural institutions that nurture democratic practices and dispositions do not have societal room to thrive. Among these institutions, I have argued, is art in public. Although it would be a mistake to treat training for political democracy as the primary reason to justify government arts funding, governments also cannot ignore this correlated outcome of interpersonal participation in relatively autonomous art in public.

Perhaps this helps explain why in 2006 the National Endowment for the Arts released a research brochure, based on data from 2002, that indicates a high degree of correlation between participation in the arts and "civic engagement." The brochure does not give causal explanations, and it is careful not to make inflated claims about the effects of arts participation on the practices and dispositions required for political democracy. Nevertheless, the preface by Dana Gioia, chairman of the NEA, concludes as follows: "Healthy communities depend on active citizens. The arts play an irreplaceable role in producing both those citizens and communities."[3] Gioia's words reinforce the appeal issued a decade earlier, quoted in Chapter 2 above, that we "support the vital part of government in ensuring that the arts play an increasing role in the lives and education of our citizens."[4] The NEA made this appeal just one year after Congress slashed its annual appropriation by nearly

[3] *The Arts and Civic Engagement: Involved in Arts, Involved in Life* (Washington, D.C.: National Endowment for the Arts, 2006), http://www.nea.gov/pub/CivicEngagement.pdf.

[4] *American Canvas: An Arts Legacy for Our Communities*, by Gary O. Larson (Washington, D.C.: National Endowment for the Arts, 1997), p. 150.

40 percent, a draconian cut from which the NEA has never fully recovered.[5]

We asked before what the government's part is and why it is vital. Now we can see that answering is more complicated than we might have expected, and that the involvement of government with the arts is both societally unavoidable and dialectically complex. The state establishes and enforces the legal and regulatory frameworks within which artists and arts organizations carry out their work. The state owns and operates arts-related ventures and sponsors arts-related services. It also subsidizes the arts, both directly and indirectly. Amid such a plethora of government involvements, it is easy to lose track of the normative and structural concerns that should guide cultural policies and inform our debates about them. Recalling previous chapters, let me mention three concerns.

The first is how to align the distinctive tasks of the state and of art as a social institution. On the one hand, the state's administrative logic, which puts systemic pressure on the arts, can easily flow through legislation, regulations, and subsidies that target the arts. On the other hand, art as a social institution has a right to pursue its own task, and legislation, regulations, and state subsidies need to uphold this institutional right if public justice is to be done. There is little hope of resolving this dialectic in the long run if the state does not undergo internal transformation. The transformation required would allow the state's administrative power to become ever more attuned to the requirements of public justice. In the short term, however, civic-sector arts organizations, artists, and art publics, along with other agents in civil society, should call the state to account. Included here would be the matter of direct state subsidies for the arts – not only their amount, which arts organizations usually find inadequate (and rightly so, in my view), but also the purpose and distribution of government arts funding. For such advocacy not to devolve into mere lobbying for a larger piece of the governmental

5 The NEA's annual appropriation in the early 1990s ranged between $170 million and $176 million. It decreased to $162 million for 1995 and then plummeted to $99 million in 1996. After five very lean years, gradual increases in the annual appropriation began in 2001 and reached $167.5 million for 2010. This amount remains below the peak of nearly $176 million reached in 1992 and significantly lower than that in inflation-adjusted dollars. See "National Endowment for the Arts Appropriations History," http://www.nea.gov/about/Budget/AppropriationsHistory.html.

pie, arts organizations will need to offer a better rationale than the mainstream justifications canvassed in Chapters 2 and 3, a rationale that gives priority to the state's normative task of public justice.

A second area of normative and structural concern pertains to realigning the proprietary economy with a social economy. Absent an economic realignment, not even the most vigorous countereconomic efforts by arts organizations and other civic-sector agencies will secure art's societal autonomy in the longer term. On the one hand, the proprietary economy, which remains the dominant sector and generates many of the resources on which the civic sector depends, impels arts organizations in the direction of hypercommercialization. On the other hand, arts organizations that give priority to imaginative disclosure cannot afford to go in this direction, even though their survival sometimes seems to hang on it. I do not think this dialectic will be overcome until the proprietary economy shifts from the pursuit of efficiency and growth for their own sakes to an economy where efficiency and growth are measured by considerations of resourcefulness – to what Goudzwaard and de Lange call a "precare economy" and what others call a "sustainable economy." Only in such an economy could the cultural resources art offers receive their proper due. In the meantime, however, and with a view to the longer-range economic transformation needed, civic-sector arts organization must rededicate themselves to fostering a social economy and call upon the state to support such efforts.

A third area of concern pertains to art's role in civil society. I have argued that art in public, as institutionalized by civic-sector arts organizations, has a double role in civil society. Its imaginative disclosure of issues and interests of general import contributes to democratic communication in the public sphere. And its ability to help people find cultural orientation fosters the social solidarity that governs the civic sector in which such arts organizations participate. Yet I have noted that the existing public sphere is exclusionary in its origins and operations, and I have suggested that the civic sector in its current form does not give sufficient weight to patterns of dialogue and inclusivity. Within art itself, these failures show up as cultural exclusion and balkanization. Civil society as it currently exists, including the arts organizations within it, can easily undermine the democratic communication and social solidarity that art can contribute.

Again we confront dialectic, one that calls for an internal trans-
formation of civil society. Arts organizations cannot pretend that the
challenges they face simply stem from political and economic systems.
They should acknowledge their own tendencies toward miscommu-
nication and a lack of solidarity, and, within the artistic practices
they support, they should find ways to counteract such tendencies.
Arts organizations also need to call upon the state to help secure
the economic and political spaces in which such internal transforma-
tion becomes possible, recognizing all the while that the democratic
transformation of civil society will not succeed if the administrative
state and proprietary economy do not also change.

These three concerns provide a larger context for rethinking the
rationale and goals of cultural policy. Justifiable direct state subsides
should help artists and their publics address such normative and
structural concerns. We need government arts funding that does not
undermine art's imaginatively disclosive character but does support
art's role in fostering democratic communication. We need govern-
ment funding that does not weaken art's ability to help communi-
ties and individuals find cultural orientation but does strengthen its
participation in the social economy of the civic sector. We also need
government arts funding that does not reinforce the cultural exclu-
sion and balkanization toward which arts organizations are prone
but instead helps them foster the critical and creative dialogue that
should characterize interpersonal participation in the arts. Along
with appropriate legislation, regulations, and indirect subsidies,
government arts funding should support art's ability to disclose and
communicate public issues and interests, strengthen art's participa-
tion in a social economy, and further the development of a demo-
cratic culture.

In the end, the question all of us face, as citizens, as workers and
consumers, and as artists and their publics, is whether we want a fully
democratic society. Such a society would go beyond one in which the
state is formally democratic, even though the practices and proce-
dures of democratic governance are a historical achievement well
worth maintaining and strengthening in their own right. It would be
a society in which the resources everyone needs in order to flourish,
including artistic resources, do not continually flow into the private
coffers of the most wealthy and powerful. It would also be a society

where the norms of participation, recognition, and freedom prevail in the institutions and organizations of culture, including the arts. The macrostructures of such a society would have undergone internal transformation; the conflicts among them would have been resolved; and people would enjoy justice, resourcefulness, and solidarity across the entire range of their social lives. We might not arrive at such a society in the foreseeable future. Imagining it, however, and disclosing the potential of a fully democratic society, will remain worthwhile endeavors for art in public.

Bibliography

Adorno, Theodor W. *Aesthetic Theory*. Translated and edited by Robert Hullot-Kentor. Minneapolis: University of Minnesota Press, 1997.

The Culture Industry: Selected Essays on Mass Culture. Edited by J. M. Bernstein. London: Routledge, 1991.

In Search of Wagner. Translated by Rodney Livingstone. London: Verso, 1981.

Introduction to the Sociology of Music. Translated by E. B. Ashton. New York: Seabury Press, 1976.

"The Meaning of Working through the Past." In *Critical Models: Interventions and Catchwords*, pp. 89–103. Translated by Henry W. Pickford. New York: Columbia University Press, 1998.

Alderson, Evan, Robin Blaser, and Harold Coward, eds. *Reflections on Cultural Policy: Past, Present and Future*. Waterloo, Ont.: Wilfrid Laurier University Press, 1993.

American Canvas: An Arts Legacy for Our Communities. By Gary O. Larsen. Washington, D.C.: National Endowment for the Arts, 1997.

Arendt, Hannah. *The Human Condition*. Chicago: University of Chicago Press, 1958.

Armstrong, Isobel. *The Radical Aesthetic*. Oxford: Blackwell, 2000.

Arrow, Kenneth J. "Gifts and Exchanges." *Philosophy and Public Affairs* 1 (Summer 1972): 343–62. Reprinted in *Altruism, Morality, and Economic Theory*, edited by Edmund S. Phelps, pp. 13–28. New York: Russell Sage Foundation, 1975.

Art Matters: How the Culture Wars Changed America. Edited by Brian Wallis, Marianne Weems, and Philip Yenawine. New York: New York University Press, 1999.

The Arts and Civic Engagement: Involved in Arts, Involved in Life. Washington, D.C.: National Endowment for the Arts, 2006. http://www.nea.gov/pub/CivicEngagement.pdf (accessed March 6, 2010).

Atwood, Margaret. *Cat's Eye*. New York: Doubleday, 1989.

Bagdikian, Ben. *The Media Monopoly*. 2nd ed. Boston: Beacon Press, 1987.

Barber, Benjamin R. *Jihad vs. McWorld*. New York: Ballantine Books, 2001.

———. *A Place for Us: How to Make Society Civil and Democracy Strong*. New York: Hill and Wang, 1998.

Baumol, William J., and William G. Bowen. *Performing Arts – The Economic Dilemma: A Study of Problems Common to Theater, Opera, Music, and Dance*. New York: Twentieth Century Fund, 1966.

Baynes, Kenneth. *The Normative Grounds of Social Criticism: Kant, Rawls, and Habermas*. Albany: State University of New York Press, 1992.

Beardsley, Monroe. "Aesthetic Welfare, Aesthetic Justice, and Educational Policy." In *The Aesthetic Point of View*, edited by Michael J. Wreen and Donald M. Callen, pp. 111–24. Ithaca, N.Y.: Cornell University Press, 1982.

Becker, Carol, ed. *The Subversive Imagination: Artists, Society, and Responsibility*. New York: Routledge, 1994.

Becker, Carol, and Ann Wiens, eds. *The Artist in Society: Rights, Roles, and Responsibilities*. Chicago: Chicago New Art Association; New Art Examiner Press, 1995.

Becker, Howard S. *Art Worlds*. Berkeley: University of California Press, 1982.

Beiner, Ronald. *What's the Matter with Liberalism?* Berkeley: University of California Press, 1992.

Bell, Clive. *Art* (1914). London: Arrow Books, 1961.

Benedict, Stephen, ed. *Public Money and the Muse: Essays on Government Funding for the Arts*. New York: W. W. Norton, 1991.

Benhabib, Seyla. *The Claims of Culture: Equality and Diversity in the Global Era*. Princeton, N.J.: Princeton University Press, 2002.

———. *Situating the Self: Gender, Community and Postmodernism in Contemporary Ethics*. New York: Routledge, 1992.

Benhabib, Seyla, and Fred Dallmayr, eds. *The Communicative Ethics Controversy*. Cambridge, Mass.: MIT Press, 1990.

Ben-Ner, Avner. "Nonprofit Organizations: Why Do They Exist in Market Economies?" In *The Economics of Nonprofit Institutions: Studies in Structure and Policy*, edited by Susan Rose-Ackerman, pp. 94–113. New York: Oxford University Press, 1986.

———. "Producer Cooperatives: Why Do They Exist in Capitalist Economies?" In *The Nonprofit Sector: A Research Handbook*, edited by Walter W. Powell, pp. 434–49. New Haven: Yale University Press, 1987.

Bialystok, Lauren. "Being Your Self: Identity, Metaphysics, and the Search for Authenticity." Ph.D. dissertation, University of Toronto, 2009.

Black, Samuel. "Revisionist Liberalism and the Decline of Culture." *Ethics* 102 (January 1992): 244–67.

Blaug, Mark. "Where Are We Now on Cultural Economics?" *Journal of Economic Surveys* 15, no. 2 (2001): 124–43.

———, ed. *The Economics of the Arts*. London: Martin Robertson, 1976.

Bolton, Richard, ed. *Culture Wars: Documents from the Recent Controversies in the Arts*. New York: New Press, 1992.

Brighouse, Harry. "Neutrality, Publicity, and State Funding of the Arts." *Philosophy and Public Affairs* 24 (Winter 1995): 35–63.

Brunkhorst, Hauke. *Solidarity: From Civic Friendship to a Global Legal Community.* Translated by Jeffrey Flynn. Cambridge, Mass.: MIT Press, 2005.

Bruyn, Severyn Ten Haut. *A Civil Economy: Transforming the Marketplace in the Twenty-first Century.* Ann Arbor: University of Michigan Press, 2000.

The Social Economy: People Transforming Modern Business. New York: Wiley, 1977.

Buchwalter, Andrew, ed. *Culture and Democracy: Social and Ethical Issues in Public Support for the Arts and Humanities.* Boulder, Colo.: Westview Press, 1992.

Calhoun, Craig. "Civil Society and Public Sphere." *Public Culture* 5 (Winter 1993): 267–80.

ed. *Habermas and the Public Sphere.* Cambridge, Mass.: MIT Press, 1992.

Carroll, Noel. "Can Government Funding of the Arts Be Justified Theoretically?" In *Public Policy and the Aesthetic Interest,* edited by Ralph A. Smith and Ronald Berman, pp. 68–82. Urbana: University of Illinois Press, 1992. Reprinted from *Journal of Aesthetic Education* 21, no. 1 (Spring 1987): 21–35.

Caust, Lesley. "Community, Autonomy and Justice: The Gender Politics of Identity and Relationship." *History of European Ideas* 17 (September 1993): 639–50.

Chambers, Simone. *Reasonable Democracy: Jürgen Habermas and the Politics of Discourse.* Ithaca, N.Y.: Cornell University Press, 1996.

Chambers, Simone, and Will Kymlicka, eds. *Alternative Conceptions of Civil Society.* Princeton, N.J.: Princeton University Press, 2002.

Chaplin, Jonathan. "'Public Justice' as a Critical Political Norm." *Philosophia Reformata* 72 (2007): 130–50.

Cherbo, Joni M., and Margaret J. Wyszomirski, eds. *The Public Life of the Arts in America.* New Brunswick, N.J.: Rutgers University Press, 2000.

Chicago, Judy. *The Dinner Party: A Symbol of Our Heritage.* Garden City, N.Y.: Anchor Books, 1979.

Cleveland, William. *Art in Other Places: Artists at Work in America's Community and Social Institutions.* Foreword by Page Smith. Westport, Conn.: Praeger, 1992.

Cohen, Jean L., and Andrew Arato. *Civil Society and Political Theory.* Cambridge, Mass.: MIT Press, 1992.

Coles, Romand. *Rethinking Generosity: Critical Theory and the Politics of Caritas.* Ithaca, N.Y.: Cornell University Press, 1997.

Collingwood, R. G. *The Principles of Art.* Oxford: Oxford University Press, 1958.

Compilation of the National Foundation on the Arts and the Humanities Act of 1965, Museum Services Act, Arts and Artifacts Indemnity Act, as Amended through December 31, 1991. Prepared for the use of the Committee on Education and Labor, U.S. House of Representatives, 102nd Cong., 2nd sess. Washington, D.C.: U.S. Government Printing Office, 1992.

Cooke, Maeve. "Authenticity and Autonomy: Taylor, Habermas, and the Politics of Recognition." *Political Theory* 25 (1997): 258–88.

"Habermas, Autonomy and the Identity of the Self." *Philosophy and Social Criticism* 18 (1992): 269–91.

Cooper, David E., ed. *A Companion to Aesthetics.* Cambridge, Mass.: Blackwell, 1992.

Crossley, Nick, and John Michael Roberts, eds. *After Habermas: New Perspectives on the Public Sphere.* Oxford: Blackwell, 2004.

Dancing in the Dark: Youth, Popular Culture, and the Electronic Media. Edited by Roy Anker. Grand Rapids, Mich.: Eerdmans, 1991.

Danto, Arthur C. "The Artworld." *Journal of Philosophy* 61 (1964): 571–84.

"From Pollock to Mapplethorpe: The Media and the Artworld." *Gannett Center Journal* 4, no. 1 (1990): 11–22.

The Transfiguration of the Commonplace. Cambridge, Mass.: Harvard University Press, 1981.

"Degenerate Art": The Fate of the Avant-Garde in Nazi Germany. Edited by Stephanie Barron. With contributions by Peter Guenther et al. Los Angeles: Los Angeles County Museum of Art, 1991.

Dewey, John. *Art as Experience.* In *The Later Works, 1925–1953,* vol. 10: *1934,* edited by Jo Ann Boydston. Carbondale: Southern Illinois University Press, 1987.

"Democracy and Education." Part I in *Problems of Men,* pp. 21–140. New York: Philosophical Library, 1946.

"Philosophies of Freedom." In *The Later Works, 1925–1953,* vol. 3: *1927–1928,* edited by Jo Ann Boydston, pp. 92–114. Carbondale: Southern Illinois University Press, 1984.

The Public and Its Problems. In *The Later Works, 1925–1953,* vol. 2: *1925–1927,* edited by Jo Ann Boydston, pp. 235–372. Carbondale: Southern Illinois University Press, 1984.

DiMaggio, Paul. "Elitists & Populists: Politics for Art's Sake." *Working Papers for a New Society,* September–October 1978, 23–31.

"Nonprofit Organizations in the Production and Distribution of Culture." In *The Nonprofit Sector: A Research Handbook,* edited by Walter W. Powell, pp. 195–220. New Haven: Yale University Press, 1987.

ed. *Nonprofit Enterprise in the Arts: Studies in Mission and Constraint.* New York: Oxford University Press, 1986.

DiMaggio, Paul, and Michael Useem. "Cultural Property and Public Policy: Emerging Tensions in Government Support for the Arts." *Social Research* 45 (Summer 1978): 356–89.

Douglas, James. "Political Theories of Nonprofit Organization." In *The Nonprofit Sector: A Research Handbook,* edited by Walter W. Powell, pp. 43–54. New Haven: Yale University Press, 1987.

Dubin, Steven C. *Arresting Images: Impolitic Art and Uncivil Actions.* New York: Routledge, 1992.

Dufrenne, Mikel. *The Phenomenology of Aesthetic Experience.* Translated by Edward S. Casey et al. Evanston, Ill.: Northwestern University Press, 1973.

Dworkin, Ronald. "Can a Liberal State Support Art?" In *A Matter of Principle*, pp. 221–33. Cambridge, Mass.: Harvard University Press, 1985.

Eberly, Don E., ed. *The Essential Civil Society Reader.* Lanham, Md.: Rowman & Littlefield, 2000.

Ehrenberg, John. *Civil Society: The Critical History of an Idea.* New York: New York University Press, 1999.

Estes, Carroll L., and Linda A. Bergthold. "The Unravelling of the Nonprofit Service Sector in the U.S." *International Journal of Sociology and Social Policy* 9, nos. 2–3 (1989): 18–33.

Featherstone, Mike. *Undoing Culture: Globalization, Postmodernism, and Identity.* London: Sage, 1995.

Feinberg, Joel. "Not with My Tax Money: The Problem of Justifying Government Subsidies for the Arts." *Public Affairs Quarterly* 8, no. 2 (April 1994): 101–23.

Ferrara, Alessandro. *Reflective Authenticity: Rethinking the Project of Modernity.* New York: Routledge, 1998.

Fischer, Marilyn. "Rawls, Associations, and the Political Conception of Justice." *Journal of Social Philosophy* 28, no. 3 (Winter 1997): 31–42.

Florida, Richard L. *The Rise of the Creative Class: And How It's Transforming Work, Leisure, Community and Everyday Life.* New York: Basic Books, 2002.

Foster, Linda Nemec. *Amber Necklace from Gdansk: Poems.* Baton Rouge: Louisiana State University Press, 2001.

ed. *A Poetry Sampler on Two Themes.* Prepared by the fourth and fifth graders of Hall Elementary School. Grand Rapids, Mich.: May 1996.

Fraser, Nancy. *Justice Interruptus: Critical Reflections on the "Postsocialist" Condition.* New York: Routledge, 1997.

Unruly Practices: Power, Discourse, and Gender in Contemporary Social Theory. Minneapolis: University of Minnesota Press, 1989.

Fraser, Nancy, and Axel Honneth. *Redistribution or Recognition? A Political-Philosophical Exchange.* Translated by Joel Golb, James Ingram, and Christiane Wilke. London: Verso, 2003.

Frey, Bruno S. *Arts and Economics: Analysis and Cultural Policy.* Berlin: Springer, 2000.

Friedman, Marilyn. *Autonomy, Gender, Politics.* Oxford: Oxford University Press, 2003.

Fullinwider, Robert K., ed. *Civil Society, Democracy, and Civic Renewal.* Lanham, Md.: Rowman & Littlefield, 1999.

Gablik, Suzi. *The Reenchantment of Art.* New York: Thames and Hudson, 1991.

Garnham, Nicholas. "The Mass Media, Cultural Identity, and the Public Sphere in the Modern World." *Public Culture* 5 (Winter 1993): 251–65.

Godelier, Maurice. *The Enigma of the Gift.* Translated by Nora Scott. Chicago: University of Chicago Press, 1999.

Gold, Richard. "No Bigness Like Show Bigness." *Variety*, June 14–20, 1989, p. 1.

Goudzwaard, Bob. *Capitalism and Progress: A Diagnosis of Western Society.* Translated and edited by Josina Van Nuis Zylstra. Grand Rapids, Mich.: Eerdmans, 1979.

Goudzwaard, Bob, and Harry de Lange. *Beyond Poverty and Affluence: Toward an Economy of Care.* Translated and edited by Mark R. Vander Vennen. Grand Rapids, Mich.: Eerdmans; Geneva: WCC Publications, 1995.

Gregory, C. A. *Gifts and Commodities.* London: Academic Press, 1982.

Gutmann, Amy. *Democratic Education.* Princeton, N.J.: Princeton University Press, 1987.

Freedom of Association. Princeton, N.J.: Princeton University Press, 1998.

Haacke, Hans. "Beware of the Hijackers!" In *Culture and Democracy: Social and Ethical Issues in Public Support for the Arts and Humanities,* edited by Andrew Buchwalter, pp. 139–53. Boulder, Colo.: Westview Press, 1992.

Habermas, Jürgen. *Between Facts and Norms: Contributions to a Discourse Theory of Law and Democracy.* Translated by William Rehg. Cambridge, Mass.: MIT Press, 1996.

"Concluding Remarks." In *Habermas and the Public Sphere,* edited by Craig Calhoun, pp. 462–79. Cambridge, Mass.: MIT Press, 1992.

"Further Reflections on the Public Sphere." Translated by Thomas Burger. In *Habermas and the Public Sphere,* edited by Craig Calhoun, pp. 421–61. Cambridge, Mass.: MIT Press, 1992.

Legitimation Crisis. Translated by Thomas McCarthy. Boston: Beacon Press, 1975.

"The Public Sphere: An Encyclopedia Article" (1964). Translated by Sara Lennox and Frank Lennox. *New German Critique,* no. 1 (Fall 1974): 49–55.

The Structural Transformation of the Public Sphere: An Inquiry into a Category of Bourgeois Society (1962). Translated by Thomas Burger and Frederick Lawrence. Cambridge, Mass.: MIT Press, 1989.

"Struggles for Recognition in the Democratic Constitutional State." Translated by Shierry Weber Nicholsen. In Charles Taylor et al., *Multiculturalism: Examining the Politics of Recognition,* edited by Amy Gutmann, pp. 107–48. Princeton, N.J.: Princeton University Press, 1994.

The Theory of Communicative Action. Translated by Thomas McCarthy. 2 vols. Boston: Beacon Press, 1984, 1987.

Toward a Rational Society: Student Protest, Science, and Politics. Translated by Jeremy J. Shapiro. Boston: Beacon Press, 1970.

Hall, Peter Dobkin. "A Historical Overview of the Private Nonprofit Sector." In *The Nonprofit Sector: A Research Handbook,* edited by Walter W. Powell, pp. 3–26. New Haven: Yale University Press, 1987.

Hanns Johst's Nazi Drama Schlageter. Translated by Ford B. Parkes-Perret. Stuttgart: Akademischer Verlag Hans-Dieter Heinz, 1984.

Hansmann, Henry. "Economic Theories of Nonprofit Organization." In *The Nonprofit Sector: A Research Handbook,* edited by Walter W. Powell, pp. 27–42. New Haven: Yale University Press, 1987.

"Nonprofit Enterprise in the Performing Arts." *Bell Journal of Economics* 12 (1981): 341–61. Reprinted in *Nonprofit Enterprise in the Arts: Studies in Mission and Constraint*, edited by Paul J. DiMaggio, pp. 17–40. New York: Oxford University Press, 1986.

"The Role of Nonprofit Enterprise." *Yale Law Journal* 89 (1980): 835–901. Reprinted in *The Economics of Nonprofit Institutions: Studies in Structure and Policy*, edited by Susan Rose-Ackerman, pp. 57–84. New York: Oxford University Press, 1986.

Harvey, David. *The Condition of Postmodernity: An Enquiry into the Origins of Cultural Change.* Cambridge, Mass.: Blackwell, 1989.

Hearn, Frank. *Moral Order and Social Disorder: The American Search for Civil Society.* New York: Aldine de Gruyter, 1997.

Hegel, G. W. F. *Elements of the Philosophy of Right.* Edited by Allen W. Wood. Translated by H. B. Nisbet. Cambridge: Cambridge University Press, 1991.

Heidegger, Martin. *Off the Beaten Track.* Edited and translated by Julian Young and Kenneth Haynes. Cambridge: Cambridge University Press, 2002.

Heilbrun, James, and Charles M. Gray. *The Economics of Art and Culture: An American Perspective.* Cambridge: Cambridge University Press, 1993.

Hein, Hilde. *Public Art: Thinking Museums Differently.* Lanham, Md.: AltaMira Press, 2006.

Held, David, and Anthony McGrew. *Globalization/Anti-Globalization.* Cambridge: Polity Press, 2002.

Hodgkinson, Virginia Ann. "Key Challenges Facing the Nonprofit Sector." In *The Future of the Nonprofit Sector: Challenges, Changes, and Policy Considerations*, edited by Virginia Ann Hodgkinson et al., pp. 4–8. San Francisco: Jossey-Bass, 1989.

Hoffman, Barbara. "Law for Art's Sake in the Public Realm." In *Art and the Public Sphere*, edited by W. J. T. Mitchell, pp. 113–46. Chicago: University of Chicago Press, 1992.

Hohendahl, Peter Uwe. "Recasting the Public Sphere." *October*, no. 73 (Summer 1995): 27–54.

Honneth, Axel. *The Fragmented World of the Social: Essays in Social and Political Philosophy.* Edited by Charles W. Wright. Albany: State University of New York Press, 1995.

The Struggle for Recognition: The Moral Grammar of Social Conflicts. Translated by Joel Anderson. Cambridge: Polity Press, 1995.

hooks, bell. *Art on My Mind: Visual Politics.* New York: New Press, 1995.

Horkheimer, Max, and Theodor W. Adorno. *Dialectic of Enlightenment: Philosophical Fragments.* Edited by Gunzelin Schmid Noerr. Translated by Edmund Jephcott. Stanford, Calif.: Stanford University Press, 2002.

Hunter, James Davison. *Culture Wars: The Struggle to Define America.* New York: Basic Books, 1991.

Hutter, Michael. "The Impact of Cultural Economics on Economic Theory." *Journal of Cultural Economics* 20 (1996): 263–8.

Hyde, Lewis. *The Gift: Imagination and the Erotic Life of Property.* New York: Vintage Books, 1979, 1980, 1983.

Jackson, Joseph, and René Lemieux. "The Arts and Canada's Cultural Policy." *Current Issue Review 93–3E.* Revised October 15, 1999. Ottawa: Library of Parliament, Parliamentary Research Branch, 1999.

James, Estelle. "How Nonprofits Grow: A Model." In *The Economics of Nonprofit Institutions: Studies in Structure and Policy,* edited by Susan Rose-Ackerman, pp. 185–95. New York: Oxford University Press, 1986.

ed. *The Nonprofit Sector in International Perspective: Studies in Comparative Culture and Policy.* New York: Oxford University Press, 1989.

Jameson, Fredric. *Postmodernism, or, The Cultural Logic of Late Capitalism.* Durham, N.C.: Duke University Press, 1991.

Kammen, Michael. *Visual Shock: A History of Art Controversies in American Culture.* New York: Alfred A. Knopf, 2006.

Kant, Immanuel. *Critique of the Power of Judgment.* Edited by Paul Guyer. Translated by Paul Guyer and Eric Matthews. Cambridge: Cambridge University Press, 2000.

Practical Philosophy. Translated and edited by Mary J. McGregor. Cambridge: Cambridge University Press, 1996.

Keane, John. *Civil Society: Old Images, New Visions.* Cambridge: Polity Press, 1998.

Global Civil Society? Cambridge: Cambridge University Press, 2003.

ed. *Civil Society and the State: New European Perspectives.* London: Verso, 1988.

Keat, Russell. *Cultural Goods and the Limits of the Market.* London: Macmillan; New York: St. Martin's Press, 2000.

Kellner, Douglas. *Television and the Crisis of Democracy.* Boulder, Colo.: Westview Press, 1990.

Kennedy, John F. "Remarks at Amherst College upon Receiving an Honorary Degree October 26, 1963." In *Public Papers of the Presidents of the United States: John F. Kennedy, 1963,* pp. 815–18. Washington, D.C.: U.S. Government Printing Office, 1964.

Klaassen, Matthew J. "Critical Theory, Feminism, and the Public Sphere." Unpublished paper. Toronto: Institute for Christian Studies, 2006.

Klamer, Arjo, ed. *The Value of Culture: On the Relationship between Economics and Arts.* Amsterdam: Amsterdam University Press, 1996.

Knight, Cher Krause. *Public Art: Theory, Practice and Populism.* Malden, Mass.: Blackwell, 2008.

Krashinsky, Michael. "Transaction Costs and a Theory of the Nonprofit Organization." In *The Economics of Nonprofit Institutions: Studies in Structure and Policy,* edited by Susan Rose-Ackerman, pp. 114–32. New York: Oxford University Press, 1986.

Kymlicka, Will. *Liberalism, Community, and Culture.* Oxford: Clarendon Press, 1989.

Multicultural Citizenship: A Liberal Theory of Minority Rights. Oxford: Oxford University Press, 1995.

Kymlicka, Will, and Wayne Norman. "Return of the Citizen: A Survey of Recent Work on Citizenship Theory." *Ethics* 104 (January 1994): 352–81.

Lacy, Suzanne, ed. *Mapping the Terrain: New Genre Public Art.* Seattle: Bay Press, 1995.

Lewis, Justin. *Art, Culture and Enterprise: The Politics of Art and the Cultural Industries.* New York: Routledge, 1990.

Lyotard, Jean-François. *The Postmodern Condition: A Report on Knowledge.* Translated by Geoff Bennington and Brian Massumi. Minneapolis: University of Minnesota Press, 1984.

MacDonald, Ann-Marie. *The Way the Crow Flies.* Toronto: Vintage Canada, 2003.

Mackenzie, Catriona, and Natalie Stoljar, eds. *Relational Autonomy: Feminist Perspectives on Autonomy, Agency, and the Social Self.* Oxford: Oxford University Press, 2000.

Macpherson, C. B. *The Rise and Fall of Economic Justice, and Other Papers.* New York: Oxford University Press, 1985.

Manning, Richard N. "Intrinsic Value and Overcoming Feinberg's Benefit Principle." *Public Affairs Quarterly* 8, no. 2 (April 1994): 125–40.

Marcuse, Herbert. *Eros and Civilization: A Philosophical Enquiry into Freud* (1955). 2nd ed. Boston: Beacon Press, 1966.

One-Dimensional Man. Boston: Beacon Press, 1964.

Marx, Karl. *Capital: A Critique of Political Economy* (1867). Vol. 1. Translated by Samuel Moore and Edward Aveling. Edited by Frederick Engels. New York: International Publishers, 1967.

Mauss, Marcel. *The Gift: The Form and Reason for Exchange in Archaic Societies.* New York: W. W. Norton, 1990.

McCarthy, Thomas. "Complexity and Democracy: The Seducements of Systems Theory." In *Ideals and Illusions: On Reconstruction and Deconstruction in Contemporary Critical Theory,* pp. 152–80. Cambridge, Mass.: MIT Press, 1991.

McGuigan, Jim. *Culture and the Public Sphere.* London: Routledge, 1996.

Rethinking Cultural Policy. Maiden Head, Berkshire, England: Open University Press, 2004.

McLellan, Andrew, ed. *Art and Its Publics: Museum Studies at the Millennium.* Oxford: Blackwell, 2003.

Meisel, John, and Jean Van Loon. "Cultivating the Bushgarden: Cultural Policy in Canada." In *The Patron State: Government and the Arts in Europe, North America, and Japan,* edited by Milton J. Cummings Jr. and Richard S. Katz, pp. 276–310. Oxford: Oxford University Press, 1987.

Merelman, Richard M. *Partial Visions: Culture and Politics in Britain, Canada, and the United States.* Madison: University of Wisconsin Press, 1991.

Miller, Toby, and George Yúdice. *Cultural Policy.* London: SAGE Publications, 2002.

Mitchell, W. J. T., ed. *Art and the Public Sphere.* Chicago: University of Chicago Press, 1992.

Möntmann, Nina, ed. *Art and Its Institutions: Current Conflicts, Critique and Collaborations.* London: Black Dog Publishing, 2006.

Mouffe, Chantal, ed. *Dimensions of Radical Democracy: Pluralism, Citizenship, Community.* London: Verso, 1992.

Mulcahy, Kevin V. "Government and the Arts in the United States." In *Public Policy and the Aesthetic Interest: Critical Essays on Defining Cultural and Educational Relations,* edited by Ralph A. Smith and Ronald Berman, pp. 6–19. Urbana: University of Illinois Press, 1992.

——— "The Public Interest in Public Culture." *Journal of Arts Management and Law* 21 (Spring 1991): 5–27. Reprinted in *Culture and Democracy: Social and Ethical Issues in Public Support for the Arts and Humanities,* edited by Andrew Buchwalter, pp. 67–87. Boulder, Colo.: Westview Press, 1992.

Mulcahy, Kevin V., and C. Richard Swaim, eds. *Public Policy and the Arts.* Boulder, Colo.: Westview Press, 1982.

Mulcahy, Kevin V., and Margaret Jane Wyszomirski, eds. *America's Commitment to Culture: Government and the Arts.* Boulder, Colo.: Westview Press, 1995.

Musgrave, Richard A. "Merit Goods." In *The New Palgrave: A Dictionary of Economics,* vol. 3, edited by John Eatwell et al., pp. 452–3. London: Macmillan, 1987.

"National Endowment for the Arts Appropriations History." http://www.nea.gov/about/Budget/AppropriationsHistory.html (accessed March 5, 2010).

The National Endowment for the Arts, 1965–2000: A Brief Chronology of Federal Support for the Arts. http://www.nea.gov/about/Chronology/NEAchronWeb.pdf (accessed June 19, 2008).

Netzer, Dick. *The Subsidized Muse: Public Support for the Arts in the United States.* Cambridge: Cambridge University Press, 1978.

Nussbaum, Martha C. *Poetic Justice: The Literary Imagination and Public Life.* Boston: Beacon Press, 1995.

Offe, Claus. *Contradictions of the Welfare State.* Edited by John Keane. Cambridge, Mass.: MIT Press, 1984.

O'Hagan, John W. *The State and the Arts: An Analysis of Key Economic Policy Issues in Europe and the United States.* Cheltenham, U.K.: Edward Elgar, 1998.

O'Neill, Michael. *The Third America: The Emergence of the Nonprofit Sector in the United States.* San Francisco: Jossey-Bass, 1989.

"Ordinary Folks Don't Care about Arts: Harper." *Toronto Star,* September 24, 2008. http://www.thestar.com/ (accessed March 6, 2009).

Oster, Sharon, and Estelle James. "Comments." In *The Economics of Nonprofit Institutions: Studies in Structure and Policy,* edited by Susan Rose-Ackerman, pp. 152–8. New York: Oxford University Press, 1986.

Ostrander, Susan A., and Stuart Langdon, eds. *Shifting the Debate: Public/Private Sector Relations in the Modern Welfare State.* New Brunswick, N.J.: Transaction Books, 1987.

Our Creative Diversity: Report of the World Commission on Culture and Development. 2nd rev. ed. Paris: UNESCO, 1996.

Peacock, Alan, and Ilde Rizzo, eds. *Cultural Economics and Cultural Policies.* Dordrecht: Kluwer, 1994.

Peters, Rebecca Todd. *In Search of the Good Life: The Ethics of Globalization.* New York: Continuum, 2004.

Pieterse, Jan Nederveen. *Globalization and Culture: Global Mélange.* Lanham, Md.: Rowman & Littlefield, 2004.

Postman, Neil. *Amusing Ourselves to Death: Public Discourse in the Age of Show Business.* New York: Viking, 1985.

Powell, Walter W., ed. *The Nonprofit Sector: A Research Handbook.* New Haven: Yale University Press, 1987.

Putnam, Robert D. *Bowling Alone: The Collapse and Revival of American Community.* New York: Simon & Schuster, Touchstone, 2000.

Raven, Arlene, ed. *Art in the Public Interest.* Ann Arbor, Mich.: UMI Research Press, 1989.

Rawls, John. *A Theory of Justice.* Cambridge, Mass.: Harvard University Press, 1971.

Ray, Larry, and Andrew Sayer, eds. *Culture and Economy after the Cultural Turn.* London: Sage, 1999.

Report of the Federal Cultural Policy Review Committee. Ottawa: Minister of Supply and Services, 1982.

Report of the Royal Commission on National Development in the Arts, Letters and Sciences, 1949–1951. Ottawa: Edmund Cloutier, 1951.

Rifkin, Jeremy. *The End of Work: The Decline of the Global Labor Force and the Dawn of the Post-Market Era.* New York: G. P. Putnam's Sons, 1995.

Robbins, Bruce, ed. *The Phantom Public Sphere.* Minneapolis: University of Minnesota Press, 1993.

Roberts, David. *Art and Enlightenment: Aesthetic Theory after Adorno.* Lincoln: University of Nebraska Press, 1991.

Rose-Ackerman, Susan, ed. *The Economics of Nonprofit Institutions: Studies in Structure and Policy.* New York: Oxford University Press, 1986.

Ross, Stephen David, ed. *Art and Its Significance: An Anthology of Aesthetic Theory.* 3rd ed. Albany: State University of New York Press, 1994.

Rubenstein, Charlotte Streifer. *American Women Artists.* Boston: G. K. Hall; New York: Avon Books, 1982.

Rushton, Michael. "Public Funding of Artistic Creation: Some Hard Questions." Regina: University of Regina, Saskatchewan Institute of Public Policy, 2002.

———. "Public Funding of Controversial Art." *Journal of Cultural Economics* 24 (2000): 267–82.

Russell, Beverly. "Artful Remodeling." *Interiors & Sources* 7, no. 78 (June 1999): 28–9.

Ryan, Bill. *Making Capital from Culture: The Corporate Form of Capitalist Cultural Production.* New York: De Gruyter, 1992.

Salamon, Lester M. *Partners in Public Service: Government-Nonprofit Relations in the Modern Welfare State.* Baltimore: Johns Hopkins University Press, 1995.

The Resilient Sector: The State of Nonprofit America. Washington, D.C.: Brookings Institution Press, 2003.

Salamon, Lester M., and Helmut K. Anheier. *Defining the Nonprofit Sector: A Cross-National Analysis.* Manchester: Manchester University Press, 1997.

The Emerging Sector Revisited: A Summary. Baltimore: Johns Hopkins University Press, 1999.

Salamon, Lester M., S. Wojciech Sokolowski, and Regina List. *Global Civil Society: An Overview.* Baltimore: Johns Hopkins University Institute for Policy Studies Center for Civil Society Studies, 2003. http://www.ccss.jhu.edu/pdfs/Books/BOOK_GCS_2003.pdf (accessed February 19, 2010).

Sandler, Irving. *Art of the Post-Modern Era: From the Late 1960s to the Early 1990s.* New York: Icon Editions, 1996.

Schafer, D. Paul, and André Fortier. *Review of Federal Policies for the Arts in Canada (1944–1988).* Ottawa: Canadian Conference of the Arts, 1989.

Schiller, Herbert I. *Culture, Inc.: The Corporate Takeover of Public Expression.* New York: Oxford University Press, 1989.

Schwartz, David T. *Art, Education, and the Democratic Commitment: A Defense of State Support for the Arts.* Dordrecht: Kluwer, 2000.

Seerveld, Calvin. *Bearing Fresh Olive Leaves: Alternative Steps in Understanding Art.* Carlisle, U.K.: Piquant, 2000.

Seligman Adam B. *The Idea of Civil Society.* Princeton, N.J.: Princeton University Press, 1995.

Sen, Amartya. "Rational Fools: A Critique of the Behavioral Foundations of Economic Theory." *Philosophy and Public Affairs* 6 (1977): 317–44.

Senie, Harriet F., and Sally Webster, eds. *Critical Issues in Public Art: Content, Context, and Controversy.* New York: HarperCollins, 1992.

Shooting Back: A Photographic View of Life by Homeless Children. Selected by Jim Hubbard. Introduction by Dr. Robert Coles. San Francisco: Chronicle Books, 1991.

Skillen, James W., and Rockne M. McCarthy, eds. *Political Order and the Plural Structure of Society.* Atlanta: Scholars Press, 1991.

Smiers, Joost. *Arts under Pressure: Promoting Cultural Diversity in the Age of Globalization.* The Hague: Hivos; London: Zed Books, 2003.

Smith, Ralph A., and Ronald Berman, eds. *Public Policy and the Aesthetic Interest: Critical Essays on Defining Cultural and Educational Relations.* Urbana: University of Illinois Press, 1992.

Smith, Steven B. *Hegel's Critique of Liberalism: Rights in Context.* Chicago: University of Chicago Press, 1989.

Snow, C. P. *The Two Cultures and A Second Look.* Cambridge: Cambridge University Press, 1965.

Standing Committee on Canadian Heritage, House of Commons. *A Sense of Place, a Sense of Being: The Evolving Role of the Federal Government in Support of Culture in Canada; Ninth Report.* Ottawa: Committee on Canadian Heritage, 1999.

Steiner, Wendy. *The Scandal of Pleasure: Art in an Age of Fundamentalism.* Chicago: University of Chicago Press, 1995.

Storkey, Alan James. *Foundational Epistemologies in Consumption Theory.* Amsterdam: VU University Press, 1993.

Taylor, Charles. *The Ethics of Authenticity.* Cambridge, Mass.: Harvard University Press, 1992.

"Invoking Civil Society." In *Philosophical Arguments*, pp. 204–24. Cambridge, Mass.: Harvard University Press, 1995.

"Irreducibly Social Goods." In *Philosophical Arguments*, pp. 127–45. Cambridge, Mass.: Harvard University Press, 1995.

"Liberal Politics and the Public Sphere." In *Philosophical Arguments*, pp. 257–87. Cambridge, Mass.: Harvard University Press, 1995.

Sources of the Self: The Making of the Modern Identity. Cambridge, Mass.: Harvard University Press, 1989.

"What's Wrong with Negative Liberty." In *Philosophy and the Human Sciences: Philosophical Papers 2*, pp. 211–29. Cambridge: Cambridge University Press, 1985.

Taylor, Charles, et al. *Multiculturalism: Examining the Politics of Recognition.* Edited by Amy Gutmann. Princeton, N.J.: Princeton University Press, 1994.

Taylor, Paul. "Authenticity and the Artist." In *A Companion to Aesthetics*, edited by David E. Cooper, p. 29. Cambridge, Mass.: Blackwell, 1992.

Thiebaut, Carlos. "The Logic of Autonomy and the Logic of Authenticity: A Two-Tiered Conception of Moral Subjectivity." *Philosophy and Social Criticism* 23, no. 3 (1997): 93–108.

Thompson, John B. "The Theory of the Public Sphere." *Theory, Culture & Society* 10 (1993): 173–89.

Throsby, C. D., and G. A. Withers. *The Economics of the Performing Arts.* New York: St. Martin's, 1979.

Throsby, David. *Economics and Culture.* Cambridge: Cambridge University Press, 2001.

"The Production and Consumption of the Arts: A View of Cultural Economics." *Journal of Economic Literature* 32 (March 1994): 1–29.

Tocqueville, Alexis de. *Democracy in America.* Edited and translated by Harvey C. Mansfield and Delba Winthrop. Chicago: University of Chicago Press, 2000.

Towse, Ruth. "Achieving Public Policy Objectives in the Arts and Heritage." In *Cultural Economics and Cultural Policies*, edited by Alan Peacock and Ilde Rizzo, pp. 143–65. Dordrecht: Kluwer, 1994.

Trend, David. *Cultural Democracy: Politics, Media, New Technology.* Albany: State University of New York Press, 1997.

Trilling, Lionel. *Sincerity and Authenticity.* Cambridge, Mass.: Harvard University Press, 1972.

Van Til, Jon. *Growing Civil Society: From Nonprofit Sector to Third Space.* Bloomington: Indiana University Press, 2000.

Mapping the Third Sector: Voluntarism in a Changing Social Economy. Washington, D.C.: Foundation Center, 1988.

Wallas, Graham. *The Great Society: A Psychological Analysis.* London: Macmillan, 1914.

Walzer, Michael. "The Civil Society Argument." In *Dimensions of Radical Democracy: Pluralism, Citizenship, Community*, edited by Chantal Mouffe, pp. 89–107. New York: Verso, 1992.
Spheres of Justice: A Defense of Pluralism and Equality. New York: Basic Books, 1983.
Thick and Thin: Moral Argument at Home and Abroad. Notre Dame, Ind.: Notre Dame University Press, 1994.
Warren, Mark E. *Democracy and Association*. Princeton, N.J.: Princeton University Press, 2001.
Weisbrod, Burton A. *The Nonprofit Economy*. Cambridge, Mass.: Harvard University Press, 1988.
"Non-profit Organizations." In *The New Palgrave: A Dictionary of Economics*, vol. 3, edited by John Eatwell et al., pp. 677–8. New York: Stockton Press, 1987.
"Toward a Theory of the Voluntary Non-profit Sector in a Three-Sector Economy." In *The Economics of Nonprofit Institutions: Studies in Structure and Policy*, edited by Susan Rose-Ackerman, pp. 21–44. New York: Oxford University Press, 1986.
The Voluntary Nonprofit Sector: An Economic Analysis. Lexington, Mass.: Lexington Books, 1977.
Wellmer, Albrecht. "Models of Freedom in the Modern World." In *Hermeneutics and Critical Theory in Ethics and Politics*, edited by Michael Kelly, pp. 227–52. Cambridge, Mass.: MIT Press, 1990.
West, Cornel. *Keeping Faith: Philosophy and Race in America*. New York: Routledge, 1993.
Westbrook, Robert B. *John Dewey and American Democracy*. Ithaca, N.Y.: Cornell University Press, 1991.
Williams, Raymond. *Keywords: A Vocabulary of Culture and Society*. Rev. and exp. ed. London: Fontana, Flamingo, 1983.
Wolterstorff, Nicholas. *Art in Action*. Grand Rapids, Mich.: Eerdmans, 1980.
Woolf, Virginia. *To the Lighthouse*. New York: Harcourt, Brace, 1927, 1955.
Wyman, Max. *The Defiant Imagination: Why Culture Matters*. Vancouver: Douglas & McIntyre, 2004.
Zemans, Joyce. *Where Is Here? Canadian Cultural Policy in a Globalized World*. Toronto: York University, Robarts Centre for Canadian Studies, 1996, 1997.
Zuidervaart, Lambert. *Adorno's Aesthetic Theory: The Redemption of Illusion*. Cambridge, Mass.: MIT Press, 1991.
Artistic Truth: Aesthetics, Discourse, and Imaginative Disclosure. Cambridge: Cambridge University Press, 2004.
"Creative Border Crossing in New Public Culture." In *Literature and the Renewal of the Public Sphere*, edited by Susan VanZanten Gallagher and Mark D. Walhout, pp. 206–24. London: Macmillan; New York: St. Martin's Press, 2000.

"Postmodern Arts and the Birth of a Democratic Culture." In *The Arts, Community and Cultural Democracy*, edited by Lambert Zuidervaart and Henry Luttikhuizen, pp. 15–39. London: Macmillan; New York: St. Martin's Press, 2000.

Social Philosophy after Adorno. Cambridge: Cambridge University Press, 2007.

Zuidervaart, Lambert, and Henry Luttikhuizen, eds. *The Arts, Community and Cultural Democracy*. London: Macmillan; New York: St. Martin's Press, 2000.

Index

discourse principle, 212
distributional inequity, 29
Dufrenne, Mikel, 256
Dworkin, Ronald, 51, 59–67, 68, 69, 72, 73, 80, 81

economic society, 97
efficiency arguments, 25–9, 35, 59, 294
Eisner, Michael, 267
Eley, Geoff, 105
elitism, 65, 71, 75
Ellul, Jacques, 201
enlightenment, 211
equity arguments, 29–31, 35, 59, 69, 295
equity in access, 29–31
expert cultures, 183
exploration, 225
expression, 221
external benefits, 25–7, 29, 35, 45, 46, 60, 68

Feinberg, Joel, 52–6, 68, 69, 71–2
feminism, 215, 275, 278
formalism, 125, 272, 290
Foster, Linda Nemec, 243–6, 265
Fraser, Nancy, 101–8, 110, 124, 127, 285, 297
freedom, 281–2
 artistic, 19–20
freedom of expression, 8
free-rider problem, 135
Frey, Bruno, 24
Frost, Robert, 49
futurity, 273

Gablik, Suzi, 254
Gioia, Dana, 312
globalization, 28, 171–5, 299
good, 35, 37–8, 50–1, 55–6, 111. *See also* cultural meta-goods; merit goods; private goods; public goods; social goods
Goudzwaard, Bob, 163, 284–5, 314
government failure, 133–5, 149

Gray, Charles, 33–4
Gutmann, Amy, 74

Haacke, Hans, 11
Habermas, Jürgen, 70, 84, 92, 96, 97, 99, 101–2, 104, 108–10, 116–18, 121, 123, 124, 127, 147, 157, 177, 178, 188, 209–20, 227, 236–40
Hansmann, Henry, 133, 135–8, 142, 144
Harper, Stephen, 4, 21
Harvey, David, 286–7
Heartwell, George, 196, 199
Hegel, G. W. F., 95, 97–9
Heibrun, James, 33–4
Heidegger, Martin, 293
Hein, Hilde, 119–26, 127, 297
Helms, Jesse, 3, 21
Horkheimer, Max, 211
Hubbard, Jim, 250
hypercommercialization, 177–82, 190, 291, 299, 314

imagination, 225
imaginative cogency, 221, 225, 227, 228
imaginative disclosure, 47, 84, 85, 127, 188, 226–8, 229, 231, 297, 301, 314
institutional deficit, 116–19
institutional pluralism, 70
instrumentalism, 50–1, 69, 73, 295
 minimal, 56–9, 69
 robust, 59–67, 68, 69
integrity, 226, 258
intergenerational equity, 58–9, 63
intracultural benefits argument, 60–1
intrinsic benefits. *See* intracultural benefits argument
intrinsic value, 53–6, 68

James, Estelle, 137–8, 144
Jameson, Fredric, 186
Jeantet, Thierry, 152

CPSIA information can be obtained at www.ICGtesting.com
Printed in the USA
LVOW13s1146271113

362938LV00003B/268/P